PRAISE FOR SAM WELLER AND
The Bradbury Chronicles

"An intimate and thorough vicarious journey. . . . Bradbury's life has been fascinating, and Weller has done a comprehensive job of narrating it. . . . Weller does an amazing job of tying Bradbury's memories to the plots and themes of many of his stories. Rating: A–"
—*Rocky Mountain News*

"Excellent. . . . [A] detailed but lively book. . . . Both admiring and honest. . . . [An] impressive biography."　　　—*National Review*

"[I]f *The Bradbury Chronicles* is exhaustive, it is never exhausting, and each anecdote adds light and color to the portrait [Weller] has painted of a writer of real accomplishment. By the end of the book, we are able to see the inner workings of the remarkably imaginative mind ticking away inside Bradbury's best-loved work."　　　—*Los Angeles Times*

"*The Bradbury Chronicles* [is] something rarely seen in the world of biography: an authorized, totally readable, fantastic story of a man's unique life."　　　—Bookslut.com

"Bradbury granted literary journalist and lifelong fan [Sam] Weller unprecedented access to his private life and private archive, and Weller has repaid the favor with a compulsively readable account of an exceptionally prescient, innovative, eccentric, and dedicated writer who has electrified the imaginations of generations of readers."
—*Booklist* (starred review)

"The first major and most welcome biography [of Ray Bradbury]. . . . A fine limning of the life."　　　—*Boston Globe*

THE
BRADBURY
CHRONICLES

THE LIFE OF RAY BRADBURY

THE
BRADBURY
CHRONICLES

SAM WELLER

HARPER PERENNIAL

NEW YORK ● LONDON ● TORONTO ● SYDNEY

HARPER ● PERENN...

Unless otherwise credited, all photographs courtesy of Ray Bradbury.

A hardcover edition of this book was published by William Morrow, an imprint of Harper-Collins Publishers.

P.S.™ is a trademark of HarperCollins Publishers.

HarperCollins books may be purchased for educational, business, or sales promotional use. For information please write: Special Markets Department, HarperCollins Publishers, 10 East 53rd Street, New York, NY 10022.

First Harper Perennial edition published 2006.

Designed by Judith Stagnitto Abbate / Abbate Design

The Library of Congress has catalogued the hardcover edition as follows:

Weller, Sam.
 The Bradbury chronicles : the life of Ray Bradbury /
 Sam Weller.— 1st ed.
 p. cm.
 Includes bibliographical references and index.
 ISBN 0-06-054581-X
 1. Bradbury, Ray, 1920– 2. Science fiction, American—History and criticism.
3. Authors, American—20th century—Biography. 4. Science fiction—Authorship.
I. Title.

PS3503 R167Z94 2005
813'.54—dc22

 2004059491

ISBN-10: 0-06-054584-4 (pbk.)
ISBN-13: 978-0-06-054584-0 (pbk.)

06 07 08 09 10 ❖/RRD 10 9 8 7 6 5 4 3 2 1

TO RAY
LIVE FOREVER

Jump off the cliff and build your wings on the way down.

—RAY BRADBURY

CONTENTS

**THE
BRADBURY
CHRONICLES**

INTRODUCTION

LIKE MANY in my generation, I am a lifelong, card-carrying member of the Intergalactic, Time-traveling, Paleontology, Mummies, Martians, Jack-o'-Lanterns, Carnivals, and Foghorn-coveting Ray Bradbury fan club.

But truth be told, Ray Bradbury belongs to all generations, not just my own. The G.I. Generation, for example—veterans of World War Two, read Ray Bradbury's early pulp magazine stories on the muddy battlefields of war-ravaged Europe. Baby Boomers blasted off to Mars with *The Martian Chronicles,* stumbled into the freak show tent with *The Illustrated Man,* and ran across the grassy fields of Green Town, Illinois, in *Dandelion Wine.* And they didn't just read his stories, they listened to them over the nighttime airwaves, as Ray Bradbury became a fixture in dramatic radio. Generation X discovered Ray Bradbury all over again, reading his lyrical prose in junior high and high school literature classes. More important, we read his stories when we *weren't* in school. Those tales of stainless steel rocket ships and of a fireman who burned books in a dark, dystopian world were at once brilliant, luminous, and, to wax Gen-X eloquent, incredibly cool.

A new generation is claiming Ray Bradbury yet again. This time as a legend, an American literary icon who has taken his place in the pantheon occupied by the ghosts of literature past, Shakespeare, Melville, Dickens, Poe. Certainly, some critics in the literati might scoff at the very notion that Bradbury, a so-called writer of "science fiction," is even

in the pantheon at all. But these critics have long since missed the rocket ship, they hardly appreciate Ray Bradbury's metaphors, his musical language, and most important, the myths he has created. Indeed, they have mislabeled Ray Bradbury altogether. He is much, much more than simply a science fiction author, as his life story illustrates.

The millennium babies will discover Ray Bradbury for themselves the way we all have—by picking up his books. And it is certain that this new generation will lionize him for themselves, in their own way, because he belongs to all the generations. So many of us are members of the fan club.

I suppose I joined while I was still in the womb, when my father read Bradbury aloud to my pregnant mother in 1967. Eleven years later, I read my first Bradbury book, a frayed paperback copy of *The Illustrated Man* I found on my father's bookshelf. On the cover of the book was a painting of the Illustrated Man himself, sitting naked on a wooden crate, his tattooed back to the viewer. The landscape around him was eerie, dreamlike, molten red. I remember staring at that cover endlessly. Every year after that, under every glowing Christmas tree, my father made sure there were Ray Bradbury books wrapped up all shiny, waiting to be opened, waiting to be read. To my mother's delight, I often had my nose buried in books.

In my early twenties, I found myself back home in Illinois caring for my mother, who was dying of cancer. My parents had separated, my older siblings moved away. I was in that house with all that illness and all that sorrow and my mother, in her early fifties, was struggling to live. She was able to sleep only a few hours at a time, and in those rare moments of peace, I would retreat into my bedroom. I remember a winter night, as I was looking out my window, large, wispy snowflakes drifted down, illumined by the glow of street lamps. It was then that I first listened to an audiobook copy of Ray Bradbury's *The Toynbee Convector*. I put the tape in my small cassette player and, with the lights off, listened to Ray Bradbury, in his comforting voice, read his own words. It was pure magic and so very cathartic for my soul, which enjoyed a brief respite from my mother's illness and all that sadness. There was a profound melancholy to one of the tales—"Bless Me, Father, For I Have Sinned," and in that moment, I felt a kinship. I was not alone. *I was not alone.*

Is that not what good storytelling is? To help us to relate? To help us understand the universal truths? To me this prose poet saw beauty in sorrow.

Eight years after my mother passed away in 1992, this book was born. I was at the Tribune Tower, pitching stories to the editor of the *Chicago Tribune Magazine*. I proposed a celebratory profile of Illinois's native son, stepchild of Mars, Ray Douglas Bradbury, the gatekeeper to that chimerical underworld known as "the October Country," Librarian Emeritus for the Athenaeum of the Imagination. My favorite author was turning eighty that year. What better time to recap his amazing life? My editor approved the story, and I was off to Los Angeles to visit Ray at his home, a sprawling, multilevel house painted, quite appropriately, dandelion yellow. As I bounded the dozen or more stone steps up to the front door, skittish cats darted out from the surrounding shrubbery. The doormat at the top of the steps was silk-screened with images of carved Halloween pumpkins hollering "Boo!"

When the Bradburys' longtime maid escorted me into the foyer, the first thing I noticed was the painting. It was the original molten artwork from the paperback cover of *The Illustrated Man* that I had so loved as a teenager. I had arrived.

The man I encountered on that fine Los Angeles afternoon on Memorial Day weekend in the year 2000 was nothing short of miraculous. Since his stroke seven months earlier, he moved cautiously. Physically, this great, jolly blurt of a man had been slowed down. But here he was, hobbling to and fro with the use of a four-pronged cane, talking at light speed, pontificating, philosophizing, positing solutions for the future of all humankind, and, most of all, referencing the past with reverie and respect. I thought this man was a great contradiction, a beautiful paradox. He wrote of the far future, but did it with the machines of old, cog-and-gear ironclad throwbacks to Wells and Verne; he wrote of the far past with a pained longing, as if to tell us all that our future would only be well served if we looked to yesteryear. Indeed, he was a contradiction. Ray Bradbury was a nostalgic visionary: He predicted the past and remembered the future.

The Bradbury house was a veritable shrine filled with what Ray liked to call his "metaphors." These were the symbols, the charms, *"the*

talisman," he said with a laugh, of his life and career. Each room was jammed wall-to-wall with the runoff of Ray's staggering collection of everything under the sun and the moon and, for that matter, Mars. That afternoon, gold-dusted sunlight beamed in through wide, white wooden shutters, illuminating a Tutankhamen-like realm of Bradburian treasure. The original cover artwork to the first edition of *Fahrenheit 451,* drawn by Ray's old friend and collaborator Joseph Mugnaini, hung on one wall. Lucite awards and shiny metal statuettes, accolades gathered over the decades, lined the fireplace mantel in the living room. In a hallway, just a few months after my visit, Ray would place the lifetime achievement medal he received in November 2000 from the National Book Foundation for his Contribution to American Letters, affirmation of his transcendence into mainstream literature. In a closet sat a thick stack of acetate animation cels, hand-painted originals from *Dumbo, Cinderella, Pinocchio,* and many other Disney classics given to Ray personally from none other than Walt Disney. Virtually every flat surface, every table and chair in the house, was piled high with mountainous stacks of papers, old photographs, story starts, newspaper articles, manuscripts, and plastic milk crates holding countless files. There were toys in every room, too: Giant stuffed animals perched on sofas; tin rocket ships and windup robots waited in corners to come to mechanized life. And in nearly every room, built-in bookcases groaned under the tremendous weight of thousands and thousands of books.

Sitting in the house for the better part of an afternoon, I watched and listened with incredulity. Part Peter Pan, part percipient sensei, this man, seventy-nine at the time, had the energy of a herd of stampeding tyrannosaurs. He was finishing two novels, a chapbook, a collection of short stories, a complete collection of his poetry, as well as numerous essays and theatrical plays. He was a creative juggernaut. He loved life and living and wanted to take full advantage of his remaining days. He yearned for life with a yearning the likes of which I had never before encountered and doubt I ever will again. He was in a constant sprint against mortality, striving to complete one project after another. But more impressive than his prolificacy was his outlook.

"If you start every day saying, 'I'm going to lose,' what kind of a day is that?" he asked, living his own words as an "optimal behaviorist."

"I don't believe in optimism," he explained. "I believe in optimal be-havior. That's a different thing. If you behave every day of your life to the top of your genetics, what can you do? Test it. Find out. You don't know what you can do. You haven't done it yet. So that's optimal behavior. And when you behave that way you have a feeling of optimism. You see, there's a difference. Not to be optimistic, but to behave optimally. At the top of your lungs shout and listen to the echoes."

Ray Bradbury and I hit it off almost immediately. Ray liked that I had read all his works. He never cared for fame or fortune, and he cer-tainly disliked the word "celebrity." What fueled him on was admiration and appreciation. When strangers approached and told him, "You changed my life," he often cried. This was the case on December 14, 2001, the day Los Angeles mayor James K. Hahn pronounced "Ray Bradbury Day." When the festivities at City Hall were over, and Ray was headed home, a disabled man emerged from the crowd and said, "Thank you for changing my life." Ray was profoundly moved. At the 2003 San Diego International ComicCon, I was pushing Ray in his wheelchair when from the sea of conventioneers, a young African-American man approached Ray and knelt down at his side. "I grew up in South Cen-tral," he said. "But I never joined a gang. Because I had you. You and Asi-mov and Clarke. *You* were my gang. Thank you." Ray's eyes filled with tears when the young man shook his hand and walked off, disappearing into the flowing crowd.

On the day of my first visit to Ray's house, I told him my own story, how he had first nurtured my imagination, then, later, how he had brought me comfort in the darkest time in my life, when my mother was dying. More than anything, Ray reveled in the idea that he had somehow affected, changed, altered the course of, or made better the lives of his readers.

We hit it off for other reasons, too. Having grown up in the same re-gion, we both had northern Illinois mud under our fingernails. When we talked of the color of Midwest sunlight in September we both under-stood and smiled. When Ray learned that I had published an essay in a Chicago alternative weekly on John McCutcheon's 1912 paean to late autumn, "Injun Summer," he rummaged through a stockpile of bric-a-brac in a side room and produced a framed copy of McCutcheon's short story and cartoon.

I would like to think that Ray saw in me an enthusiasm that mirrored his own. We both reveled in the wonderment of ideas. We both loved the initial stages of story conception, and, as writers, shared a belief that good story is everywhere: One just has to, as Ray would say, "witness and celebrate" it.

On that first visit, I also met Ray's wife of more than a half century, Marguerite Bradbury. She emerged from a back room of the house, wearing a blue housecoat and a pair of slippers, and in her raspy, nicotine voice said, "I have ears like a cat and I have been listening to your entire interview." She went on to say that she was impressed, that she'd found the questions intriguing. In the years that followed, over the course of the hundreds of hours of conversations I had with Maggie Bradbury, we forged a close, tender relationship. And I became acutely aware that Maggie's support, belief, and hard work enabled Ray's early career to blast off. Ray was the first to admit that Maggie was the intellectual of the duo. Fluent in four languages, she was a voracious reader, a lover of history books, mysteries, biographies and, most of all, the works of Marcel Proust. The day of my first visit, I spotted Maggie reading a biography of Proust in French. In my frequent trips to Los Angeles, I also had the privilege of meeting Ray and Maggie's four daughters and their eight grandchildren. All of them welcomed me into their midst without hesitation, with generosity and kindness.

When that initial interview in 2000 was over, Ray invited me to call him. He gave me his fax number and told me to write. We stayed in touch, fostering a weekly correspondence. A few months later, I was in Los Angeles again and paid him a visit. Within six months, the idea for this book was hatched. As a journalist, college professor, and Bradbury researcher, I was dumbfounded to discover that no full-fledged biography of Ray Bradbury existed. "I have too much life left to live," Ray reasoned, stating that a biography constitutes the bookends of life and his final bookend was a long, long ways off.

In the months that followed, as Ray and I exchanged letters and talked, I was able to convince him that a Bradbury biography was long past due. His story needed to be told. One day, over lunch at the Pacific Dining Car in Santa Monica, he agreed, and from that day forward every three or four weeks, I flew from Chicago to Los Angeles and spent some

of the most magical times imaginable, listening to a man whose life is nothing short of astounding. We drove around Los Angeles in his limousine, dining late into the night in Chinatown. We went to his plays, produced by his own company, the Pandemonium Theatre. I watched him lecture to captivated audiences at libraries and in churches and before civic groups. I accompanied him to book signings all over Southern California. We went often into Hollywood, where, one bright day, he turned to me and said, "Do you want to see my star?" We laughed at how absurd and even egomaniacal it sounded, and then went to stand over his star on the Hollywood Boulevard Walk of Fame, given him on April 1, 2002. He guided me through the Hollywood Forever cemetery, where he used to wander as a teenager—at play among the granite pillars of Hollywood's old guard. We drove downtown and admired the architecture of the new Disney Concert Hall, a muscular monolith deftly integrated into the surrounding cityscape. The building's design evoked the forward-thinking structures of the World's Fairs of Ray Bradbury's childhood—futuristic, inventive, everlasting.

On other days, we drove to Ray's vacation home in Palm Springs. We dined on Mexican food, all the while clocking thousands of hours of interviews that surveyed all eras of this man's life story.

For his eighty-third birthday, my wife and I joined Ray as the Planetary Society threw a birthday celebration in his honor. The special gift that evening was celestial in scope. The planet Mars—mythologized in Ray's timeless book *The Martian Chronicles*—was drawing some 34.6 million miles toward Earth, the closest the Red Planet has been to us in nearly 60,000 years.

On still another night, Halloween 2003, I sat with Ray and his youngest daughter, Alexandra, and carved pumpkins well into the evening as a torrential rainstorm cooled the sunbaked streets of Los Angeles. Halloween was always Ray's favorite holiday, an appreciation he had developed as a child from his beloved aunt Neva—his greatest creative mentor. Even as an octogenarian, Ray still reveled in the ritual of All Hallows' Eve.

There were many other special occasions. We made annual summer pilgrimages to the San Diego comic book convention. During our first trip in 2001, Ray found and bought a comic book adaptation of Marcel

Proust's *Remembrance of Things Past* for Maggie, knowing that she would roll her eyes and curse under her breath that her beloved Proust had been adapted into that most lowly of narrative forms—the comic strip. We brought it home and she had a good laugh.

From my initial meeting with Ray Bradbury in 2000, I have spent countless privileged days with this American icon, discovering the personal, human side to a man who has been a household name for decades in well-read households around the world. I discovered a few random Ray Bradbury personality traits that illuminate the very private side to the very public man.

He has an insatiable appetite for sweets; Clark Bars are his favorite. At restaurants, for dessert, he always orders vanilla ice cream with chocolate sauce, even if it is not on the menu. One day while dining in a Paris café with Maggie, Ray ordered his usual. The waiter dutifully agreed to deliver the dessert, only to find he had none of the ingredients on hand. Panic-stricken, the waiter sent a restaurant staffer into the center of Paris to a renowned ice creamery. An inordinate amount of time lapsed, and, just as the Bradburys were ready to give up and leave, the dessert arrived, having traveled halfway across Paris, down cobblestoned backstreets and heavily trafficked thoroughfares.

Other interesting asides: Ray Bradbury has never driven a car, yet there is a chocolate brown 1971 Jaguar sitting in his garage; Maggie was the family driver. Ray resists taking medicine. When he has a headache, he favors self-hypnosis. He does not read other science fiction and fantasy writers. "I don't want to inadvertently steal from them," he states. As for religion, he does not believe in anthropomorphizing God. "It's too limiting," he says. "This universe is all such a great mystery. We just don't know how it was created." But he does have his own theory. "It's always been here. Why not? That's just as plausible as the big bang."

Though Maggie whispered on the side one day that his favorite book is *Dandelion Wine*, he claims not to have a favorite book from among his own work. "They are all my children," he proclaims. "You can't pick favorites when it comes to children."

Ray has a boisterous sense of humor—something that comes as a surprise to those who expect the author of *Fahrenheit 451* to be a brooding, dark, and paranoid visionary. Late one night, arriving home at two

A.M., we got out of his limousine and Ray was, as usual, telling a story, all arms and hands and booming voice. He was laughing as he talked. Across the street, a neighbor's window cranked open and a dark figure peered out, yelling into the night, "Shut up!" Imagine, telling Ray Bradbury to shut up. Ray laughed and we went upstairs, noisy and clamorous as ever.

He doesn't much like profanity. He was raised in a household and a time when bars of soap were regularly inserted into foul mouths for sinful utterances. But as the years went on, he grew more comfortable with the occasional curse employed for dramatic effect. Even then, he only cursed in rare instances, such as the time he was lecturing at a local university and a literature class tried to tell him what *Fahrenheit 451* was really about. They were wrong and he told them so. But they insisted that they were right. "No, you're wrong," he said. It went back and forth like this for some time, a lit-crit Ping-Pong volley, until, finally, incensed that the professor and his students thought they knew more about the work than the author who created it, Ray told them all to F-off. Afterward, angered, he stomped out of the room.

While he may not often curse, Ray Bradbury does cry. Often. Tears of joy. Tears of sorrow. He cries when watching the news; he cries when people say kind things to him; he cries when recalling fond memories. Sometimes he cries several times a day. He is not afraid to express deep emotion. He is an unabashed sentimentalist. He is also fun, generous, gregarious, temperamental, brilliant. In my estimation, he is a genius, one whose formal education ended at high school, but who went on to educate himself at the Los Angeles Public Library.

But more than anything else, Ray Bradbury was a child born and bred on popular culture who himself went on to leave an indelible tattoo on popular Americana. Short stories. Novels. Radio. Comic books. Movies. Television. The stage. Architecture and design. Arguably, no other twentieth-century literary figure can claim such sweeping cultural impact. This book charts that influence, and in the process, it answers the one question Ray Bradbury is asked most often: "Where do you get your ideas?"

This is the epic tale of a twentieth-century icon, a man beloved by multiple generations, whose fans number in the millions, myself just one

of them. But because I *am* a fan, and Ray had given his blessing for this biography, the inevitable question arises concerning objectivity. The memories in *The Bradbury Chronicles* are Ray Bradbury's. On rare occasions, research contradicted his memories, and these instances are duly noted. In the course of my interviews with Ray, his family, friends, and collaborators, as well as the research that took me through the files of the Federal Bureau of Investigation, to university collections, to Ray's own private vaults, not once did he interfere, make suggestions, or insist on reading the manuscript. He knew and respected my commitment to telling the complete story of his life.

And here it is: the life of Ray Bradbury. Whether you are already a member of the fan club or you are just joining, it's an amazing rocket ride.

—SAM WELLER
Chicago, Illinois
Summer 2004

1

REMEMBRANCE OF THINGS PAST

*Ray Bradbury's most significant contribution to our culture is show-
ing us that the imagination has no foreseeable boundaries. His skills as a storyteller
have inspired and empowered generations to tell their stories no matter how bizarre
or improbable. Today we need Ray Bradbury's gifts more than ever, and his stories
have made him immortal.*

—STEVEN SPIELBERG, *Academy Award–winning director*

"I REMEMBER the day I was born."

With this Dickensian flourish, so begins the life story of Ray Brad-
bury. The birth recollection was one of Ray's favorite stories to tell. Not
surprisingly, it often provoked audible incredulity from his audiences—
whether one person or a room full of Bradbury devotees.

"I have what might be called almost total recall back to my birth," he
continued. "This is a thing I have debated with psychologists and with
friends over the years. They say, 'It's impossible.' Yet I remember."

This much is certain: Ray Douglas Bradbury arrived in the world, in
Waukegan, Illinois, at 4:50 P.M. on August 22, 1920, with Dr. Charles
Pierce presiding at Maternity Hospital, a few blocks west of the small
Bradbury family home. Ray had overstayed his time in the womb by a
month, and it was his theory that the additional incubation time may
have heightened his senses. "When you stay in the womb for ten

months, you develop your eyesight and your hearing. So when I was born, I remember it," he insisted. And who is to argue?

"Born to Mr. and Mrs. Leo Bradbury, 11 South St. James Street, a son," proclaimed the birth announcement in the *Waukegan Daily Sun*. Although the name on his birth certificate was spelled *"R-a-y,"* Ray said he was originally given the name "Rae" after Rae Williams, a cousin on his father's side, and that it was not until the first grade that, at a teacher's recommendation, his parents changed the spelling of his first name. The name was too feminine, the teacher said, and the boy would be teased.

The origin of his middle name, however, is not in dispute. Ray's mother, a great cinema fan who would soon pass this love on to her son, chose his middle name, Douglas, for the swashbuckling screen star Douglas Fairbanks.

Of his birth, Ray claimed to remember "the camera angle" as he emerged into the world. He recalled the terrific pain of being born, the sensation of going from darkness to light, and the desperate desire to remain enshrouded in the shadowy realm of the womb. Lending further Freudian fodder to skeptical developmental psychologists everywhere, Ray added, "I remember suckling, the taste of my mother's breast milk, and nightmares about being born experienced in my crib in the first weeks of my life."

Two days after the birth, Ray recalled his first encounter with real fear. His father wrapped him in a blanket and carried him into downtown Waukegan. They climbed a dark stairwell and entered a second-floor doctor's office. Ray remembered the bright, otherworldly light and the cold tiled room and what he would later realize was the scent of Lysol. He distinctly recalled the milk-white ghost face of a doctor holding a stainless steel scalpel. And then he felt the sharp pain of circumcision.

Many years later, a friend of Ray's, the author, critic, and editor of the *Magazine of Fantasy and Science Fiction,* Anthony Boucher, remarked that Ray Bradbury had a "back to the womb complex." Ray responded, with typical Bradburian aplomb, "Yes . . . but whose womb?"

THE BIRTHPLACE of Ray Bradbury, Waukegan, Illinois, is perched on the edge of a gently rising bluff that overlooks the slate-green waters of Lake Michigan. The city stands some forty miles north of downtown Chicago, as the raven flies. Centuries ago, this land was densely forested. Carved at the end of the ice age by melting glaciers that scored the soft heartland soil, it is marked by deep ravines that scar the landscape, eventually opening out into Lake Michigan. While the land to the west of the city is level farmland, Waukegan, with these dramatic, densely forested ravines, coldwater creeks, and the bluff the city stands on, offers a gentle contrast to the popular image of table-flat American heartland.

Today, Waukegan is a city at a crossroads. The turn-of-the-century grandeur of this lakefront community has given way to a long economic decline. In Ray's childhood, the Waukegan lakefront, with its sandy beaches, was a popular destination, vibrant and crowded with people. On warm summer days, it bloomed with colorful parasols, and men, women, and children swam in the cool lake. But decades passed and the crown jewel of Waukegan, its beachfront, shriveled under industry and pollution. Though the factories are mostly abandoned today, they still stand, like rust-laden skeletons on cold winter days as the winds gust in off Lake Michigan. Downtown Waukegan has also changed. Storefronts stand vacant; For Lease signs are propped up in many window displays. While some of the wealthiest suburbs in the nation are nestled on the lakefront between Waukegan and Chicago, Waukegan remains peculiar in its decaying isolation, an aging town with a rich history and the high hopes of future revitalization.

Ray Bradbury's connections to fantasy, space, cinema, to the macabre and the melancholy, were all born of his years spent running, jumping, galloping through the woods, across the fields, and down the brick-paved streets of Waukegan. His lifelong love of comics was born here, along with his connection to magic and his symbiotic relationship to Halloween. Although he moved away from the Midwest for good at the age of thirteen, Ray Bradbury is a prairie writer. The prairie is in his voice and it is his moral compass. It is his years spent in Waukegan, Illinois—later rechristened by Ray as "Green Town" in many books and stories—that forever shaped him.

In his fiction, from *Something Wicked This Way Comes* to the semi-autobiographical *Dandelion Wine* and its unpublished sequel, *Farewell Summer*, Ray Bradbury would immortalize Waukegan as an idyllic slice of small-town Americana. And indeed, in the 1920s and 1930s it was idyllic. The barbershops, traveling carnivals, and electric trolley cars were all a part of daily life, as were the annual parades of aged American Civil War veterans marching through town. On summer days, there was the rustling of maple, oak, and elm—a canopy over the sun-dappled streets. There were corner drugstores and cigar shops with wooden Indians perched at their entrances. Ice-cream parlors with their snow-white marble tops and their thumping ceiling fans offered summer solace.

But as with most American towns, Waukegan was more than its apple-pie visage revealed. A city with a rich history, it had a palpable magic and a shadowy dark side—just like its native son, Ray Bradbury.

Peering beneath his hometown's romantic surface is paramount to understanding the mind of Ray Bradbury. It is as if the city of Waukegan, with uncanny prescience, had offered itself up as yet another metaphor for Ray's imagination. Indeed, the city's history is full of images and events that appear sewn through the subtle fabric of its most famous son's stories.

THE FIRST people to settle in the region that would later become Lake County, Illinois, were a nomadic Native American group known as "Mound Builders," so called because they buried their dead, along with pieces of pottery, agricultural tools, and weapons of war, under large mounds of dirt. The Mound Builders, the ancient ancestors of many tribes of Native Americans, flourished in North America for some four thousand years. For centuries, this region belonged to them.

Western European settlers arrived in 1673, when Father Jacques Marquette, a French Jesuit missionary, assisted by a band of Pottawatomie Indians, landed north of Waukegan Bay, seeking shelter from inclement weather. More French explorers followed in subsequent

years, as a trading post was established in the region between the new settlers and the Native American people. This trading post became known as "Little Fort," or, in the language of the indigenous Pottawatomie Indians—"Waukegan."

More settlers arrived at "Little Fort," to stake land claims, and on September 26, 1833, the Pottawatomie surrendered the area to the United States government and moved west of the Mississippi River. On April 2, 1860, one year after the settlement was incorporated as a full-fledged city, now officially christened Waukegan, a prominent fifty-one-year-old attorney by the name of Abraham Lincoln arrived by passenger train from Chicago. As urban legend has it, Abraham Lincoln received his last shave at a downtown Waukegan barbershop before growing his trademark beard.

Six weeks before the national convention, Lincoln was on the campaign trail for the presidency. In his speech, delivered in downtown Waukegan to more than 1,500 people at Dickinson Hall, Lincoln presented an argument regarding popular sovereignty and the growing national dialogue concerning slavery. A town member who attended the event recalled it several decades later in a 1909 interview in the hometown newspaper: "Lincoln declared that civilization had pronounced human slavery wrong," said J. P. Hull. "He said that we alone, the United States, with our boasted freedom, gave it the standing of an institution and that we did wrong."

A gifted orator, Lincoln mesmerized the crowd, but his speech lasted just twenty-five minutes before being interrupted by fire bells. The glow of flames could be seen through the windows of Dickinson Hall. A conflagration had ignited in an old warehouse near the lakefront. The crowd rushed out of the hall to the lakefront to battle the blaze. Lincoln followed the group, but as they neared the inferno, they could see the warehouse was lost.

Another noteworthy Waukegan event occurred in 1894, when resident Edward H. Amet invented the Amet Magniscope, later recognized as the world's first motion-picture projector. A pioneer in the film industry, Amet produced short movies in his backyard. It is fitting that one of the most important technological breakthroughs of Ray's lifelong love, moviemaking, was very nearly invented at his doorstep.

Waukegan, in 1920, the year Ray Bradbury was born, was a booming city of 33,499 people. Some fans of the Green Town novels, *Dandelion Wine* and *Something Wicked This Way Comes,* find this number sizable; Waukegan was, in reality, much larger than Ray's fictionalization of small-town America. In 1920, the city was a bustling industrial town; the harbor was busy with Great Lakes ship traffic; and the American Steel and Wire Company, where Ray's maternal grandfather, Swedish-born Gustav Moberg, worked, was thriving. In the late summer of 1920, the beaches along Lake Michigan were a popular retreat, and often the Bradbury family spent their afternoons there. Genesee Street, with its whirling barber poles and storefront display windows, was picturesque Main Street USA. Peace and serenity presided over this slice of the Heartland. The First World War had ended victoriously. The country was at the dawn of the Jazz Age. Indeed, it was a good time and a good place to be born, and throughout his life, Ray Bradbury returned to Waukegan again and again for inspiration.

Certainly, the Bradbury family tree extended well beyond Waukegan, Illinois. Bradbury genealogical records document the family's history to the year 1433 in England. In 1634, Thomas Bradbury, born in 1610 in Wicken-Bonant, England, was the first in the family to cross the Atlantic and arrive in the colonies. He quickly became an influential member of his new community, serving as Deputy to the General Court and later as an associate judge. But it was Thomas's wife, Mary, who would make family history. On July 26, 1692, Mary Bradbury was summoned to the Salem Town courthouse: She was charged with witchcraft.

The seventy-two-year-old mother of eleven stood before the magistrate. How fearful this elderly woman must have been. "I am wholly innocent of any such wickedness through the goodness of god that have kept me hitherto," she proclaimed. But her plea fell on deaf ears.

Mary Bradbury—née Mary Perkins—was a prominent and respected resident of Salisbury, Massachusetts, in the county of Essex. In all, 118 members of the community signed a petition, testifying to her good character. Yet even with her reputation, the support of friends and neighbors, and her husband's influential position, she could not avoid the charge.

In 1692, a tempest of fear stormed through the Massachusetts Bay Colony, prompting what would become the infamous Salem Witch Trials. What began with two young girls experiencing convulsive seizures escalated into an unprecedented inquisition. From May to October 1692, nineteen convicted "witches" were put to death by hanging, one more was tortured, and at least five died while imprisoned; all told, at least 160 people were accused. The town of Salem was consumed by hysteria. A perceived malevolent outbreak of the "Evil Hand" had overtaken the colonial New England settlement and the townspeople would stop at nothing to rid themselves and their community of this curse.

The charges against Mary Bradbury stemmed from wild allegations made by two men who, while walking by the Bradbury home, claimed to have seen a blue boar charge out of her yard's open gate. More people cited Mrs. Bradbury as responsible for an outbreak of sickness aboard a seafaring ship bound for Barbados; she had made the butter for the crew and, it was alleged, the butter had made the crew ill (never mind that refrigeration did not exist). A man testified to have seen Mrs. Bradbury aboard the ship. The weather had turned foul, he recalled, and there she was, in the moonlight, perched on the capstan of the vessel, an apparition portending doom.

With all this testimony leveled against her, on September 6, 1692, Mary Bradbury was found guilty and sentenced to die. But she escaped prison and the gallows. History presumes that, given her husband's prominence, guards were bribed, helping the woman escape execution. Mary Bradbury, convicted of witchcraft and sorcery during the Salem Witch Trials, died a free woman, at the age of eighty-five, on December 20, 1700.

More than 250 years after the tragedy at Salem, Mary's descendant Ray Bradbury would stand up against another set of incriminators and decry a new American witch hunt begun in the McCarthy era. How fitting that the man who wrote one of the quintessential works of anticensorship, a book that lambasted totalitarian rule, a book about government run amok, was a direct descendant of an accused Salem witch. In many ways, *Fahrenheit 451* can be read not only as a response to the McCarthy hearings, but as a centuries-old response from a long-lost relative.

Ray wrote about his genetic connection to Mary Bradbury in 1955's *20th Century Authors*, months after *Fahrenheit 451* had been published. "From her," he said, "I suppose I get my concern and dedicated interest in freedom from fear and a detestation for thought-investigation or thought control of any sort."

Familial influences continue to resonate metaphorically in the Bradbury line. Samuel Irving Bradbury, five generations removed from Thomas and Mary Bradbury, was born in Albany, New York, on November 8, 1828. By the age of fourteen, Ray's great-grandfather Sam was apprenticed to the printing business. But the young man had an adventurous spirit and desired to see the world. At the end of his printing obligation, he served as a hand aboard a ship on the Hudson River. When he was nineteen, Sam Bradbury's father died, leaving his eldest son to care for the family.

In the fall of 1847, he moved his family west to Waukegan—still known then as Little Fort. It was the pioneer spirit that brought the Bradbury family to Illinois aboard a steamer ship that landed on November 26, 1847. They had friends living in the area, and Sam had high hopes for a more prosperous life. A simple journal entry detailed his adventure: "Dec. 1st, felled the first tree on my building spot."

The similarities between Samuel I. Bradbury and his great-grandson Ray Bradbury are, on the surface, somewhat elusive. But the connection is there, forged of printer's ink and the written word, and of that pioneering spirit. It is the spirit that would serve as the narrative thread through Ray's 1950 classic, *The Martian Chronicles*.

Little more than a month after arriving in the Midwest, Sam Bradbury's mother passed away and he was left to care for his four younger siblings. Sam Bradbury resumed his shipboard work, but quickly resolved to return to the skills he had acquired as a printer's apprentice. On November 25, 1851, he married Mary Spaulding, daughter of Luther and Charlotte Spaulding, a well-to-do family in Waukegan. The Spaulding family owned a parcel of land in town named "Spaulding Corners." The family also founded Union Cemetery, where many Spauldings and Bradburys are buried. Ray would later use the Spaulding name for the family in his autobiographical fantasy *Dandelion Wine*. He would also use "Leonard Spaulding" (a combination of his father's first name

and his great-grandmother's maiden name) as a pseudonym when he first published the story "The Highway" in 1950.

Sam and Mary had three children—Frances, Dewitt, and Samuel (a popular name in the Bradbury line). Ray's grandfather Samuel Hinkston Bradbury was born on May 3, 1858. Samuel Sr. had moved into the printing business and worked for several newspapers, marking the beginning of a long family relationship with publishing. He acquired a reputation as a fine printer, and was known as a detail man—methodical, thorough, and painstaking in his work.

By 1860, the same year Lincoln came to Waukegan, Samuel Sr. had launched his own newspaper, the *Lake County Patriot*, serving as editor, writer, and publisher.

But the career of Ray Bradbury's great-grandfather reached well beyond the newspaper and printing business. In 1881, Samuel I. Bradbury, riding on his good reputation and having already entered the local political arena as an alderman, ran for mayor of Waukegan and won. In the years after the election, years during which the Bradbury name became respectable and prominent in Waukegan, the family lived in an imposing Victorian home.

The house has long since vanished, but it once stood at 22 North State Street, which would later become Sheridan Road. From the living-room windows, through lace curtains, one could see the expanse of Lake Michigan. The house had an ornate wraparound front porch with a lacework of wooden railings and banisters and a central tower that rose four stories high; the grand residence was the inspiration for the fictional Spaulding grandparents' home in *Dandelion Wine*. Though Ray's grandparents lived in a smaller, more humble home, he chose to imagine them in the old Bradbury residence, with its high attic window looking out upon the entire green world below.

In 2001, Ray would reimagine the home in another incarnation—as the dark yet welcoming Victorian manor of the Elliot family in the novel *From the Dust Returned*.

> . . . *with its cellar roots deep in Chinese tombyards, it was of such magnificence, echoing facades last seen in London. . . . There were enough beams within to roof St. Peter's and enough windows to*

sun-blind a bird migration. There was a porch skirted all around
with enough space to rock a celebration of relatives and boarders.

Ray Bradbury subconsciously and consciously conjured fiction from
his rich family history. The characters of *From the Dust Returned*, a fam-
ily of dark and wild creatures, are a phantasmagoric reimagining of Ray's
own kin. The gothic mansion on the cover of *From the Dust Returned*, a
painting done in 1946 by famed *New Yorker* cartoonist Charles Addams,
bears a remarkable resemblance to photographs of the old Bradbury
house.

The house overlooking Lake Michigan, with its high attic and its
central spire, its ornamental crests and the coat of fish-scale shingles,
was a place which, in Ray's imagination, had "a mouse in every warren, a
cricket in every hearth, smoke in the multitudinous chimneys, and crea-
tures, almost human, icing every bed."

THE NEXT personage of note on the Bradbury family tree is Ray's own
grandfather Samuel Hinkston, youngest child of Samuel Irving. In 1885,
at the age of seventeen, Samuel Hinkston began working for his father's
publishing business, learning the skills of the trade: typesetting, design,
writing, editing, and printing. How appropriate, then, that the word-
smith's quirky, often misunderstood, ever-imaginative grandson would
one day be given one of the highest honors the publishing world has to
offer—the National Book Foundation's 2000 Medal for Distinguished
Contribution to American Letters, and that a fictional incarnation of
Samuel Hinkston himself had been immortalized as the stoic, loving
grandfather with the gentle spirit in *Dandelion Wine*.

Samuel Hinkston was strong and silent, loving and learned. He was
a man who often spent his days with a book or a newspaper spread on
his lap. Samuel Hinkston was destined to work in his father's printing
and publishing business, Bradbury and Sons. But he also held other, less
conventional dreams—of travel, the Wild West, and striking it rich.

However, Samuel Irving had expectations of his son, and so Samuel H. worked for his father in an office in the burgeoning section of downtown Waukegan.

In 1889, Samuel Hinkston, by all accounts a quiet, thoughtful man with intense, steely eyes, married Minnie Alice Davis. It seemed as if his thirst for adventure would be shelved, at least for the time being, in favor of family. A year into their marriage, on December 1, 1890, their first child, Ray Bradbury's father, Leonard Spaulding Bradbury, was born; a second son, Samuel Hinkston Jr., arrived in November 1894. Meanwhile, Samuel Hinkston Sr. started the Waukegan Steam Laundry Company, though he was still working as a printer. The two businesses, the laundry and printing companies, were located side by side at 106 Sheridan Road.

While much has been written concerning Ray Bradbury's paternal family, until now, the birth of a baby daughter in Samuel Hinkston's household—Ray's aunt—on January 21, 1896, has never been unearthed or published. Historians have just recorded one girl in the household—Ray's aunt Neva—born more than a decade later, but a birth certificate in Lake County, Illinois, indicates that Samuel Hinkston was age thirty-eight and Minnie was twenty-five at the time of their third child in 1896. On the certificate no name for the baby girl is given; it simply states: "Bradbury 3rd child." By the time the 1900 Census was completed, no girl was listed in the Bradbury household at all. Ray had vague memories of hearing talk in his childhood that there may have been a baby girl; his memory on the subject was cloudy, but he recalled that the baby might have died very young and, because of sorrow, the family refrained from discussing the loss. Lending further mystery to the unidentified baby girl, no death certificate is on file in Lake County or in any of the surrounding county offices. The baby, it appears, simply vanished. Spotty record keeping may be one reason there is no record of her death; at the turn of the last century, death certificates were not always issued. But oddly enough, the 1910 Census indicates that a Rose M. Bradbury, age thirteen, was living in the household of Samuel Hinkston and Minnie Bradbury, along with her siblings Leonard, Sam Jr., Bion, and Neva. The children were listed as living, and able to read and write. However, there have never been any photos of a thirteen-year-old girl in

the Bradbury family archives. Ray's father and his aunt Neva had never discussed having a teenage sister. Waukegan school records offer no answers—no Rose M. Bradbury ever attended. It might have been that when the Census takers stopped by the Bradbury home, they were informed that there was a deceased daughter and she would have been thirteen, and it was mistakenly documented that she was alive in 1910. Whatever the case, Rose M. Bradbury appeared ever so briefly in 1910, never to be seen or heard from again. It is more than likely that this girl, born in January 1896, died close to that date and was only named, like so many babies of that era, posthumously.

By April 1902, Samuel Hinkston and Minnie welcomed their third son, Bion Edward. Though the family was growing, its patriarch's dream of chasing adventure in the West had not waned. By 1906, Samuel Hinkston was bored with his father's printing business and tired of his laundry company. He had amassed a minor nest egg and convinced his wife that it was time to follow his vision. Minnie Bradbury surrendered to her husband's fancy. While she and the children remained in Illinois, he traveled west to Nevada, where he invested in the Goldfield Mining Company and Bullfrog Mining Company. As Ray recalled from stories told in his childhood, Samuel Hinkston would go west for months at a time, hoping to strike it rich and provide a better life for his family.

That same year, Ray's father, Leonard Spaulding Bradbury, missing his own father, ran away from home. Leonard headed west to join Samuel H. in the foothills of Nevada. Leonard traveled across the country by hopping freight trains and riding in boxcars, and, as Ray recalled his father's tales, Leonard even occasionally rode the couplers underneath the freight cars. This was a dangerous, often fatal practice of the early hobos. But Leonard was a scrappy, tough young man—a stocky five-foot-seven-inch-tall bulldog who had played football in high school. He made it to the desert and joined his father in the quest for precious metals and wealth. But Leonard had been in Nevada for less than a year when his father finally gave up on his dream. Financially depleted and broken in spirit, Samuel Hinkston Bradbury brought his son Leonard home in 1907. Samuel Hinkston Bradbury would never be the same; the failure of his mining dreams haunted him for the rest of his days.

After returning home, Ray's father, Leonard, went to work for the

family printing business. Meanwhile, Samuel H. and Minnie conceived another child. Nevada Marion Bradbury, who would one day become Ray's favorite aunt and a guiding force in the development of his imagination, was born on March 10, 1909. As is evident from his new daughter's name, Samuel Hinkston's attention was still on his failed dreams of finding gold out west.

IN 1912, Leonard Bradbury began courting Ray's mother, Esther Marie Moberg, a small, round young woman with a thick head of dark hair and a thin smile. She was a proper, polite, quiet person whom Ray later described as "having her corset on too tight," a woman of Victorian times. Leonard and Esther married two years later on Saturday, August 8, 1914, at St. Elisabeth's Church in the city of Glencoe, Illinois, south of Waukegan.

The Moberg family had immigrated to the United States in 1890 from Stockholm, Sweden, where Esther was born in 1888. The family lived in Massachusetts for eight years and then joined family in Waukegan in 1898. Like many other Swedes in Waukegan, Gustaf Moberg, Ray's maternal grandfather, worked in the local steel company. The Mobergs were a large clan. Esther had three brothers, Lester, Philip, and Inar, and two sisters, Victoria and Signey. All of the Mobergs were fluent in Swedish except for Esther, who understood but could not speak the language. Ray Bradbury recalled his two aunts fondly as the "Swedish sisters." Ray's uncle Philip worked for the local Bureau of Power and Light as an administrator, earning the sizable wage of two hundred dollars a week. Ray's other uncle, Lester Moberg, was a dashing, strikingly handsome young man. Inar Moberg, one of Ray's very favorite relatives whom he later immortalized as a loving vampire with a vast span of green wings in the short story "Uncle Einar," worked as a driver for the local Snow White Laundry service and stopped by the Bradbury house often to deliver fresh linens and clean clothes (very often for a reduced price or free). "He was the joy of my life," Ray said.

"He was my loud, boisterous, drinking Swedish uncle who burst into our home with a great cry and left with a shout."

Part of Inar's appeal for the boy may have been that such exuberance was not an ordinary part of young Ray Bradbury's immediate family. A quiet, polite couple, Ray's parents were staid and serious, much a product of their well-mannered generation.

After their 1914 nuptials, the newlyweds lived with Leonard's parents in their two-story home at 619 Washington, along with Sam Jr., Bion, and Nevada, affectionately called Neva. As World War One began, Samuel H. Bradbury continued to run his printing business, as well as his steam laundry company, which he co-owned with a friend. Leonard Bradbury worked for a short time as a town deputy, while Sam Jr. went off to the West Point Military Academy. Ray's father, Leonard, quickly followed suit, joining the navy. He was stationed at the nearby Glenview Naval Base, just south of Waukegan, for the entirety of his service.

On July 17, 1916, Leonard and Esther welcomed twins into the world, Leonard Jr. and Samuel. Esther doted on her pudgy baby boys who, as the months went by, grew thick curly mops of blond hair. Esther often walked the twins in a two-seat wicker stroller. She was ever the proud mother. But just a few months after their second birthday, tragedy struck. The Spanish influenza epidemic took the life of one of her twins, Sam, on September 30, 1918. Esther Bradbury was devastated. The grieving parents buried Ray's older brother at Oakwood Cemetery, at the southern edge of Waukegan. Under the deep shade of trees more than a century old, down a row of cracked headstones, lies a small, simple plot without a grave marker. The Bradburys had no money to purchase a headstone. The leatherbound cemetery log stored in the basement of Waukegan's City Hall has a line written in a spidery hand: Baby Bradbury.

Just two weeks later, Leonard's brother, also named Samuel, a 1917 graduate of West Point Academy, was shipped off to the battlefields of France. Captain Sam was yet another Bradbury with a literary side. While a student at Central High School in Waukegan in 1912, Sam Bradbury, known to his friends as "Brad," was recognized as a poet. Under his picture in the Waukegan Annual Yearbook are these words:

> *For that fine madness still he did retain,*
> *Which rightly should possess*
> *A poet's brain.*

Later, in 1938, Ray Bradbury would also be recognized for his literary aspirations in his own Los Angeles High School yearbook, *The Blue and White Annual*. But Ray and his uncle Sam would share very different fates. In 1918, with the war coming to a close, Sam died on his way to France, never seeing battle, a victim of the same flu epidemic that took Leonard and Esther's son. Like many American soldiers at the time, Captain Sam Bradbury was buried in France, at the Oise-Aisne American Military Cemetery.

Less than two years later, in late autumn of 1919, Leonard Bradbury was out of the navy and Esther Bradbury became pregnant again. The couple, along with their surviving son, Leonard Jr., moved into a smaller home, just behind Samuel Hinkston's house at 619 Washington. Samuel Hinkston owned the residence, a modest frame house he rented out, located at 11 South St. James Street. After losing one child, Esther Bradbury pledged that her new baby—Ray—along with Leonard, would be kept safe from all harm. Esther kept close watch on baby Ray. The summer of his first birthday, she even went so far as to tie him with a rope to an apple tree so he would not crawl away as she hung out the laundry. She was not going to let him out of her sight. He was a sheltered child, bottle-fed until he was six, spoon-fed to the edge of his teenage years. The makings of an extraordinarily sensitive child had been set into motion early. But a dark side emerged during this time, too—the inky underworld of nightmares and unexplained fears. Ray attributed his fascination with the macabre, the weird, and the outright scary to the very first years of life. "I have a feeling my mother infected me. She was a very fearful woman. I think a lot of her fears were transferred over to me. She was afraid that something might happen to me," explained Ray.

The Bradburys hardly noticed that they had a precocious baby. Edna Hutchinson, married to Ray's uncle Bion in 1924, recalled meeting little Ray. "He was just an ordinary little boy," she declared. But as the bottle-fed mama's boy grew, his personality began to surface. Ray's lifelong love

of the limelight, of being acknowledged, took shape. Ray was the baby of the family and fit perfectly into the prototypical role of the youngest child. He loved to entertain. He loved attention. "He used to play out in the yard in the dirt," recalled Edna Hutchinson. "He had a spoon and when I would walk by he would say, 'Look, Edna!' and he would take a spoonful of dirt and eat it."

The family traditions of those years have been immortalized in Ray's elegy to the Midwest summer, *Dandelion Wine*. On summer evenings, as dusk settled across Waukegan, the extended Bradbury family often gathered after dinner on the front porch of Ray's grandparents' home at 619 Washington. Some of Ray's earliest recollections are of these twilight gatherings. Sam Bradbury would light his pipe as the boys sprawled on the planked floor and listened to the crescendo of nightfall. The adults chatted, murmuring softly. "Through the xylophone of floorboards," Ray remembered, "I could hear the vibrations of my grandfather's voice. If you think about it, that was primitive radio."

Though Ray was too young to understand every nuance, listening to the voices of the gathered adults, he noted a palpable loneliness of those days. No matter how beautiful these times were, they always came to an end. He described this atmosphere in *Dandelion Wine*:

> About seven o'clock you could hear the chairs scraping back from the tables, someone experimenting with a yellow-toothed piano, if you stood outside the dining room window and listened. Matches being struck, the first dishes bubbling in the suds and tinkling on the wall racks somewhere, faintly, a phonograph playing. And then as the evening changed the hour, at house after house on the twilight streets, under the immense oaks and elms, on shady porches, people began to appear, like those figures who tell good or bad weather in rain or shine clocks. . . . Sitting on the summer-night porch was so good, so easy and so reassuring that it could never be done away with. These were the rituals that were right and lasting.

When he was two, radio entered Ray's life. Grandfather Bradbury had built a crystal radio in 1922, using the standard components—a piece of crystal, a spool of sewing thread, and some copper wire. He

kept the radio in an upstairs bedroom and one day brought little Ray up there, sat him on one knee, and placed a set of headphones over the child's ears. "I could hear music in Far-Schenectady. And that was my first real experience with radio," remembered Ray. "Listening to far music with distant voices. I didn't realize at the time that I was listening to the future."

The convergence of mass-media influences on the impressionable mind of Ray Bradbury had begun. Little more than a year later, in the winter of 1924, the dazzling flicker of a silent black-and-white movie cast a glow over the boy, enrapturing him for the rest of his life.

ESTHER BRADBURY was passionate about the cinema, and she passed this love on to her baby boy—her greatest influence on her son's future; the cinema would forever play a vital role in his life and his writing. Her husband didn't share this fever, so she would often take her baby boy to afternoon matinees. Ray believed that his mother averaged at least a film a week. On hot days, when the sun pressed down hard on northern Illinois, she escaped with Ray to the darkness of the cinema, into another world. She likewise bundled him on cold winter days to seek out the warm embrace of the movie theater.

It was February 1924 when Esther and Ray first walked the short distance from home to the Elite Theatre in downtown Waukegan. The marquee heralded the arrival of Lon Chaney in *The Hunchback of Notre Dame*; the cost of a bargain ticket for the two-hour-and-thirteen-minute film was fifty-five cents. While Ray never recalled much about the old theater or the crowd on that winter day, he never forgot the black-and-white images that flickered on the screen before him. To say that the three-year-old was stunned would be an understatement; this movie laid the groundwork in his fertile mind for what would later become Ray's trademark—the strange, the fantastic, the imaginative all wrapped up in a story most decidedly human.

"God created me as a metaphoric stick 'em creature," Ray elabo-

rated. "Any metaphor I saw stuck to me, starting with *The Hunchback of Notre Dame.*"

This movie classic featured Lon Chaney in his most ambitious role as the Hunchback, a distorted outcast with a fragile heart. "The Hunchback appealed in some secret way to something inside me which made me feel at the age of three, impossible as it seems, that perhaps I was some sort of Hunchback myself. How this film could have evoked in a three-year-old a feeling of sympathy, I don't know, except Chaney was so incredible at doing his portrayal and his lost love was so touching and immediate that my whole soul went forward at that young age and, it seems amazing that in my small body, I would crouch down inside myself and become the Hunchback, but that's what happened," Ray said.

Even at three years old, Ray Bradbury had the sense that he was somehow different from his family—somehow an outcast himself. *The Hunchback of Notre Dame* comforted him; it showed him that he was not alone, that he had a kindred spirit who lived in a high tower in the macabre world of medieval Paris. But the Hunchback did more than fascinate a boy who felt like an outsider. *The Hunchback of Notre Dame* ignited a lifelong love of film—a medium that later forged his keen sense of story and his grasp of quick narrative movement. Like the best films, so much of the work of Ray Bradbury can be defined as "high concept." His ideas are simple. They are memorable and they are metaphorical, and because his ideas are so cinematically visual, generations of schoolchildren have flocked to the imaginative literary worlds of Ray Bradbury as if, as he put it, he were "the Pied Piper." "When I talk of myself as being a child of my time, perhaps the biggest truth is that I am a cinematic child of my time, in that this influence has probably had a lot to do with the direction my writing has taken over the years, the type of writing I have done, and the way I have expressed myself," mused Ray.

It was the cinema that first launched this soaring imagination. It was the cinema that first exposed him to what he called "the breakfast of champions"—metaphors. It was the cinema that set Ray Bradbury rocketing off into the future.

2

GLINDA THE GOOD

He is a long-lived inspiration of the fantasy world that tweaks our curiosity.

—EDWIN "BUZZ" ALDRIN, *Apollo 11 astronaut*

THERE WAS one person who, more than any other, influenced young Ray Bradbury. Neva Bradbury, just ten years Ray's senior, was always more than an aunt—she was a partner in the fantastic, a fellow outcast. A creative person, Neva painted, made linoleum block cuts, sewed costumes and dresses, acted in the high school dramatics club, and loved cartooning. With all her energy and flair and passion for the arts, there was something in her that kept her from professionally attaining her own artistic aspirations. "She flinched from life," Ray said, always with a hint of sorrow when talking about his aunt's great, unrecognized talent. Her nephew was perhaps Neva's greatest creation; in many ways, Neva gave the world Ray Bradbury. Certainly, his imagination and drive would have developed without her—Ray Bradbury was born to be Ray Bradbury, but Neva helped foster and steer him.

Ray spent the third and fourth years of his life sheltered by his mother, and fed, in part, by a bottle. His mind was fueled on a steady diet of movies, but at Christmas in 1925, Neva, a petite teenager, with short chestnut hair and striking gray eyes, gifted her little friend with true nourishment. Christmas at the Bradbury home had a simple, heartland charm that perfectly embodied a gathering of what Ray described as "a middle class—fallen on their luck" family. There was little money for presents. Still, each year, there was a tree in Ray's house on St. James and at his grandparents' home next door. Both trees were adorned with

real candles. Neva always led the charge to decorate, for she loved holidays, particularly Christmas and Halloween.

On Christmas Day, snow covered Waukegan. Ray and his brother, who slept together in a pull-out sofa bed in the living room, woke up eager, like all kids, to open their gifts. Among the packages under the tree was a present addressed to "Shorty," Ray's nickname. (Ray's brother, Leonard Jr., now went by the nickname "Skip.") The gift, from Neva was *Once Upon a Time;* it was his first fantasy book and it would change his life. (Though Ray Bradbury would later be pigeonholed by critics and scholars as a science fiction writer, he would maintain that if a label must be used at all, he was a fantasy writer.) *Once Upon a Time* was a collection of timeless fairy tales—"Jack and the Beanstalk," "Beauty and the Beast," "Tom Thumb," "Cinderella," and many others. First published by Rand McNally and Company in 1921, the collection was edited by Katharine Lee Bates, the author of the 1893 poem "America the Beautiful," which would become, very literally, a second United States national anthem.

Ray's parents had been teaching their son how to read that winter of 1925. Fittingly, as he is a child of popular culture, Ray learned to read by studying the words in the Sunday comic strips. "They taught me by reading 'Happy Hooligan,' 'Bringing up Father,' and what have you." While he relished the stories in *Once Upon a Time*, it was the lavish illustrations of Margaret Evans Price that captivated him. "Now, when I go into a bookstore," Ray said at the age of eighty-two, "I rush right to the children's section because of the illustrations." It is certain that the early allure of illustration influenced Ray to direct the cover art of nearly all his books and even, in certain cases, the interior artwork. One might say that the reason Ray Bradbury's work is so very visual, so driven by concrete imagery, springs in large part from his lifelong love of illustration—and of the cinema.

When Ray was five, his aunt Neva showed him her collection of books, which included the *Oz* series, and he was enchanted. The series by L. Frank Baum was like nothing he had ever read; it was full of colorful illustrations and alive with myth and whimsy and dreams. "I have often thought that Neva was from Oz herself," Ray wrote in a 1940s unpublished essay about his aunt, entitled "The Wingless Bat." She

launched the beginning of what he liked to call his "Journey to Far Metaphor." Despite the very ordinary trappings of his life with his mother, father, and brother, and later, with his own wife and daughters, it was a journey that would never end.

THE BRADBURY house on St. James Street in Waukegan was modest and ordinary. The home had only one bedroom, a tiny kitchen, a dining room, and a living room in which the boys slept. Leo and Esther's bedroom was a tiny space consumed by a brass bed so long that its end stuck out of the sliding, double doorway at the entrance to the room. At the foot of the bed was a phonograph record player that Ray listened to frequently. His mother collected the phonograph albums, and her young son would play them continually. Ray distinctly recalled listening to a scratchy version of the song "The Lady Picking Mulberries" over and over. While Neva directly introduced Ray to her creative interests, Ray's mother left her own indirect impression; she loved movies and she loved music and young Ray picked up on these passions.

In the little house on St. James Street, there was a staircase off the living room leading upstairs to the attic, and the only bathroom in the house. Ray wrote about his fear of waking in the middle of the night and having to venture upstairs into the darkness to use the lavatory in the story "The Thing at the Top of the Stairs" from the collection *The Toynbee Convector*. The Bradbury family was so thrifty that Leo Bradbury kept the light off at the top of the stairs to save on the electric bill. This meant that little Ray, terrified of the dark, had to climb into the unknown. He was convinced that a monster lurked in the attic, so he would rather hold it or urinate on the staircase. Frustrated, Ray's father placed a chamberpot under Ray and Skip's sofa bed.

Ray Bradbury turned this boyhood fear, as he did with other childhood memories, into a metaphor in his work. The question Ray is asked most frequently, as are most writers, is where he finds his ideas. His response? He often took life events and imbued them with the dark fantastic.

Bradbury scholar David Mogen, author of the critical work *Ray Bradbury,* called these particular stories, numerous throughout Ray's oeuvre, "autobiographical fantasy." "Bradbury discovered early in his career that his best prose symbolically interprets personal experiences, that he could bring exotic subjects to life as metaphors for things we know. . . . Transforming fact into fiction, Bradbury weaves myth and fantasy out of both commonplace and bizarre experiences in his own life," wrote Mogen.

By the spring of 1926, thanks to Neva and his own proclivities, Ray was sodden with the power of fantasy. But tragedy struck his family: Samuel Hinkston Bradbury, Ray's beloved grandfather, fell ill. This quiet man, long troubled by the financial failure of his gold-mining endeavors, had contracted meningitis. He spent weeks in his upstairs bedroom; Ray recalled visiting him one late-spring afternoon and talking to his grandfather as he lay dying. On the morning of Friday, June 4, 1926, after lying in a coma for six days, Ray's grandfather Samuel died. Gone was the cornerstone of evening porch rituals; gone was the man who quietly smoked his cigar into the hushed hours. Gone, too, was the voice of primitive radio, that baritone heard through the floorboards.

The last Fourth of July that Ray spent with his grandfather—nearly a year before Sam Bradbury's passing—remained Ray's fondest memory of him. On that warm summer evening, the family had gathered on the porch and on the front lawn. Ray's uncle Bion had brought his small homemade brass cannon, which he fired off, thunderclapping the still night to the children's delight and to the adults' dismay. Ray spoke of this memory in an unpublished 1971 interview with his agent, Don Congdon.

> . . . *when all the fireworks were gone and my Uncle Bion had cracked a few windows with a last blast of his home-made cannon, it was finally the end of Fourth of July Night, and the special time, the sad time, the time of beauty, the time of rare philosophy exemplified in my helping my Grandpa carry out the last box in which lay, like a gossamer spirit, the paper-tissue ghost of a fire balloon waiting to be breathed into, filled, and set adrift on the midnight sky.*

My grandfather was the high priest and I his altar-boy at such moments. . . . I helped take the lovely red, white, and blue paper ghost out of the box and Grandpa lit the little cup of dry straw which hung beneath the balloon. Once the fire got going the balloon whispered itself fat with the hot air rising inside. By that time, I was generally brimming with tears, anyway. Even that young I was beginning to perceive the endings of things. Things, like this lovely paper light, went away. That same year, my Grandpa was to go away for good. I think it is incredible that I remember him so well; the two of us on the lawn in front of the porch with twenty relatives for audience, and the paper tissue held between us for a final moment, filled now with warm exaltations, ready to go. But I could not let it go. It was so lovely, with the light and shadows dancing inside. And only when Grandpa gave me a look, and a nod of his head, gently, did I at last let the balloon drift free and go away up past the porch, illumining the faces of my dear family, off up above the apple trees over the beginning to sleep town and away across the night country among the stars. We stood watching it for at least ten minutes, until we could no longer see it any more, and by that time tears would really be streaming down my face and Grandpa, not looking at me, would at last clear his throat, and shuffle his feet, and the relatives would begin to go in the house or around on the lawn to their other houses, leaving me to smell the firecrackers on my hands and brush the tears away with sulphured fingers.

The story of Grandpa Bradbury and the fire balloon, like all great Ray Bradbury stories, is a metaphor—a metaphor for letting go—and it is a recollection that Ray was quite fond of telling. He further examined his last Fourth of July with his grandfather in his essay "Just This Side of Byzantium," which became the introduction to later editions of *Dandelion Wine.* The memory would also turn into the Martian fantasy "The Fire Balloons," collected in *The Illustrated Man.*

Samuel Hinkston Bradbury was buried at Union Cemetery on Waukegan's west side. At age fifty-four, Minnie Bradbury was now widowed; Leo Bradbury, his younger brother, Bion, and seventeen-year-old

Neva had lost their father. They all felt an immense loss. They also felt a financial burden. After Samuel Hinkston passed away, to make ends meet, Minnie Bradbury decided to rent three bedrooms of her house to boarders. Some guests stayed a short time, others lived at 619 Washington much longer.

With his grandfather's passing, little Ray, not yet six, had experienced death for the first time. In the days and weeks after Samuel Hinkston Bradbury's death, Ray took in every detail, every overheard conversation, all sounds and smells, and humdrum objects in the house; they were all triggers for his runaway-freight-train mind. In the wake of death, he saw the world in a different light. His imagination was maturing every day.

Ray often liked to press his hands against the cool stained-glass window in his grandparents' home. The two rectangular windows were set into the wall on the staircase to the second floor. Sometimes, Ray stuck his nose to the glass and peered out through the kaleidoscope hues reminiscent of marmalades, jellies, and iced summer beverages. Yellow dandelions speckled the tiny lawn along the side of the house. Occasionally, through the stained glass, Ray spied a cat slinking across the grass or a pedestrian strolling by. He loved looking at the world through this sweet spectrum that altered the universe, and long after he moved from Waukegan, he still viewed the world in much the same way—through the rainbow lens of his grandparents' stained-glass window. These windows appeared in his short stories "The Man Upstairs" (originally collected in *Dark Carnival*) and "The Strawberry Window" (*A Medicine for Melancholy*); both stories may be classified as "autobiographical fantasy"—tales of the fantastic, mined from memory.

In 1926, Ray and his brother, Skip, went to see the movie *The Phantom of the Opera* at the Academy Theater in downtown Waukegan. Lon Chaney's performance as the phantom captured Ray's imagination, much as Chaney's Hunchback had mesmerized him three years earlier. The boy was enraptured by the theme of unrequited love, and he empathized with the tragic figure who lived in the underworld. The film let out by nine at night, and the two brothers walked home from downtown Waukegan, taking the path through the ravine, as they were wont to do. There were wooden steps into the green darkness, and Skip, sprinting

ahead of his brother, ducked beneath the bridge over the creek. Ray moved tentatively down the steps; his older brother loved to "ditch him," and Ray trembled at the darkness. "When I crossed over, afraid of the dark," said Ray, "Skip jumped out and I screamed all the way home." Not a prankster, Leo Bradbury fumed when he saw Ray burst through the front screen door, in tears. When Leo was provoked he pulled out a leather strop. "My father beat the hell out of Skip," said Ray, "and," he added with a laugh, "I was very happy."

The phantom stayed with Ray from that night on. In the sympathetic, misunderstood character, Ray had seen a bit of himself. Ray's father and his brother, Skip, were athletes, tough, chiseled, and masculine, while Ray was creative, sensitive, and imaginative. Only Neva really understood him, but in November 1926, the family would move away from Illinois and Ray's beloved aunt.

That fall, Ray entered first grade at Waukegan's Central School. His teacher was Miss Morey, the same woman who had taught Neva and Ray's father. But Ray's days in Waukegan, at least for the time being, were short lived. Like his father and grandfather, Leonard Bradbury suffered from wanderlust. He treasured the memory of riding the rails across the country and joining his father in his quest for gold. Leo loved the West and yearned to return. After Samuel Hinkston Bradbury's death, Leo was prepared to leave Waukegan, looking for a new start and a new adventure.

The family packed up and was soon traveling by passenger train from Chicago to the desert of New Mexico. For six-year-old Ray, leaving Neva and everything he knew was devastating.

While it is nothing more than an interesting, coincidental footnote, the first city in which the Bradbury family decided to settle was Roswell, New Mexico. UFOlogists know this southwestern town as the infamous site of a purported crash of an unidentified flying object in July 1947—the year that Ray Bradbury's first book, *Dark Carnival,* was published. While there were numerous reasons that interest in space aliens and UFOs exploded in the late 1940s and the early 1950s, two of them must have been Roswell, New Mexico, and Ray Bradbury, the writer who brought Mars and Martians to life in his 1950 novel *The Martian Chronicles.* For a brief time in the fall of 1926, both Ray and Roswell were connected.

The Bradbury family stayed in Roswell for all of two weeks before his father pressed to go farther west, to Arizona. "My father had been to Arizona when he was sixteen and he was very attached to it," said Ray. The family moved on to Tucson, traveling, as Ray recalled, in a large taxi with five other passengers. In Tucson, Leonard rented a small duplex apartment on Lowell Avenue, near the University of Arizona.

It was a dramatic change for a boy reared on the prairie. Here the land was parched, with blue hills rising from the horizon, and days blazed well after sundown. Ray, in fact, loved it, though he missed Neva terribly and wrote her every few weeks, begging her to move to Arizona. But Neva was in her senior year in high school and wrote her nephew that she could not leave, though she missed him dreadfully.

Leonard Bradbury was unable to find work, but he was in the West, which was, for the time being, all that mattered. His wanderlust was satisfied. Ray was to discover his own wandering spirit soon, but first he had to give up bottle-feeding. "Who do you know ever took the bottle until he was six years old?" Ray asked, years later. While he only took one bottle a day, usually before his afternoon nap, Ray's father had had enough. "My father got mad one day when I wouldn't eat my vegetables and he took the bottle and he broke it in the kitchen sink. It was very traumatic. That was the end," said Ray.

Tucson marked the beginning of a newfound freedom for Ray. His overprotective mother was allowing him to explore a bit more, and he was no longer tied to the proverbial apple tree. Though parents today would not dream of allowing their six-year-olds to wander the neighborhood alone, in 1926, Esther Bradbury gave her "Shorty" the run of the area. Tucson, still a primitive rodeo town in 1926, was waiting to be discovered by Ray. "I was immediately in love," Ray said. "There's nothing like being in a place that's growing, that's being built, the excitement of anything new, that's starting. That applies to all the things we do in our life—a marriage, a new love affair, a new building, a part of a city that needs to be rebuilt, or a town that's growing like Tucson."

Ray spent sunbaked afternoons running wild across the sprawling grounds of the University of Arizona campus. He roamed the halls of the Natural Sciences building, staring wide-eyed at exhibits of skeletons, snakes, scorpions, tarantulas, and dinosaur bones. In another building,

the blond-haired boy watched with piqued curiosity as workers built a lo-comotive. "I was a student when I was six—the youngest inhabitant of the University of Arizona," declared Ray. But not everyone was pleased with the cherubic scholar exploring the university's halls. Security guards regularly and roughly escorted Ray out of the buildings and sent him home. But the next day, or the next week, he was back. During this time, many of Ray's interests were either formed or solidified. He marveled at the dinosaur remains in the Hall of Sciences which, many years later, led Ray to write the short story *The Fog Horn*. In 1953, filmmaker John Huston read this story of the last dinosaur on Earth, crawling from the depths of the sea after hearing the bellow of a lighthouse and mistaking it as the plaintive call of its lost mate. Huston sensed a bit of Herman Melville in Bradbury and suggested that Ray write the screenplay for the film of *Moby Dick*. "You pose the question," Ray said, decades later, "what if I had given up on dinosaurs? I wouldn't have had my career."

While Ray was discovering new passions, there was excitement in the Bradbury house. On March 27, 1927, a few months after settling in Tucson, Esther Bradbury gave birth. Ray now had a little sister, Elizabeth Jane Bradbury, and was no longer the baby of the family, which quietly gnawed at him. He had been the center of attention, the star attraction, and now he was simply the middle child. Although he loved his little sister, he couldn't help but feel a slight pang of resentment.

At that time, Ray's father made a decision: While he loved the West, there was no work for him, and running short on resources, the family had but one choice—to return to Waukegan.

THE ANCIENT Greeks called fate the "daimon," a concept that derives from Plato's Myth of Er from his masterwork, *The Republic*. In essence, one is hardwired from birth with a calling that one might hear, ignore, misinterpret, or miss altogether; the Romans had a term for this idea, as well, referring to it as the "genius." Christianity explains it as a "guardian angel." The Romantics Keats and Blake abided by this theory as well.

Author James Hillman examined this notion in *The Soul's Code*: "The concept of this soul-image has a long, complicated history; its appearance in cultures is diverse and widespread and the names for it are legion. Only our contemporary psychology and psychiatry omit it from their textbooks." Ray Bradbury would caution readers not to look at his creative evolution too "metaphysically," but as one examines his artistic development, three factors cannot be ignored—the great amalgam, as it were: Neva, Waukegan, and an inner calling, an autopilot program that even Ray has coined. He wrote of this creative encoding in the essay "My Demon, Not Afraid of Happiness."

"I have a strange and incredible Muse that, unseen, has engulfed me during my lifetime," wrote Ray. "I have renamed my Muse. In a Fredrick Seidel poem I found a perfect replacement, where he tells of 'A Demon not afraid of happiness.'

"That perfectly describes that Demon that sits now on one shoulder, now on the other, and whispers things no one else hears."

As the Bradburys readied to move back east, Ray was returning to Neva and Waukegan. And while he wasn't aware of it, after his brief tenure living in Arizona, his demon was now more awake, more perceptive, more impressionable than ever before.

3

THE THEORY OF EVOLUTION

When I was first learning my way around science fiction as a writer, I didn't find many contemporaries who made me think, "I'd like to write something like that." Sometimes Theodore Sturgeon did—almost always Cordwainer Smith did—and, in Fahrenheit 451 *and* The Martian Chronicles, *Ray Bradbury certainly did. I saw how his humane concern, the exactness of his writing, his fierce but controlled imagination, all worked together to create beauty, and those vivid*

scenes you remember from a story decades later as if you'd lived them. So, when my mother was curious why I was writing stuff about space ships, I gave her The Martian Chronicles, *and said, "Because in science fiction you can do things like this." She read the book, and I didn't have to explain any further.*

—URSULA K. LE GUIN, *author*

IN LATE spring of 1927, the Bradbury family moved back to Illinois, returning as they had left—by passenger train to Chicago's Union Station. They moved back into their old house on St. James Street, which they rented from Ray's grandmother. For Ray, it was a mixed blessing. While he would miss the adventurous Marscape of Arizona, he was coming home to his aunt Neva.

Leo Bradbury returned to work as a lineman with the Bureau of Power and Light. His wanderlust had momentarily been satisfied. Back in "Green Town," Ray followed Neva like an impish shadow, consuming the *Oz* books under her tutelage. That year Neva graduated from Waukegan's Central School and enrolled at Chicago's School of the Art Institute and took classes in drawing, design, art history, and composition. She spent a few days with friends in the city each week, then took the train north to Waukegan for long weekends. In the St. James house, Neva converted the attic space into an art studio. On the pitched ceiling, she painted faux windows with images of cityscapes, trees, and green pastures behind the false panes; these painted windows, of course, captivated little Ray. In this new art space, Neva housed all her colorful fabrics for sewing, art easel, sculpting clay, and painting supplies. The Bradbury family could often smell the oils and turpentine when she painted. "When mother and father and I were seated at our various tasks of sewing, smoking, and lolling, we could hear the footsteps of all the marvelous people up in Auntie's studio," Ray said. "The dark people who came and went, the phonograph whining, the tinkling of glasses and the gush of wine. It was the Great Gatsby era, but Neva's world was half-Gatsby, half-Dracula. The people who unlatched her door were writers and painters and absinthe drinkers, or at least I tried to imagine this."

By 1927, the Jazz Age was in full swing, ushering in a postwar so-

phistication and a devil-may-care sensibility, and Nevada Bradbury was in the midst of it all. She looked the part, too. Her hair was cropped in a wavy, flapper-styled bob, and she wore dresses that bared her legs from the knees down. She pursued her passion in art and she socialized with her glamorous friends well past the witching hour. In this staid family—in which the women were reserved and the household was most definitely patriarchal—Neva, like Ray, was an outsider looking in.

In 1927, Calvin Coolidge was nearing the end of his presidency—the first American president to have his inauguration broadcast over radio; Charles Lindbergh flew solo over the Atlantic; and the Academy of Motion Picture Arts and Sciences had just been founded, the organization that would, many decades later, count Ray Bradbury among its coveted membership. And in Waukegan, the doors to the newly constructed Genesee Theatre opened at one o'clock on Christmas Day, 1927. The movie palace featured "an acre of seats," and tickets were sixty cents apiece. The program for the grand opening featured newsreels, short films, musical acts, and the film *The Valley of the Giants*. That evening, spotlights outside the theater played across the cold Illinois sky, visible from four miles away.

With the arrival of the new year, Ray's sister, affectionately nicknamed "Betty Jane," was growing into "a beautiful baby," as Ray remembered. She was Esther Bradbury's delight, and Ray grew ever more envious of the attention, once lavished on him, now given to the new baby of the family. Ray's mind was filled with dark thoughts. He wished his little sister dead. Before sunrise, on the morning of February 8, 1928, Ray and Skip, hearing their mother sobbing in her bedroom, roused from sleep. Betty Jane, who had been suffering from a bad bout of influenza, was lying motionless in her crib; she was not breathing and no one could revive her. At dawn, men arrived and placed the lifeless infant into a wicker basket and carried her out into the morning light. Two days later, Elizabeth "Betty Jane" Bradbury was buried at Union Cemetery, where Samuel Hinkston Bradbury, her grandfather, was also buried.

Esther Bradbury was devastated by the second death of a child. Even Leo, the stoic husband and father, cried; it was the first time Ray had ever seen his father shed tears. Ray felt somehow responsible: He had wished dark thoughts, and they had come true. In Ray Bradbury's

work, themes of censorship, loneliness, technology, religion, racism, magic, and nostalgia are prevalent, but the most ubiquitous subject is mortality; "Live Forever" is a phrase that appears time and again in his work. With the death of his grandfather and sister in less than two years, even a boy understood the finality of death. Scarred by loss and guilt, he retreated ever further into fantasy as a means of escape, and immersed himself deeper into the land of *Oz*, into movies and into magic.

CENTRAL SCHOOL, today replaced by the Waukegan Public Library, once faced the backside of the Academy Theater, and when Ray was in the second grade in 1928, he recalled being awestruck by a large billboard on the rear wall of the Academy. The boy schemed for a way to peel the poster from the brick building and take it home. At least twenty by ten feet, as Ray remembered, the poster pictured Blackstone the Magician. Stage magic was sweeping the nation, and audiences packed theaters nationwide to watch a new breed of vaudevillian magicians, and Harry Blackstone was among the best. "He was at the center of it, surrounded by all of his tricks—the dancing handkerchief, the canary in the cage . . . ," said Ray.

"His show had lots of action, lots of pretty girls, and lots of energy," said Daniel Waldron, author of the biography *Blackstone: A Magician's Life,* in a 2003 interview. "It was a very fast-moving show which was quite different from the shows up to the time of the First World War which were much more mannered. He took advantage of the spirit of the time. Blackstone was the perfect embodiment of the Jazz Age."

The billboard advertising the magician's upcoming Waukegan engagement excited Ray terrifically. "By the time Blackstone finally arrived in Waukegan for his first appearance, I was on the verge of a nervous breakdown," said Ray. When Blackstone appeared at the Genesee for a week, Ray bought tickets for all the shows and sat in the front row each time. After school Ray rushed to the theater for the matinee shows and stayed until evening, watching back-to-back performances. He made

sketches and took copious notes to capture each illusion, and decon-
structed many of the complicated tricks. By the time Blackstone left
Waukegan, Ray was consumed by magician fever. "Blackstone caused
me to be like Ahab, madness, maddened," said Ray, who began haunting
the aisles of the Carnegie Library and borrowing all the books on magic
he could find.

In the summer of 1928, a mysterious figure invaded the formerly
safe night landscape of Waukegan, a cat burglar nicknamed "the Lonely
One," who, like Blackstone, captivated the eight-year-old's imagination.
The idea of a shadowy cat burglar creeping about town, breaking and
entering at will, taunting the police, was unbearably tantalizing for Ray,
who would later use the Lonely One as a character in what is arguably
one of his finest tales of terror, 1950's "The Whole Town's Sleeping"
(the story would later be woven into *Dandelion Wine,* in which the
Lonely One would play a central role). The identity of the real-life
Lonely One would never come to light. The cat burglar was never cap-
tured.

RAY'S GRANDMOTHER'S library, where his grandfather had spent many
golden afternoons reading the newspaper, had a large bay window, sev-
eral easy chairs, a reading lamp, a sofa, and a bookcase that filled an en-
tire wall, housing all five hundred volumes of Samuel Hinkston
Bradbury's books. On the west wall was a framed black-and-white pic-
ture of Ray's uncle, Samuel Hinkston Jr., wearing his dark brown hair in
a short mop. In the photo, he is dressed in his gray bridge coat from the
West Point Academy. "When my grandmother was seated in my grand-
father's reading chair by the lamp, she could look across the room and
there was her son forever," Ray said. "I grew up thinking I knew him be-
cause I saw him every day of my young life." On another wall was
Neva's bookcase, lined with, among others, the *Oz* books, *Alice in Won-
derland,* and Edgar Allan Poe's *Tales of Mystery and Imagination.* The li-
brary also had a console radio, around which the family would gather to

listen. Grandmother Bradbury's regular house boarders also used the library, and among the guests lodging in the house in 1928 was a boisterous girl in her late teens who left the fall edition of a pulp publication, *Amazing Stories Quarterly*, in the room. The issue's cover story was "The World of Giant Ants," by A. Hyatt Verrill, an author, archaeologist, explorer, and noted authority on South America; the cover art by Frank R. Paul, an acclaimed illustrator deemed "the best candidate for Father of Modern SF illustration" by *The Encyclopedia of Science Fiction,* depicted an African-American hunter chased by a rampaging, supersized ant. Much like the illustrations in the Oz books, the cover of the *Amazing Stories Quarterly* caught Ray's fancy; and the stories of mythical creatures, distant planets, flying machines, rocket ships, and steel-riveted, cog-driven technology born of Victorian times sparked his imagination.

With each new popular culture discovery Ray Bradbury was subconsciously taking notes, preparing for his eventual contributions in film, fantasy, and pulp science fiction. Notably, though, Ray was never very interested in the technological underpinnings of science fiction. Indeed, esteemed science fiction writer, editor, and critic Damon Knight said that though Ray Bradbury "has a large following among science fiction readers, there is at least an equally large contingent of people who cannot stomach his work at all; they say he has no respect for the medium; that he does not even trouble to make his scientific double-talk convincing; that—worst crime of all—he fears and distrusts science." The purists, in their myopic love affair with hardware, did not understand that Ray Bradbury cared little about technological accuracy. His stories are, at their nucleus, human stories dressed in the baroque accoutrements of his early science fiction influences.

Soon after discovering the copy of *Amazing Stories Quarterly* in the family library, Ray began reading *Wonder Stories*, another popular pulp magazine. Nearly twenty-five years later, Ray Bradbury would rise to the summit of the field he fell in love with in 1928; in 1953, *Time* magazine labeled him "the Poet of the Pulps."

In THIRD grade, Ray was a self-described "wimp." He had little athletic ability and lived in the muscular shadow of his older brother, Skip. Further complicating matters, unbeknownst to him or anyone else, Ray's eyesight was worsening. When his brother, his father, or his friends tossed him a football, he inevitably dropped it. In school he had trouble reading words on the blackboard. Ray was a chatty student and compensated for his lack of physical prowess with verbal acumen, which thoroughly displeased some of his teachers; they had quite a time quieting the blond boy who loved to talk.

His energy seemed boundless until one day, in late 1928, he was besieged by a bout of whooping cough. Having already lost two children to illness, Esther Bradbury swiftly removed her boy from school and quarantined him to bed for six weeks. Being bedridden for that long a time for this energetic eight-year-old was akin to restraining a Saturn rocket after liftoff. Still, Ray's parents were strict disciplinarians and their two boys listened well; if they misbehaved, well, there was the leather strop hanging on the kitchen wall. So Ray spent his days resting in his parents' bedroom, on their large brass bed, reading. Sometimes Neva visited and read to him. "Neva was constantly around while I was sick," Ray recalled. "She read to me from *Alice in Wonderland* and Edgar Allan Poe." Forced to remain in bed, Ray delved further into the realm of the imagination. At every turn, every moment of discovery, there seemed always to be an illness, a specter of death, or some sorrow lurking. All too soon, another tragic turn of events struck Ray, his family, and the nation—the stock market crash in October 1929.

4

THE SORCERER'S APPRENTICE

I read his books when I was young. I remember Fahrenheit 451 *and* The Illustrated Man. *He was and is a great writer. A very imaginative man.*

—STAN LEE, *father of the Marvel Comics universe*

THE FUTURE arrived in the autumn of 1929. It landed with a terrific thud on the front porch at 619 Washington. Despite the onset of the Great Depression, Ray found inside the pages of the *Waukegan News* a new comic strip, *Buck Rogers in the 25th Century.* For the nine-year-old, destined one day to be dubbed, for better or worse, "the World's Greatest Living Science Fiction Writer," it was a glimpse into the future. "I was raised, all of the Twenties' boys were raised, in the last steams of Steamboat America, in the last go-round of the fringed surreys, milk trucks, and ice wagons drawn by summer lazy horses," wrote Ray in the introduction of *Buck Rogers: The First 60 Years in the 25th Century.* This is why *Buck Rogers,* a story set in an imaginative, far-distant future, packed such a tremendous punch in the little world of Ray Bradbury.

The adventures of William "Buck" Rogers began appearing in the daily newspapers in October 1929, and Ray began collecting the comic strip religiously, almost madly, cutting it from the newspaper. He didn't miss a single edition. Created by writer Phil Nolan and drawn by Dick Calkins, the *Buck Rogers* space opera was the first science fiction comic strip. Its cartoon panels, replete with images of hovercrafts, rocket guns, paralysis rays, and jumping belts that lifted people high into the clouds, awed Ray, a boy born during the era that bridged the dusk of Victorian times and the dawn of the rocket age. "In 1929, our thinking was so primitive we could scarcely imagine the years before a machine capable

of footprinting moon dust would be invented. And even that prediction was snorted at, declared impossible by ninety-nine percent of the people. And *Buck Rogers* offered us more: a trip to the asteroids, a journey to Venus, Mercury, and, yes, Jupiter itself. . . . And in 1929, think of it! Why good grief, Armstrong, Aldrin, and Collins hadn't even been born yet!" said Ray Bradbury.

While Ray was enamored with his newfound passion, America was hit by the Depression. The Bradbury family, already struggling, was pushed to the edge; Ray's father, Leo, clung to his job with the Bureau of Power and Light. Ray Bradbury never really understood the state of his own family, much less that of the country, and unlike many people who lived through the Depression, Ray never developed the habit of worrying about money.

Consumed by a *Buck Rogers* fever, Ray talked incessantly about his great love for Buck, Wilma Deering, the Rocket Rangers, Dr. Huer, Killer Kane, and the wicked and beautiful Queen Ardala. Ray's schoolmates teased him mercilessly for his "childish" interests. Ray remembered the children's hurtful words, "'Why are you collecting *Buck Rogers*?'" they prodded. "'There aren't going to be any rocket ships. We aren't ever going to land on Mars or the moon.'" Wounded, the sensitive boy rushed home from school one afternoon, tore into the house, and began, one by one, tearing up and tossing out his entire collection of comic strips. He believed his friends—it was all kids' stuff, the ray guns and the rocket ships. "My *Buck Rogers* collection!" Ray remembered. "[It was] like giving away my head, my heart, my soul, and half a lung. I walked wounded for a year after that. I grieved and I cursed myself for having so dumbly tossed aside what was, in essence, the greatest love of my life. Imagination. Romance. Intuition. Love."

Not long after he abandoned *Buck Rogers,* Ray realized his mistake. Never mind the other kids in their haste to grow up, he thought vehemently. Forget the so-called "friends" and their premature quest for adulthood. One day, he knew, they would pine for their childhood. He learned this harsh lesson at a young age and it remained with him throughout the rest of his life. He never lost touch with his inner child, and became the quintessential man-child, a poster boy for the Peter Pan syndrome.

It was an important turning point for young Ray. It was also the launch of a healthy, sizable ego; he would believe in himself, his passions, and his ideas no matter what others said. Ray returned to *Buck Rogers* and stayed with him for the rest of his life. Tearing up the comic strips had taught him a crucial lesson: Never abandon one's dreams and loves.

DURING RAY'S early *Buck Rogers* period, he began a weekly ritual of visiting the public library with his older brother, Skip, a sacred Monday-night event for the two boys. The Carnegie Library, built in 1903, was a stately granite building, located downtown on the corner of Washington and State streets. It was a quarter mile from the Bradbury house and the boys, Shorty and Skip, easily walked, or rather, ran there. "We always ran," Ray declared. "A lot of times I ran because my brother was ditching me or I ran because he was chasing me. No matter, we ran to the library."

The Bradburys could not afford to buy many new books, so the library was a blessing, particularly for Ray. It was a playground for his imagination. Weekly treks to the Carnegie Library would later become a cherished memory for Ray. When, decades later, he was asked about the library excursions, Skip, the family athlete, the future muscleman and surfer, could not even remember them. But he was a devoted older brother and always escorted his knowledge-thirsty sibling to the public library. "I inundated myself at the library," said Ray. "I plunged in and I drowned. When I visited the library, suddenly, the outside world didn't exist. I found a lot of books and I would sit down at a table and drown in them."

There were *Oz* books that Ray had never seen, books on magic, demonology, and dinosaurs; there were also the Nancy Drew mysteries (Ray checked out *The Secret of the Old Clock* and *The Hidden Staircase,* but he did so furtively, as they were considered "girls' books"). At night, the Carnegie Library was lit by tabletop bankers' lamps; in the 1983 cin-

ematic adaptation of *Something Wicked This Way Comes,* the prop department used old, green glass–shaded bankers' lamps in the library scenes, a nod to Ray and the Carnegie Library. (After the film wrapped, Ray took one of the lamps home, where he placed it in the living room of the Cheviot Hills house.)

Though Ray did not know it at the time, he was educating himself in the dark, labyrinthine corridors of the Carnegie Library, where the scent of leather bindings, gilt-edged pages, printer's ink, and old paper engulfed him. But the library was not the only literary treasure trove that Ray found. In the summer of 1930, he made a discovery at his uncle Bion's house that would also creatively propel him.

Bion Bradbury, his wife, Edna, and their three-year-old son, Bion Jr., lived at 618 Glen Rock Avenue, just around the corner from Ray's family. Leo Bradbury's younger brother was a handsome man with dark hair, steely eyes, and a brooding disposition. He was a macho man who loved Edgar Rice Burroughs's adventure stories of *Tarzan of the Apes* and *John Carter: Warlord of Mars.* When Ray saw these books on Bion's shelf, it was love at first sight. Ray spent that summer running back and forth between his house and Bion's to borrow books. He was so enthralled that he tried memorizing many of the stories word for word, and this time, he ignored what his friends said. Like Tarzan himself, Ray pounded his chest and cried out—to anyone who would listen—his incredible new discovery. Ray wrote of the great influence of Burroughs and Tarzan and the mad summer of 1930 in the introduction to Irwin Porges's biography *Edgar Rice Burroughs: The Man Who Created Tarzan.*

> At breakfast I climbed trees for my father, stabbed a mad gorilla for my brother, and entertained my mother with pithy sayings right smack-dab out of Jane Porter's mouth.
> My father got to work earlier each day.
> My mother took aspirin for precipitant migraine.
> My brother hit me.

Burroughs's Mars novels—*A Princess of Mars, The Gods of Mars,* and *The Warlords of Mars*—inspired Ray to, twenty years later, write his own Red Planet book, *The Martian Chronicles.*

Discovering these books in the summer of 1930 was instrumental in Ray's assimilation of ideas, images, and, most important, Ray would insist, his absorption of metaphors. Indeed, Ray was loyal to his passions and his metaphors. When the movie *The Phantom of the Opera* had a return engagement in Waukegan shortly after Lon Chaney's death on August 26, 1930, he rushed downtown to see it, ignoring a mystery ailment that was burning his side. In terrible pain and perhaps suffering from appendicitis, Ray went to see the movie anyway. "I sat there thinking, 'Next week, I won't be alive, but I'll be damned if I'll leave the theater. I've got to see *The Phantom* one more time.'" Clutching his abdomen, Ray stayed through several screenings. That evening his father, Leo, arrived, marching down the aisle as the projector light flickered, and collected his son, who had been missing much of the day. Ray's mystery ailment—the presumed appendicitis—vanished.

There were a few more contributing factors in Ray's early development. He continued to foster his wild interest in magic and magicians, and one afternoon that summer, his parents took him by train to Chicago and visited a magic shop, Ireland's Magic Company. The glass cases were filled with magic tricks and Ray marveled at the elaborate accessories. Since Leo Bradbury was making just dollars a week, Ray knew there was no money, and was content simply to look. "When we walked in, all the store clerks looked at us instantly and knew that we had no money. We were no good. We couldn't buy a thing," said Ray. Still, Leo and Esther managed to buy one small item for their son, a quarter magic trick.

When he was ten, after watching Blackstone the Magician many times and studying his tricks diligently, Ray made a silent pledge: to become the world's greatest magician. He began by putting on shows at home. Uncle Inar; his wife, Arthurine; their daughter, Ray's cousin Vivian; Skip; and Esther gathered in the small living room to watch the performances. "They had to put up with me," said Ray with a laugh. His father served as magician's assistant. "My father was quite wonderful. He was very patient. We hung a sheet across a doorway and we put on shadow pantomime shows. I would play a dentist and he was a patient and I would pull an immense tooth out of his jaw," said Ray. His parents added to his cache of tricks by giving him new magic sets on his birth-

days and Christmas. Very soon, Ray took his living-room show "on the road." With two schoolmates—the twin Schabold brothers, who were themselves amateur magicians—Ray began performing at the Oddfellows Hall, the Elks Club, the Moose Lodge, and, just across the ravine from his house, the VFW Hall. Ray loved the sense of power and control that performing magic gave him; it was the reason, he claimed, so many young boys become interested in it as a hobby. Ray also loved being in the limelight as he performed for an audience.

In the last week of 1931, Blackstone returned to Waukegan for a weeklong run at the Genesee Theatre. Of course, Ray was there. As part of the performance, Blackstone invited a few audience members onstage to assist him, and Ray was called up to help with an elaborate illusion. As Ray remembered it, a horse was brought onstage and a curtain was draped in front of it. "I helped Blackstone fire a gun and then when the curtain went up, the horse had vanished," Ray said. Before Ray left the stage, Blackstone handed his apprentice a rabbit to take home with him. Elated that his hero had given him a gift, Ray held the animal to his chest for the remainder of the show. After the performance, Ray ran across the ravine all the way home. His new pet was promptly named "Tilly" and, within days, she had babies. Leo and Esther were not pleased with the new additions, so Ray gave the bunnies to his school friends, the twin brothers who had performed magic with him. "I kept Tilly," Ray said, "until she started leaving rabbit pellets all over the house and my mother said, 'This has got to stop.'" Reluctantly, Ray gave her to the Schabold twins, too. "They had a pen full of rabbits and I put Tilly inside," Ray recalled with laughter, "where then the rabbits began to fight immediately. At least that's what I thought they were doing!"

5

WELCOME BACK TO THE WORLD

I just love Ray's enthusiasm. And for as long as I can remember, he's always had it. An effervescence and a desire for achieving his end. It's probably his prime asset. He bubbles over with such enthusiasm, it's catching.

—RAY HARRYHAUSEN, *godfather of stop-motion animation*

IN THE summer of 1932, the Bradburys took their annual vacation to the woods of southern Wisconsin, as they had done for the last five years. Leo Bradbury had managed to hold on to his job with the Bureau of Power and Light as the Great Depression gripped the U.S. economy. Each year the utility company sponsored a retreat for its employees at Lake Lawn Lodge in Delavan, Wisconsin, where many families rented cabins near the lake. In 1932, Ray's uncle Inar and his family joined the Bradburys for the retreat. Inar, still employed with the Snow White Laundry service in Waukegan, drove the family in his laundry truck to Lake Delavan.

The two Bradbury boys loved exploring the wooded shoreline and swimming in the lake. The Lake Delavan evenings were wonderfully entertaining, as well; the main hotel had a new pavilion where movies, mostly silent, were shown. Inside the pavilion, a big band played, and outside, tree frogs and crickets sang in the Wisconsin summer twilight. At nine o'clock, the orchestra began playing and, for the first song or two, as Ray remembered, the children were invited to dance. "All the girls were romantically inclined toward the orchestra leader," said Ray, laughing. Shortly after, the children went outside and the adults moved onto the floor. Ray, Skip, and their cousin Vivian, Inar's daughter, stood outside with their hands pressed to the windows as they watched the waltz-

ing adults. It was a magical nightly event, a ritual that gave Ray much comfort, like so many rituals did, but it also made him melancholy. He knew these sweet Delavan evenings could not last. Like the memory of his grandfather and the fire balloons on Fourth of July night, Ray had begun lamenting the end before it arrived.

In 1950, Ray wrote of this simple, childhood memory in the story "Someone in the Rain," but, like many of his stories, it remained unpublished, collecting dust in his files, until years later, when it was discovered by Ray's longtime bibliographer and friend Donn Albright. "Once I learned to keep going back and back again to those times," Ray wrote in "Just This Side of Byzantium," the 1974 introduction to later editions of *Dandelion Wine,* "I had plenty of sense impressions to play with, not work with, no, play with."

These memories, as he discovered after writing many of his stories, were very often metaphors for a greater universal human truth. He often stated that the stories "wrote themselves," and that he never intentionally planted a metaphor before writing. Only after the story was completed did he realize that the story represented another idea. In "Someone in the Rain," a thinly veiled adult Ray Bradbury returns years later to a tired, run-down Lake Lawn Lodge with his wife and, upon taking her out onto the pavilion dance floor, he looks out the window and sees children peering in. Are they the ghosts of yesteryear? In that instant, he yearns to be a child gazing in, rather than the dancing adult, who, from the child's mistaken perspective, is having much more fun. It is a universal realization; most children hanker to grow up too soon and, once grown, adults long to be young again. This very theme, oft-explored in his work, is telling of the true Ray Bradbury. He is an unabashed, unapologetic sentimentalist, and his work, reflecting this, has been criticized by some over the years because of it.

Despite his love of childhood and its wonders, in 1932 Ray Bradbury was coming of age. At twelve, his hormones were beginning to stir, but such topics were forbidden in the Bradbury home—Ray's mother, Esther, saw to that. Only once could Ray ever recall hearing his parents make love as he was lying awake at night on the sleeper sofa at home. Because their brass bed stuck out the sliding doors to their room, there was no privacy, and so Leo and Esther tried their best to be quiet. But

just a few feet away, in the living room, their youngest son, ever aware, was flat on his back, his eyes wide open. Ray nudged his brother, Skip, and they both listened curiously to their parents' soft, discreet noises. Because intimacy was never discussed, there was an innocence and a naïveté to the Bradbury boys; they really did not understand what they were hearing. Even Skip, four years older than Ray, could not explain to Ray their parents' intimacy. "He knew less than I did!" said Ray.

So, in 1932, while on summer vacation, Ray was puzzled by his own curious sensations of budding sexuality, brought on by his cousin Vivian. Vivian Moberg was two years older than Ray and, as Ray said, "the best kind of girl cousin to have." The two would sneak away into the woods at night to tell ghost stories. They were a good distance from the cabin lights and the conversing parents, and when Vivian was scared, she held Ray's hand. Before long, they were kissing and touching. It was a breakthrough moment for Ray in his transition into young adulthood.

Another significant event happened on the trip to Lake Delavan that year. It was an incident that Ray would later write of, in 1945's "The Big Black and White Game," anthologized in *The Golden Apples of the Sun*. The Bradburys were spectators of a baseball game that was rife with racial tension, as several of the white male employees of the utility company and other lodge guests were pitted against some of the African-American resort workers. On that hot summer evening, Ray, Skip, Esther, Leo, Inar, Arthurine, and Vivian gathered at the baseball field near the lake for the twilight game. The mosquitoes were out, and the crowd in the grandstands fanned themselves with magazines and newspapers, feebly combating the late-day heat and insects. It was an odd thing, pitting blacks against whites. Ray remembered a kind black man—the popcorn salesman in the pavilion during the evenings—and used him as a central character in "The Big Black and White Game," which he would write thirteen years later, his first official departure from fantasy.

The incident at Lake Delavan provided the springboard for one of Ray's rare, early forays into realistic fiction. Later in his career, he would write much more of this type of fiction. The story, Bradbury scholar Wayne L. Johnson noted in his critical work *Ray Bradbury,* was virtually "journalistic" in tone and "a fine piece of sports writing." Indeed, this singular example of Ray Bradbury as sports reporter was collected in the

1987 baseball anthology *On the Diamond*. "The Big Black and White Game" stood up well alongside baseball tales by Ring Lardner, P. G. Wodehouse, and Thomas Wolfe, among others. But the wonderful details of the story—the stitches on the ball; the way the ball hung in the air, defying gravity after connecting with the yellow timber of the bat; the serpentine wind of the pitcher—were secondary to the theme of prejudice and racism. Racial injustice was to become an important theme in his early short stories, from "I See You Never" to "Way in the Middle of the Air" (*The Martian Chronicles*) to "The Other Foot" (*The Illustrated Man*).

Ray Bradbury never recalled his parents displaying overt racism, but, as he said, "even if we are not aware of them, we all have our hidden prejudices." If anything, as a preteen the only prejudices he was aware of in his own family were his father's disdain for Catholics and the Irish. Ironically, Ray Bradbury would grow up to marry an Irish Catholic. But it is in a story like "The Big Black and White Game," a thoughtful rumination on the ignorance that fuels racism and hatred, that Ray suggests a bit of his parents' own beliefs and distrust of African Americans in the early 1930s. People could change, as Ray was always quick to point out, and he believed his parents did, but on that evening, as they sat on the banks of tranquil Lake Delavan and their two boys cheered for the black popcorn salesman during a baseball game, a bit of Leo and Esther's prejudices surfaced.

ON LABOR Day weekend in 1932, with school to begin on Monday, Ray attended the annual lakefront festival that the local chapter of the Veterans of Foreign Wars—Post 281—sponsored. There was so much for twelve-year-old Ray to take in. On Lake Michigan, there was a Venetian boat procession; a beauty contest was held with sixteen local contestants in bathing suits; and a ragged, tired, arthritic carnival, The Dill Brothers Combined Shows, was in town. Ray fondly described the carnival as a "steaming calliope, strung mazda bulbs and high wire acts . . . smelling

of cabbage, it was rusty and worn at the edges, like a mangy lion-pelt." But as threadbare as the carnival might have been, it and subsequent events left an indelible impression upon the boy.

After that fine summer, the family experienced more hard times. Leo had been laid off from the Bureau of Power and Light and was planning to move his family back to Arizona, and Ray's uncle Lester, his mother's younger brother, had been tragically shot and killed, a victim of a random holdup.

Lester Thomas Moberg, a veteran of the First World War, was by all accounts, a handsome, dashing man known for dressing stylishly. He worked as an attendant at the Veterans Hospital just south of Waukegan. He was divorced and had one child, a daughter named Carol. On a clear Monday evening, Lester took a co-worker, a staff nurse, Ethel Miller, to see a show at the Genesee Theatre. Ethel was separated at the time from her husband; she also had a child, a boy. About eleven that night, Lester and Ethel left the Genesee and hopped in Ethel's car, a Ford Coupe, and went for a drive. They headed out of Waukegan and into the darker, remote countryside. They turned down a gravel road and passed a farmhouse, and Ethel pulled the car into a drive just past the house. They sat in the car on that still night for twenty minutes. Minutes later, there was a beam of bright light in the passenger's side window, startling the two lovers. In the glow of the flashlight, they could see the cold sheen of a gun. The man, whose face remained in shadow, ordered them out of the car. The man then rifled through the automobile, looking for money, and removed the keys from the ignition, for he did not want to be followed. When he was done, he stepped out of the car and started to walk away, down the road. Lester called out to the man for their keys, and the man said to send Ethel to fetch them. Lester refused to do so, he stepped out of the Ford, and a scuffle ensued. During the brief fight, Lester was shot through the liver.

As his uncle lay in the hospital, clinging to life for nearly a week, Ray remembered his family gathering at his uncle Inar's house. One night, as the family was waiting for a call from the hospital for an update on Lester, Ray, Skip, Vivian, and their cousin Shirley, unaware of the gravity of the situation, were upstairs telling ghost stories. "Ghost stories, what a thing to tell tonight," Ray wrote in the 1948 story "House Divided," a

fictional account of that somber night. "Ghost stories," Ray said, "was another word for hanky-panky." The adults waited downstairs, hoping and praying that someone at the hospital would call with the news that Lester had pulled through. Meanwhile, the children upstairs turned off the lights and told scary stories in the darkness, and before Ray knew it, Vivian was touching Ray and Ray was touching Vivian. Skip and Shirley were soon off in another dark corner. But the prepubescent romp was soon broken up. The telephone rang downstairs with news that Lester had died from complications of the gunshot wound. Two days later, all the Bradburys and Mobergs gathered on the north side of town, off a country lane, at Pineview Cemetery to bury Lester Moberg. Given the family's financial situation (his parents paid for the funeral), the grave had no marker. To this day, it remains unmarked.

The evening before Uncle Lester's funeral, as Ray remembered it, he walked to the carnival on the lakefront. Dusty tents were pitched, flags flapped in the wind, and the carousel spun round and round. A hint of autumn was in the air. Ray entered a sideshow tent and took a front-row seat on a bench that sat on the sawdust floor. The performer in the tent was a magician named Mr. Electrico. "He sat in an electric chair," Ray said, "while his assistant yelled, 'Here go ten million volts of pure fire, ten million bolts of electricity into the flesh of Mr. Electrico!'" The assistant pulled a lever and a voltaic charge thundered and coursed through Mr. Electrico's body. "Reaching out into the audience, his eyes flaming, his white hair standing on end, sparks leaping between his smiling teeth, he brushed an Excalibur sword over the heads of the children, knighting them with fire," Ray said. The electricity transferred from the magician's body through the heavy sword into the children, causing their hair to stand on end with a static charge. Mr. Electrico then approached the bespectacled, wide-eyed boy in the front row. Taking the sword, he tapped Ray on each shoulder, then on the brow, and finally on the tip of his nose and cried, "Live forever!"

For Ray it was a stunning moment. The man hadn't said anything to the other children. Why had he said it to Ray? As lightning surged through the boy, "jiggling in my eardrums, the blue fire swarming into my brain and down my arms and out my fingertips like electric founts," Ray marveled at his fortune. "Why did he say that?" Ray asked seventy years

later, in 2002. Whatever the answer, the twelve-year-old had come to his own conclusion about living forever. "I decided that was the greatest idea I had ever heard," said Ray. "Just weeks after Mr. Electrico said this to me, I started writing every day. I never stopped."

The first time Ray told this carnival story in print was in the pages of William F. Nolan's self-published 1952 booklet *The Ray Bradbury Review*. Ray recalled that the next day, Labor Day, Saturday, September 3, 1932, the family buried Lester Moberg. "Driving back from the graveyard with my family in our old Buick," Ray remembered, "I looked out of the car, down the slope toward the lake and saw the tents and the flags of the Dill Brothers carnival and I said to my father, 'Stop the car!' and he said, 'What do you mean?' and I said, 'I have to get out!'" Leo Bradbury protested, but the independently minded boy, dressed in his Sunday best, insisted. The Buick came to a halt along Sheridan Road, and Ray clambered out of the car with his parents in the front and Skip still seated in the back. Ray galloped down the grassy incline toward the Dill Brothers carnival and found Mr. Electrico sitting outside a tent. As an excuse to chat with the mysterious magician, Ray told him he couldn't figure out a nickel magic trick that he had in his pocket; Mr. Electrico took the small toy, and showed Ray how it worked. Then the magician asked Ray if he would like to meet some of the carnival freaks. Without hesitation, Ray agreed and Mr. Electrico brought him to another tent and peered inside the doorway.

"Clean up your language," Mr. Electrico yelled. "Clean up your language!" What Ray Bradbury saw next would bolster his passion for all things big-top, freaks, midway rides, carousels, acrobats, and magic. There, behind the scenes of the Dill Brothers Combined Shows, Mr. Electrico introduced Ray to the dwarf, the giant, the trapeze people, the seal boy, the fat lady, and the illustrated man. It was an experience that would not only solidify his lifelong infatuation with carnival and circus culture, but, as Jonathan R. Eller and William F. Touponce point out in their scholarly treatise *Ray Bradbury: The Life of Fiction*, it helped provide a foundation for the "carnivalization" that would be a thematic touchstone throughout Bradbury's canon. Carnivalization, the authors point out, was "first coined by the Russian critic Mikhail Bakhtin to designate the transportation of carnival images and themes into literature."

Eller and Touponce posit that carnival imagery and themes, in their myriad forms, comprise the bedrock of Ray Bradbury's writing.

After the meeting with the freaks within the dusty canvas tents, Mr. Electrico walked Ray toward the rocky shoreline of Lake Michigan and they sat down. The magician shared with Ray that he lived in Cairo, Illinois, and that he was a defrocked Presbyterian minister. He gave Ray his address and told him to write any time. "He spoke his small philosophies and I spoke my big ones," Ray often said of that fateful long-ago conversation. Most important to young Ray Bradbury, he felt as if Mr. Electrico treated him as an equal. "We've met before," Mr. Electrico said, surprising Ray. "You were my best friend in France in 1918, and you died in my arms in the battle of the Ardennes forest that year. And here you are, born again, in a new body, with a new name. Welcome back."

Ray was stunned. "I staggered away from that encounter with Mr. Electrico wonderfully uplifted by two gifts: the gift of having lived once before (and of being told about it) . . . and the gift of trying to somehow live forever," he said.

On his way home that night, Ray walked back through the carnival grounds. It had rained on and off that day and it started to rain again. Ray stood next to the spinning carousel and began crying as the calliope played "Beautiful Ohio." "I knew something important had happened that day, I just wasn't sure what it was," Ray said.

Ray Bradbury told this story many, many times over the decades and, more often than not—including the first time it was recited in print in the pages of *The Ray Bradbury Review*—he included the detail about his uncle Lester Moberg's funeral. In leaving the funeral and rushing down the hillside, Ray would explain, he was "running away from death and running toward life."

Ray's memory of the date of his uncle's death and county records and newspaper reports do not match up. Lester Moberg's death certificate, the coroner's inquest, and published reports in the local papers list the date of his death, not during the week before Labor Day, but seven weeks later, on October 24, 1932. But Ray Bradbury was certain it was Labor Day, as were Ray's brother, Skip, and cousin Vivian. Even Lester Moberg's daughter, Carol Moberg Treklis, who was seven at the time, remembered that her father's funeral was on that holiday weekend. "I'm

certain of it," she said, and added that her mother, Lester's ex-wife, Lucy Carroll, always said that her father's funeral was on Labor Day weekend. Though Skip, Vivian, Lester's daughter Carol, all children at the time, agree with Ray, the headline on the October 24, 1932, edition of the *Waukegan News-Sun* proclaims: MOBERG DIES FROM BANDIT SHOT. His death certificate lists the cause of death as a "gun shot wound in body," on October 17 due to a "hold up by parties unknown." His date of death on the certificate was October 24, 1932.

Ray had simply and inadvertently combined the long-ago events of magic and murder—the story of his uncle Lester's death with the arrival of the Dill Brothers carnival and the fateful tap of Mr. Electrico's charged sword. The symbolism of the two events, death and life, occurring concurrently in Ray's story may be trampled by the facts, but the mystery of Lester Moberg's murder is not diminished and neither is the enigma of the man known only as Mr. Electrico. Lester Moberg's killer was never captured and, to this day, the case remains unsolved, and Mr. Electrico's identity, his true secret, remains a mystery, as well.

After the magician had given Ray his address, Ray wrote a letter to him in Cairo, Illinois. Mr. Electrico even wrote back. But over the decades, Ray lost the letter. In 1983, during the production of the Disney film *Something Wicked This Way Comes,* the producers attempted to locate the man who had turned Ray's life around, told him to live forever, and set him on the path toward literary eternity, but they were unable to locate him. There was also no record found of The Dill Brothers Combined Shows or the carnival performer named Mr. Electrico.

NEW FRONTIERS

The most important short story in my life as a writer is Ray Bradbury's "The Rocket Man." I read it for the first time when I was ten. In one scene, a family traveling by car stops along a rural road to rest, and the young son notices bright butterflies, dozens of them, trapped and dying in the grille of the car. When I got to that brief, beautiful image comprising life, death, and technology, the hair on the back of my neck began to stand on end. All at once, the pleasure I took in reading was altered irrevocably. Before then I had never noticed, somehow, that stories were made not of ideas or exciting twists of plot but of language, systems of imagery, strategies of metaphor. I have never since looked quite the same way at fathers, butterflies, science fiction, language, short stories, or the sun.

—**MICHAEL CHABON**, *Pulitzer Prize–winning author*

WHETHER LESTER Moberg was laid to rest on Labor Day weekend, as Ray and his brother, Skip, recalled, or in late October, as the official documents attested, Ray insisted that the day after the funeral, Leo Bradbury moved his family. He was without work and needed new prospects. He still had friends in Tucson, Arizona; and, an adventurer at heart, he loved the desert. "My dad had the travel bug ever since he ran away from home when he was sixteen," Ray said.

The Bradburys packed their possessions and piled into the 1928 family Buick and headed west. In fourteen years, Esther Bradbury had lost two babies, both of her parents, and now her younger brother. It must have been terribly painful for this woman who always managed, somehow, to conceal her feelings from her two boys. "She was a strong, stoic Swede," Ray said.

Cutting down through Illinois and through St. Louis and Spring-

field, Missouri, the Bradburys rumbled west along old Route 66, with lit-
tle money, but much hope. "We'd pull up to a place to stay for the night,
cheap motels with tiny bungalows," said Ray. "We'd pull up in front of
those motels and the owner would come running out and tell us it was a
dollar fifty a night to stay, and my dad would say, 'We won't pay a dollar
fifty.' The owners would lower the price to a dollar a night and my dad al-
ways said, 'No.' And he'd step on the accelerator and we'd start to drive
away. The owner of the place would jump on the running board of our
Buick and say, 'Seventy-five cents!' And my dad would say, 'Okay, yeah.'"

The road trip, averaging at most, as Ray remembered, two or three
hundred miles a day, snaked through Oklahoma. With so few resources,
traveling through the barren dust bowl of Oklahoma with two boys sit-
ting in the backseat bickering and jabbing each other with elbows must
have been difficult for Ray's parents. It was hot, and red dust covered the
roads through most of the state. After it rained, the dust turned to red
sludge. Abandoned cars, whose drivers had traveled too fast and lost con-
trol and rolled or turned or skidded, littered the muddy embankments of
the highway.

Leo Bradbury's knuckles wrapped tightly around the steering wheel.
He was focused on making it through the slick mess, keeping the Buick's
speed at five miles per hour. It was a painful journey, bleak and desper-
ate, and while he never said it, Leo must have wondered if moving his
family west with so little money and no employment was wise. But the
Bradburys motored on, with little Ray and burly Skip in the back of the
automobile, blissfully unaware of the despair gripping their father. As
they neared Amarillo, Texas, Leo decided it was time to stop for the
night. It was ungodly hot, and Leo was exhausted. The family stayed at a
small, dilapidated motor lodge. "That motel was fantastic," Ray said. "It
was built over a chicken ranch and the chickens ran under each little
bungalow so all the rooms smelled to high heaven. You can't have a thou-
sand chickens wandering around without it smelling bad."

This motel later sparked Ray's 1969 story "The Inspired Chicken
Motel," from the collection *I Sing the Body Electric!* "The Inspired
Chicken Motel" was one of those tales Ray insisted was thoroughly true.
The story illuminated the Bradbury family dynamics at that time, as well
as the long cross-country trip toward what they all hoped was a new be-

ginning. Ray wrote the story, as he said, exactly as it happened. "Little did we know," the story goes, "that long autumn of 1932, as we blew tires and flung fan belts like lost garters down Highway 66, that somewhere ahead that motel, and that most peculiar chicken, were waiting."

The Bradburys paid fifty cents for a night at the motor lodge. The room, as Ray wrote, "was a beaut, not only did all the springs give injections wherever you put flesh down, but the entire bungalow suffered from an oft-rehearsed palsy." The motel's proprietor was a friendly woman who, Ray surmised, had seen travelers crushed by the dust bowl and Great Depression. Leo Bradbury was one of those people; tired and downtrodden, he just wanted work so he could feed his family. They had enough money to take them west for six months; if Leo failed to make a living for his family, they would return to Waukegan and live with Grandmother Bradbury. But he determined not to fail. The proprietor must have seen the despair in Leo Bradbury's eyes and recognized it.

In the short story, she produced two eggs that she claimed had been laid by one precocious chicken. The eggs had cracks and raised calcium lines that somehow, amazingly, formed shapes. One particular chicken, among the thousands clucking around the ranch, was, like young Ray, an aspiring artist—a curious, wondrous freak of nature. The proprietor showed the eggs to the Bradburys. The first eggshell had a raised shape of a longhorn steer skull and horns. The second egg, placed on a bed of cotton inside a small box, had the words inscribed on the shell: REST IN PEACE. PROSPERITY IS NEAR. The Bradburys were thoroughly amazed. The words also gave them a brief sense of comfort.

The next day, the family hit the road once more and headed for New Mexico. In the town of Gallup, one of the Buick's tires blew, forcing Leo Bradbury to steer the road-hiccuping vehicle to the shoulder. The bright desert sun pressed down upon Leo as he removed the jack, tire irons, and repair kit from the back of the car. As Ray, Skip, and Esther sat inside, Leo began jacking up the car. Across the street, a Mexican woman sat on her front porch and watched Leo Bradbury's irritation grow as he tried to fix the flat. Changing a tire in those days was tricky; one had to work the tube out to repair it and take the rims on and off with tire irons. "In the middle of all this, nothing worked right and my dad just jumped up, screamed, 'Goddammit to hell!' and he took all the tire irons

and all the tools and threw them into an empty lot of weeds right near where we were parked and then, of course, we had to go try to find the tools," said Ray.

The boys climbed out into the heat and scoured the vacant lot for their father's tools. Seeing this, the woman from across the street offered Esther and the boys lemonade on her shady porch. As for the flat, Ray recalled with a laugh, his father "gave up trying to fix the tire and Skip rolled it further into town and found a gas station where they repaired it for a dollar."

After nine days on Route 66, the Bradbury Buick finally rumbled into Tucson, Arizona. Leo had an old friend who, as Ray remembered, had tuberculosis and had moved from Waukegan to Arizona for the warm weather. The friend had a small bungalow behind his house, which was on the outskirts of town on Stone Avenue. The bungalow, modestly furnished, had a single room and a bathroom; this was the new Bradbury home. Ray's parents slept on one side of the room in a bed, while Ray and Skip slept on a foldout bed as they had done in Waukegan.

School had already begun, so the boys were hurriedly enrolled; Ray in seventh grade at Amphitheater Junior High and Skip in eleventh. It was a mile walk each way for them. "That was great. I would walk through cacti and I would see snakes and Gila monsters and horny toads," said Ray. "I loved it." Ray befriended a classmate, John Huff, who soon became his best pal. The two were about the same height; Ray was stockier than his friend, but John was more athletic and played baseball. Ray's hair shone white blond under the Arizona sunshine; John had a full head of dark hair. On school days, the two twelve-year-olds sat under the shade of a tree outside their classroom during lunch, eating their sack lunches and talking about the *Tarzan* comic strip. Ray often spent weekends at the Huff house, with its menagerie of goats, dogs, and cats running amok. Besides his aunt Neva, Ray had never met anyone else who so understood him. "We both wanted to be magicians," remembered John Huff. "Ray would come over to the house on the weekends, and we tried magic tricks—not very successfully. Then we wanted to make movies. Western movies were real popular at the time so we drew them all on long strips of paper and that was our film reel."

While Ray had found a soul mate of sorts, Ray's father, Leo, had not found a job. He tried the railroad, but there was nothing. Ray was unaware of his family's economic straits, for his father never spoke of it. John Huff's family was struggling, too; his father made little through his automobile upholstering business. "It was Depression years," said John Huff. "We didn't have much, we just made do with what we had."

For cheap entertainment during the Depression, everyone listened to the radio. Ray soon discovered that a local station, KGAR, broadcast the program *Chandu the Magician* in the evenings and he tuned in religiously. He also amused himself by writing short stories; he had decided that not only would he be the world's greatest magician, he would also be a writer. And he could act. One day his school music teacher asked him to audition for the upcoming Christmas operetta, *A Wooden Shoe Christmas*. At first, he was reluctant because he would have to sing, but the teacher persuaded him to audition. The next day, when he arrived at school, a classmate called him "Hans," the lead character's name in the play. Ray had landed the role. Acting was addicting for the boy, and he soon discovered that getting up onstage in front of an audience was exhilarating. "I felt bathed in attention and love," Ray said of his first acting experience.

But Ray had not abandoned writing and talked incessantly about becoming a writer. It was all his parents heard that fall and winter of 1932. For Christmas, though they had barely the means, Leo and Esther bought their son a tin toy-dial typewriter. What a joyful surprise it was for Ray! The first assignment he gave himself was to write a sequel to the Martian novels of Edgar Rice Burroughs. It was a slow and laborious process to peck on the small toy typewriter, but he was determined and wrote virtually every day. He finished the Burroughs sequel and moved on to writing original *Buck Rogers* scripts. Though many credit Waukegan, Illinois, as the place that was most influential on Ray Bradbury's imagination, Tucson, Arizona, was where he discovered this creative side. On his small typewriter, he pecked fiercely, producing stories and letters to his cousin Vivian and Aunt Neva in Waukegan.

In 1933, Leo Bradbury found a more spacious house for the family in downtown Tucson at 417 South Fourth Street. Sharing the big brick house with several other tenants, the Bradburys were given the back of

the home. Leo and Esther had a bedroom of their own (still without a door, as Ray recalled), and Ray and Skip slept on yet another foldout bed on the screened-in porch. Next door, about a hundred feet from the Bradburys' new home, lived two brothers, twins, Austin and Jaustin, whom Ray befriended (in 2002, Ray wrote a short story, yet unpublished, about them—"Austin and Jaustin"—in which one boy was convinced he would live forever while the other knew with certainty that he would die an early death). Ray found his new house quite magical, with a rambling junkyard in an adjacent lot (which became the inspiration for the setting in the short story "The Rocket," in which Fiorello Bodoni builds a mock rocket from scrap to take his children on pretend voyages around Mars). Six blocks away was a railroad graveyard, packed with corroding locomotives that had long been retired; when they wanted an adventure, Ray and Skip came here.

While Ray was busy exploring this new wonderland, and spending weekends at John Huff's house across town, Leo Bradbury, still unemployed, decided to sell homemade "chili-bricks," dried chili that could be cooked in boiling water. Meanwhile, Ray discovered that the radio station broadcasting the *Chandu the Magician* serials was located two blocks from his house, and he began telling his schoolmates that he would work at the station, an odd, brassy proclamation for a twelve-year-old to make. But it became a self-fulfilling prophecy. This was a habit that he would continue indulging for the rest of his life—verbalizing his dreams and then, assuredly, attaining them.

Early in 1933, Ray Bradbury began to visit the KGAR studio—boldly bargaining his way inside by offering to empty ashtrays, run for Cokes, and throw out trash. The engineers and producers at the radio station were impressed with the boy's tenacity. Ray was hardly shy. Each night, he showed up at the radio station to act as a gofer, and when he was not working, he had his nose pressed against the thick audiobooth glass. After two weeks spent relentlessly shadowing the station workers, Ray was asked if he would like to be on air. Ecstatic, Ray accepted immediately. With several other children, Ray read bit parts of various Sunday comic strip characters and supplied sound effects for the live programs of *Tailspin Tommy, The Katzenjammer Kids,* and *Bringing Up Father.* In the spring of 1933, just twelve years old, Ray Bradbury was

reading the funny pages, which he often did at home anyway, on air for children all across southern Arizona, and working in one of his favorite fields of popular culture, radio. He was even paid for this terrific job—with movie tickets. Now, though the Bradburys could barely afford tickets to the movies, thanks to his job, Ray was able to attend the movies regularly. Voraciously, he watched *The Mummy, Murders in the Wax Museum,* and, an influential film for his storytelling development, *King Kong.* As a writer, Ray Bradbury ascribed to a Hitchcockian form of storytelling, building suspense slowly. "A good story," Ray maintained, "should be told like Chinese water torture. You drop one drop at a time, slowly, painfully building suspense." *King Kong,* he thought, followed this method beautifully. And it also featured a sympathetic antagonist in Kong, a tragic creature not unlike the Hunchback in Ray's early favorite, *The Hunchback of Notre Dame.*

In Arizona, Ray's creative force blossomed, forged of myriad popular culture influences, but he would soon have to leave this new and wonderful world. Leo Bradbury's entrepreneurial endeavor in the chili-brick business never took off, and he was forced to move his family back to Illinois yet again. For Ray's last night on air, the announcer said good-bye to him; Ray was elated that the man acknowledged him over the airwaves. It was an evening of bittersweet emotions for Ray; that night in the studio, Ray cried. It was a heartbreaking good-bye to John Huff, as well. The night before their move, Ray stopped by John's father's business to say farewell to his first true friend. It was gut-wrenching. The next morning, with the Buick loaded, the family began their trek back to Illinois. After the nine-day voyage, the Bradburys were back in Waukegan.

For Ray, moving back to Illinois would have been bleak had it not been for Neva, who had missed her Shorty tremendously, and for the 1933 World's Fair, brought to Chicago to commemorate the centennial of the city's incorporation. Opened to much fanfare on May 27, 1933, the Century of Progress World's Fair was held on a stretch of 427 acres along Lake Michigan, just south of downtown Chicago. Soon after its opening, Leo and Esther brought Ray and Skip to the fair. "It hit me like an avalanche of architecture," Ray said. "The whole thing so stunned me, I just wandered through the fair, enchanted and in a spell all day." At

the exposition, Ray encountered life-sized statues of dinosaurs at the Sinclair exhibit; he also discovered audio-animatronic dinosaurs that moved and roared. The exhibit featured a moving turntable—a people mover—that carried the crowd past the great artificial beasts risen from seventy million years of extinction. "I went in there and the exhibit went by so quick on that turntable that I walked backwards so I could stay in there for ten minutes. The people who ran the ride saw me and thought I was holding up traffic so they came and threw me out," said Ray, remembering how captivated he was by the exhibit. He also marveled at the fair's stunning architecture, structures that pushed the envelope of design. The buildings were a fusion of Art Deco and Greek mythology— monoliths rising straight from the pages of his beloved *Buck Rogers* comic strips. He was mesmerized.

Later that summer, Neva brought Ray to the fair for another visit. She had been involved in making costumes for an exhibit titled "The Streets of Paris," and had enlisted her nephew to help carry the costumes by train to the fairgrounds. At the fair, Ray was again so overwhelmed that he asked Neva if he could explore on his own. As ever, Neva obliged. They agreed to meet in the evening in front of the General Motors building and then parted. Ray spent the entire day exploring every exhibit; when he returned at seven o'clock to the prearranged meeting point, Neva was not there. Nightfall was just beginning to descend on the fair grounds. "After two hours of wandering around, trying to find her," Ray recalled, "I went to the lost and found and I said, 'I'm not lost, but my aunt is.'" Another two hours later, Ray's flummoxed aunt showed up at the lost and found, discovered Ray, and breathed a heavy sigh of relief. She had waited for him at the wrong building. By the time the duo returned to Waukegan, it was one o'clock in the morning. The entire town was dark and still. "All the lights were out in Waukegan," recalled Ray. "There were no streetlights. So we had to walk from the train station up near Genesee Street and Washington, down past the ravine to my grandmother's house at one in the morning with no Moon and only the stars for light. We walked over the ravine scared witless."

The Century of Progress, with its towering buildings and grand visions of the future, so jolted Ray Bradbury that he woke the next day de-

termined to build his own world's fair. Ray gathered cardboard boxes, construction paper, and glue and marched out to the backyard on St. James Street and began building. He had found a new passion, architecture, to add to his list of loves—movies, books, radio, and comic strips.

Luckily Leo Bradbury was rehired by the utility company and, for the time being, though the family never quite had enough, all was well. In 1934, Ray's uncle Inar decided to move with his wife, Arthurine, and daughter Vivian to California. Inar had worked in the laundry business in Waukegan for years, and his wife's family owned a dry cleaning business in California. Once there, Inar often sent postcards home; he wrote of the balmy weather and lush orange groves and suggested that the Bradburys come west. Leo Bradbury was tempted. That spring, he was laid off once again and decided to accept Inar's invitation. The Bradburys would move to Los Angeles.

On the Sunday before their move, Ray attended Sunday school at the First Baptist Church in Waukegan. The Bradburys were never a particularly religious family. Mostly, as Ray remembered, they attended church on Easter and Christmas and, on rare occasion, a few other Sundays throughout the year when Esther Bradbury had the inclination. On this Sunday morning before the family move to Los Angeles, there was a new Sunday school teacher and, after class, she invited the students to her house. Seventy years later, during an interview, Lydia V. McColloch remembered clearly the day when the nearly two dozen teenagers visited her home. "The kids found out that we had this setup where you could talk into a microphone in the basement and it would come out of the radio upstairs and that was *real* intriguing to Ray," said McColloch. With his professional experience in radio broadcasting, Ray proceeded to direct all the kids to the upstairs, where he put on a program for his audience. McColloch marveled at Ray's talent and noted how much he reveled at being the center of attention. A few days later, Leo Bradbury loaded the family into the Buick yet again, this time bound for Los Angeles. And this time, they were leaving for good.

Waukegan—the Green Town immortalized in Ray's works—had an incalculable effect on his life, for Ray Bradbury would always be a midwesterner at heart. By the age of thirteen, however, he had outgrown

Waukegan. After his experiences in Arizona, he realized there was much more to life than ravines and the Genesee Theatre. He had run wild on the brick-paved streets of Green Town long enough. It was now time to discover something utterly new: Hollywood, California.

7

HOORAY FOR HOLLYWOOD

> *There is so much joy and poetry in Mr. Bradbury's stories, joy for the universe, the love of language. Whether time is being altered through the crushing of a butterfly or an astronaut is burning up as he enters the atmosphere so as to become our shooting star, even here in these dark moments there is somehow joy. It is irresistible.*
>
> —FRANK BLACK, *founder of the Pixies*

"THERE YOU are, you little son of a bitch!" said W. C. Fields, handing the autograph book back to the brash thirteen-year-old. It was Ray Bradbury's first week in Hollywood, and already, poised on his roller skates outside the gates of Paramount Studios, he was making friends. This boy, who was in love with the world of movies, was now living in the middle of it all. It was the day after the Bradburys had arrived in Los Angeles, and Ray had strapped on his roller skates and headed out of the family's new apartment at 1318 Hobart Boulevard. At the corner of Western and Pico, he stopped to get directions from a corner newspaper salesman.

"Which way is it to MGM?" Ray asked.

The salesman pointed to the west and Ray began skating in that direction. "Wait a minute!" the man yelled. Ray skidded to a halt and turned. "That's five or six miles!" the man informed him.

Ray thought for a moment. "Well," he said, "where's the closest studio?"

That was how Ray landed outside the gates of Paramount, where, the moment he arrived, author Irvin S. Cobb, orchestra leader Ben Bernie, and actor W. C. Fields walked out of the studio's gated entrance. Ray approached them all for autographs. Fields called him a son of a bitch (*after* acquiescing to the autograph request). This was Ray's introduction to Hollywood.

From that moment on, Ray haunted Paramount. It was mid-April 1934, and he and Skip had pulled a fast one on their parents. The Bradbury boys had lied, telling Leo and Esther Bradbury that school in Los Angeles would be letting out in just a few weeks. The boys argued that it would be ridiculous to enroll at the very end of the academic year. Leo and Esther, not bothering to check the story, allowed the boys to remain home. Actually, school was not done until mid-June, but their parents never found out, and Ray and Skip enjoyed an extended summer vacation.

One afternoon during the first week in L.A., outside the tall white walls of Paramount, Ray spotted another autograph hound—a boy around his own age, lurking about waiting for a glimpse of Hollywood royalty. The boy's name was Donald Harkins and, as Ray learned, they would be attending Berendo Junior High School together come autumn. Donald Harkins was a shy, self-effacing kid, and his family was, like Ray's, suffering financial woes. If anything, the Harkinses were even worse off than the Bradburys. Donald and Ray shared an ardent love of motion pictures and they became fast companions, often arranging to meet each other outside Paramount or, when Ray did not roller-skate across town, taking the streetcar there together. Through the summer months, Ray and Donald happily loitered outside the studio walls, collecting autographs at a prodigious clip. Ray also started to collect *Flash Gordon* comic strips, which premiered that year. The space opera was just one more piece of popular culture that comprised the Ray Bradbury mosaic.

The Bradburys lived on the second floor of a two-story building. A small balcony looked out to the north from which Ray could see the rooftop of the Uptown Theatre several blocks away. The movie palace

had a red light on top, and about one night a week a movie previewed—
a showing of a film in the late stages of the editing process. When this
happened, the light on the rooftop was illumined. Ray would see the red
beacon and rush to the theater. He stood outside many nights, spotting
all manner of stars rolling up in their limousines. Helen Hayes and Brian
Aherne arrived for *What Every Woman Knows*. He saw Laurel and
Hardy, Irving Thalberg, Norma Shearer dressed in a flowing silver lamé
gown; he saw Clark Gable, Jean Harlow, and many others. They were all
there, right before his eyes. He always had his autograph book with him
and he asked for signatures from them all. He was even bold enough to
ask some to inscribe "To my pal, Ray Bradbury." But Ray seldom had
enough money in the pockets of his patched corduroys (hand-me-downs
from his brother) to go into the 1,600-seat theater himself. He decided
to remedy this. It would take time, but gently he began making his pres-
ence known to the Uptown's manager. Ray was applying the same sort of
pushy charm that he had used in securing his on-air post at the radio sta-
tion back in Tucson.

Los Angeles agreed with Ray. Leo Bradbury, however, had applied
for work all across town and still could not find a job; he had only enough
money to sustain the family for two months and he was worried. Time
was running out. After eight weeks, he still had no job. They would have
to move back to Waukegan yet again. But Leo Bradbury did not want
this. His family loved California. Only twice in his life could Ray ever re-
member seeing his father cry: The first time was after his baby sister
Elizabeth had died in 1928, and the second was in the kitchen of the
Hobart Boulevard apartment. Leo was unaware that his son was in the
doorway as he sat at the kitchen table and silently wept. Ray looked on,
watching as a single tear slowly descended down the bridge of his fa-
ther's nose. But before the family packed up again, General Cable Com-
pany hired Leo Bradbury as a lineman. They were staying.

Even with the family's dire financial state, it was a good time. They
had each other, along with Uncle Inar, Aunt Arthurine, and cousin Vi-
vian living just a few blocks away. Ray remembered with fondness one
evening when his father, Uncle Inar, and Skip played a game of kick the
can out on the street in front of the Hobart Boulevard apartment. It was
getting dark. They ran in the street, screaming with laughter, the tin can

skittering across the warm pavement. "For that brief moment, Dad became a boy again," said Ray. They were making such a racket that a police cruiser rolled up and the officer told them to keep it down.

With his cousin Vivian living so nearby, Ray continued his hormonal antics, sitting on the front steps of Hobart Boulevard in the evenings and trying to kiss her. When asked to describe Ray Bradbury at age fourteen, Vivian was succinct: "He was horny."

One summer night Vivian had gathered a few girlfriends, one of whom had an admirer, a fellow named Eddie Barrera. Upon meeting Eddie, Ray realized that they shared a similar passion for radio and film, and they soon became close friends. By the autumn, Ray had started the ninth grade at Berendo Junior High School, as had his friends Donald Harkins and Eddie Barrera. In Waukegan he never really had any close friends, and had only met his first true friend in John Huff while in Tucson. Now he had two more lifelong chums. Meanwhile, Skip Bradbury joined the Emergency Conservation Work, later rechristened the Civil Conservation Corps. The CCC was a peacetime army of the young and the unemployed, established by President Franklin Delano Roosevelt to help save the country's natural resources by battling soil erosion and renewing declining forests. The work would take Skip throughout southern and northern California; his three-year tenure began in San Bernardino, and eventually took him to the high Sierra Mountains. He made thirty dollars a month, sending twenty-five of it home to help his parents and Ray.

While his older brother was away, after classes on Wednesday afternoons, Ray often roller-skated across town to the Figueroa Street Playhouse where George Burns and Gracie Allen broadcast their renowned radio show. "In those days," Ray said, ". . . there were no audiences for radio broadcasts. Seeing George Burns outside the theater, I skated up to convince him that he should take me and my friend Donald Harkins in to watch their rehearsals. Why George agreed, I'll never know. Perhaps we looked as poor and pitiful as we truly were. In any event, George led us in, seated us in the front row of an empty theater, and the curtain went up on George and Gracie playing to an audience of two ninth-grade kids."

Tinsel Town was all around him. Even the proverbial girl next door

had a connection; the girl's mother played piano for the Meglin Kiddies, an acclaimed children's workshop and song-and-dance troupe that spawned child prodigies. Ray's neighbor took him one afternoon to the Meglin Studio, where he met the Gumm Sisters, a sibling group who had gained fame on the radio and in short-subject films. The group included twelve-year-old Frances Gumm, who would later change her name to Judy Garland.

By November 1934, with steady work at long last, Leo Bradbury moved his family a few blocks away to an apartment at 1619 South St. Andrews Place. A house with a small front yard, it was divided into four units; the Bradburys lived on the ground floor on the north side of the building. Their neighbors in the adjacent unit to the south were the Hathaways, a friendly married couple whose name Ray would use for the physician-geologist character in the story "—and the Moon Be Still as Bright" from *The Martian Chronicles*. Ray would later maintain that naming his characters was never a laborious process as it often is for other writers; he contended that most of his characters were given names from his subconscious and only later, he said, did he discover that some of the names had symbolic meanings. Montag, for example, from *Fahrenheit 451* was the name of a paper manufacturer. Faber, from the same novel, was the name of a pencil maker. Bodoni, from the short story "The Rocket," was the name given to a printer's typeface.

In this modest apartment, once again, as with every place they had ever lived, Ray slept out on a foldout bed in the front room. But with Skip away in the CCC, Ray at least had a bed to himself.

At school, Ray excelled in his English and art classes, but failed miserably in mathematics. After school, he rushed over to Hollywood to pace outside the various studios. One day, Ray and Donald Harkins walked through the Hollywood Forever Cemetery that backed up against the wall of Paramount (a setting used in the novel *A Graveyard for Lunatics*) and climbed atop a woodpile and then up and over the wall of the movie studio. They had made it into the back lot of Paramount—a symbolic act of arrival in show business. But their visit was short-lived. Ray and Donald had walked just a few feet into the studio's carpenter shop before a hulking security guard confronted them. The man promptly escorted the teenage trespassers out.

The two starstruck boys roamed all over Los Angeles, casing the studio gates, gathering autographs. They had learned where actor George Murphy lived and would hang upside down from the trees across from his home. The actor never emerged.

Meanwhile, Ray, the self-described "wimp," was having problems with a bully in school. "I was a smart-ass," said Ray. "I was in history class and the teacher asked a question and this Armenian boy sitting in front of me gave the answer and under my breath, I said, 'Good guess.' And the teacher heard that and she said to the boy, 'Was that a guess?' Like a damn fool, he said, 'Yes.' So he got a zero and he started beating up on me. Every time he saw me, he would hit me on the arm. My arm was a series of bruises for years."

Though Ray was bullied at school, he was able to escape the trouble in the afternoons, when he and Donald Harkins headed to the movie studios. Occasionally, Ray was able to talk his father into letting him borrow the family camera—a "box Brownie." It was against Leo Bradbury's better judgment to let his son skate all over Los Angeles with the equipment, so he made an agreement with Ray. Ray had to tie a piece of string to the camera and leash it to himself. In a photo of Ray standing next to George Burns outside the Brown Derby restaurant in Hollywood in 1935, this string is visible. Burns is wearing a fedora and clutching his ubiquitous cigar, his arm is locked around Ray's, and the string is attached to the belt of Ray's raincoat. The string travels out of the frame and is attached to the camera that took the photo.

On another afternoon in 1935, Ray was visiting Eddie Barrera at his house on Washington Boulevard when they heard a terrific crash outside. The boys bounded out the front door and saw a smoldering car about a hundred yards up the street, in front of a cemetery. The car had hit a telephone pole head-on and the passengers had been catapulted onto the pavement. Ray and Eddie ran to the car, the first to arrive at the accident scene. Blood was everywhere. Three people had already died; another—a woman—was barely alive. Her face horribly disfigured, the woman looked at Ray as he loomed over her and in that instant as they made eye contact, her eyes fluttered shut and she died. "It was a scene out of a nightmare," Ray said. "I stumbled home that day, barely able to walk. I had to hold on to trees and walls I was so stunned." It so stunned

him, in fact, it was the main reason why Ray never learned to drive. The experience would also later serve as the inspiration for the 1943 short story "The Crowd," in which Ray would ponder the very nature of those who arrive first on the scene of deadly accidents. Recalling that the cemetery was nearby, he wondered if those people could even be ghosts. Seventy years after witnessing the horrific crash, Ray was still scarred. "About once a month," he admitted, "I still have nightmares about that poor woman who looked at me."

After that, Ray spent many days with Eddie Barrera. The two tried to forget the accident's gruesome images. They spent their time scheming to become famous. One afternoon, Eddie paid twenty dollars (his parents had a bit more money than Ray's) to book a recording studio in downtown Los Angeles and, along with another friend, Frank Pangborn, the trio taped a comedy radio show titled "Our General Petroleum." The material during the recording is, predictably, juvenile, and squeaky-voiced Ray hammed it up considerably. After making the recording, Eddie and Frank were convinced that this great, unrecognized comedy trio could make it to the big time. They begged Ray to run away with them. "The dreams of boys are so impractical," Ray remarked. "I said to them, 'Where are we going to go?' and they said, 'To a big city,' and I said, 'We're already in a big city and nobody wants us.' I refused to run away from home and go with Eddie and Frank out to conquer the world. It's a good thing I decided that."

At the Figueroa Street Playhouse, the radio program *Hollywood Hotel* was broadcast on Friday evenings, featuring actor Dick Powell as the emcee and a woman many considered to be one of the most powerful women in Hollywood, gossip columnist Louella Parsons. Parsons certainly noticed the outgoing young blond man who wandered about the theater. She invited him in one Wednesday afternoon, where he sat next to Gary Cooper for a broadcast of *The Lives of the Bengal Lancer*. Ray even befriended Parsons's chauffeur. Before he knew it, he was riding with the driver in the Rolls-Royce limousine, running errands. "There I was," said Ray, "in my poor clothes, sitting in the back of the limousine. We would pull up to a stoplight and all the people would look to see who was sitting in the back and it was just poor Ray Bradbury. I would smile back and wave."

Louella Parsons soon learned that the teenager was stealing rides in her car and banished him from the theater, but this did not prevent Ray from rummaging through the Dumpsters behind the theater after the program was finished. He was looking for scripts from the show. Those *Hollywood Hotel* scripts were stored in his file cabinets for decades.

Soon after, during the summer of 1935, Ray chased actress Marlene Dietrich inside a building and up the staircase at the House of Westmore Beauty Salon. The reclusive actress was trying to flee the eager teenager, but he eventually won out, getting the star's autograph before being escorted away by salon employees. Not long after chasing Dietrich up the stairs of the salon on Sunset Boulevard, Ray spotted the actress again outside Paramount and asked her to pose for a picture with him. Ever bold and brash, he made a request of the camera-shy celebrity. "I suggested since the sun was on the wrong side of the street, she might be willing to cross over. On the verge of refusal, Dietrich inexplicably relented and made the trek."

Ray did receive encouragement for his early writing career. George Burns was kind and actually gave Ray the time of day when they met outside the Figueroa Street Playhouse. Ever driven, Ray sensed an in. He had just started his first year, the tenth grade, at Los Angeles High School. It was the fall of 1935. During his typing class, Ray began writing speculative scripts for Burns and Allen, and each Wednesday afternoon he would skate over to the Figueroa playhouse to hand them personally to George Burns.

"He told me I was a genius and the scripts were brilliant. Of course they were lousy and he knew that but he was polite," said Ray. Eventually, though, Burns and Allen took one of Ray's jokes, an end-of-the-program routine that aired on February 26, 1936:

GRACIE:　Ohhhhhhhooooooo!
GEORGE:　Quick, somebody . . . Gracie has fainted. . . . Hurry. . . . Bring a glass of water. . . . Gracie! . . . Talk to me. . . . Gracie . . . say something. . . . Gracie. . . . Can't you say something?
GRACIE:　Sure . . . this is the Columbia . . . Broadcasting System!

Listening to his words live on the Burns and Allen show only solidified this fifteen-year-old's determination. He wanted to write, to direct, to act, he wanted to be a part of this world he was looking at from close up. He wanted it so desperately. It had been nearly twelve years since he had first fallen under the spell of the cinema when he saw *The Hunchback of Notre Dame*. Moving to Hollywood, at play in a vast field of stars, only heightened his obsession, convinced him further of his own destiny. In Bradbury parlance, he was "madness maddened." He had unflinching determination but, as Ray was the first to admit, there was one problem. His writing was dreadful. But that didn't stop him from pursuing his dream.

"When I think back on how I must've looked, sailing through Hollywood on my roller skates, a big chubby lunk of a kid with my autograph book under one arm and my cheap box Brownie under the other," he said, "I mean, who would've predicted that lout would ever write anything anyone would ever want to read?"

8

LEARNING TO FLY

Ray Bradbury's collection of short stories R Is for Rocket *led me to a lifelong love of science fiction. It was my pleasure to work with Ray during the first One Book, One City Los Angeles project. One Book, One City is a sort of giant reading club for the whole city and I knew that the choice of books that very first year was perhaps the most important decision in determining the success of the program. So I chose a classic. One of my very favorite books,* Fahrenheit 451, *proved to work beyond my wildest dreams. It captured the hearts and imaginations of the whole city. Never since have we seen such a successful reading program as we did the year we chose Ray's masterpiece. On a personal note, I got to spend some*

time with Ray and I can honestly say that I've rarely encountered such warmth, intelligence, and personality as I found in Ray. I loved working with him, and I so appreciate the joy of reading that Ray helped spark for the people of Los Angeles.

—JAMES K. HAHN, *mayor of Los Angeles*

IN 1936, Ray experienced a night terror so vivid that it stayed with him for years. In it a bulldog—black, vicious, and as big as a small house, all sinew and muscle and fang—was chasing him. Running as fast as he could, Ray could not run fast enough. The beast was closing in. Like a great tyrannosaur, the bulldog moved with a hunter's intent, tilling the ground with its talon claws. Ray couldn't escape. The black bulldog's ferocious mouth opened as he bore down on Ray, and in an instant, he was gone. Devoured by the great, black dog.

Ray woke up in a cold night sweat in the front room of the apartment on St. Andrews Street. He had died in his dream. And right away, somehow, he knew what the dream represented. It was a vision. The nightmare had portended the inevitable. War was coming. It was 1936, and while America was still consumed by the Great Depression, across the globe, the Fascist dictator of Italy, Benito Mussolini, had ordered the bombing of Ethiopia and was leading the world toward all-out conflict. Ray didn't know where and he didn't know when, but he knew that World War Two was coming. And he couldn't escape it.

The prospects of getting shipped overseas to some far-off battlefield frightened him beyond belief. His uncle Sam Bradbury had had dreams of becoming a great writer and poet. And those dreams had been extinguished when he died of influenza on his way to fight in World War One. Ray knew that if he were to be sent into war, he too would die, and never have the great literary career that he so desired. "I was scared that I would never get the chance to live for my country," said Ray. "People don't ever talk about that. I wanted to live so I could contribute."

Despite the chilling midnight vision, Ray continued to write, hoping to publish. Fittingly, just four days before Ray's sixteenth birthday, on August 18, 1936, in the city where he was born, the *Waukegan News-Sun* published a poem he had submitted on the occasion of the one-year

anniversary of the death of screen and radio star Will Rogers, who had
died in a plane crash. Ray had no publishing connections in Los Angeles,
but in Waukegan, where his grandmother lived and where the Bradbury
name still had cachet, he knew he had a chance of publishing his poem
in the town paper. His instincts proved correct. The *News-Sun* printed
the poem in its entirety. It began:

> IN MEMORY TO WILL ROGERS
> *The man who jested through his life*
> *And chased away all care and strife.*
> *The man whom we called, "Just plain Bill."*
> *Our ambassador of Good Will,*
> *Has laid away his ink and pen*
> *To see his maker once again.*

The poem concluded with a note from the editor:

*IT WAS A YEAR AGO LAST SATURDAY THAT GENIAL
WILL PLUNGED TO DEATH WITH WILEY POST. THE
ABOVE RECOLLECTION OF THAT SAD EVENT COMES
FROM A FORMER WAUKEGAN RESIDENT, RAY BRAD-
BURY, SON OF LEONARD S. BRADBURY, WHO WAS
BORN IN WAUKEGAN IN 1920 AND LIVED HERE UNTIL
TWO YEARS AGO.*

The verse was childlike. As Ray said, "It was very primitive. But it
was an emotional response to an important sadness in my life. At the
heart of it was the fact that I loved Will Rogers and his death diminished
me. If I had learned to do more of that sort of writing during the next few
years, I would have become a published writer much sooner. I was latch-
ing onto something in myself but I couldn't see it. And that's the trouble
with living, you don't see yourself. You can't see what you're doing. And
then suddenly you look back and realize, 'Oh God, if only I had looked
closer at what I had done, maybe I would have learned something.' But
we don't have the ability to do that at that age."

After this accomplishment and his sixteenth birthday, Ray and his

friend Eddie Barrera made a decision: They would lose their virginity. Neither had a girlfriend and both suffered from an acute case of shyness when it came to the opposite sex (except, of course, for those earlier times Ray had spent with his cousin Vivian). Ray's facial acne and boils on his neck made him unpopular with the girls in school. So the two boys, with two dollars apiece, wandered downtown on San Pedro, walking the streets until they happened upon two prostitutes in their early twenties, one rail thin, the other a full-figured redhead.

"Eddie gave me the plump one," recalled Ray with a laugh. The women brought the boys to an apartment building that, as Ray remembered, actually had a red light glowing outside its door—the proverbial symbol of a house of debauchery. In a second-floor apartment, Eddie was led into a bedroom and Ray into the bathroom. Ray's escort drew a bath and slowly undressed Ray, wide-eyed with terror and arousal. He stepped his toes into the warm water and glided slowly down into the porcelain tub.

"She washed me off," Ray said. "And, of course, that was almost fatal. To have a woman soak you and wash you at that age, if you're not careful, it's all over."

After the bath, Ray and the young woman went to a bedroom, and the big romp of his adolescent fantasies was over in three minutes. Afterward, the two boys parted company with their respective *filles de joie* and, in a postcoital stupor, walked to a nearby pharmacy to buy salve. Just sixteen, they had no idea what they were doing. They both worried that they had contracted a sexually transmitted disease. "For the next month," recalled Ray, "I would look down there to make sure it hadn't fallen off!"

It was a telling moment. Although he had entered the world of manhood, he was still that exuberant, pimply-faced, gee-whiz, stargazing, toy-coveting, celebrity-chasing, roller-skating boy, a bit naïve and innocent, filled with childlike wonder. It was the persona Ray Bradbury would embody for all his days—half man, half boy.

In the fall of 1936, Ray and Eddie began eleventh grade at Los Angeles High School. Ray's other good friend, Donald Harkins, who lived downtown, attended Metropolitan High School, but the two pals continued to meet at least once a week to hound the stars outside the studios.

After receiving numerous postcards imploring her to move, Ray's aunt Neva joined the Bradburys in Los Angeles. Neva rented the apartment directly above Ray and his family on St. Andrews. Ray was thrilled that his beloved aunt—his first and foremost muse—was nearby once again.

During his junior year, though he never abandoned his love of comic strips and pulp fiction magazines, Ray began reading more literary material, visiting the library and studying *The Best American Short Stories of the Year* anthologies, and pledging to himself that one day his own work would be published in the pages of these revered collections. He also promised himself to publish in the *Saturday Evening Post,* a magazine his father greatly admired. But Ray's talent didn't match his determination. By his own admission, he was a poor writer in high school; his work was too derivative. He imitated rather than trying to develop his own voice, spending his time copying Conan Doyle's *Sherlock Holmes,* P. G. Wodehouse's *Jeeves,* and Edgar Allan Poe's tales. "Imitation is fine for a while, but then you've got to move on and take a chance on something that's really you," he said later.

Occasionally, Ray would write about his own experiences, but he was too much of a neophyte to recognize its potential. Once, he wrote about the ravine in Waukegan, with its dark and twisted tangle of jungle malevolence, but he was self-conscious about penning it. (Of course, much later, the ravine would be central to *Dandelion Wine, The Halloween Tree,* and the unpublished sequel to *Dandelion Wine*, *Farewell Summer.*) And so he discarded the short story about the ravine and continued imitating his literary heroes. It would be another six years before Ray discovered that drawing from his own experience would produce a wealth of material. In the meantime, his lack of writing chops frustrated him.

"Ray was a suffering soul in high school," recalled Bonnie Wolf, a writing classmate one year younger than Ray. "He had this burning ambition and at that time it really wasn't based on anything. That was a source for a great deal of despair on his part. At that age, you don't really have any material. None of us did."

His painful shyness with girls, coupled with his anguish to become a great, successful writer, made Ray's junior year in high school miserable. He was a good student, even though his math scores were barely above

passing and his wood shop projects took weeks longer to complete than did all the other students'. Unlike the popular kids who drove cars, played sports, and dated, Ray roller-skated, wrote stories, and only lost his virginity by paying for it.

Complicating matters, Ray was writing mostly science fiction, a genre with little literary credibility, as he soon discovered. He struggled for his classmates' acceptance, and years after he established himself as a writer, he would seek the literary establishment's as well. Nonetheless, Ray's ambition was undeterred, and he wrote every day.

At school, Ray enrolled in a poetry class and club, both led by one of his favorite teachers, Snow Longley Housh, a gentle, older woman who wore glasses and a bob of graying wavy hair. He also took a short-story class, taught by another favorite instructor, Jennet Johnson. These two teachers changed Ray Bradbury's world, so much so, in fact, that he later dedicated his 1962 novel *Something Wicked This Way Comes* to them. Housh and Johnson encouraged the young, untamed writer. Housh told Ray that he was a poet, even though, as Ray described it, he wrote "lousy poetry." On one of his early science fiction stories, Johnson scribbled "I don't know what it is you're doing, but don't stop." These simple words of inspiration gave Ray the confidence to continue, and after that, Ray always maintained that the fundamental responsibility of a good teacher is to inspire.

But "I still didn't have a real typewriter," Ray recalled. "So every day I gave up my lunch period and I would go to the typing room and write stories." In that room by himself, surrounded by forty typewriters, he wrote furiously, and minutes before the lunch hour ended, he ran to the cafeteria to eat. The sixteen-year-old's determination was almost fanatical. He was writing, on average, one short story a week. Ray could also be something of a bulldozer; in his writing classes, he had no compunction about the discussion of his work monopolizing class time. He was certain he would, one day, make a name for himself as a great American writer.

He was so convinced of his destiny, he began sending his stories to several top-tier New York magazines, but his submissions were all promptly rejected. *Esquire* editor Arnold Gingrich, in a handwritten note, summed up Ray's writing at the time, stating that "while it's a fair

job, the idea is one of those that are constantly occurring." Despite rejection, he continued writing. "I just figured the editors didn't know what they were doing," Ray said. The boy persevered and, in March 1937, his poem "Death's Voice" was selected by Snow Longley Housh for the school's *Anthology of Student Verse*.

While he was fixated on a career as a writer, thanks to his great love of movies, a part of him dreamed of becoming an actor. Since his seventh-grade appearance onstage in the Tucson school Christmas pageant, Ray had fallen under the spell of the live audience. So that year, in addition to his writing course and club, he joined the school drama club, the L.A. Players. It was these extracurricular activities that made high school palatable for him.

In the spring of his junior year, the call went out for actors, writers, and musicians for the annual talent show, the Roman Revue. With a résumé that included reading the funny pages over the Arizona radio airwaves, contributing a sketch to the vaunted Burns and Allen show, and publishing a poem in the *Waukegan News-Sun,* Ray had a steely confidence and a growing ego, even though, as he said, it was "based on nothing." And so he went to the Roman Revue auditions in the spring of 1937 and presented himself as an announcer, a director, a sound-effects man, and a writer. Ray then wrote an entire speculative script and plunked it down in the hands of the faculty adviser in charge of the student talent show.

"I loved radio shows so much at the time and was going to broadcasts constantly," Ray recalled. "I went into the tryouts for the student talent show which had no shape, no plans. I thought . . . What the hell? I'll write a radio-style show—all the bits and pieces and the introduction."

The adviser, the junior choir instructor, was impressed with his speculative script. "She came to me," Ray recalled, "and said, 'My God, you've got the job.'" So he was assigned as writer and producer. On the day of the show, he was even onstage with the applause sign.

The Roman Revue was a resounding success. It was so popular, in fact, that for the first time in the history of Los Angeles High School, the student talent show returned for a repeat performance. Ray felt a sense of arrival. Suddenly, other students were looking at him with acceptance and appreciation.

During this time, Ray also began contributing to the school newspaper, *The Blue and White Daily*. He wrote movie reviews and a series of short articles that included a story on the popularity of the Jack Benny radio program. With the piece, Ray was not only writing about one of his many passions—radio—but he was also writing about Benny, a fellow native of Waukegan, Illinois.

That year, Blackstone the Magician made an appearance in Los Angeles. Ray, of course, was in the audience for the show. During the performance, Blackstone called out for a volunteer to assist him with an illusion. Before hands even went up, seventeen-year-old Ray bolted from his seat and hurried onstage. Blackstone was unaware that several years earlier the enthusiastic teenager had helped him with a different illusion in Waukegan, Illinois.

As the magician began his trick, he leaned into Ray. The boy smelled a heavy odor of whiskey on Blackstone's breath, which sent chills of disappointment and disenchantment through Ray. More than that, Ray realized he pitied the man. The boy who had once dreamed of becoming the greatest magician on Earth—in large part because of Blackstone—knew in that instance he had aspirations far beyond silk scarves and sleight-of-hand. "I realized that Blackstone was bored," said Ray. "All those performances day after day doing the same thing. It got to him. From that moment onward, I made a promise to myself that I would never do the same thing. I never wanted to get bored."

More and more, writing seemed the answer. Ray realized that he could captivate an audience through words, rather than through illusions. His stage props were different; as a writer he would use language and metaphor, but the outcome was much the same. Storytelling allowed him to enrapture an audience, oftentimes tricking them with literary bedevilment, and, in the end, entertaining them.

That fall, Ray spotted a handbill hanging in a secondhand bookshop on the corner of Western Avenue and Hollywood Boulevard, a flier advertising a local group called the Science Fiction Society. The group, a regional chapter of the national organization founded by *Wonder Stories* editor Hugo Gernsbach, was meeting Thursday night in downtown Los Angeles in the Brown Room at Clifton's Cafeteria. Excited, Ray took the flier and left his name and address with the bookshop's owner. Days

later, he received an invitation in the mail from T. Bruce Yerke, the society's secretary, inviting him for a visit. The following Thursday, Ray took the streetcar downtown to Clifton's Cafeteria.

"I bought myself a ten-cent malt," recalled Ray, "and went upstairs and I looked in the room at all these weird people."

One person stood out in particular, a lanky, energetic young man named Forrest J Ackerman. The year before, Ackerman, at age twenty, started the group with a few other fans. A year later, in October 1937, the group was holding regular meetings in a wood-paneled room on the third floor of Clifton's.

Ackerman, credited with inventing the term "sci-fi" later in his career, would become a legend to collectors and creators. Known as "Forry," "4E," or "4SJ," he acted in 106 films over the course of his life (mostly bit parts in B-movie monster matinees), and he served as a literary agent to science fiction and fantasy greats Isaac Asimov and L. Ron Hubbard, among others. He would also go on to create and edit the magazine *Famous Monsters of Filmland*.

Ackerman, who would later sell international rights to some of Ray's early pulp stories, remembered his first impressions of seventeen-year-old Ray. "Ray was a rather boisterous young boy. He liked to imitate Hitler and W. C. Fields. It's a wonder we didn't strangle him," Ackerman declared.

Despite Ray's occasionally grating sense of humor, the members of the Los Angeles Science Fiction Society embraced him immediately. His energy was infectious. Ackerman said that Ray had "an overwhelming enthusiasm about his work."

Meetings usually lasted an hour. Ackerman, who corresponded with science fiction writers across the country, gave updates on these exchanges. The members of the Los Angeles Science Fiction Society took the future seriously and invited guest speakers, often experts in the fields of science and technology. The presentations were discussions on the technology of the future, similar to what one might find in the feature stories of *Popular Science* magazine. Ray recalled guests pontificating on topics from painless childbirth to hydroponics. Scientist Jack Parsons (who later cofounded Jet Propulsion Laboratories) gave a lecture on space travel well before the technology existed. And among the other

members in the room the first night Ray arrived were writers Roy Squires, Arthur K. Barnes, and Henry Kuttner.

Ray became an active society member immediately. In November, he wrote his longtime hero Edgar Rice Burroughs, and invited him to talk to the group. Burroughs, who cocreated the character Tarzan, lived in nearby Tarzana, California. To Ray's amazement, Burroughs replied; he declined the invitation, as he had a conflict on Thursday evenings. Ray persisted, writing Burroughs again and offering to make special arrangements to change nights to accommodate the author's busy schedule. On November 22, Burroughs again replied:

> My dear Mr. Bradbury:
>
> Now you have really put me on a spot and compelled me to explain to you that I never appear or speak in public, if there is any possible way in which it can be avoided.
>
> I hope that you understand that it is not due to any lack of desire to co-operate with you and that I fully appreciate, and am grateful for having been honored by the invitation.
>
> With all good wishes, I am,
> Very sincerely, yours
> Edgar Rice Burroughs

Though Ray was disappointed that Burroughs would not come talk, he was thrilled that his hero had written him two hand-signed notes.

Shortly thereafter, Ray bought his first real typewriter. He bought it from a fellow group member, but since Ray didn't have any money, he made a deal to pay the fellow a dollar a week until the debt was paid. To do this, Ray decided to forgo his twenty-five-cent school lunch and use the money to repay his loan.

During his last year of high school, things took a turn for the better, mostly because of the camaraderie Ray found in the Science Fiction Society. He had been befriended by a group of strange and imaginative outcasts like himself. "The group changed my life. They took me in. I was nowhere, I had nowhere to go. They gave me focus," Ray explained.

Recognizing Ray's drive, Ackerman invited Ray to help put together

the group's publication, a 'zine (shorthand for fanzine) titled *Imagination!*
Ray accepted readily. As editor, Ackerman assigned Ray to hectograph
the magazine—a process using gelatin-coated sheets to make multiple
copies. By November 1937, Ray had contributed a short humor piece,
"Foolosofy & Scientificrax," and a drawing. In January 1938, his first
short story, "Hollerbochen's Dilemma," was published in *Imagination!*
Ray was not paid for the story, but it was his first short fiction piece to
see print. He was ecstatic. Sixty years later, Ackerman admitted that at
the time he thought the short story was weak, but he needed material for
the magazine. Ray agreed: "It was terrible." For the first time, though, the
frustrated writer felt that he had a purpose, and the Los Angeles Science
Fiction Society and Forrest J Ackerman had provided it.

But obstacles got in Ray's way. In his two years taking the high
school short-story class, Ray, with his tech-heavy tales of science fiction,
was shut out of the school's annual anthology of short fiction. It is a great
irony given all that he would one day achieve, but Ray was one of the few
students *not* to place a story in the Los Angeles High School Fiction
reader. Fortunately, he had better luck with his verse. In May 1938, be-
fore graduation, Ray's poem "A Truck Driver After Midnight" was se-
lected for the school poetry anthology. The poem was about the lonely
life of the truck driver, and, while he would later describe it as a bit
heavy-handed and green, it nonetheless hinted at the visually evocative
writing that portended Ray's future.

His senior year was coming to an end, and surprisingly for Ray, it
was hard to leave. School had mostly been a painful hindrance for him.
But in the last two years, he actually enjoyed himself. During his last
term, Ray even managed a perfect report card: He received straight A's.

In June 1938, Ray graduated from Los Angeles High School. He at-
tended commencement wearing the only suit he owned—the suit his
uncle Lester had been shot in. One could still see the bullet hole under-
neath Ray's blue-and-white cap and gown. And ever the great storyteller,
Ray made sure everyone knew about it.

FUTURIA FANTASIA

I think Ray is one of the most important American writers of the
20th Century, because his books expanded the minds of millions who didn't realize
there was more to the universe than one small planet orbiting a second-rate star.

—SIR ARTHUR C. CLARKE, *author*

RAY BRADBURY hated waking at seven on school days, but thankfully those early mornings were behind him. He loved having finished school because he could now sleep in until nine A.M. Oh, the freedom!

Ray continued meeting with the Science Fiction Society at Clifton's on Thursday evenings and assisting with the society's fanzine, *Imagination!* He contributed more short humor pieces and artwork. And he remained steadfast about establishing himself as a big-name writer. But he wouldn't settle for anything less than becoming one of the greatest writers who ever lived. Somehow, some way, he would write a book that would be shelved alongside his heroes, Wells, Baum, and Burroughs. He was certain of it.

In the meantime, there were the petty, everyday irritants like finding work to contribute to the family coffers. In the summer of 1938, Ray's grandmother Minnie sold her house—and the adjacent house Ray had lived in—in Waukegan and headed to Los Angeles. She moved in with her twenty-eight-year-old daughter, Neva, in the apartment above Ray's on St. Andrews. Skip was back home too, after his duty in the Civil Conservation Corps, following in the footsteps of his father as a lineman for the Los Angeles Bureau of Power and Light.

In August, Ray landed a job. A former classmate who sold newspapers on a street corner offered his post to Ray for eighty dollars. It was an

expensive endeavor, but Ray jumped at the opportunity. He borrowed the cash from his brother and father and was soon a newspaper salesman for the *Herald Express,* the late-afternoon edition of the Los Angeles *Herald Examiner,* a Hearst publication. Ray worked five days a week from roughly four to six-thirty P.M., which left the morning and most of the day—as well as weekends—for him to write. A bundle of newspapers would be dropped off on the northeast corner of Olympic and Norton each day, and Ray would stand in front of Acton's drugstore. A grocer and a plumber's office were next door, and the railcar clattered by, running down Olympic. It was a bustling corner—a fine place to sell newspapers. At first, Ray assumed the classic newspaper boy persona, crying out, "Extra! Extra! Read all about it!" Then he decided to try a more subtle approach. "I experimented to see if I shut up, if I would sell just as many papers, and I did." He realized that the shouting didn't help (though he didn't entirely shut up, for he was forever engaging his customers in conversation). "People either want a newspaper or they don't," said Ray. His discovery of this sales pitch was similar to the way he was slowly discovering his writing method. At first, he imitated, then he found his own unique approach.

Ray was soon a well-known fixture on the corner of Norton and Olympic. He was charismatic and engaging, and there was a magnetic energy to the young, bespectacled man. Bob Gorman, who sold the competing Los Angeles *Daily News* at the same intersection, recalled working near Ray Bradbury: "He was aggressive and outward and very sociable as a salesman. He worked hard. He was real easy to talk to. He talked a lot about when he would go into Hollywood and the people he would meet. The stars." Gorman also recalled that when Ray wasn't selling papers, he was almost always on his roller skates. "I felt sorry for him. While a lot of other young kids were driving automobiles, he never learned how to drive," said Gorman.

The fact that Ray didn't drive hardly bothered him, though. He liked his job and was meeting and talking to all sorts of people (screen stars John Barrymore and Buster Keaton were regulars of his). And he was making a decent wage. Averaging ten dollars a week, Ray earned enough to buy his own clothes and pay for movies, books, and magazines. At the end of his shift, he either walked or roller-skated home, which was less

than a mile away. A few nights a week a bakery driver, who stopped at the corner pharmacy for a sandwich and a malt, offered Ray a ride in his delivery truck. "I'd go home in this bakery truck surrounded by the wonderful odor of sourdough bread, and pie, and cake. There was a leftover donut and the driver always gave it to me. These are the memories to me that count most. Simple. Beautiful. Nice people," said Ray.

Decades later, Ray insisted that he never worked a day in his life, including his job selling newspapers. Even standing on his corner in the pouring rain, he reveled in it. Ray loved the rain. The word "love" was his lifelong four-letter secret: He only did things he loved. And he loved his job selling papers as much as he loved writing.

At the time, a revival of *King Kong* was playing at a local theater. The movie house manager was unable to find any stills or posters for the film, so he contacted a well-known collector, Ray's friend Forry Ackerman. Ackerman agreed to lend his *King Kong* posters for display at the theater.

A young man, Ray Harryhausen, had seen the movie and asked the manager for the posters. "He saw the film and when he came out of the theater," said Ackerman, "he was all excited to think maybe the manager would let him have the posters." The manager explained that the posters belonged to Forry Ackerman and gave Harryhausen Ackerman's name and address. Soon after, Harryhausen came calling at Ackerman's house. Both men discovered their shared interest in monsters and movies, so Ackerman invited Harryhausen to Clifton's Cafeteria. It was there that Ray Harryhausen met Ray Bradbury, and the two made an instant connection.

Harryhausen invited Ray to his house in the Leinert Park district of Los Angeles, where he had a workshop in the garage. He built model dinosaurs from scratch and wanted to show Ray his creatures. Painstakingly detailed and painted, they were constructed of metal, with ball-and-socket joints, and covered in rubber and plastic. He used the models for early stop-motion animated short films that he produced in his workshop. Ray Bradbury was thoroughly impressed.

"We had a mutual interest in dinosaurs," recalled Ray Harryhausen, "and we both loved *King Kong*—and so did Forry—and the three of us would many times jump on the red car and go to Eagle Rock or Pasadena to find a replay of *King Kong* or *The Most Dangerous Game* and all the Merian Cooper pictures."

Though Ray Harryhausen joined the Science Fiction Society, he did not have the same gusto for the future that other members—and Ray Bradbury—had. "The future to me seemed very cold and indifferent with everyone shooting each other out of the universe," said Harryhausen. "I preferred the past. It was much more romantic."

In November 1938, Ray's family moved yet again. Ray's father was tiring of literally living "underfoot" his own mother in the apartment on St. Andrews. "That's just a theory," said Ray, surmising that it couldn't have been easy for his father suddenly to live so near his mother again. The family moved a few blocks west to an apartment located at 1841 South Manhattan.

These were halcyon days. Ray was free from school, free to sleep in, free to do whatever pleased him. He spent a few hours every day writing. When he wasn't working on his short stories, he roller-skated to the studios—albeit not as frequently as he had been—and he often saw movies with his aunt Neva. And Ray satiated his sweet tooth at the ice-cream fountain regularly. At night, Ray and his mother sat in front of the radio and listened to the Jack Benny program, *Amos and Andy*, and the *Lux Radio Theatre*. Leo Bradbury wasn't much interested in radio shows and Ray's brother, Skip, preferred playing ball outside. But Leo and Skip listened assiduously to the University of Southern California Trojan football games and, on occasion, went with Ray to see the games.

In January 1939, Ray was considering college. His parents didn't pressure him to do so, but many of his friends had gone off to school. Ray certainly wanted to better himself, so he went to Los Angeles City College and took the entrance exam; he passed and was accepted. Then Ray had second thoughts. He never really liked school—the grind of classes and the early mornings were too much to bear. But he could meet girls in college. "I'm going to meet girls," he thought to himself. "That's it. It's the only reason I want to go to college—and that's not a good enough reason." And so Ray opted to forgo the traditional route to higher education. Instead, he made a commitment to educate himself at the public library. Once a week he went to Central Library downtown and lost himself in the tall, dark corridors of bookshelves, and twice a week he visited the smaller local branch, the Pio Pico Library.

He soon discovered Thomas Wolfe's novels *Of Time and the River*

and *Look Homeward, Angel*. They were tremendous influences on Ray, and he learned quite a lot from his early studies of Wolfe, whom he found exuberant. "He's perfect for people around eighteen, nineteen, twenty, when you don't know anything but you think you do," said Ray. Later in his career when Ray gave lectures, he shared his approach to writing: "Throw up in the morning and clean it up in the afternoon!" he coached at the top of his lungs. He credited Thomas Wolfe for teaching him this approach. "Wolfe taught me how to throw up. His books were immense upchuckings. Not much plot, but he was wild about life and he tore into it and he jumped up and down and he yelled." At that time, Ray discovered another book that reinforced this writing philosophy: *Becoming a Writer* by Dorthea Brande. Not only did Brande's book teach Ray to write quickly and passionately, it taught him to trust his subconscious, to not overthink or second-guess his words.

Ray slipped into a comfortable rhythm of writing in the morning, selling newspapers in the afternoons, and educating himself at the library weekly. Two months later, in March 1939, Ray's grandmother fell ill and was sent to the hospital. Her condition worsened, and on March 16 she passed away. Ray didn't find out until he returned home that evening from a Science Fiction Society meeting and his mother broke the news. Ray was devastated that "Grammy," as he called her, was gone.

Two days later, the family buried Minnie Bradbury, but Ray did not attend the funeral. Filled with sorrow, Ray was walking the streets downtown; he caught a double matinee in the afternoon, the farcical combination of *Hold That Co-Ed* and *The Mysterious Mister Moto*. When he arrived home that night, he had to explain to his displeased father his absence. "I said, 'Look, Pa, I want to remember Grandma the way she was. I don't want her to be dead,'" Ray said. Leo Bradbury may have seemed a steely man, toughened from his years of scaling utility poles, but though he rarely showed it, he was gentle and loving, and he understood that his younger son was extraordinarily sensitive. How could he be angry at Ray because he was unable to cope with the loss? He wasn't.

Ray continued working on his writing. He was still contributing to the Science Fiction Society's fanzine, *Imagination!* When he discovered

that others were publishing their own 'zines across the country, Ray decided to launch one, too; he called it *Futuria Fantasia*. Forry Ackerman generously gave him the start-up money, and his friend Hans Bok illustrated the cover. The magazine was twelve pages, typed and mimeographed in green ink. Ray wrote the introductory editorial, as well as a poem, "Thought and Space," and a short story, "Don't Get Technatal," under the pseudonym Ron Reynolds (he wanted to give the appearance that there were other writers, though Forry Ackerman and society secretary T. Bruce Yerke contributed). The print run was, as Ray recalled, nearly one hundred copies.

That summer on July second and third, the First World Science Fiction Convention was assembling in New York City. Nothing of its kind had ever been organized, and fans from across the country were planning to make the pilgrimage. Along with the ardent fans, authors, artists, agents, and editors were attending as well. When Ray learned of the convention during a society meeting, he itched to go. Not only was the Science Fiction Convention in New York, but the 1939 World's Fair would be there, too, and after his magical experience with the 1933 Century of Progress in Chicago, he was more than eager to attend this new world's fair. But there was that ever-present dilemma in the Bradbury household—no money, even though Ray was working. Forry Ackerman knew Ray wanted to make the trip to New York, so, without being asked, he lent his friend the money (fifty dollars by Ackerman's recollection; ninety if you asked Ray). At the time, Ackerman was living rent-free with his maternal grandparents and also held a job at the Academy of Motion Picture Arts and Sciences earning eighty-five cents an hour, and could well afford to lend his friend money. Ray offered to pay Ackerman a dollar a week until the debt was paid. Ray also offered to take his friend Hans Bok's artwork with him to New York, acting as an agent of sorts, since Hans couldn't afford to make the trip himself.

And so, at the end of June 1939, Ray boarded a Greyhound bus bound for New York City. It was a momentous trip—his first without his parents or Skip. Intent on bolstering his vocabulary, he carried with him a dictionary and a book called *Hartrampf's Vocabulary*. Ray's eagerness to show off his lexical arsenal in his writing was, by his own admission, ob-

vious and forced. "I was using big words that I found in *Hartrampf's* that I didn't even understand," Ray remembered with a laugh.

While in Denver, Colorado, at one of the scheduled stop-offs, Ray went into a restaurant to shave. "I didn't hear them call that the bus was leaving," said Ray. "I ran out and the bus was gone with my typewriter on it and all my belongings." Fortunately, another bus came shortly afterward and soon Ray was back on the road, albeit without his beloved typewriter and his luggage.

DESPITE THE multitude of remarkable people Ray would meet and work with over the decades, it was often the average person he encountered who impacted him indelibly. One such person was on the Greyhound bus with Ray. Edwina Potter, a tall, slender blonde, was sitting across the aisle from him. She was a few years older than Ray, and was heading to upstate New York for a job as a swimming instructor. They talked as hundreds of miles of America rushed by outside the windows. Ray was never sure why this beautiful woman paid him any attention at all. Looking back on the journey, he described himself as "a pimply-faced eighteen-year-old boy . . . overeating on Cokes, pie, and Clark Bars, unwashed, my hair long—especially for 1939, and in no way worthy of attention except I talked too much, or yelled all the time, because I loved being alive."

The Greyhound dieseled into gray and gloomy Elizabeth, New Jersey, after four days and four nights on the road. Ray disembarked, then turned and looked back at the bus as it pulled away with Edwina looking out the window at him. They waved to each other. Nearly seventy years later, ever the sentimentalist, he would often talk about this small, tender moment in his life and this woman he met briefly.

To Ray's relief, he discovered his luggage and his portable typewriter waiting for him in the bus terminal lost and found. Ray then met a friend he had been corresponding with, pulp editor Charlie Hornig, and after the sun had risen, the two boarded a ferry to Manhattan. It was Ray's

first glimpse of New York, gleaming in the morning sunshine, and he thought of the immigrants who had arrived in the city and seen much the same view.

Ray checked into the Sloane House YMCA and on Sunday, July 2, headed over to the convention, held at Caravan Hall on East Fifty-ninth Street. In so many ways, the convention altered the science fiction landscape. Until that point, fans of the genre (mostly poor teenage boys) had corresponded chiefly by mail; a lucky few with enough money to travel during the Depression visited other science fiction clubs in various cities. On this steamy July weekend, nearly two thousand fans, editors, writers, artists, and agents converged for the First World Science Fiction Convention. WorldCon was the first of its kind, and it paved the way to the myriad Star Trek, comic book, fantasy, and horror conventions that sprouted in the decades to follow. And Ray's pal Forry Ackerman was at the forefront of the subculture of eccentric enthusiasts. When the doors to the convention hall opened, Ackerman and his girlfriend, Myrtle R. Jones (known as Morojo), appeared garbed head-to-toe in futuristic regalia, costumes based on the H. G. Wells story "Things to Come." As science fiction author Frederik Pohl said, they were "stylishly dressed in the fashions of the 25th century." Ackerman was surprised that he and Morojo were the only ones dressed in character. "I just kind of thought everybody was going to come as spacemen or vampires or one thing or another," admitted Ackerman. "We walked through the streets of Manhattan with children crying and pointing, 'It's Flash Gordon! It's Buck Rogers!'" Unbeknownst to Ackerman and Morojo, they had started a trend at conventions that continues to this day. By the time WorldCon took place in Chicago the following year, a dozen fans arrived in costume.

It was the dawn of the Golden Age of Science Fiction, and many giants of the field were in attendance. Julius "Julie" Schwartz, who would later become Ray's first literary agent and long-running editor at DC Comics, was there and recalled fans mobbing writers Jack Williamson and L. Sprague de Camp on the streets of New York, hounding them for autographs. The guest of honor at the convention was famed artist Frank R. Paul (it was Paul's illustration of "The World of Giant Ants," on the cover of *Amazing Stories* in 1928, that had set Ray Bradbury's imagination

afire). A young Isaac Asimov, just beginning his writing career, was in attendance, as well as renowned editor John W. Campbell. Well-known fans Jack Darrow and Milton A. Rothman were there, too. Darrow, Rothman, and Forry Ackerman were three of the most ardent fans of science fiction at that time, and it was this trio, Asimov noted in his book *Asimov on Science Fiction,* "whose letters had littered the [science fiction] magazines." It was a veritable who's who of the science fiction Golden Age. "The number of young people who were attending who had the creative essence is remarkable," said writer David A. Kyle, a convention attendee. "It was really, truly, a magical time."

The disparate fans and creators of the genre who had gathered for the first time helped build momentum for the oft-maligned and misunderstood field of science fiction; the convention was even briefly mentioned in *Time* magazine. And Ray Bradbury, who had always felt himself an outsider—alone in his imaginative world—was not feeling so alone anymore. David A. Kyle recalled Ray Bradbury as "so typical of us all. He was young, enthusiastic, idealistic, and had great visions of the future."

As part of the convention program, there was a banquet at the Wyndham restaurant, but that cost additional money that Ray did not have. And, unfortunately, Forry Ackerman had no more cash to lend him. As Ackerman recalled, only 28 of the 185 attendees made it to the dinner. "It was a dollar a plate. No food mind you, just a dollar a plate," recalled Ackerman sarcastically. "On top of that, we were expected to be generous and leave a ten-cent tip!" But Ackerman did arrange for Ray to hear artist Frank R. Paul, the guest of honor, speak at the dinner. After the speech, Ray was able to meet Paul, one of his early heroes since his childhood in Waukegan.

Ray brought several short stories with him to New York, hoping to interest agent Julius Schwartz in representing him. Schwartz passed on Ray's material, saying his writing had not yet developed sufficiently. But the agent encouraged Ray to continue writing and to send his material to him in the months ahead. No matter how much it frustrated him, Ray was still far from achieving his first turning point as an author.

Ray did meet *Weird Tales* editor Farnsworth Wright while in New York, who, as Ray recalled, was suffering terribly from Parkinson's dis-

ease. He showed the oil paintings and illustrations of his friend Hans Bok to Wright, who fell in love with them. "I felt so great," remembered Ray, "as if it were my career on the line." The career of Hans Bok, who would later win the 1953 Hugo Award for Best Cover Artist, had been launched, thanks to Ray Bradbury.

Aside from attending the convention, Ray spent a good amount of time gallivanting around New York. He acted as scorekeeper in a softball game between the Queens Science Fiction Society and the Philadelphia S-F Society; he went with friends to Coney Island, and got badly sunburned; and, of course, he visited the 1939 World's Fair, which had launched that June in Flushing Meadows, New York. "I visited the fair with a group of my science fiction friends and I was entranced," said Ray. "I never wanted to leave."

That night, standing outside the Russian exhibit, Ray watched as fireworks shot up into the darkness. He stood for a long time taking in the display as explosions of light reflected in his tear-filled eyes. In his mind, he knew it was only a matter of time, three or four months, perhaps, before the United States would enter the war. Everyone knew it— the daily newspapers, radio reports, and film reel clips portended the worst. "The sky was full of fireworks exploding and the war in the future exploding," said Ray. Tears streaked his cheeks. The scent of gunpowder hung in the heavy summer air. But Ray's fear of the future only reaffirmed his connection to the present moment and the joy and comfort the World's Fair brought him. "It made me love it that much more," Ray said.

PULP HEROES

When I think of Ray Bradbury's writings, unlike some writers who would make you look at the world through rose-colored glasses, I would look at ordinary things and not just look at them, but look through them and beyond.

—ACE FREHLEY, *the Spaceman, lead guitarist for KISS*

AFTER THE convention, Ray was back on the Greyhound, heading to Waukegan, where his mother was staying with her sister Signe. It was his first visit back since his family left five years earlier. While he was there, he walked his old stomping ground on Genesee Street, past the movie houses, the soda fountain, and the barbershop. Ray saw in the United Cigar Store's display window a copy of John Steinbeck's new book, *The Grapes of Wrath,* and bought it. Two weeks later, once he was aboard the Greyhound bus again, he read it cover to cover as the bus crossed the nation. It was the tail end of the Great Depression, and Ray was reading what would one day be recognized as the seminal Depression-era novel.

Back in Los Angeles, Ray returned to selling newspapers on the street corner. He also continued attending the Thursday-night meetings of the Science Fiction Society. One evening, an unknown writer, Robert Heinlein, and his wife dropped in on the society. Heinlein had just published his first short story in the August 1939 issue of *Astounding Science Fiction* magazine, and he was on the verge of becoming one of the most well-known science fiction writers the field has ever known. But when he walked into the Brown Room at Clifton's Cafeteria that Thursday night, he had just sold one story, "Lifeline," though it had already caused a stir in the tight-knit science fiction community.

Robert Heinlein was an ex-military man, a naval officer who had left

the service after he had been diagnosed with pulmonary tuberculosis and deemed medically unfit for duty. But since the age of three, when Halley's comet had blazed over Kansas City, where he lived, Heinlein had held a deep affinity for astronomy, and, as an offshoot, a love of science fiction. After a brief attempt at a career in Los Angeles politics, he began writing science fiction. While the majority of fandom comprised the postadolescent set who had gathered at the recent WorldCon, Heinlein was different; he was a wise thirty-two when his first story saw publication. There was a refined quality about him, an affectation of his years in the military. He was dashing with his dark hair and movie-hero mustache. Heinlein eventually befriended Ray and became an important mentor, reading Ray's work occasionally and lending gentle advice. "He mainly just told me to keep writing," said Ray. "Heinlein taught me human beings. He had human beings in his stories and they were much more personal." Heinlein's wife, Leslyn, wasn't a writer, but she accompanied her husband to the meeting, finding great interest in the Science Fiction Society and in Ray. While some of the older members were put off by Ray's juvenile antics, Leslyn was kind—though she was sometimes as annoyed with his behavior as the others—and paid him much attention and the two became friends.

Ray was writing every day, but he was young and, by all accounts, creating page after page of overwritten prose, what he later called "baroque." He was still copying writers like Poe, Henry James, and H. P. Lovecraft. Though he was sure he wanted to be a writer, Ray was distracted by his acting bug. One day he spotted an item in a newspaper column about a new theater group, the Wilshire Players, led by a promising brunette actress named Laraine Day. Day, under the name Laraine Johnson, had parts in two 1938 westerns that starred George O'Brien. A year later, she signed with MGM and changed her name to Day. She would go on to star in the popular Dr. Kildare series—seven films beginning with 1939's *Calling Dr. Kildare*—and in Alfred Hitchcock's 1940 film *Foreign Correspondent*.

When Ray saw the newspaper blurb that mentioned Day's theater group, he immediately proclaimed to his science fiction pals that he would be part of the group. He said it as if he had already been accepted. Ray discovered that the Wilshire Players met a few blocks from his

house, in a Mormon church. Wearing hand-me-down clothes and long hair, Ray walked over one evening, hauling all his manuscripts with him ("My lousy short stories and bits of plays and things," remembered Ray) and introduced himself to Laraine Day. She looked at him skeptically, and he saw that she was ready to reject him, and pleaded, "Please, you've got to let me in your group because I've told all my friends that you did."

Day was taken by him. "He asked very earnestly to be part of the group," said Day. "He wanted to be in the play we were producing. We certainly weren't being crowded with people who wanted to be a part of the show and Ray was pushy. He hung around and he was very pushy." He was also endearing, and Day allowed him to join the Wilshire Players. However, Ray faced a dilemma. The group gathered on Thursday evenings, the same night the Science Fiction Society convened. Ray was torn, but he chose the acting group. At first, he wrote publicity for the group and helped paint sets, but he soon auditioned for a play written by Day, *Lame Brains and Daffodils*. To his delight, he was cast in a small role. When rehearsals began, Ray presented Day with jokes and gags to add to the script. "Laraine Day would go crazy," recalled Ray. "She'd say, 'No, we don't want that, but, on the other hand, that's pretty good. Let's put that in.'" Day thought his writing was rather clever.

On those Thursday nights when the theater group didn't meet, Ray made certain to attend all Science Fiction Society gatherings. And this is where he met Grant Beach, who, like a lot of people who became members of the society, stopped in one night out of curiosity. Beach was not much of a writer, but he had dreams of writing; moreover, he was a science fiction fan. Ray and Grant struck up a friendship, one that was so influential that Ray would later dedicate his first book, *Dark Carnival*, to him.

On September 1, 1939, Germany invaded Poland, setting World War Two into motion. As a newspaper salesman of draft age, Ray was acutely aware of the turbulent global political situation. It frightened him terribly. Would his nightmare about the war taking his life come true? Would he be sent overseas? Ray tried not to dwell on these thoughts. He threw himself into work with the Wilshire Players and his writing.

That fall, the Bradburys moved again, to an apartment located at

3054½ West Twelfth Street, not far from the old place on Manhattan. The new apartment was on the second floor of a two-story house that sat behind a larger home on Twelfth Street.

Shortly after they moved, Ray published the second installment of his 'zine, *Futuria Fantasia*, with Hans Bok's art on the cover. The mimeographed print run was again approximately one hundred copies. Like the first issue, much of the material was written by Ray under pseudonyms. He wrote a poem, "Satan's Mistress," under the name Doug Rogers, a coupling of his middle name and the surname of his childhood hero, Buck Rogers; an article about writer Henry Kuttner, "Is It True What They Say About Kuttner?," under the pseudonym Guy Amory; a short story, "Return from Death," under the name Anthony Corvais. Additionally, Ray wrote a wrap-up of the New York WorldCon titled "Convention Notes"; another article, "Local Society Life"; and the opening editorial, all without giving himself a byline. Three Science Fiction Society members contributed to the second issue: Henry Hasse, Henry Kuttner, and Erick Freyor.

Though he was busy with the Wilshire Players, Ray was still active in the science fiction community. He often corresponded with other fans and wrote pulp magazine editors. In November 1939, he wrote a letter to Wisconsin-based publishers August Derleth and Donald Wandrei of Arkham House to praise their first book, *The Outsider and Others,* written by H. P. Lovecraft. "I, like many other fans, have known and loved H.P.L.'s work," Ray wrote, but his interest in Lovecraft was short-lived once he stopped imitating writers. What is more interesting about the letter was that, for the first time, Ray had reached out to August Derleth, the man who would seven and a half years later, in the spring of 1947, publish Ray's first book, *Dark Carnival.*

Meanwhile, Robert and Leslyn Heinlein, who were regularly attending the Science Fiction Society meetings, launched the Mañana Literary Society, which convened on Saturday nights at their home in Laurel Canyon, in the Hollywood Hills. This new group included some of the older members of the Science Fiction Society and several current and future heavyweights of science fiction, fantasy, and mystery—Henry Kuttner, Edmund Hamilton, Leigh Brackett, Jack Williamson, and C. L. Moore. Other notable writers, such as Anthony Boucher and L. Ron

Hubbard, showed up sporadically. While the group was a more mature version of the rowdier Clifton's Cafeteria crew, they did invite Ray on a few occasions. But even when they allowed him to visit, Ray was always asked to sit off to the side and drink Coca-Colas as the rest of the group sipped alcoholic beverages. Ray didn't join the group often because, as Jack Williamson recalled, he was "still so brash and noisy that Leslyn didn't always want him." But they let him in, and a few of them—notably Robert Heinlein—went out of their way to nurture Ray.

Once, Ray visited Heinlein at his home and stood behind him and watched him type; Ray knew that just standing there as witness he was privileged. In the fall of 1940, Heinlein helped Ray publish a short story. When Heinlein read Ray's story, "It's Not the Heat, It's the Hu . . . ," about a man who couldn't bear hearing clichés, he told Ray, "I can sell that for you." Since he knew editor Rob Wagner, Heinlein sent the story to Script, a Hollywood literary magazine with a sizable following and a good reputation in Los Angeles (to some, the magazine was a lesser, West Coast *New Yorker*).

Not long after submitting the story, Ray received a letter at the house on West Twelfth Street. He tore open the envelope and unfolded the paper in his hands. The story had been accepted. There was no money—payment was three copies of the magazine—but Ray had made his first professional sale. He yelled for his mother, and when Esther Bradbury came rushing he told her the news. Her round face lit up with joy and she grabbed her son's hands and they danced together on the soft grass in the front yard, waltzing back and forth in the sunshine. Ray remembered this moment as one of his proudest, if not *the* proudest, moment of his writing career. And he owed it to Robert Heinlein.

Having a story published in *Script* only fueled his ambition that much more. And he also learned the importance of friends and mentors. Jack Williamson, the elder statesman of the Los Angeles science fiction community, also critiqued Ray's work. Williamson, who had published his first short story in 1928 in *Amazing Stories*, was quite patient. "I would go over to his apartment and I'd take some of my dreadful short stories and show them to him," recalled Ray. "He could hardly keep his gorge from rising they were so bad. But he was so sweet. We'd go to movies at night and he treated me as an equal even though I wasn't."

Ray also counted on Henry Kuttner, a well-established pulp writer, to mentor him. Though Ray always felt that Kuttner was simply putting up with him, thinking him immature and crazy, the older man critiqued Ray's manuscripts with a meticulous editorial eye when Ray visited him in his Beverly Hills apartment. Those times Ray handed him an over-written, overdescribed story, Kuttner said, "If you ever write another short story like this, I'll kill you." Kuttner flat out told Ray his writing was bad, calling it "purple." He had been trying to write like Poe and Love-craft, using words he found in *Hartrampf's Vocabulary,* and his work sounded archaic and contrived. Kuttner also told Ray to "shut up." Kuttner felt Ray was spoiling his stories by sharing his ideas before they were written. He warned Ray that by the time he wrote them down, the spon-taneity and life would be completely exhausted. Ray listened and zipped up until after the story was done.

"The best thing I think I got out of my relationship with Henry Kutt-ner," said Ray, "the thing that I discovered about myself, was that I could take advice and listen to my elders and keep my mouth shut." In the years leading up to the publication of Ray's first book, *Dark Carnival,* Kuttner continued to be a conscientious critic. After he moved from Los Angeles to upstate New York, Kuttner still gave Ray advice, sending long critical letters.

Henry Kuttner was also well read, his interests ranging far outside the fields of horror and science fiction, and over the course of their rela-tionship through the late 1930s to the mid-1940s, he introduced Ray to many writers who would become important influences—John Collier, Katherine Anne Porter, and Willa Cather. Kuttner also gave Ray a copy of Sherwood Anderson's *Winesburg, Ohio,* and, after Ray finished it, he made a note for a novel concept similar in structure to Anderson's book, with similar characters, but all set on Mars. It would be years before Ray would write it, but the idea eventually became 1950's *The Martian Chronicles.*

All the while, Ray was still publishing *Futuria Fantasia,* putting out the third issue in the winter of 1940, with the same print run—about one hundred copies—as the previous two. Bok once again handled the cover art, but this time the artist also wrote a short story under the byline "H.V.B." The issue ran twenty pages cover to cover and included contri-

butions from Science Fiction Society members Henry Hasse and Ross Rocklynne, who had gained notoriety primarily in the pages of *Astounding Science Fiction*. Again, Ray contributed short stories, verse, and commentary, this time without attribution.

In the fall of 1940, Ray published the fourth and last issue of *Futuria Fantasia*. He didn't want to continue borrowing money from Forry Ackerman to fund the 'zine and, after publishing in *Script,* Ray wanted to focus more on his writing. The last issue was illustrated beautifully in black and white by Hannes Bok (in the issue's masthead, Hans Bok had changed the spelling of his first name to "Hannes"). Henry Kuttner contributed a short piece, and Robert Heinlein, under the pseudonym Lyle Monroe, wrote the short story "Heil!" Again, Ray only printed about a hundred issues, making it a highly sought-after collectible for Heinlein fans. But perhaps it was the short story "The Piper" that Ray wrote that makes the last issue of the fanzine most noteworthy. Under the pen name Ron Reynolds, Ray had written his first Martian story.

In the Science Fiction Society, Ray had found a group of people who taught him much. "If I were to give advice to young writers," said Ray years later, "I would say, number one, they should start writing every day of their lives. Number two, they should go out and seek other people in a similar situation—find an ad hoc church, you might say."

Henry Hasse was one of those in the "ad hoc church" who also helped Ray develop as a writer. In 1941, Ray and Hasse, whose plotting skills Ray admired, decided to collaborate on several stories. Ray wrote the first drafts and Hasse edited them, cutting them down to their essence. The duo decided to take one of Ray's stories, "Pendulum," from the second issue of *Futuria Fantasia* and expand its concept. Once done, they sent the 5,500-word story to New York pulp agent Julius Schwartz, who finally, after turning down several of Ray's stories since the 1939 WorldCon, agreed to represent it.

On July 18, 1941, Schwartz sold "Pendulum" to the pulp magazine *Super Science Stories,* which paid a half-cent a word. Ray's first paycheck, before Schwartz's customary 10 percent commission, was $27.50, which he split with Hasse. Ray was elated. He had taken another big step. Many of his friends and mentors in the Science Fiction Society had already broken into the pulps, and he had always felt behind

them, even if he was younger than they were. But now he had arrived. The issue of *Super Science Stories* with his short story "Pendulum" hit the Los Angeles newsstands on August 22, 1941—Ray's twenty-first birthday.

11

THE POET OF THE PULPS

Science fiction, science thought, thinking about fantasy, exploring universes beyond are the highest priorities to me. Society just places them a little lower down the ranks. To me Ray Bradbury is one of about three science fiction authors of my time, when I was younger, that you have to place on a pedestal for making us have dreams of wanting to go somewhere in life. Reading his works is really what made me want to do great things with computers.

—STEVE WOZNIAK, *cofounder, Apple Computers*

LIKE A lot of Americans, on December 7, 1941, Ray sat near a radio and listened. He had been visiting a friend in Hollywood when the news came over the airwaves. Two hundred and thirty miles north of the Hawaiian island of Oahu, an armada of Japanese warships had amassed, moving in under cover of night. As the sun rose over the Pacific, the first wave of 183 planes launched from the decks of six imperial aircraft carriers, initiating a surprise attack on the Pearl Harbor naval base. The Japanese warplanes emerged out of the towering clouds just before eight and, one by one, they swooped down, the scream of mechanical gnats breaking the quiet of the American military base below. As the bombers and torpedo planes dropped their shells, American aircraft were destroyed and battleships were sunk. When the Japanese planes were fin-

ished, nearly 2,400 men, women, and children had died. War had been raging in Europe for two years, and until now the United States had managed to steer clear of it. But the attack at Pearl Harbor all but guaranteed U.S. involvement in the simmering global conflict. The next day, Franklin Delano Roosevelt delivered his "day of infamy" speech to the United States Congress, and Ray stood at the corner of Norton and Olympic holding a newspaper in the air with the headline proclaiming WAR DECLARED BY U.S.

As the early reports of the devastation came over the radio in the living room of the apartment on West Twelfth Street, Leo and Esther Bradbury worried their boys would be drafted; Skip was twenty-five years old and Ray was twenty-one. Skip desperately wanted to fulfill his patriotic duty. When he was summoned for his physical examination, it was discovered that he had a damaged eardrum (perhaps from pursuing his hobby as a surfer), and he weighed far more than the average man of five feet eight inches should. Skip lifted weights every day and, as a consequence, he was 215 pounds. Even though he begged and pleaded to be drafted, he was sent home.

Ray had not been summoned for his physical yet, but he worried about fighting in a war. It was not that Ray Bradbury was unpatriotic; he simply had a sinking feeling, a sense that if he were called to service, he would never come home. He would either die on a muddy battlefield or, even before that, the big, tough American soldiers would chew him up. "I was a geek, a nerd. They would have destroyed me," noted Ray. Very simply, Ray was afraid. He was also, admittedly, a pacifist. He didn't believe in war.

Rather than fretting or allowing anger to gnaw at him, he tried to turn his emotions into creative energy. As the United States marched to war in Europe and the South Pacific, Ray Bradbury focused on his writing regimen. At the beginning of 1941, he made a silent pledge to write one story a week, every week, for a year. He thought that if he wrote fifty-two stories that year, "at least one of them had to be decent."

He was right. After selling "Pendulum," Julius Schwartz landed two of Ray's stories in *Captain Future* magazine that year, "Gabriel's Horn," another Bradbury/Hasse collaboration, and "The Piper," a reworking of the Mars story that was first published in the final issue of *Futuria Fantasia*. Schwartz was now officially acting as Ray's agent. "Gabriel's Horn"

and "The Piper" fetched sixty dollars each, but the collaboration between Ray and Henry Hasse had run its course. "I discovered that collaborators use each other as crutches and you lean on the other person," Ray admitted. "You need to learn to walk by yourself." He broke the news to Hasse, who was none too pleased. "He never forgave me."

With his stories selling, Ray was growing ever more confident and wanted to work on his own. Now, with war consuming the headlines and shadowing his dreams, he was more determined than ever to stick to his pledge—a short story a week. During this time, Ray's friend writer Leigh Brackett, a fellow member of the Los Angeles Science Fiction Society (and also a client of Julius Schwartz), began mentoring Ray. Leigh, five years older than Ray, had achieved considerable success in 1940 and 1941 in the pages of *Planet Stories* and in John W. Campbell's *Astounding Science Fiction,* and she was another member of the older crowd whom Ray greatly admired. Perhaps even more than Heinlein or even Henry Kuttner, Leigh Brackett became Ray Bradbury's greatest writing mentor.

Ray and Leigh had much in common (even their middle name was the same, though Leigh's was spelled "Douglass"). Like Ray, she adored everything from Edgar Rice Burroughs's Mars to the actor Douglas Fairbanks. The two had lost loved ones early in life; Ray had experienced the heartbreaking loss of his grandfather and baby sister, Elizabeth, and Leigh had known tragedy when her father died in the Spanish flu epidemic of 1918.

In the 1940s, Leigh Brackett, as writer Jack Williamson described her, was although "maybe not beautiful, attractive enough, athletic and bright and engaging." She was toned and tanned from playing volleyball at Santa Monica Beach, and with her chiseled body and her short hair, she was often mistaken for being a lesbian (for the record, she married fellow society member and longtime Bradbury friend Edmond Hamilton in 1946). And Ray, with his unusually long locks of sun-bleached blond hair, his "purple" language, and his deep sensitivity, was more than once accused of being gay himself. They were an inseparable duo, and it is a marvel that Ray Bradbury did not pursue a romantic relationship with Leigh. "We were very close to an affair at one time," Ray admitted. "She drove me home a couple nights from Science Fiction Society meetings

and along the way she gave heavy hints that she wouldn't mind climbing in the backseat with me." But he decided against it, as Ray said, "to protect our friendship."

In the early forties, Leigh lived in Venice, close to the beach, in a bungalow near the Pacific. On Sunday afternoons, Ray visited her at Santa Monica's famous Muscle Beach, an early stomping ground for the weight-lifting, Charles Atlas crowd. Often dressed in faded blue denims, Ray was "an ebullient kid," according to Leigh Brackett in the 1978 book *Speaking of Science Fiction,* "bursting at the seams with drive and talent that he hadn't yet learnt to control." And, as she contended, he made horrible puns and lived on a diet of hamburgers and pineapple malts.

On those Sunday afternoons, Ray brought his short stories and sat with his toes buried in the warm sand and read Leigh's work as she read his. When Leigh showed Ray her latest *Planet Story* adventure he proclaimed it "gorgeous" and wept. "There was nothing I could criticize, it was always perfect, a wonderful adventure in its own terms, and then she'd read my stories and kick the hell out of them, God bless her," Ray recalled. They had what they called "The Odd Muscles, Malts, Manuscripts, and Bergman and Bogart Society." They played volleyball, swam in the ocean, lay in the sun, and talked writing. Leigh introduced Ray to a score of new writers, including many of the greats of detective-noir, such as Raymond Chandler and Dashiell Hammett; she also was a fan of Hemingway and persuaded Ray to read much more of the author.

They were glorious, magical Sunday afternoons. The beach, the salty air, the muscle-bound subculture, and the long Santa Monica pier stretching out into the shimmering, cool Pacific. They were afternoons that changed Ray Bradbury's life. "Leigh taught me pure story writing," said Ray. "Her stories were very simple, and well plotted, and very beautiful. I learned from her how to pare my stories down and how to plot." He spent almost every Sunday afternoon for nearly five years learning from Leigh.

He may have never gone off to college, but Ray never stopped being a student. He still frequented the library, feasting on books as wide ranging as ancient Egyptian history to the annual O. Henry Prize anthologies. Left to his own devices, he was getting what Bradbury scholar

Garyn Roberts called "a liberal arts degree," and doing it on his own. Along the way, he had a host of accomplished writers who taught him much about the art of writing. From Robert Heinlein, he had learned that all good stories are of human beings; from Henry Kuttner, he had learned to cut the "purple" language and not blurt out his ideas until they were written; and in Leigh Brackett, Ray found a dear friend and possibly his best mentor. Those Sunday afternoons on the sprawling Santa Monica beach with Leigh were supremely invaluable to Ray's development.

In the years to follow, like Ray, Leigh Brackett traveled far beyond the field of the pulps. She cemented her name in the annals of science fiction and fantasy with novels such as *The Long Tomorrow*; the 1944 crime book *No Good for a Corpse*, a hard-boiled story that dripped of the influence of one of her heroes, Raymond Chandler; and the 1946 film *The Big Sleep*, in which she collaborated with William Faulkner and Jules Furthman. As she was cowriting the screenplay to *The Big Sleep* for director Howard Hawks, she was also working on a novella, "Lorelei of the Red Mist," for *Planet Stories*. Overextended, she turned to Ray for assistance. She told Ray, "I can't finish this. Will you finish it for me?" After all the Sunday afternoons reading stories and analyzing writing, Ray knew Leigh's style inside and out. With typical Bradbury flourish, Ray wrote his half of "Lorelei" in a few short days of wild inspiration. As he acknowledged many times over the years, "I wrote the last half of the novella and you can't tell where Leigh's writing ends and mine starts. To this day, I'm still not even sure myself."

She continued working with Howard Hawks on more pictures, including 1958's *Rio Bravo*; and her last screen credit was for the second film of the *Star Wars* trilogy, *The Empire Strikes Back*. Leigh Brackett was certainly a talent, and her best student was Ray Bradbury.

In June 1941, Ray finished the macabre tale "The Candle," which he sent to Henry Kuttner, who was at that time living in New York. Kuttner

wrote Ray back, telling him he didn't think the ending was quite right and included a page with an alternate ending for the story. After reading Kuttner's suggestion, Ray responded, "I can't think of a more perfect way to end this story. Do you mind if I use your ending?" Kuttner gave Ray his heartfelt approval, and on June 2, 1941, Julie Schwartz sold "The Candle" to *Weird Tales,* marking Ray's entrée into the esteemed pulp publication and into the dark fantasy genre. It was a portent of grander things to come.

At this time, Laraine Day decided to halt the meetings of her theater group, the Wilshire Players. Day's career was taking off and she no longer had time for the weekly gatherings. While Ray loved his involvement with the group, thanks to his string of recent publishing successes, he was already leaning away from acting.

On February 15, 1942, Ray was forced to face his fear of going to war. He registered with the draft board. While waiting to be called for a physical examination, Ray steadfastly adhered to his self-imposed writing schedule. "On Monday morning, I wrote the first draft of a new story," said Ray. "Tuesday I did a second draft. On Wednesday a third. On Thursday a fourth. On Friday a fifth. And on Saturday, at noon I mailed the sixth and final draft to New York."

Soon after Ray registered with the draft board, Leo Bradbury was offered a job as a utility lineman with the Bureau of Power and Light in the Los Angeles coastal community of Venice. Throughout the Depression, Leo had been in and out of work, and from 1934 to 1937 often had to rely on money his son Skip sent home while working in the Civil Conservation Corps. The Venice offer included a small rental home, located at 670 South Venice, for thirty dollars a month. Leo took the job and the family moved to the small beach community. Ray kept his job selling the *Los Angeles Herald Express,* even though it meant that he had to commute across town by streetcar each day. He was not yet making enough as a writer to give up his day job.

Venice, California, in 1942 was a once-gleaming coastal community on a long, sad decline. Built at the turn of the century, it was modeled after Venice, Italy, with its stretch of canals, now filled with stagnant black swamp water layered with trash. The old Venice amusement pier, with

its three roller coasters, dance hall, and arcades, had also fallen into disrepair.

The Bradburys' house in Venice was a Craftsman-style bungalow, built in 1923. Painted white and nestled a little less than a mile inland from the ocean, the 750-square-foot home had two bedrooms, a small kitchen with a window that looked out on the yard and driveway, and a small bathroom. Skip and Ray shared a bedroom, but at least now, for the first time, they had a real bed rather than a sleeper sofa. Next door to the house was a humming redbrick powerhouse that the Bureau of Power and Light owned. This structure would be the inspiration for the 1948 story "Powerhouse," first collected in *The Golden Apples of the Sun*. Set back just a short distance from the new house was a one-car garage, with a workroom in the rear corner that Ray commandeered as an office. He set up a small desk with his typewriter and continued with his mad story-a-week production schedule. He was to stick to this prolific work ethic for virtually the entirety of his career.

ONE AFTERNOON, Ray visited his friend Grant Beach and his mother at their small home on the corner of Temple and Figueroa in downtown Los Angeles. Grant's father had recently passed away, and Grant had also been diagnosed with heart problems, which would later prove to be a false alarm. That afternoon, when Ray paid a call to the Beaches' house, he found his friend and his mother both in understandably somber moods. They were having trouble carrying on without the patriarch, and Grant's own health problems were weighing heavily on their spirits. After giving it some thought, Ray hatched a plan to cheer up Grant and his mother. He told them, "I'm getting you out of the house." He enrolled Grant, Mrs. Beach, and himself in a night class in ceramics at a local high school. Ray believed ceramics could cure a lot of ills. "It helps to get your hands in the clay," said Ray, "to get your mind out of your head."

Grant Beach soon discovered that he had a talent for ceramics. "There were things in his fingers he didn't know he had," said Ray. As they continued with the classes and Grant's talent emerged, he asked Ray if he would help him convert his garage into a ceramics studio. Ray obliged and began spending a few nights a week at the Beaches' house helping Grant pursue his dream. Mrs. Beach owned a large tenement building next door, which was inhabited by a mostly Hispanic population, a setting that would inspire many of Ray's later Latino stories, most notably "En La Noche," "I See You Never," and "The Wonderful Ice Cream Suit." He also based the character of Fannie Florianna, the overweight, reclusive opera singer in the mystery novel *Death Is a Lonely Business* on a real-life tenant in the building.

Ray brought his portable typewriter with him on the days he stayed at the house at Temple and Figueroa, and he would often spend afternoons in the backyard, behind the Beaches' house, where Grant's father had lovingly built a Japanese garden in the years before his death. It was here on a sun-soaked day that Ray wrote what he deemed his first truly good story. He began by typing the words "The Lake" on the top of a blank sheet of paper. He often did this, scribbling down nouns that bubbled up from his subconscious, and then following whatever path the words gave to his writing. Ray was soon typing furiously. As this oft-told tale goes, two hours later he was finished. Tears ran down his nose and the hair on the back of his neck bristled. He knew he had done something different; he had written a story that was neither imitative nor derivative.

"I realized I had at last written a really fine story. The first in ten years of writing. And not only was it a fine story, but it was some sort of hybrid, something verging on the new. Not a traditional ghost story at all, but a story about love, time, remembrance, and drowning," Ray explained.

It was anything but a typical "weird tale." With "The Lake," Ray had turned inward and explored his childhood memories of Waukegan, Illinois, and in doing so, he inadvertently mined a tale of "autobiographical fantasy" that was at once lyrical, sentimental, and haunting. Ray had, at long last, discovered his distinctive voice.

"The Lake" told of a twelve-year-old boy whose golden-haired girl-

friend drowned in the waters of Lake Michigan. Her body was never found. Years later, the boy, grown up and married, returns to the town and strolls the beach on a late-summer day and finds closure when the little girl from his past appears from the depths.

The themes of the story would one day become classic Bradbury motifs—nostalgia, loneliness, lost love, and death. And the story's lyrical tone would resonate throughout his career:

> It was September. In the last days when things are sad for no reason. The beach was so long and lonely with only about six people on it. The kids quit bouncing the ball because somehow the wind made them sad, too, whistling the way it did, and the kids sat down and felt autumn come along the endless shore.
>
> All of the hot dog stands were boarded up with strips of golden planking, sealing in all the mustard, onion, meat odors of the long, joyful summer. It was like nailing summer into a series of coffins. One by one the places slammed their covers down, padlocked their doors, and the wind came and touched the sand, blowing away all of the million footprints of July and August. It got so that now, in September, there was nothing but the mark of my rubber tennis shoes and Donald and Delaus Schabold's feet, down by the water curve.
>
> Sand blew up in curtains on the sidewalks, and the merry-go-round was hidden with canvas, all of the horses frozen in mid-air on their brass poles, showing teeth, galloping on. With only the wind for music, slipping through canvas.

Over the years, Ray has told conflicting versions of the childhood memory that spawned what he has repeatedly called his "first great story." In a 1961 interview, he said, "I came upon the recollection of a girl I knew who drowned when I was eight or nine. I remember hearing about it and not believing that this could have happened to someone I knew. She was a girl with long golden hair. I never really knew her very well. I don't remember her name now; but, suddenly, she was gone, and she had drowned. I think they found her body several days later, and I was at the lakeshore with my mother when I heard the news. I must have

been seven or eight or nine; and then, in playing with my typewriter, when I was twenty-two or twenty-three, I put down these words: 'The Lake.'"

In the 2001 reissue of *Dark Carnival*, Ray recounted the story differently: "When I was around eight I was down at Lake Michigan. I was playing with a little girl making sand castles, and she went into the water and never came out. When you're eight years old and that happens, what a mystery that is! Well, she never came out—they never found her. So that mystery stayed with me, an encounter with death."

In recent years, Ray was certain the second rendition of the story was the true origin of "The Lake." He insisted on this. But in the end, whether he just knew of the girl or he was actually with her when she disappeared, Ray had conjured his own childhood fears, found a memory, and morphed it into a tale of the dark fantastic. This was a formula that, once identified, would prove successful for him time and again. His elation with this accomplishment was tempered, however, when he received notice to report to the draft board office for a physical. Uncle Sam wanted him.

Ray appeared on July 16, 1942, for his physical. He stripped down to his underwear and lined up apprehensively next to the other young men. When it came time for his eye exam, the doctor directed Ray to remove his round, wire-rimmed spectacles and to cover one eye.

"Read that chart," the physician said, pointing to an eye exam chart hanging on a wall.

"What chart?" Ray asked.

"That chart," the doctor said, pointing again at the poster with the standard pyramid of letters.

"I don't see a chart," Ray responded.

Ray was, of course, as good as blind without his glasses, so the physician listed him as "4-F"—physically ineligible. He would not be sent off to battle or be devoured by the big, black bulldog of his dreams. He would be left to, as he put it, "live for his country."

While Ray was quietly elated by the news, at least one of his friends was incensed. Robert Heinlein, a graduate of the naval academy and a former officer who could no longer serve because he had been diagnosed with pulmonary tuberculosis, felt that Ray was betraying his country,

that he was a coward. Heinlein believed that this, if any, was the time to heed the call to arms. If Ray couldn't serve because of his health, fine. He could somehow volunteer. During the war, Heinlein moved to Philadelphia, where he worked as a civilian at the naval yard. He was also able to persuade his friends and fellow science fiction writers Isaac Asimov and L. Sprague de Camp to join him. But perhaps Heinlein sensed that Ray did not believe in war; Ray was a pacifist, while Heinlein felt there was no higher calling than to defend the honor of one's country. As a result, Heinlein cut Ray off, and they didn't speak again for decades.

Like many young men who were ineligible for the draft, Ray did, in fact, find another way to contribute to the war effort. He began working for the American Red Cross, writing promotional materials. He wrote advertising copy as well as radio spots encouraging blood donation. Robert Heinlein had left Los Angeles by then, and had no way of knowing that Ray had, indeed, done his duty for God and country.

The day after Ray's appearance at the draft office for his physical, Julius Schwartz sold Bradbury's short story "Promotion to Satellite"—another attempt at a traditional science fiction tale—to *Thrilling Wonder Stories*. Ray was again dabbling in the science-heavy realm of writers influenced by editor John W. Campbell, notably Asimov and Heinlein.

Even though Ray had found his voice with "The Lake," he had returned to writing imitative pulp stories (it would take two years for "The Lake" to be published). "Did I learn a hard, fast, or even an easy lesson from 'The Lake'? I did not. I went back to writing the old-fashioned ghost story," mused Ray. It would take some time for him to fully understand what he had accomplished in writing "The Lake."

But soon after, he wrote another story that strongly suggested his writing was indeed maturing. The story, "The Wind," was a gothic, paranoid tale of a man convinced that the howling winds he hears at night mean to kill him. Again, the story began with a noun; Ray had written the words "the wind," and it prompted him to recall the chilling sound of the prairie winds of his Illinois childhood. "The Wind" was what longtime Bradbury friend, researcher, and author William F. Nolan called the first "classic" Bradbury story. Ray was beginning to decipher what it was that he had subconsciously accomplished with "The Lake."

At the end of 1942, "The Wind" sold to *Weird Tales*. After this and the other two sales of his stories in 1942, Ray was feeling more assured and, confident that he could make a living as a writer, finally quit his job as a newspaper salesman. His instincts were correct. The following year, 1943, Ray sold twelve stories, including what would become the Bradbury dark fantasy classics, "The Crowd" and "The Emissary," as well as his first quality science fiction stories, "King of the Gray Spaces" and "I, Rocket." Along the way he was earning a name and a following for himself in the pulp magazines. On these publications' covers, his name appeared next to those of his heroes and mentors, Edmond Hamilton, Henry Kuttner, and August Derleth. Derleth, the Arkham House publisher, was himself a well-regarded writer for *Weird Tales,* and Ray had been corresponding on and off with Derleth since 1939. The pen-pal friendship would soon yield big dividends.

ON DECEMBER 31, 1943, Ray joined the throng of Angelenos for the downtown New Year's Eve celebration. Pershing Square was packed with people waiting for midnight to arrive. Ray spotted a group of police officers as they slowly made their way through the thick crowd, stopping young men and questioning them. Ever curious, Ray went over to investigate. The police were asking for draft cards and when Ray approached them, they asked for his. "My heart sank right there," recalled Ray. Two days earlier he had lost his card, which proved that he was, indeed, registered. When Ray couldn't produce his card, the officers escorted him to a patrol car, and he was driven to a local police station, where he was transferred to a paddy wagon that would take him downtown for booking. When Ray climbed in the back of the paddy wagon, it was crowded with mostly drunken and disorderly men. As the vehicle pulled way, Ray sat in the back in complete fear; he had been arrested. During the trip, an altercation ensued between two drunks, and arms and legs flailed about in the tight confines of the police wagon. Punches landed with terrific thuds and young, innocent Ray Bradbury looked on in terror from

just a few feet away. He crouched on the floor with his knees tucked up in a fetal position and closed his eyes. "I kept thinking," Ray said, "that this is the last night of my life."

He survived nonetheless and was brought to a police station, where he was booked, photographed, and fingerprinted (this was the only time Ray was ever arrested). He was allowed the customary phone call, and reached his brother, Skip, who reassured him that everything would be okay and that he would come down to the jail.

Ray was escorted to a large cell, where, as he remembered, at least another hundred men were being held. All eyes fell upon the fresh-faced kid who stood five feet ten inches tall, but felt at that moment smaller than ever before. It would take some time for the police to verify that Ray was registered for the draft: It was a Friday night and nothing could be done until Monday morning, when the draft board reopened. Ray would have to spend the weekend behind bars.

The jail cell was cold. Tin-sheeting bunk beds lined the walls, three tiers high. Ray found a top bunk and climbed up near a heat duct and tried to stay warm. What if the draft board had lost his records, he wondered. What then? Would he be locked away for years?

"In the middle of the night," said Ray, "I got up to go to the bathroom. When I came back there was a big black guy up on my bunk and his head was swathed in bloody bandages from a fight he had been in the night before. It was like Muhammad Ali sitting up there. I looked up at him and all the people in the jail cell were watching me.

"Sir," Ray said. "You're sitting on my bunk."

The big man sitting in the darkness slowly looked down at the wholesome kid standing below. "This blanket and this bunk got your name on it?" he asked.

"No, sir," said Ray, his voice a mouse squeak.

"This tin here on this bunk, got your name on it?"

Ray looked around. All the inmates were watching him.

"No, sir," Ray said.

"Then it ain't your bunk, is it?" the man asked.

And again, in his terrified voice, Ray said: "No, sir."

Ray later found another bed without a heat duct, away from immediate trouble. But his jailhouse nightmare was far from over. By sheer co-

incidence, as Ray recalled, there was a man in the cell by the name of "Ray Bradley." This man with the unfortunately similar name was servicing willing inmates under their blankets. Ever naïve, Ray was mortified. "I thought the guards outside would hear there was someone in the cell named Ray Bradley in there relieving all these people!"

Ray spent the weekend in terror. Skip came and assured him that he would be let out as soon as the draft board offices opened and the FBI could find proof of his registration. "By Sunday morning," Ray said, "I was feeling pretty sorry for myself." A church choir visited the jailhouse that morning—followers of the popular female evangelist Aimee Semple McPherson. They rolled in an organ and gathered around it. "The six people in the choir asked for requests," said Ray, "and I said, 'Onward Christian Soldiers.'" He had no idea why he requested that. The Bradbury family had never been particularly religious, and were a Christmas-and Easter-only family. The choir and the organ kicked into the first bars of the hymn:

> Onward, Christian Soldiers,
> Marching as to war,
> With the cross of Jesus,
> Going on before!

Ray, frightened and feeling alone, listened and cried. "The next morning, Monday, my draft board was open and the FBI checked me out and I got out of jail. But never again. Never again."

THROUGHOUT 1943 and 1944, Ray cemented a reputation as a different sort of science fiction and fantasy scribe. His stories were untraditional, even for these untraditional genres; they were profoundly human, filled with poetic prose, and high on crystalline imagery. By now Ray had become a regular contributor to the pulps. "The Lake" was finally published in the May 1944 issue of *Weird Tales,* and it boosted his popularity more so.

In 1944, still writing a story a week, he sold twenty-two tales. Writer and publisher August Derleth took notice. Derleth, who was planning an anthology of weird fiction, approached Ray for a story. Ray was ecstatic about the offer. If it came to fruition, it would be his first story published in book form. Initially, Derleth and Ray thought they would use the story "There Was an Old Woman," first published in the July 1944 issue of *Weird Tales*. But instead they chose "The Lake." They both knew it was Ray's best.

Following in Leigh Brackett's footsteps, Ray also began writing for the detective pulps, particularly *Dime Detective,* edited by Ryerson Johnson. Johnson purchased a number of Ray's stories in 1944. "He encouraged me and promoted my stories in his magazines a couple of issues ahead to tell readers that he had my stories coming up. He's one of the few editors who ever did that," Ray said. Decades later, Ray considered most of these stories to be generally mediocre. But he was publishing more and more, writing every day, and improving greatly.

Plans for August Derleth's collection of short stories, *Who Knocks?*, were firmed up; it would include "The Lake." Corresponding with Derleth, Ray pondered a professional name change:

> It might be wise, since I hope to make the better markets eventually, to change my name now. I was baptized Ray; my mother didn't think to give me the longer form of the name. Perhaps one of the names listed below would sound more appropriate:
> Ray Douglas Bradbury
> Douglas Bradbury
> R. D. Bradbury
> I'd like your opinion. Of the three listed above, my preference is for the first. It seems to be a good compromise between pomposity and flippancy. I hope you agree; if not, tell me, and I'll mull the matter around some more.

In the end, it was decided that Ray would keep the byline he had been using in the pages of the pulps. Ray Bradbury would remain Ray Bradbury. Ray's letter to Derleth also indicated that, even at this early stage of his career, he had his sights firmly set on breaking out of the pulps and into the literary market.

His career was gaining momentum. Over the course of 1944, nineteen Bradbury stories appeared in print. Some of these tales, "The Lake," "There Was an Old Woman," and "The Jar," would become Bradbury classics. At twenty-four, he had developed a following of pulp magazine readers across the country, and would soon be published in a book by fan-favorite Arkham House publishers (though he was still living at home, still sharing a bed with Skip). At this time, the editors of *Weird Tales* were pressuring him to conform to the conventions of genre fiction. As Ray remembered it, editor Dorothy McIlwraith (who replaced the ailing Farnsworth Wright in May 1940) had grown weary of his poetic tales of ghosts and ghouls, and suggested he write more traditional tales of the macabre. He was writing too many tales rooted in his childhood. Ever the nonconformist, Ray refused to alter his stories.

Although he was publishing regularly, it wasn't enough for him. He was in a hurry to make his mark on literary history, and he was frustrated that he was not achieving this kind of success quickly enough. Ray knew that his friend Grant Beach had been seeing a psychiatrist, and asked Grant if he could pay a visit to his therapist. It was twenty dollars for a forty-five-minute visit—twice what Ray had earned in a week as a newspaper salesman. "I saved up my money and I went to see the doctor," Ray recalled. "In his office, I sat across from him and he asked, 'What is it that you want to find out about yourself? What do you want?'"

Ray was quiet for a moment. He knew what he wanted. And so he blurted it out: "I want to be the greatest writer who has ever lived."

The psychiatrist gently laughed. "Well then," he said, "you're going to have to wait a while, aren't you?"

The psychiatrist suggested that Ray pull out the *Encyclopaedia Britannica* and read about the lives of history's famous writers. Some of them got ahead very quickly, he explained to Ray, while others took ten or fifteen years. "But read their lives," Ray remembered him saying. "Read their lives and you'll understand what writing is, and what fame is, and all about getting established."

It wasn't advice that rattled the Earth to its core, but Ray heeded it. He went to the library and began reading up on the lives of famous writ-

ers. And in doing so, it made him want to secure his own immortality even more.

Trying to help his friend reach greatness, Grant Beach suggested that Ray was far better than the pulps and recommended that he send his story to the "slicks," as they were called, high-quality magazines such as *Mademoiselle, American Mercury,* and *The New Yorker.* Ray was hesitant. Although he was confident in his ability, he had submitted to many of these publications while he was in high school and had been summarily rejected by every one of them. But Grant was persuasive. After all, Ray had helped him; he had assisted Grant in converting his garage into a pottery studio, which Grant christened "Tortilla Flats," in a nod to the recent John Steinbeck novel, and Grant's ceramic art was selling to respected galleries in Los Angeles and San Francisco. Now Grant wanted to return the favor. But Ray's name had been plastered across the cover of so many pulp magazines in recent months that he worried he would be pigeonholed. In high school, many of his fellow writing classmates hadn't understood or respected his inclination toward genre fiction. Now he was concerned that the editors of the fine New York literary magazines would do the same. He had gained a reputation as "The Poet of the Pulps." The big question was: Could he now break free?

12

DOWN MEXICO WAY

Ray's books were actually some of the very first I bought with my own money. I would have been about nine years old and the English boarding school I was at had a traveling book shop that would turn up once a term and set up in the music room. The first thing I bought was a book called The Silver Locusts. *That was immediately followed by* The Golden Apples of the Sun, *followed*

by Dandelion Wine, *and then somewhere in there I read* The October Country *and realized that my favorite story since I was about seven was actually a Bradbury story, "Homecoming," which I'd read in some big, old hardback anthology at a friend's house.*

—NEIL GAIMAN, *author*

As AUGUST Derleth was putting together the forthcoming dark fantasy anthology *Who Knocks?*, he wrote Ray and suggested they do a book of Ray's weird fiction. Ray was, not surprisingly, elated by Derleth's offer and wrote the publisher back on January 29, 1945:

> *First, I want to thank you for your suggestion that some time in the next two years Arkham House might try an anthology [sic] of Bradbury stories. I certainly hope to continue turning out stories of the calibre [sic] necessary to make such a volume possible. Some of my early stories, if ever reprinted, would need quite a bit of rewriting to re-shape them into my present way of thinking and producing. For over a year now I've been working and planning an entire volumn [sic] of short stories concerning children in fantasy and weird settings . . . this volumn [sic] to be titled A CHILDS [sic] GARDEN OF TERROR. I hoped to eventually submit the completed book to a publisher in 1946 or 1947, depending on the development and quality of each yarn. And now that you've suggested ARKHAM might be interested later in my work, I hope I shall one day be able to submit the finished work to you. I think it would be a definite off-trail thing, something a little different in the outré pattern . . . and I'm especially pleased with the title. Anyway, the project gives me much to look forward to and work on. Thanks very much for the generous offer.*

The groundwork for *Dark Carnival*, Ray's first book, had been established. Of course, there was the business of Ray's initial title, *A Child's Garden of Terror*. Derleth wrote back suggesting the title was too limiting, and Ray quickly agreed. Harking back to his days of wandering cir-

cus and carnival grounds, of meeting Mr. Electrico and the other after-hours freaks, Ray rechristened his collection-in-progress *Dark Carnival*. He even suggested a cover concept for the book:

> *The cover jacket might possibly illustrate a small carnival that has set up its merry-go-round and side-show tent and banners in a dark green woodland glade at twilight—the entire atmosphere of the picture would be one of remoteness, of a carnival in the wilderness going full steam, but with no one in sight except one small boy in the foreground, tiny, very alone, staring at the moving carousel and the high banners. And on the banners instead of portraits of Fat Ladies, Thin Men and Tattooed Freaks would be pictures of strange, nebulous creatures. And on the carousel, instead of horses sliding up and down the gleaming brass poles, would be other, impossible, vaguely, disturbingly delineated creatures of such indistinct cast and line that one's imagination could make them anything in the whole universe.*
>
> *So there is the Dark Carnival, discovered in a forest, glowing with light, the new night over and around it, and silence, and the small boy standing alone and struck numb in the foreground, listening but hearing nothing. . . .*

It was during this time that he wrote "The Big Black and White Game." "[M]any of my short stories were not based on my knowledge of other people's characters at all, or on any great philosophical knowledge of the world and its problems; but, more often than not, I wrote about my own childhood or about childish people or my immediate fears of some sort, very immediate things, very close to me in my life," mused Ray. "It's interesting that when I made my break over into the quality field, it was with the story of a boy again."

It was 1945—well before the civil rights movement—but in "The Big Black and White Game," Ray had prophetically painted a picture of a national dilemma. According to Ray, he didn't consciously consider this when he wrote the story; he simply remembered an incident from his childhood about a baseball game that pitted blacks against whites and, in retelling the tale, stumbled onto something much deeper. He

submitted the manuscript to *American Mercury* magazine and, to his astonishment, it sold. "The Big Black and White Game" was published in the August 1945 issue of the magazine.

By late summer 1945, World War Two had finally ended. Soldiers were coming home; the pall of the Great Depression had lifted; and things were, at long last, looking up for the Bradburys—Leo had steady work. Ray's friend Grant Beach proposed they take a road trip through Mexico—a young man's quest for high adventure. Ray was intrigued by the concept, but his short stories were earning him, on average, forty or fifty dollars apiece from the pulps and he had no extra money. Grant encouraged Ray to submit more stories to mainstream publications, which paid much more than the pulps.

Throughout 1945, Ray established himself as one of the brightest new stars in pulp fiction. But he feared that this would interfere with his ability to move into the mainstream. That summer, though, he had written a story, "Homecoming," about a lovingly ghoulish family of monsters coming together for a family reunion, that scholar David Mogen later deemed an "extraordinary perspective on the ordinary," and it was one of the stories that would soon propel Ray outside the realm of the pulps.

Surrendering to Grant Beach's pressure, he asked his agent Julius Schwartz to submit some stories to more prestigious publications. However Schwartz had few connections to the New York literati, so he suggested that Ray send the manuscripts himself. In the same week, Ray submitted three tales—"Invisible Boy" to *Mademoiselle;* "The Miracles of Jamie" to *Charm;* and "One Timeless Spring" to *Collier's*—under the pseudonym William Elliott (Ray borrowed the surname from writer T. S. Eliot). The odds were almost insurmountable. The chances that a story by a young, unknown writer with no publishing history whatsoever might be plucked from a Manhattan magazine slush pile were slim to none. The probability that all three would be selected and make it through the arduous, hierarchical editorial process was little better than zero. In short, Ray didn't stand a chance.

In the third week of August, Ray received word from not one but all three magazines congratulating William Elliott on his excellent stories. The news of the sale of the third and final story, "Invisible Boy," came on

August 22, his twenty-fifth birthday. "I've never had a week like that since," said Ray.

All three tales had sold, collectively, for a thousand dollars. It was twice as much as he had earned in an entire year of selling newspapers. He was rich! Unfortunately, the checks had been made out to William Elliott. Ray quickly contacted the various editors and told them about the pseudonym. Checks were redrafted, payable to Ray Bradbury. And his stories appeared under his own name. He had broken out of the pulps and into the slicks.

Since Grant Beach had been the one to push him, Ray felt an obligation to take the road trip to Mexico, although he had no burning desire to do so. In late September, they loaded into Grant's Ford V8 and hit the highway. It would prove to be a bumpy ride.

Ray Bradbury had never been the adventurous type. He was a mama's boy, hesitant to stray beyond the border of his comfort zone. He had gone through his first twenty-five years eating, almost exclusively, hamburgers, egg sandwiches, Campbell's tomato soup, his mother's Swedish meatballs, and her strawberry shortcake. (This was his primary diet. It's a wonder he lived to write as much as he did.) He never ate vegetables and he wouldn't try salad until he met his wife, Marguerite, in 1946. He never ate seafood after a childhood bout with food poisoning. To put it mildly, he was a finicky eater. Add to this the fact that he didn't know how to drive a car, and the road trip to Mexico was doomed from the onset.

Nonetheless, Ray packed his suitcase and his typewriter and piled into the passenger seat of Grant's Ford, agreeing to act as navigator. They were off. They crossed the border at Laredo, Texas, and ventured down through Monterrey, Mexico, staying in fine hotels. "You could get anything in Mexico for a dollar," Ray remembered. "The best hotels for a dollar a night." But soon Ray and Grant's friendship was beginning to show cracks. Grant quickly tired of acting as sole driver. He wanted a break, but Ray couldn't drive. After having witnessed the aftermaths of the fatal car accident in 1935 and being legally blind without his glasses, Ray never got behind the wheel. And he wasn't doing a particularly good job as navigator, either. Grant would send Ray into service stations for

directions or to find lodging, but Ray knew very little Spanish and could not communicate with anyone. Grant felt as if he was doing everything, and the two friends began bickering. "The whole trip was a mistake," said Ray. "It was a bad idea. I shouldn't have gone."

Still, Mexico helped Ray mature. Amazingly, at the age of twenty-five, Ray ate for the very first time asparagus, corn, peas, and filet mignon, which he ordered thinking it was hamburger steak, and ended up choking down with water and bread. (He couldn't find a burger south of the border to save his life.) He resented it at the time, but these experiences would help him socially in the years to come when wining and dining with great film directors, renowned authors, even world leaders. However, that was all a long way off. For now, he was in Mexico and hating every minute of it.

Mexico disturbed Ray. The economy was depressed, and Ray felt as if many of the people hated him, assuming he was a rich American. He didn't speak the language. The food was foreign. The landscape was alien and desolate. But above all, the thing he feared the most, the thing that permeated so much of his writing, seemed to be ubiquitous: death. Passing through one Mexican town after another, Ray and Grant encountered numerous funerals—lavish and ornate death marches, processions of somber families moving toward age-old graveyards. Most troubling to Ray were the funeral marches in which grief-stricken fathers carried their children's caskets hoisted above their heads. The deeper into Mexico Ray and Grant traveled, the more fearful Ray became. Within a week, they had driven into green jungle country where nature reigned supreme. Ray felt insignificant in the face of it all. What if they broke down? They had heard the stories of murderous machete-wielding natives from town locals.

"We got out in the jungle one day," Ray recalled, "and all of a sudden an Indian, a naked Indian, popped up on the road near us wearing just a loincloth, trotting along carrying a machete. Well, you know, immediately I thought, this is it. Goodbye, world, my head's gonna go. Well, he didn't care about us. He was on his way somewhere, I don't know where, but he was running, and the last I saw of him he took off through the jungle on his own business, carrying a machete to clear his way."

Ray was a long way from Los Angeles. He would lie in bed at night

with his eyes wide open. All the images of death coupled with his sense
of vulnerability were almost unbearable. Added to this, the annual Day
of the Dead celebration—Día de los Muertos—was fast approaching.
The Mexican holiday, held at the end of October and the beginning of
November, is a colorfully macabre celebration of the dearly departed,
whose spirits, as the legend goes, are believed to return during the festi-
val. In preparation, families decorate gravesites with flowers, candles,
skeleton figurines, and wild-eyed masks. Celebrants eat, drink, and
dance late into the night to commemorate the return of the dead. Death,
it seemed, was all around Ray. He couldn't escape it.

On the eve of the festival, following hundreds of revelers, Grant and
Ray took a dugout canoe and, with an Indian guide, paddled out to the
island of Janitzio in Lake Patzcuaro in west central Mexico. The island's
annual celebration was the stuff of international legend. Janitzio's small
cemetery was adorned with exotic flowers and flickering votives. "The
whole scene was lit by a thousand candles so it looked like a constella-
tion fallen from the sky and landing in the middle of the graveyard," re-
membered Ray. Women and children knelt at grave sites placing old
photos of their departed loved ones next to tombstones. Men stood
around the periphery of the cemetery eating home-cooked food and
drinking tequila long after midnight. A few of them strummed guitars.
While on the island, Ray and Grant met an elegant Frenchwoman
named Madame Man'Ha Garreau-Dombasle, and her teenage daughter,
Francion. Ray struck up a conversation with the aristocratic woman,
who took great interest in Ray's writing career and was duly impressed
by his recent accomplishments in the pages of the literary magazines.
They all ended up spending the entire night chatting and watching the
festival.

The next morning, after they had returned from the island, Ray and
Grant were walking the streets of the highland town of Patzcuaro when
a limousine wheeled up alongside them and a window slowly lowered. A
woman's voice called out. It was the woman from the island with whom
they had talked until dawn. She formally introduced herself as the wife
of the French ambassador to Mexico. She had enjoyed Ray's company
and told him that if he was ever in Paris, to look her up. In the twenty-
odd times he traveled to Paris in the decades to follow, he met and dined

with Madame Garreau-Dombasle often. He wrote her each year on the anniversary of Día de los Muertos, and dedicated his 1972 book, *The Halloween Tree,* to her. Before they had bid adieu on the streets of Patzcuaro, Madame Garreau-Dombasle spoke of another haunting spectacle the two boys might investigate: the mummies of Guanajuato. Just the sound of it gave Ray the chills.

Grant was battling illness—he had suffered a strep throat earlier in the trip—and they were still bickering as they rumbled into the town of Guanajuato. Roughly four hours northwest of Mexico City, Guanajuato was tucked into a mountainous landscape. The narrow cobblestoned streets and alleys were lined with buildings in the French and Spanish colonial styles. Flowers cascaded from balconies of the colorful pastel-hued stucco buildings. Ornate mission bell towers marked the city skyline. On Madame's word, Ray and Grant's morbid curiosity brought them looking for the infamous mummies of Guanajuato. Ray and Grant were directed to a local cemetery, where they descended a long stairway to a lengthy subterranean corridor. There, stacked against the walls, some of them wired in place, stood more than one hundred naturally mummified corpses. The bodies had been exhumed and displayed as a form of extortion by graveyard groundskeepers after families fell behind on payments for the plots. When the dues were paid in full, the deceased would be returned six feet under. In the meantime, an odd natural phenomenon occurred with the recently unearthed corpses—because of the soil composition and the dry climate, the bodies had been naturally mummified. The visit to the mummies of Guanajuato would haunt Ray Bradbury—and his work—for decades.

Grant and Ray next made their way to Mexico City, where they stayed at a bed-and-breakfast that had been recommended to them by Neva's friend Anne Anthony. While personal relationships and sexuality were never discussed in the Bradbury household, Anne Anthony was Neva's lifelong partner; they shared a home for decades until Neva's death in 2001. While Ray never discussed Neva's sexual preference or her relationship with Anne, it is likely that they were already a couple in 1945. Anne was a photographer, and had traveled through Mexico on assignment for *National Geographic* magazine.

Ray and Grant checked into the charming private home and on their

first morning, while in the breakfast room, a large sheepdog with, as Ray recalled, one blue eye and one brown eye bounded in, followed by its owner, a tall man who was just a little tipsy from a morning cocktail or two. The man was John Steinbeck.

"I went into shock," Ray said. He recognized the author right away. Steinbeck was in Mexico as the film version of his book *The Pearl* was being produced nearby. *The Grapes of Wrath* had been one of Ray's very favorite books ever since he first read it in the summer of 1939. Now Ray was sitting across the breakfast table from its author. "He was a happy drunk," recalled Ray, who remembered Steinbeck as having a great sense of humor. Ray, uncharacteristically, was too shy to tell Steinbeck that he, too, was a writer. He was too shy even to mention his great love of *The Grapes of Wrath*. He simply sat there in awe.

Meeting one of his great literary idols was the high point of the trip for Ray, along with a letter he received in Mexico City, which had been forwarded by his parents. The letter was from an editor named Don Congdon at Simon & Schuster Publishers in New York. Congdon had just left his post at *Collier's* magazine, where, before leaving, he had heard office scuttlebutt about a recent short-story acquisition, a tale titled "One Timeless Spring," written by an unknown named William Elliott. Congdon wrote Ray a fan letter, unaware that the Elliott name was a pseudonym:

> *Dear Mr. Elliott:*
>
> *The people in* Collier's *fiction department, of which I was a member until a month ago, tell me you write very well and might be interested in doing a novel. If you are considering anything of length, I'd like very much to hear from you.*
>
> *Cordially,*
> *Don Congdon*

Ray was amazed. Even before the publication of his first book by a small house in Wisconsin, he was being courted by Simon & Schuster. Ray had only a rough outline of a novel he had been contemplating, a concept tentatively titled *The Small Assassins*. As with *Dark Carnival*, this new idea also focused on the themes of his childhood fears, but this time,

it was a novel-in-stories all gleaned from his Illinois boyhood. The novel examined the themes of youth and old age. It was a book that would later become, in part, *Dandelion Wine* and its unfinished sequel, *Farewell Summer*. What he had was all very preliminary, hardly more than a glimmer. Nonetheless, a dialogue had been started up between Ray and Don Congdon. It was a dialogue that would continue for the rest of their lives.

Ray was ready to go home. He was frightened at what he perceived as constant reminders of his own mortality. And he and Grant were not getting along at all. "I couldn't do anything right," said Ray. Grant bristled at Ray's natural ability to meet new people and make new friends. It seemed to annoy him when Ray shared the story of his recent publishing success. "He was jealous of everything I did," said Ray. "My first story in *Mademoiselle* was on the newsstands while we were in Mexico and I showed it to everyone. My God, it was a big magazine. I was excited. But Grant thought I was being arrogant and egotistical."

After six weeks and seven thousand miles, relations between the two former friends reached the boiling point. One day, as they neared the U.S. border, they wheeled into a small service station and Grant asked Ray to keep an eye on the gas pump as the vehicle filled. Ray happily obliged, but as the tank topped off, gasoline began overflowing, pouring down the side of the car. Grant exploded.

"You can't do anything right!" he yelled at Ray. Very little gasoline had been wasted, but that didn't matter to Grant. He had had it with his inept friend with the poor Spanish skills and the myopic diet and the lack of automotive know-how. They argued much of the way back into the United States. "He wouldn't let up," Ray said. They stopped one night in a small Arizona town to rest. By sunup, Ray had made a decision. He was leaving. Without saying a word, he left the hotel, found a Greyhound bus station, and bought himself a ticket. He would head back to Los Angeles on his own, leaving Grant to travel the rest of the way alone. In his haste, Ray forgot his typewriter—the portable typewriter he had purchased in 1937. Ray later learned that when Grant had discovered that he had left, he grabbed the typewriter and carried it to the bank of a nearby river. In a symbolic and defiant gesture, Grant hurled the old typewriter into the murky water, where it quickly sank.

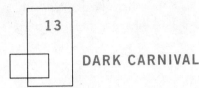

13

DARK CARNIVAL

Ray is bold. He is not a shrinking violet. He'll tackle all kinds of things, some of them beyond my understanding, and acquit himself always well, often brilliantly. He is a phenomenon and I'm very lucky to know him.

—NORMAN CORWIN, *godfather of the Golden Age of radio*

RAY RETURNED to Los Angeles the day before Thanksgiving 1945, regretting he had ever embarked on the adventure in the first place. Still, Mexico had left an indelible impression. It wasn't a complete loss. He had met John Steinbeck, one of his great literary heroes. He had met Madame Garreau-Dombasle, a woman who would become a lifelong friend. He had received his first correspondence from Don Congdon, a man who would guide his career. Ray had experienced much in Mexico that would later inspire several remarkable short stories, including "The Next in Line," "The Lifework of Juan Diaz," "The Highway," and "The Fox and the Forest." And, as mementos of his trip, he had purchased a series of small, primitive wooden masks from a native woodcarver in Guanajuato. The tribal masks caused him to reconsider the carnival-themed cover concept for his forthcoming collection, *Dark Carnival*. Ray jettisoned his original idea of using an illustration of a carousel in the forest, and instead he set out to find a photographer who could do something with the Mexican masks.

Throughout his career, Ray would be actively involved in the dust jacket designs for his books. In the years to come, he would help conceptualize many more first-edition jackets, among them *The Illustrated Man, Fahrenheit 451,* the English edition of *Something Wicked This Way Comes, Long After Midnight, The Toynbee Convector,* and *Green Shad-*

ows, White Whale. Although he contributed detailed original sketches for book-cover illustrations over the years, it wouldn't be until 2004 that his own original art would be used on a first edition, for the story collection titled *The Cat's Pajamas*.

In late 1945, he went to the Los Angeles Arts Center, a local school for the arts, and inquired about talented student photographers. After viewing the work of several, and at least a hundred photos in all, Ray's eye was caught by the photographs of George Barrows, a protégé of Ansel Adams. Barrows was in his early twenties and had already exhibited his work in San Francisco and L.A. After a phone call and a meeting, Barrows agreed to take shots of Ray's Mexican masks and see what he could come up with.

"He came back with two different designs and I sent them off to August Derleth," said Ray. The cover art for *Dark Carnival* was born. But as much as Ray loved the dark drama of Barrow's cover art for the book, more than a half century later, he had some criticism of it too. "The main problem is, when you put it down in a bookstore among other books, it disappears. It was too dark."

Amazingly, even after all their trouble in Mexico, Ray was still frequenting the Beaches' home, and his friendship with Grant Beach remained intact, though it was sorely strained. They never discussed the trip or what had occurred between them. And Ray, who shared a special relationship with Grant's mother, commiserated with her about his troubles with her sometimes difficult son.

Ray was still writing at the Beaches' home a few days a week, using 413 North Figueroa Street as his business mailing address. It was there that Ray was inspired to write one of his greatest mainstream literary stories. It was late in the day and Ray was sitting with Grant and his mother at their small kitchen table. There was a knock at the door and Mrs. Beach went to answer it. Standing there, between two police officers, was one of the Mexican tenants from the building she owned next door. "He was being deported back to Mexico," Ray said. "His visa had expired and the last thing he said in broken English as he stood there in the doorway, as he reached out and grabbed Mrs. Beach's hand, was, 'Mrs. Beach, I see you never. I see you never.'" The rhythm and the sadness of

the words reverberated in Ray's mind. The next day, he sat down and wrote the short story "I See You Never."

Even as Ray was still frequenting the Beaches' house, Grant's jealousy over his publishing success was escalating. And soon the jealousy turned malicious.

Monumental news had arrived. Ray's story "The Big Black and White Game," recently published in the August issue of *American Mercury* magazine, had been selected for inclusion in *The Best American Short Stories of the Year* anthology, edited by Martha Foley. Since 1936, when Ray discovered this series at Central Library in downtown Los Angeles, it had been a dream of his to have a story chosen for the esteemed collection. But the letter from *American Mercury* arrived at Figueroa Street and had been intercepted by Grant Beach, who opened it.

"Grant wrote back under my name," recalled Ray, "and he refused the honor." Of course, Ray didn't know any of this until a week later, when an editor from the magazine sent him a telegram:

URGE YOU STRONGLY TO GIVE PERMISSION TO FOLEY TO REPRINT YOUR MERCURY STORY IN BEST AMERICAN SHORT STORIES. IT WILL BE TO YOUR ADVANTAGE IN EVERY WAY. PLEASE REPLY COLLECT IMMEDIATELY.

When Ray read the Western Union telegram, he was flummoxed. He wasn't sure what the editor was talking about, but he had a sneaking suspicion. Ray called the editor and assured him that he enthusiastically accepted the honor of being included in the anthology. He then took the streetcar downtown to Figueroa Street to confront Grant Beach. Ray put his friend on the spot. "Have you been intercepting my mail?" he asked. Cornered, Grant admitted what he had done. "He had been jealous all along," said Ray. "He was a secret writer and he never told me." Ray felt angry and betrayed, and from that day forward, their relationship was never the same.

"Just get your work done," Ray always said, and that's exactly what he did. His work on assembling the various stories for *Dark Carnival* was progressing at a prodigious clip. Yet, interestingly, as Bradbury scholars

Jonathan R. Eller and William F. Touponce, authors of *Ray Bradbury: The Life of Fiction*, note, the book, even before its publication, already "represented a backward glance at the first (and perhaps most important) phase of his development as a professional writer. By 1946 he had gone as far as he could with weird fiction."

Ray's recent sales to mainstream literary magazines portended big things for his future, and marked the beginning of the end of his career as the "Poet of the Pulps." He had learned his lessons well from his early mentors and he was now outpublishing them. When he told Ed Hamilton about the sale of "One Timeless Spring" to *Collier's*, Hamilton affectionately prodded, "You are the viper at my bosom!" When Ray told Leigh Brackett the same news, her stunned retort was, "You son of a bitch!"

In March 1945, *Who Knocks?* the anthology of dark fantasy that included Ray's short story "The Lake," was published. It was Ray's first appearance in book form—another milestone. He continued working on the *Dark Carnival* manuscript, as the book went through several incarnations reflecting the speed in which he was maturing as a writer. The book was initially intended as a retrospective of the weird fiction that he had published in the pulps. But it had grown into something much more, thanks to his recent successes in the mainstream magazine market. As *Dark Carnival* took shape, it served as a sort of bridge between his provincial pulp past and his wide-horizoned literary future. The book included early Bradbury pulp classics, such as "The Lake," "The Crowd," "The Jar," and "The Wind." Now, dissatisfied with the caliber of writing in these tales, Ray polished each of them with varying degrees of rewrites. Other early weird tales, such as "The Poems," "The Ducker," "Trip to Cranamockett," and "The Watchers," were eventually deemed unworthy by their creator and excised from the book altogether. "A story like 'The Watchers' is not a good story. It's clumsy," said Ray. "The style is very inept."

Ray continued to change the architecture of the collection. Throughout the assembly of *Dark Carnival,* he discarded stories he no longer liked and replaced them with new ones that he felt better reflected his current abilities. But the ongoing revisions frustrated his publisher, August Derleth, who begrudgingly allowed his new author to

continue tinkering with the manuscript right up to the brink of publication.

In retrospect, it is most fascinating that *Dark Carnival* would not only become a groundbreaking work of American gothic horror, but the book—Ray's first—would be the seminal influence behind several Bradbury classics yet to be written. The short story "The Night," for example, a tale gleaned from Ray's memory as a child in Illinois, would spark many more midwestern stories to come, and it would ultimately become a part of 1957's *Dandelion Wine*. The short story "Homecoming" would be the first in a series of ghoulish Illinois family tales, ultimately becoming the cornerstone tale of 2001's novel-in-stories, *From the Dust Returned*. During the time he was putting his *Dark Carnival* together, Ray began writing the short story "The Black Ferris," which would later evolve into 1962's *Something Wicked This Way Comes*. Although he didn't know it at the time, with *Dark Carnival,* he was sowing the seeds of his literary future.

Ray had earmarked his story "Homecoming" as the leadoff tale for *Dark Carnival*. The story had been rejected by the *Weird Tales* editors, dismissed, according to Ray, as too offbeat, too quirky, too untraditional. Ray's relationship with the pulp publication was winding down. But while "Homecoming" had been turned down by *Weird Tales,* Ray nonetheless had a good feeling about the story. A tale of a foundling human child raised by a family of vampires, its essential metaphor resounded well beyond genre fiction. This was the story of so many children who felt like outsiders—a decidedly human yarn, dressed in the gothic accoutrements of dark fantasy. It sprang from Ray's own experience as a sensitive, imaginative, oft-misunderstood boy in Waukegan, Illinois, in the 1920s. On a hunch, Ray sent "Homecoming" to *Mademoiselle,* the women's fashion magazine, which at the time was known for publishing strong and original new fiction. Since *Mademoiselle* had published his story "Invisible Boy," Ray hoped this story might have a chance there, too. But despite the magazine's editorial daring, this charming tale about an eccentric family of monsters was hardly their typical fare. Ray fired it off in the mail nonetheless. Upon arrival at the magazine's East Forty-second Street offices, it was promptly relegated to the slush pile with scores of other unsolicited submissions until one day an office as-

sistant plucked it out of the pile and read it. He was a young New York writer who had recently achieved some publishing success of his own in the pages of *Mademoiselle* and *Harper's Bazaar*. His name was Truman Capote.

Capote liked "Homecoming" and brought it to the attention of the magazine's fiction editor, George Davis, and his assistant, Rita Smith. "Homecoming" was odd, to say the least. But Davis had a reputation for pushing boundaries. Davis and Smith wrestled for weeks over the question of how they could work with Ray's Halloween vampire family story. At first, they considered asking the author to revise the story to fit their publication. However, it quickly became clear that by doing so, the charm of the tale would be lost. Almost as quickly, they came up with another, bolder idea. They would change the publication to fit the story. It was an inspired, unprecedented move.

"They put together an entire October issue built around my 'Homecoming,'" said Ray, "and got Kay Boyle and others to write October essays to round out the magazine. They hired the talented Charles Addams, who was then an offbeat cartoonist for *The New Yorker*, and beginning to draw his own strange and wonderful 'Addams Family.' He created a remarkable two-page spread of my October house and my Family streaming through the autumn air and loping around the ground."

The sale of the story to *Mademoiselle* pleased August Derleth. He was proud of his young author, and he knew that each new Bradbury story appearance would only bolster *Dark Carnival* when it was finally published. "Homecoming" was slated to be the first story in *Dark Carnival*, and now it had the added cachet of initial publication in a well-regarded New York magazine. Before *Dark Carnival* had even rolled off the press, Ray Bradbury had moved beyond the caliber of its publisher. Ray had been accepted into the world of the New York literati.

ONE DAY in April 1946, Ray walked into Fowler Brothers Bookstore in downtown Los Angeles. It was an unseasonably warm day, yet Ray was

wearing a favorite military-style trench coat, lined with several deep pockets, and carrying his briefcase. There had been a recent rash of thievery in the shop and the owner, Mr. Fowler, had asked his employees to keep an eye out for the culprit. A young woman spotted Ray and was instantly suspicious. Based on his getup, she was convinced she had the crook, and from a distance, she began following him around the bookstore. The woman's name was Marguerite McClure. She was twenty-four years old. She had short, stylish brown hair, hazel eyes, and a porcelain complexion; and she possessed a slightly aristocratic air, a quiet elegance that was enhanced by her preference for couture clothes. Ray set his briefcase down on top of a pile of books—another odd gesture surely hinting that he was the book bandit—and she approached to investigate. "May I help you?" Marguerite asked, more accusatory than friendly.

Ray inquired if the store stocked the collection *Who Knocks?* He informed her that he was a writer and that one of his stories was included in the book. Marguerite McClure's curiosity was piqued. Since childhood, she was a voracious reader, and books were her passion. And now, standing before her in Fowler Brothers Bookstore was a young man telling her he was a published writer. Ray didn't know it at the time, but it was the perfect thing to say. He then added that one of his short stories was in the brand-new *Best American Short Stories* collection. Marguerite was even more intrigued. And Ray was smitten. But whenever he met an attractive woman, he was no longer loquacious and outgoing, and, too shy to ask Marguerite out, he left the store after a brief conversation with her. Afterward, Marguerite, who now believed that Ray was not the crook in question, located a copy of *Who Knocks?* She took it home that night and read "The Lake." "I was dazzled by the style of the story," said Maggie Bradbury, many years later. "His phrases were so memorable." The macabre content wasn't her literary cup of tea, as it were, but the writing was most impressive.

Ray returned to the bookstore a few days later and mustered up the nerve to ask Marguerite out for coffee. She accepted. "His energy was enchanting," said Maggie of that rendezvous. "I had never encountered anyone who could talk like him," she said with a laugh.

The young man was so full of ideas, literary aspirations, and philoso-

phies for the future; he never stopped talking. He was opinionated and entertaining. When he stopped to catch his breath between his passionate rants, he was impressed by Marguerite's vast knowledge of literature. It far surpassed his own, and he loved that about her. "I looked up to her," said Ray. "I've never understood men who have love affairs with women who are inferior. Those men don't want to be threatened."

Along with her love of books, she was also a natural student of language; she was fluent in French, Italian, and Spanish. "I think it's something you are probably just born with," she surmised. It also didn't hurt that throughout her childhood, Marguerite's mother, who spoke German and Slovak, would speak both around the house. "When she didn't want me to know what she was talking about, she spoke in these languages. That gave me an intense interest in language," Marguerite said, admitting that she never learned to speak those languages herself.

Ray and Marguerite's afternoon coffee soon turned into lunch, which quickly turned into dinner. In May, they went to an upscale restaurant in downtown Los Angeles. He couldn't afford it, so she recommended they go dutch. She was eloquent and well off and sipped martinis at dinner. She had gone to UCLA to study literature and languages, but left before graduation after an argument with an instructor. Maggie, a headstrong Irish girl, disliked being told that a swim class was mandatory. When the class instructor suggested that her figure could use it, Maggie retorted that the teacher's figure needed it more. Of course, she failed the course, didn't get the credit, and walked away from the university.

Ray, on the other hand, was a young, self-educated, penniless writer who had worked his way up from nothing. Maggie was an only child who loved long days being left alone with her books. He was a bold, brash kid (except when it came to the opposite sex, of course) who had grown up in Illinois surrounded by a colorful extended family. She was a child of the Depression who had never gone without. He was a child of the Depression whose family barely got by. He still loved comics and pulp fiction. She loved Proust and Yeats.

Whatever it was—the yin and the yang; opposites attracting—they hit it off immediately. "Once I figured out that he wasn't stealing books," said Maggie, "that was it. I fell for him."

Marguerite Susan McClure, nicknamed "Maggie," was born on January 16, 1922, to Lonal and Anna McClure. She had a rich genealogy; among her father's family were the founders of *McClure's* magazine. Another relative had invented the coupler that connected freight train cars. Her great-grandfather had married a full-blooded Cherokee Native American in the wheat plains of Kansas in the late 1800s. Marguerite's father was a Los Angeles restaurateur. During the First World War, he served as head chef to General John Joseph Pershing, commander of the American Expeditionary Forces in France. In his lifetime, Lonal owned many restaurants in the Los Angeles area. But his greatest source of pride was his only child, Marguerite, delivered into a silver-spoon world that knew no want, no hardship, no poverty.

Maggie lived with her parents in a nice, comfortable home in the Lienert Park neighborhood of L.A., near the intersection of Slauson and Crenshaw. From the day they began dating, Ray and Maggie were nearly inseparable. When they weren't together, they spent long periods of time talking to each other on the telephone. But only after several dates did Ray finally find the nerve to hold Maggie's hand.

During the early days of their courtship, Ray was still publishing stories in the pulps, while he continued putting *Dark Carnival* together. It was during this time that he sold his first piece to radio. The producers of the NBC program *Mollé Mystery Theater* in New York had seen one of Ray's stories, "Killer, Come Back to Me," in the July 1944 issue of *Detective Tales* magazine, and bought the rights. The drama starred the popular radio actor Richard Widmark, who would move to Los Angeles the following year to embark on a long and successful film career. "Killer, Come Back to Me" aired on May 17, 1946.

Ray's foray into radio prompted him to submit more material for the medium. "I had sent tear sheets of some of my short stories from *Weird Tales* to William Spier, at CBS in Hollywood," said Ray. Spier was a well-known producer and director for the nationally broadcast radio program "Suspense." He read Ray's stories and wrote back, inviting him to come to his house in Bel Air for a visit. Spier was married to Kay Thompson, a noted singer, composer, actress, and vocal coach to many, including Judy Garland and Frank Sinatra. "She danced just as well as Fred Astaire," commented Ray. A decade later, in 1955, Thompson would create

Eloise, the popular children's literary character. Ray arrived at their house and Thompson handed Ray a drink. Spier sat him down and went through many of Ray's stories. "Bill bought a couple of my stories right there," said Ray. He had crossed over into yet another storytelling medium.

As his career continued to take off, his personal life was soaring, too. Ray and Maggie were head over heels in love. It's amazing he was getting any work done at all. They soon knew they wanted to spend the rest of their lives together. Maggie had visited the Bradbury house a few times by then, and Esther Bradbury pulled her son aside and demanded to know who this girl was who had stolen her son's heart. Esther was protective of her little bottle-fed-until-he-was-six boy and she wasn't going to let him go so easily. But it was too late. In June 1946, Ray and Maggie became engaged.

Curiously, neither of them remembered the exact moment of the engagement. Maggie recalled that Ray proposed to her one evening after they had kissed good night. Ray insisted that Maggie proposed to him, yet he couldn't recall the details. "It's too far back," claimed Ray (this from a man who recalled his own birth!). He did remember a night that, as he said, was likely the clincher. He had kissed Maggie good night. "It was the kiss that broke my eardrums," he said. Ray had left in a daze, intending to take a streetcar home. But he boarded the wrong train and, lost in thoughts of Maggie, rode it all the way to the end of the line in Redondo. When the conductor approached and asked the final, lone passenger to disembark, Ray realized the mistake he made in his lovesick stupor. "I just kissed my girlfriend," he told the conductor. The conductor smiled. "I've done something like that," he said, sympathetically. The man made a deal with Ray. He asked Ray to help flip all the seats as the streetcar reversed and headed back toward Los Angeles. In return, Ray could ride home for free.

Despite the fact that Ray rarely explored sexual themes in his writing, he was a highly sexually charged young man. Maggie summed it up best: "He couldn't keep his hands off of me." Added Ray: "We made love underneath every pier along the coast."

On occasions when Ray and Maggie had the Bradbury house to themselves, the young couple made love on the living-room floor. "Why

we did that, I don't know," he said. "There was a bedroom!" Another time, Maggie's father, a stern man, actually caught his daughter and her fiancé in the act. Ray was visiting Maggie in the living room of her house, when Lonal McClure entered the room unexpectedly and caught them on the sofa. Lonal McClure didn't say a word; he simply turned and left. He didn't speak to Ray again until he had finally married his daughter.

One day in June, Ray and Maggie went to a ritzy jeweler's shop in downtown Los Angeles and bought two thick gold rings for thirty-five dollars apiece. These are the wedding bands they both wore for the rest of their lives.

Earlier that month, Ray had sent August Derleth a completed manuscript for *Dark Carnival*. He had continued to alter the table of contents up until the last minute, rewriting stories such as "The Wind," "The Crowd," and "The Poems." He had added new stories: "The Maiden," "Interim," "Let's Play Poison," and "Uncle Einar," another story about his fictional vampire family, the Elliots. This new tale was an homage to his favorite uncle, his mother's brother Inar Moberg. Inar had always been the life of the Bradbury party, a laundry delivery driver who frequently stopped by the old house in Waukegan and burst through the back door with great energy, laughter, a hint of liquor on his breath. In the short story, Ray changed the spelling of his uncle's name, gave him glorious green wings, and turned him into a lovable vampire. "Uncle Einar" was yet another offbeat piece of "weird" fiction centered upon the theme of the misfit.

Rounding out *Dark Carnival* was "The Next in Line." In this newly written story, Ray had drawn from his experiences visiting the mummies of Guanajuato, Mexico. The result was one of the most powerful stories in the book, a psychologically complex creation, dripping with gothic atmosphere that displayed Ray Bradbury at his poetic best.

In early September 1946, Ray traveled by train to New York. With his appearance in the *Best American Short Stories* anthology and his string of sales to the respected slicks, he had become a minor darling of the New York literary establishment. As he made his way east, he stopped in Waukegan to visit family, and in Sauk City, Wisconsin, where he met his publisher, August Derleth, for the first time. Aside from their business relationship, Ray and Derleth shared many interests. They both

had grown up reading comic strips, and while they were both well regarded for their pulp stories, they shared a keen interest in contemporary fiction. As an armchair architecture buff, Ray was taken by Derleth's house, built by renowned architect Frank Lloyd Wright.

While he was in New York, Ray met with editors from *Harper's, Collier's,* and *Good Housekeeping.* He met with Martha Foley, the editor of the *Best American Short Stories* anthology, and was the guest of honor at a party hosted by *Mademoiselle* fiction editor George Davis. He had come a long way in four short years, from shilling newspapers on a street corner wearing his brother's hand-me-downs to this—a party thrown for him by New York's literary luminaries. When Ray walked in, a drink was thrust into his hand and a crowd swarmed around him. Along with George Davis, Ray mingled with *Mademoiselle*'s Rita Smith and her sister, author Carson McCullers. Ray also met *New Yorker* cartoonists Sam Cobean and Charles Addams, who had been commissioned to create the artwork for Ray's story "Homecoming" in the upcoming October issue of *Mademoiselle.* "I was kept constantly inebriated by all and sundry," said Ray. That night, in the small New York apartment, Ray waltzed with Carson McCullers.

A few days later, he lunched with Charles Addams, and the two struck up a friendship. Addams had created his own ghoulishly wonderful brood—the Addams Family—a recurring series of cartoons appearing in *The New Yorker.* Ray and Addams discussed the possibility of one day working on a book together. Ray would write more tales of his vampire family from "Homecoming" and Charlie Addams would furnish the illustrations. "It will become sort of a *Christmas Carol* idea," Ray wrote Addams, later, "Hallowe'en after Hallowe'en people will buy the book, just as they buy the *Carol,* to read by the fireplace, with lights low. Hallowe'en *is* the time of year for story-telling." Addams and Ray agreed to stay in touch on the project.

Ray also met with Simon & Schuster editor Don Congdon, who had written Ray while he was in Mexico asking him if he had a novel. "I didn't have a novel, but I had some ideas," recalled Ray. Those ideas revolved around a series of stories, set in the Midwest, about a young boy, as Don Congdon remembered, "who was going to try to prevent the continuation of time, and didn't want to grow older and so on, and keep his boyhood as it were."

It was a highly autobiographical premise that was once again rooted in Ray's all-important childhood recollections. It had started as an outline under the title "The Small Assassins," but was now renamed "The Blue Remembered Hills." The title would soon change yet again, rechristened "The Wind of Time" and then "Summer Day, Summer Night." At the time, it was only a concept, one that would take many years to come to fruition.

Although Congdon had high hopes of making him an offer, Ray felt he didn't yet have a book idea that was adequately developed enough to warrant a contract. So the two men promised to stay in touch until that time came.

Ray returned to Los Angeles and began work on the final stages of *Dark Carnival*. The book, scheduled for an April 1947 publication, was now in galley form, allowing for one last stage of revisions. Ray continued to make wholesale changes to the book, excising whole paragraphs from stories and replacing other tales altogether. August Derleth had been exceedingly patient with Ray throughout the long editorial process, allowing the author to fine-tune the collection to an unprecedented degree. Ray made so many changes to the book so late in the game that he even offered to personally pay for any expenses incurred by the many alterations. Derleth indicated to Ray that he had allowed more changes to be done to the *Dark Carnival* manuscript than had been made to all previously published Arkham House titles combined. It was time to let it go, but Ray hardly did that.

With his first story having been produced for the radio, Ray was inspired to try his hand once again at the medium. He wrote a one-act script, "The Meadow," and submitted it to a contest sponsored by the World Security Workshop, a program on ABC. The script was selected, produced, and aired on January 2, 1947. Ray had sold his second piece to radio in less than a year. "I listened to radio all the time when I was a kid. And by the time I was in high school, I was seeing half a dozen films a week," said Ray. "All this junk I put into my system, along with the great stuff—I was learning all the time. The best kind of learning is the secret learning you're picking up all along and then you go back later and you dredge through all this material and it helps you write radio scripts. By the time I wrote 'The Meadow,' I was full up with radio."

In March 1947, one month before publication, Ray sent in his final round of revisions for *Dark Carnival*. Around the same time, he sold two more tales from the collection to major magazines. He had placed "Cistern" with *Mademoiselle* (a sale he had set into motion during his autumn visit to New York), and "The Man Upstairs" to *Harper's,* his first sale to that publication. The latter story was yet another one culled from his Illinois childhood, this time using the memory of the stained glass window in his grandparents' home as a portal through which is viewed the sinister truth about a boarder in the home.

Harper's had been a particularly difficult publication for Ray to break into. Editor Katherine Gauss had taken a pass on several Bradbury stories that would, ironically, later be recognized as Bradbury gems. Stories rejected by *Harper's* included "The Emissary," "Jack-in-the-Box," "El Dia De Muerte," and "Powerhouse." But with "The Man Upstairs," which fetched $250, Ray had at long last made it into the pages of *Harper's*.

His star continued to ascend. *Dark Carnival,* originally intended as a retrospective of his best pulp fiction, had evolved into a book that showcased a rising literary force. On April 29, 1947, Ray received his first author's copy of *Dark Carnival* in the mail, one of the 3,112-copy initial print run.

He was wildly in love and engaged to be married. His first book had been published. He also received word that his short story "Homecoming," which, of all ironies, had been rejected by *Weird Tales* and subsequently published by the more respected *Mademoiselle,* had been selected for *The O. Henry Prize Stories of 1947.* It was a magical time. Late one afternoon, with his copy of *Dark Carnival* held tightly in hand, Ray hopped on a red streetcar and headed to the intersection of Norton and Olympic, where he had sold newspapers from 1939 to 1942. He got off the railcar and rushed to the corner and waited until the late-day crowd of commuters began to emerge from their office buildings. One by one, he found many of his old customers, people who remembered the vociferous newspaper salesman. With great pride, Ray showed them his new book. He visited the drugstore on the block, the meat market, and the plumber. He couldn't contain his excitement. It was his first book. And it was just the beginning of a long rocket trip toward pop culture stardom.

14

LOVE AND MARRIAGE

In my opinion, Ray is the greatest practitioner of the short story in the twentieth century.

—MARGUERITE BRADBURY

THINGS WERE going well for Ray Bradbury, both personally and professionally. In early May 1947, Ray, who was engaged to be married to the love of his life, and August Derleth were contacted with the news that Hamish Hamilton, a British publisher, was interested in buying the rights to publish *Dark Carnival*. Ray's reach now extended overseas.

His professional progress didn't stop with his first foray into the world of international rights. Ray's recent inroads into radio led him to a meeting with one of the biggest players in the business—Norman Corwin. Corwin had already cemented a name for himself as an incomparable radio dramatist, a pioneer of the medium's Golden Age, who had redefined radio as an art form. His prominence was due in no small part to his wartime radio work, culminating in the airing of his acclaimed program "On a Note of Triumph," broadcast the night of Germany's surrender in World War Two. Corwin's distinguished career has prompted many to refer to him as the poet laureate of Golden Age radio.

Norman Corwin resided in New York and kept a Los Angeles office in the same CBS building on Sunset Boulevard where Bill Spier worked. Like many Americans in the 1940s, Ray was an ardent Corwin fan. When Ray learned that Corwin worked in the building where *Suspense* was produced, he befriended Spiers's secretary and got Corwin's home address.

"I sent Norman a copy of *Dark Carnival* with a note saying, 'If you

like this book half as much as I love your work, I'd like to buy you drinks some day,'" recounted Ray. A week later, Corwin called the Bradbury bungalow at 670 Venice Boulevard. "You're not buying me drinks," he said, "I'm buying you dinner." Corwin was dazzled by the work of the young fantasist. "I just felt that this young man had a lot of power," said Corwin. "Great reserves of power. He was very flexible. He could write what was conveniently called science fiction, he could write poetry, and he had a great sense of humor, which he employed very effectively."

Of course, Ray accepted Corwin's offer to have dinner, meeting the great radio director at a fancy restaurant on the Sunset Strip. Over dinner, Ray was as ebullient as ever, sharing his ideas and enthusiasm with Corwin. One of the stories Ray told Corwin was about a new short story he had written, about a Martian woman named Ylla, who was having premonitions that Earthmen were coming to her planet. Corwin loved the idea and suggested that Ray write more Mars stories. Ray took the advice to heart. He didn't know it at the time, but *The Martian Chronicles* was coming together.

Ray was on a roll. By the summer of 1947, after reading Ray's tale in the *Best American Short Stories* collection of 1946, *New Yorker* editor Katharine S. White—wife of noted American author E. B. White—wrote Ray suggesting he submit some material. Ray took White up on her request, and sent her the short story "I See You Never," the tale of a Mexican man deported back to his homeland. By mid-September, Ray received a response to his *New Yorker* submission. The story had sold. The "Poet of the Pulps" had waltzed right into the most revered literary magazine in the country.

In September 1947, Ray received a note from Simon & Schuster editor Don Congdon. "I got a letter from him saying, 'I'm not going to be an editor anymore, I'm going to become an agent. Do you need one?' I wrote back to him and said, 'Yes, I need one, but only for a lifetime.'"

Ray's words were prophetic. Ever since Congdon had contacted him in 1945, while Ray was traveling in Mexico, Ray had liked the man. In a May 6, 1946, letter, Congdon, still with Simon & Schuster, had expressed his admiration for Ray and his work.

I don't have to tell you, that I am thoroughly sold on the ability of one Ray Bradbury and I would be disappointed if somebody moved in on my chances to publish you, either in story collection or in novels.

Now Congdon was striking out on his own as a literary agent, and Ray was elated at the prospect of signing on with him. Since Ray had begun publishing in the mainstream literary magazines, he had been forced to submit all his stories on his own, as his pulp agent and friend Julius Schwartz did not handle sales to the slicks. In fact, Schwartz had advised Ray to procure the services of an agent who knew the mainstream literary field. Further, Schwartz had been moving out of the literary agent business; in 1944, he had taken an editing post with National Comics, publishers of *The Flash, Green Lantern,* and *All-American,* among others. As the company would later be acquired by DC Comics, he would go on to become a guiding editorial force in the "Silver Age" of comics. Schwartz and Ray amicably parted company, and Ray signed on with Don Congdon, who had joined the Harold Matson Agency. Schwartz continued to peddle a few last remaining Bradbury stories to the pulps; his final Bradbury sale was made in January 1948 with "The Black Ferris" to *Weird Tales* (the story would later become the cornerstone of the novel *Something Wicked This Way Comes*). While the business relationship with Schwartz was concluding, a lifelong friendship had only just begun. Julius Schwartz had been a valiant champion of Ray's early work, landing Ray's first professional sale, and giving invaluable editorial advice to many of Ray's best-loved early pulp tales.

In the autumn of 1947, Ray and Maggie finalized their wedding plans. They had made the necessary arrangements with a minister, but there was one stipulation. "The minister asked if Ray had been baptized and he hadn't," recalled Maggie. She accompanied Ray to a church near her house, where a newborn baby and twenty-seven-year-old Ray Bradbury were baptized side by side. "It makes a wonderful picture," recalled Ray, "the two of us at the baptismal font."

On the morning of September 27, 1947, Ray and Maggie went to the Mount Calvary Church in Los Angeles to marry. Ray's pal Ray Har-

ryhausen served as best man, while Maggie's best friend, John Nom-land, a former classmate from UCLA, served as her untraditional male "maid" of honor. If anything, Maggie's gay friend acting in this role illuminated just how progressive Ray and Maggie were in 1947. Maggie and Ray avoided a big wedding celebration and they were the only four there. Bride and groom insisted on simplicity and understatement.

The financial status of the couple on their wedding day was one of Ray's favorite stories to tell, and he told it often. "Maggie took a vow of poverty when she married me," said Ray. "The day we were married we had eight dollars in the bank and I put five dollars in an envelope and gave it to the minister. And he said, 'What's this for?' and I said, 'That's your fee for the ceremony today,' and he said, 'You're a writer, aren't you?' I said, 'Yes.' He said, 'Then you're gonna need this,' and he handed the envelope back to me because we had no money."

Ray and Maggie rented a one-bedroom apartment at 33 South Venice Boulevard, a few short blocks from the beach. After the brief morning ceremony, the small wedding party went to the Beverly-Wilshire Hotel for a reception. For ten dollars, they received a tiny wedding cake cut into four pieces, and a bottle of champagne. "In the afternoon," Ray Harryhausen recalled, "I drove Ray and Maggie home and dropped them off at their new apartment."

It was a completely new life for the couple. Maggie had always lived at home with her parents, as had Ray who, up until that week, still shared a bed with his older brother, Skip. Late in the day, the newlyweds walked hand in hand to a nearby pharmacy to buy new toothbrushes. On their way home, a group of children began to follow the couple. As twilight settled over Venice, the children began to sing: "Happy Marriage Day to you, Happy Marriage Day to you," to the melody of the birthday song. The children had no way of knowing that the young couple had just married. "We were just dressed in ordinary clothing," recalled Maggie, bewildered by the children's uncanny intuition. Added Ray, "How could they know? How could they know? It was very dear." It was a sweet and profound beginning to Ray and Maggie's partnership—one of the couple's fondest memories.

Venice, California, in late 1947 was much as Ray described it in his mystery novel, *Death Is a Lonely Business*. Fog rolled in from the sea late

in the night and sometimes kept its grip on the coastal community long into the day. Just to see some sunshine, on a few occasions, Ray rode the streetcar inland to Culver City, where he would sit on a bench and bask in the warmth. The train ran just a short distance from the Bradburys' new apartment. As he described it in his mystery novel, it was "a loud avalanche of big red trolley car that rushed towards the sea every half-hour and at midnight skirled the curve and threw sparks on the high wires and rolled away with a moan which was like the dead turning in their sleep. . . ."

Venice was a poor community, as it had been when Ray and his parents and Skip had moved there in 1942. The old Venice pier, once a major tourist attraction, was closed and in disrepair. An old movie house stood on the pier, where Ray and Maggie saw the picture shows during their courtship. While they were in their seats, they heard and felt the rising of the tides beneath the cinema and the crashing of the waves against the pier's wooden support columns. In the 1950s, Venice would enjoy a rebirth as a haven for students and artists. Ray always considered himself and Maggie, with their literary interests and their meager bank account, as "early beatniks."

In the early days of their marriage, Maggie took a secretarial job with Elwood J. Robinson, an advertising agency in Los Angeles. She soon found a better-paying position in the advertising department of Abbey Rents, a medical supply rental company with retail stores throughout California. Maggie was the editor of the company's monthly newsletter, "Abbey Rants and Raves." She also served as a company secretary.

Meanwhile, Ray kept up his writing regimen. He had not faltered from his one-short-story-a-week schedule since he adopted it in the early 1940s. In the evenings, Maggie would come home from work and she would either cook a simple meal or they would go to Modesti's, a family-owned restaurant where they dined for eighty-nine cents apiece. One night Ray endeavored to make a black-bottom pie. The result was a culinary disaster—a burnt brick that was all bottom and no pie. Ray never attempted cooking again. "Other nights we'd walk down to Ocean Park," recalled Ray, "get a couple of hot dogs and play at the penny arcade where the games were still a penny apiece." More than once, the couple crammed into a coin-operated photo booth and posed for pictures. To

this day, the weathered black-and-white prints capture the unmistakable newlywed glow of the young couple.

Maggie Bradbury was not the prototypical wife of the 1940s. Without question, it was she who made it possible for Ray Bradbury to blossom as a writer. She was the breadwinner in an era not known for wives working; she worked so that Ray could concentrate solely on his writing. Maggie believed wholly and completely in her husband's ability. Without her dedication, Ray would have been forced to find full-time employment and the future of the man known for writing about the future might have been very different.

Maggie and Ray woke each day at seven, and she would catch the big red car by seven-thirty. Most days, Ray would get straight to work on his short stories, but other days, he had a secret. "I didn't tell Maggie, but occasionally I would go back to bed after she left," confessed Ray.

One evening, Maggie arrived home and walked into the apartment. "I called out for Ray, but there was no answer," said Maggie. She put her belongings down and walked through the small living room into the tiny bedroom. Ray wasn't there either. She opened the closet door, and there, sitting on the floor of the closet, was Ray with a carton of ice cream in one hand and a big spoon in the other. The sugarmonger had been discovered. Ray's insatiable sweet tooth was curtailed only by the fact that the young couple was on a strict budget and there was no additional money for treats. They were so poor, in fact, that Ray had to buy one stamp at a time in order to send out his weekly manuscripts. To Maggie's credit, the girl who had everything she could ever want as a child never once complained about money to her husband. And so there she was, staring down at her husband, who was hiding in the back of the closet eating contraband ice cream. Maggie had married a man who was still very much a boy at heart and she knew it and she loved him for it.

"What are you doing?" she asked, pointedly.

"Eating ice cream," he answered, sheepishly.

Lack of money didn't just keep Ray from devouring sweets. The tight finances also put a squeeze on his writing career. Here he was, at twenty-seven, establishing himself in the world of literature and radio; he needed to carry himself off like a pro. But Ray and Maggie couldn't even afford a telephone. Ever imaginative, Ray improvised.

"Right across the street from our apartment was a tiny gas station," Ray said. "At the time, there was an outdoor phone booth. So I kept the window open in our front room and when the phone rang, I jumped up and ran across Venice Boulevard and answered the phone and people thought they were calling my home. That's how poor we were."

But the little apartment within earshot of the thundering Pacific surf was perfect in all of its cramped imperfection. These were thrilling days, with new surprises and accomplishments around every corner.

One evening, Ray joined Bill Spier and other members of the *Suspense* cast and crew for a drink after the radio broadcast, at a restaurant near the radio studio in Hollywood. He brought a copy of *Dark Carnival* as a gift for his friend. "I went in and found Bill Spier," remembered Ray. "He was sitting with Orson Welles and Ava Gardner." Ray was introduced to the Hollywood heavyweights and he handed his book to Spier. After Spier admired it, Welles asked to see it. He held the book in his hands, admiring the cover with the images of haunting Mexican masks. After a few moments, Welles looked up at Ray. "I, too, have masks," he said, in his deep, resonant voice. And that's all he said. Ray, of course, said more, taking the opportunity to tell Welles how much he admired his work. "When I saw *Citizen Kane* in 1941," said Ray, "I told all of my friends I've just seen the greatest film ever made and that's the way it turned out. It tops every list all over the world."

On November 13, 1947, Ray's third radio piece, "Riabouchinska," aired on *Suspense*. Ray and Maggie were in the theater the night the program was performed and broadcast.

The days and months of 1948 flew by; it was a splendid year. Ray's script "The Meadow," written for ABC's radio show *World Security Workshop,* was included in *The Best American One-Act Plays of 1947–1948.* His short story "Powerhouse," which had been summarily rejected by *Harper's* and *Collier's,* was finally published in *Charm* magazine, and it went on to win third prize in the 1948 *O. Henry Prize Stories* collection, behind Truman Capote and Wallace Stegner, respectively.

And, as if these accomplishments weren't enough, Martha Foley, the editor who had selected "The Big Black and White Game" for the *1946 Best American Short Stories* anthology had again named Ray to her 1948 collection, this time giving the nod to his *New Yorker* story "I See

You Never." But even with the sales to major magazines and the new radio work, Ray and Maggie were still broke. In 1948, according to their income tax return, they earned as a couple only $4,883.94.

In early 1949, Don Congdon had shopped a new collection of Bradbury stories to Farrar, Straus with poor results. The respected New York publishing house had deemed Ray's material subpar. "They sent it back and said that the writing wasn't good enough," said Ray. "They said that some of the stories were good, but others had overtones of pulp writing. It was a very snobbish letter, and I was angered because some of the stories that they half indicated as being pulp were stories that had been in the quality magazines, or quality stories that had been in the pulp magazines. So I knew they were not sure themselves, and that there was some sort of prejudice against me because I had come up through the pulp magazines."

It was fast becoming a recurring theme. In high school, Ray's short stories were misunderstood because they were science fiction. When Ray first submitted material to mainstream literary magazines, he did so under an assumed name so he wouldn't be recognized as Ray Bradbury the pulp writer. He had long been concerned with being stigmatized for writing genre material and, with the rejection from Farrar, Straus, his fears of being discriminated against had materialized.

In the spring of 1949, still smarting from the rejection of his second collection of short stories, there was more pressure put on Ray to increase his annual income, and quickly. Maggie was pregnant, and the baby was due in November. "I was panicked," said Ray.

Ray's new friend Norman Corwin had some sage advice. "He insisted that I go to New York." Corwin and his wife would be in New York in June and offered to accompany Ray around the city. Maggie would soon be quitting her job at Abbey Rents, and as she was the primary wage earner, Ray desperately needed to make some big sales.

Corwin suggested that Ray put a face to his name, shake some hands in New York, pitch some stories, make his presence known. In June 1949, just as he had done a decade earlier in June 1939, with just eighty dollars in the bank, Ray boarded a Greyhound bus for New York City.

15

THE RED PLANET

Well, of course without Ray Bradbury, there is no Stephen King, at least as he grew. Bradbury was one of my nurturing influences, first in the EC comics, then in Weird Tales, *then in* Arkham House *editions which I saved up for over a period of months (and in the case of* Dark Carnival, *years—that was a lot of summer jobs). I never "studied" him, I just absorbed what he was up to, mostly in the early small-town horror stories but also in the early science fiction stories (mostly* The Martian Chronicles*), as if through my pores. What was striking was how far down into the viscera he was able to delve in those stories—how far beyond the prudish stopping-point of his 1940s contemporaries. In that sense, Ray was to the horror story what D. H. Lawrence was to the story of sexual love.*

—STEPHEN KING, *author*

ONE COULD never accuse Ray Bradbury of an inability to multitask. While he was assembling his first collection, *Dark Carnival,* he had been simultaneously writing and submitting new stories to major literary magazines. He was also pitching stories to radio programs and continuing to sell tales to the pulps. As if that weren't enough, he had several book-length concepts in various stages of development. And, of course, there was the highly autobiographical novel based on his Illinois childhood.

He also had a new short-story collection in mind, which would include a broad-ranging survey of his science fiction, fantasy, and weird tales, as well as his realistic fiction. The working title for the book was *The Illustrated Man.* And, in 1948, Ray came close to working with *New Yorker* cartoonist Charles Addams. The project had garnered interest from Helen King, an editor at William Morrow. The Bradbury/Addams collaboration was to be a Halloween gift book of Addams's illustrations

accompanying Ray's vampire family stories. But Addams's asking price was three hundred dollars a drawing, which was much too high. The artist refused to lower his fee, and the project was shelved. Both men would soon become entrenched in their own projects and, sadly, outside of the beautiful artwork Addams furnished for "Homecoming" in *Mademoiselle* (later used as the cover artwork for 2001's *From the Dust Returned*), the collaboration between two creative powerhouses never occurred.

While juggling all of his various projects, Ray had been steadily writing a series of short stories set on the planet Mars. The first tale, "The Million Year Picnic," had been published in the summer of 1946 in the pulp magazine *Planet Stories*. It was followed by many more tales, as yet unconnected, set on the Red Planet.

The long road to Mars began in 1944, when Ray's friend and mentor, Henry Kuttner, had given him a copy of Sherwood Anderson's novel *Winesburg, Ohio*. After reading it, Ray had made a note to himself to one day combine midwestern Americana with his love of Mars, which had first been sparked by his discovery of Edgar Rice Burroughs's Mars stories. Ray hoped someday to write a book like *Winesburg*, but to set it millions of miles in outer space, on Mars.

In June 1949, Ray arrived by Greyhound in New York City, with a suitcase in one hand and his (new) portable typewriter in the other. With very little money to his name, he checked into the Sloane House YMCA. "I took my stories around to a dozen publishers," Ray recalled. "Nobody wanted them. They said, 'We don't publish short stories. Nobody reads them. Don't you have a novel?' I said, 'No, I don't. I'm a sprinter, not a long-distance runner.'"

Fortunately, Don Congdon had managed to drum up some interest from Doubleday in a collection of Bradbury short stories. The publishing house was launching a list of science fiction books. They would consider a Bradbury collection but wanted only his science fiction material; they weren't interested in Ray's fantasy stories, his weird tales, or his contemporary fiction. Near the end of Ray's weeklong stay in New York, Don and he met Walter Bradbury (no relation) for dinner at Luchow's restaurant, a time-honored German establishment on East Fourteenth Street near Union Square. During dinner, Walter Bradbury said, "What about

all those Martian stories you've been writing for *Planet Stories* and *Thrilling Wonder*? Wouldn't there be a book if you took all those stories and tied them together into a tapestry?"

Eureka! It was such an obvious solution, Ray thought. Why hadn't he thought of it? he wondered. To a degree, he had. What Walter Bradbury was suggesting was not far removed from Ray's own vision of *Winesburg, Ohio,* on Mars. "I made that note back in 1944," said Ray, "and I called it *Space Toward Mars* or something like that. Over the years, my subconscious kept writing Mars stories and then Walter Bradbury comes along and tells me what I've been doing."

Ray agreed to prepare an outline by the next morning and deliver it to the Doubleday editor. He rushed back to the YMCA, went to his room, pulled out his portable typewriter, and went to work. "It was a typical hot June night in New York," Ray wrote in the essay "The Long Road to Mars," an introduction to the fortieth-anniversary edition of *The Martian Chronicles*. "Air conditioning was still a luxury of some future year. I typed until 3 A.M., perspiring in my underwear as I weighted and balanced my Martians in their strange cities in the last hours before arrivals and departures of my astronauts."

While putting his outline together, Ray didn't have any of his previously penned Mars stories with him. He pieced them together entirely from recollection. In short order, he assembled the stories into a narrative mosaic that would literally change the field of science fiction.

At noon the next day, Ray and Don Congdon met at Walter Bradbury's office, and Ray presented his outline. He had decided on the narrative arc that would pull his Martian tales together, one that followed colonists from earth to the Red Planet. The colonists unwittingly brought with them all of their human problems—racism, censorship, environmental destruction, and the threat of atomic annihilation. It was an allegory that would reflect all of humankind's flaws at the dawn of the Space Age. Thematically, he was wrestling with political, social, and philosophical concerns near and dear to his heart.

"I decided first of all that there would be certain elements of similarity between the invasion of Mars and the invasion of the Wild West," Ray wrote in the unpublished essay "How I Wrote My Book," dated October 17, 1950. "I had heard from my father's lips, and my grandfather's,

stories of varied adventures in the West, even in the late year of 1908, when things were plenty empty, still, and lonely. So I knew that Mars, in reality, would be that new horizon which Steinbeck's Billy Buck mused upon when he stood upon the shore of the Pacific and the 'Going West' was over, and the adventurers were left with nothing else to do but simmer down."

This idea for a novel-in-stories would provide a mirror for humanity, its faults, foibles, and failures. The book would be a cautionary tale, warning against the cultural perils that lay ahead. This was always the reason that Ray loved science fiction; it afforded the writer an opportunity to play social critic by using tomorrow's metaphors to symbolize today's problems.

Walter Bradbury was convinced. He loved the idea behind *The Martian Chronicles*. He had already read some of the Mars stories in the pulp magazines, and he knew Ray Bradbury was a rising literary talent who could be a key player in Doubleday's new science fiction line. Walter Bradbury offered Ray a book deal for *The Martian Chronicles* right there, on the spot. Years later, both Ray and Don Congdon were unclear about certain aspects of the career-altering meetings with Walter Bradbury. It was Ray's recollection that Walter Bradbury had even suggested the title, *The Martian Chronicles*. Files in Ray Bradbury's own papers suggest, however, that Ray had been considering the title *The Martian Chronicles* for a collection of his Mars-related stories before the now-legendary dinner meeting where the classic book was born.

After Walter Bradbury had offered Ray a contract for *The Martian Chronicles,* as the story goes, he asked Ray if he had any other projects. It was Ray's long-standing recollection that it was at this point that a second Bradbury classic was conceived—*The Illustrated Man*.

"I was wrong about that," Ray said. "My memory was incorrect." Ray did receive two offers that day. The first was for *The Martian Chronicles*. The second, apparently, was for *The Creatures That Time Forgot*, which, as detailed in Ray's book contract, was to be a fifty-thousand-word novel revised from a Bradbury short story of the same name that had run in the fall 1946 issue of *Planet Stories*.

By the time Ray boarded the Greyhound for his return voyage to Los Angeles, he had with him a check for $1,500—$750 for *The Martian*

Chronicles and $750 for *The Creatures That Time Forgot. The Martian Chronicles* was due to the publisher in just three months. With a pregnant wife waiting for him in California, the money and the book deals lifted a tremendous burden. For the short term, at least, he was rich. "Fifteen hundred dollars was a lot of money in those days," Ray said.

Maggie had quit her job at Abbey Rents and Ray was now the sole breadwinner. If his friend Norman Corwin hadn't pushed him to go to New York, there's no telling what would have happened to Ray's career. Certainly, without the meeting and creative recommendation of Walter Bradbury, *The Martian Chronicles* would never have been written as what Ray called "a book of stories pretending to be a novel."

When the bus arrived at the Greyhound terminal in downtown Chicago on the afternoon of June 23, 1949, Ray decided to live lavishly for the first time in his career. He got off the bus, retrieved his luggage and his typewriter, and went to Chicago's Union Station. He'd had it with the four-day journey across the nation by motor coach. Ray bought a ticket for a seat on the Union Pacific train *The City of Los Angeles*, departing at 7:45 that evening. Ray boarded, took seat number 42 in car four. He was headed home. And for the first time, doing it in relative luxury.

Upon his return to Los Angeles, Ray set out to write a book that would be considered one of his greatest achievements. With Maggie at home in the tiny Venice apartment, each morning Ray rode his bicycle down Venice Boulevard to his parents' house. In the corner garage office of 670 Venice Boulevard, he began work on *The Martian Chronicles*. Mornings were usually spent at his typewriter, pecking out the book at a quick clip. At lunchtime, Ray would take a break and go into his parents' house, where Esther would prepare him an egg sandwich. At two in the afternoon, he bicycled home to take his daily nap. Afterward, he'd return to the garage office to put in a few more hours' work on the book.

While assembling *The Martian Chronicles,* something he was fond of calling a "half-cousin to a novel," Ray had an epiphany. "When I set out to write it, I thought, 'How in hell am I going to take all of my Martian stories and make a novel?'"

Ray harked back to *The Grapes of Wrath*, which he had read in 1939 while crossing the country by Greyhound bus, returning from the First

World Science Fiction Convention. "I looked at that book and thought, my God, Steinbeck put together his novel with every other chapter serving as a metaphorical prose poem about turtles, or religion, or the atmosphere of the time, and I could learn from that." With Steinbeck's story structure in mind, Ray began to piece together his various Mars tales by writing short "bridge chapters" to set up and connect the disparate stories. Throughout the summer of 1949, Ray reviewed his more than two dozen Martian stories, deciding which ones to weave into the tapestry of the book. Some, like "—And the Moon Be Still as Bright" and "The Earth Men" had already appeared in print. As he had done with *Dark Carnival,* Ray seized the opportunity to fine-tune and polish previously published stories before they appeared in book form.

Ray's Mars was influenced by the visions of Giovanni Virginio Schiaparelli, a nineteenth-century Italian astronomer who discovered and mapped a series of deep lines crisscrossing the Martian surface. Schiaparelli called the lines "channels," but when translated into English, it became "canals." The very thought of waterways on Mars ignited a Victorian-era uproar over the possibility of life on the Red Planet. But Ray's Mars was influenced even more by Percival Lowell, an American astronomer who furthered the idea of canals. Lowell had published three books detailing his telescopic research of the Red Planet beginning in 1895; he created lavish maps of the Martian surface, diagramming the hundreds of lines and intersections he concluded were waterways and oases that could only have been constructed by intelligent beings. Crystalline water flowed through this system, he theorized, from the melting polar ice caps, feeding dark areas on the planet that Lowell posited were lush with vegetation. Bright spots on the surface, he surmised, were deserts. It was this romantic Victorian vision that imprinted itself onto Ray's image of the planet.

Ray's Mars was beautifully impossible. His planet had an atmosphere, and it had blue hills. For the author, science was not the point. If his readers could believe in his stories, even if the science was flawed, then accuracy was simply unimportant. It was the metaphor that mattered. His Mars was at odds with the hard science fiction established by *Astounding* editor John W. Campbell. And this is why Ray Bradbury was

always considered an outsider to purists in the field, a writer excluded from the big triumvirate of Isaac Asimov, Robert Heinlein, and Arthur C. Clarke (although Ray *is* popularly considered one of the "ABCs of Science Fiction": *A*simov, *B*radbury, and *C*larke). This never bothered Ray. In his mind, he was working on something much bigger: He was creating a myth.

Ray's Mars story was shaping up to be a human story, filled with human problems, populated by human themes, an allegory transplanted to another world. In creating his version of the Red Planet, he let his imagination run amok.

"[Bradbury] created moods with few words," wrote Isaac Asimov in 1981. "He wasn't ashamed to tug on the heartstrings and there was a semipoetic nostalgia to most of those tugs. He created his own version of Mars straight out of the nineteenth century, totally ignoring the findings of the twentieth century.

"In fact, one gets the idea that Bradbury lives in the nineteenth century and in the small-town Midwest in which he grew up. . . ."

As *The Martian Chronicles* neared completion, Maggie typed the final manuscript even as her due date was fast approaching. Ray worked on one typewriter in the garage at 670 South Venice, while Maggie retyped all of Ray's stories into a single manuscript on another typewriter in the apartment at 33 South Venice. They were an efficient team.

In early October 1949, Ray sent his completed manuscript to Walter Bradbury. The book consisted of eighteen stories and eleven bridge chapters. In all, the book ran a little long. A large part of his revision process entailed cutting, and Ray anticipated having to excise a few of the stories from the submitted manuscript.

As Walter Bradbury was reviewing *The Martian Chronicles,* the big day in the tiny Bradbury apartment finally arrived. "We didn't have a car," recalled Maggie Bradbury, "so we had made arrangements with the people who lived in the apartment next door. They said, 'When you're ready, come knock on our door and we'll take you to the hospital.'" On the fifth of November, just after midnight, they did just that. With his heart pounding, Ray rapped on his neighbors' door and the two couples raced to the Santa Monica Hospital. Maggie was in labor well into the morning

while Ray, playing the expectant-father stereotype, paced the halls, sat restlessly on the hospital's front steps, and stole a few moments of sleep in the waiting room. At 9:38 A.M., Maggie gave birth to a girl, whom they named Susan Marguerite Bradbury. The young parents were elated. Ray wrote August Derleth to share the news, humorously referencing one of his own stories about a murderous baby: "I am pleased to announce that we have a baby girl! . . . A very healthy, pink little girl, with siren lungs and improper manners. She does not, alas, resemble in any way, a Small Assassin."

Ray and Maggie brought their little girl home, and with no space in their apartment for a crib, little Susan slept in her baby buggy. She was a colicky infant, and her fits of tears stirred Ray's memories of his own childhood, and his deep-seated fears of the dark. He worried that his girl would one day have the same nightmares. In response to this, just a week after Susan was born, Ray decided to write his first children's book, *Switch on the Night*. The eleven-page manuscript followed a young boy overcoming his fears of the night with the help of a girl named Dark. Ray's original manuscript was simply a storyboard, with the script of the story to the left and his own primitive illustrations and magazine cutouts to the right.

Even though Ray had received a generous advance for two books from Doubleday, the family was still living without many luxuries. Ray applied for a Guggenheim Fellowship in November 1949, seeking and receiving the requisite recommendation letters from an impressive group. Writing on behalf of Ray were Martha Foley, series editor of *The Best American Short Stories of the Year* anthology; August Derleth, author and publisher of Ray's first book; Ray's friend the noted radio writer and director Norman Corwin; and respected author and University of California at Berkeley English professor Mark Schorer who had, as Ray remembered, struck up a recent correspondence with him.

But the Guggenheim Fellowship wasn't meant to be. Ray was turned down. He believed that once again, prejudice against his genre background had played a hand in the decision. Even with all of his appearances in high-brow literary magazines and in lauded literary anthologies, at the end of the day, Ray Bradbury was still considered a genre writer. He couldn't shed the label.

RAY WAS no longer using his "office" phone across the street at the filling station since the news of Maggie's pregnancy; they had a telephone line installed in their apartment. In December 1949, at the age of twenty-nine, Ray had his first long-distance conversation, discussing with Walter Bradbury what stories needed to be cut from the manuscript of *The Martian Chronicles*. It was determined that four chapters would be excised—"They All Had Grandfathers," "The Disease," "The Fathers," and "The Wheel." These stories remain to this day unpublished.

Ray had forged a close working relationship with Walter Bradbury and relied on him to help him see the proverbial forest through the trees. Throughout his career, Ray surrounded himself with a small and dependable inner circle that included his wife, Maggie; his agent, Don Congdon; various editors over the years; and a few friends. As Ray tightened up *The Martian Chronicles* for publication, he consulted closely with his editor to determine the proper flow to the stories. Walter Bradbury expressed concerns over two more tales in the book. The editor had reservations about "The Earth Men" and its importance to the overall architecture of the Mars story, as well as "Usher II." Walter Bradbury felt the latter tale, about a man inspired by the works of Edgar Allan Poe who builds a second house of Usher on Mars, was a bit too fantastical. Ray agreed to rework "The Earth Men," and convinced his editor to leave the other tale in the book as is. *The Martian Chronicles* was coming together on short order.

In early 1950, Norman Corwin invited Ray to a new program he had developed for United Nations Radio. As Ray took his seat in the front row, he noticed a couple moving into the row directly behind him. It was John Huston and his pregnant wife, Ricki. Ray was completely awestruck at the sight of Huston, his favorite director. Ray had seen both *The Treasure of the Sierra Madre* and *The Maltese Falcon* numerous times. "He knew how to get actors to live inside the skin of their characters so you weren't watching actors acting, you were watching people living," Ray said. "When a director can do this, you forget that you are looking at a motion picture."

Ray was occasionally asked by his friends when he was going to write a screenplay. His response was always the same: "When John Huston asks me to." It was a typically brassy Bradbury response, similar to telling his friends in 1939 that he would land a part in Laraine Day's theater group before he had even met the actress, and when, at the age of twelve, he proclaimed that he would get a job on air at radio station KGAR in Tucson, Arizona, and did. As Ray said, "I've known my destiny all along, haven't I?"

Sitting at the Corwin radio broadcast, it took all Ray's self-control not to turn around and confess his profound admiration for the Hollywood director. After the broadcast, Corwin invited Ray to join him and the Hustons at a Sunset Strip restaurant. In an unusual response, Ray declined the dinner invitation. "Well, it's one of those times in your life when you want to jump up, turn around, shake hands, and introduce yourself; but, at the time, I'd only had one book published, and I felt I should have had a few more published to be fully armed to meet Huston," admitted Ray.

The Martian Chronicles was scheduled for publication in May 1950, and Ray planned a trip to New York to mark the event and to visit his agent, Don Congdon, and his editor, Walter Bradbury. Maggie and Susan stayed behind in Los Angeles with Maggie's parents. He didn't take the bus this time, as there was enough money to travel by rail. On his way across country, Ray made a brief stop in Chicago to have lunch at the Art Institute with a science fiction fan with whom he had been corresponding. As Ray ascended the broad steps of the museum, a group of people rushed toward him. They were science fiction fans and they all clutched brand-new copies of *The Martian Chronicles*. The friend Ray was meeting had told them that the author was in town. And somehow—Ray never knew how—they had all obtained copies of his new book days before its official publication. On the steps of the Art Institute of Chicago, the group of young adults swarmed Ray, their hands reaching out in his direction, holding copies of books and pens. They all wanted Ray Bradbury's autograph.

16

THE ILLUSTRATED MAN

The idea of a futuristic society where being an astronaut was a routine job, something as tedious as a long-distance truck driver was fascinating, psychedelicize this with some drug culture references and a little peripheral esoteric mumbo-jumbo and presto. My main goal, however, was to project a sense of the overwhelming loneliness space offers us; in this I think we succeeded.

—BERNIE TAUPIN, *lyricist for Elton John's "Rocket Man"*

RAY HAD begun to lecture sporadically at colleges and universities in April 1948. After he received the O. Henry Memorial Award for his shorted story "Powerhouse," the University of Southern California chapter of the Epsilon Phi English honorary fraternity invited Ray to speak. He soon learned that his public-speaking acumen mirrored that of his writing process. He quickly learned he should trust his instincts and neither overthink nor overprepare his lectures. "There were 150 people in a big auditorium. It was the biggest crowd I'd ever talked to. Of course, I prepared too much with notes, and I looked up in the middle of lecturing and saw that I put everyone to sleep," confessed Ray. "So I yelled at them. I said, 'Attention!' And I threw my lecture on the floor and jumped on it. And then I looked at them and said, 'To continue!' From then on, I was free from the stupid manacles of lecturing."

When Ray began to speak extemporaneously, to speak from his subconscious, he discovered that his real character shone. He was loud and effusive, a bit prone to hyperbole, but when he made an overstatement, it was from the heart. He recommended to all the young writers in the audience that they not slant their writing for publications but, rather, that they remain true to themselves. "If the story is good," he said that

night, "there will be a market for it." With his lecture notes scattered like fallen leaves about the floor, Ray inspired the audience in a wicked amalgam of preacher at the pulpit, professor at the lectern, half-time coach in the locker room on the day of the big game. That night, Ray had discovered how to give a lecture, with passion and honesty.

More offers followed from colleges and universities throughout California. In 1949, he participated in a lecture series hosted by the English department at USC. One of the other guests on the program was English author and playwright Christopher Isherwood. Sometime in late spring of 1950, after Ray had returned from New York City, he was in a Santa Monica, California, bookshop when he recognized a familiar face: Christopher Isherwood.

As Ray was wont to do, he was in the shop on that fine spring day to see if it carried copies of his new book, *The Martian Chronicles*. When *Dark Carnival* had first come out, Ray often perused bookshop inventories. If the shop had the book in stock, he made certain the copies were at eye level to catch customer attention. "They would often have my books low on the shelf and I would take them out and put them on top," said Ray, chuckling. "Then, when I left, they'd take my books and put them down below again."

After spotting Isherwood, Ray grabbed a copy of *The Martian Chronicles,* autographed it, and rushed up to him. Isherwood, a quiet and elegant man, had been through the routine before—a respected author being bushwhacked by an earnest young writer pushing his hack novel. A "not again" look washed across Isherwood's face. Ray handed him the book, told Isherwood who he was, and said, "I hope you like it." Ray had a suspicion that Isherwood, like so many literary intellectuals, was prejudiced against science fiction, but Isherwood was gracious. He thanked Ray, and the two men parted.

A few days later, the telephone rang at 33 South Venice Boulevard. It was Christopher Isherwood calling.

"Do you know what you've done?" he asked Ray.

"What?" Ray asked.

"You've written a fine book."

Isherwood had just been named to a new post as a critic for *Tomorrow* magazine, and he gleefully told Ray Bradbury that the first book he'd

like to review was *The Martian Chronicles*. The issue would run later that year, in the autumn. It was a resounding seal of approval from a respected intellectual, and it would mark the beginning of a friendship between the two. They were an unlikely pair: a well-regarded aesthete and a young teller of tales who had made a name for himself in, of all places, the pages of *Weird Tales*.

Neva Bradbury, now living in Seattle, Washington, wrote Ray on August 21, 1950, after reading *The Martian Chronicles*: "My nephew—you awe me. I read you and my great feeling of pride detracts from the story, I am so aware of it—and I must read and re-read portions over and over. At times I have cried, not from the sadness of the story, but because I am so proud of you. I think, perhaps, my dear, that you may live as one of our great writers, in the future."

SHORTLY AFTER Ray had signed his contract for the two books with Doubleday in 1949, the book to follow *The Martian Chronicles* changed in scope. While the initial intention had been to take Ray's short story "The Creatures That Time Forgot" (later retitled and published as "Frost and Fire") and turn it into a short, fifty-thousand-word novel, this idea was quickly scrapped. As a writer who preferred creating in quick spurts of inspiration, Ray was hesitant to take on the longer novel form. He forever maintained that the initial first-draft writing process was reliant on gut instinct rather than on intellectual thought. "In quickness is truth," he wrote in the 1987 essay "Run Fast, Stand Still, or The Thing at the Top of the Stairs, or New Ghosts from Old Minds." "The faster you blurt," Ray continued, "the more swiftly you write, the more honest you are. In hesitation is thought. In delay comes the effort for a style, instead of leaping upon truth which is the only style worth deadfalling or tigertrapping."

The novel form was a much different beast from the short story. While Ray very often wrote first drafts of short stories in a matter of hours, novels took months, even years to complete. And so, the ever-

agreeable Walter Bradbury allowed Ray to alter his contract and to submit a collection of science fiction short stories instead of the novel. Walter Bradbury was delighted by *The Martian Chronicles* and wanted to keep his young author happy. The due date for the manuscript of the new book was February 1950; Ray asked for and received a six-month extension. *The Martian Chronicles* had been released in May, and his new book was now due in August.

Ray was more than contented with Doubleday, and had fostered a trusting and comfortable working relationship with his editor, yet there was one aspect of this new partnership with the New York publishing firm that troubled him: the dreaded label. *The Martian Chronicles* had been released as part of Doubleday's new science fiction line; on its cover was emblazoned the colophon "Doubleday Science Fiction." Ray didn't like it. While he had loved the genre since childhood, and he felt that it was the best form a writer could use to act as social critic, he also recognized that the genre was stigmatized. Ray feared his new book would be prejudged and pigeonholed. Snobbery could prevent his work from ever receiving the attention it deserved.

Ray continued to work in the garage at his parents' house, while Maggie cared for Susan in the cracker-box apartment by the sea. The new collection, *The Illustrated Man,* was shaping up, comprising largely the stories that Ray had been writing and publishing since the publication of *Dark Carnival.* Fourteen of the eighteen short stories that would ultimately make up the new book were published in either pulp magazines, literary journals, or mainstream magazines between 1947 and 1950. Don Congdon and Ray pushed hard to sell the stories prior to the book's publication, as the magazines didn't pay as much for second serial (post-book) rights.

Since finishing *Dark Carnival,* Ray had continued to produce a short story a week and had quickly amassed an impressive stockpile of science fiction stories to choose from. Early on in the assembly of his new collection, he had determined to use stories such as "The Veldt," "Kaleidoscope," "The Rocket Man," "The Other Foot," "The Highway," among others. He was also seriously considering the inclusion of the longer novellas "Pillar of Fire," "The Creatures That Time Forgot," and "The Fire Man." It is this last tale that would soon be expanded into *Fahrenheit*

451. But Walter Bradbury warned Ray against using these tales. "I think it's better to keep the stories down to more or less uniform length," he suggested.

As Ray rapidly assembled stories for *The Illustrated Man,* he was writing other remarkable tales that didn't fit the science fiction motif of his new book. One such story was "The Fog Horn." It is one of Ray Bradbury's most well-known and beloved short stories, born on a night when Ray and Maggie were strolling along the beach not far from their apartment. Ray was fond of telling the origins behind "The Fog Horn," because it clearly answered the one question he was asked most often over the years: Where do you get your ideas?

Venice, California, once a proud tourist destination—a kitschy fusion of Coney Island amusement and ersatz Italian street scene—was in complete disrepair. In 1946, the City of Los Angeles opted out of its lease with the owner of the Venice pier, choosing to let the beachfront return to its original sun, sand, and surf incarnation; the days of the penny arcades and thrill rides were over. The old Venice pier was torn down, leaving the structural remnants strewn and scattered amidst drifting sand and the slow-rolling waves of the Pacific.

"I was walking with Maggie one night on the beach as the fog rolled in," recalled Ray, "and looked out and saw the old roller coaster lying over on its side with its bones in the sand and the water, and the wind blowing over its skeleton. I looked at it and said to Maggie, 'I wonder what that dinosaur is doing lying on the beach.'"

A few nights later, Ray woke in the middle of the night and heard the sad bellow of a foghorn far out in Santa Monica Bay. As he sat up in bed in the pale blue moonlight, it suddenly dawned on him. "I had the answer," Ray said. "The dinosaur, hearing the foghorn blowing and thinking it was another dinosaur after it had waited for a million years or more, came swimming into the bay and when he found out it was only a lighthouse and a foghorn calling, he died on the shore of a broken heart. That's why the dinosaur came in and is lying on the sand there."

Once he had the idea, Ray wrote "The Fog Horn" in short order. But it wasn't a good fit for his forthcoming book of far-traveling, socially conscious science fiction, so he held on to it for inclusion in the later collection, 1953's *The Golden Apples of the Sun.*

Just as *The Martian Chronicles* had shown a considerable growth spurt both stylistically and thematically from the stories in *Dark Carnival,* the tales Ray selected for *The Illustrated Man* were top-shelf Bradbury. The language was poetic, the stories steeped in metaphor, the themes transcendent. While the stories he had assembled for this new book were all tales of the far-fantastic—science fiction fairy tales that displayed a soaring imagination—Ray was again addressing contemporary social and political issues about which he cared deeply in 1950: civil rights, the threat of atomic war, the misuse of technology. Yet while the themes were relevant for 1950, the continuing relevance of *The Illustrated Man* shows that, as with *The Martian Chronicles,* Ray Bradbury had struck a chord among readers; his tales spoke to the common American popular culture experience.

In "The Veldt," a husband and wife pamper their children by giving them a state-of-the-art nursery, where dreams and fantasies come alive on the crystal walls, floor, and ceiling of an automated playroom-cum-television of tomorrow. When the children become dependent on the new technology, the parents endeavor to wean them from it. But the children aren't so willing to let go. "The Veldt," written at the dawn of the television age, was at once dark and tragic, while at the same time a satirical commentary on the potentially dangerous power of TV and parents who use it as a babysitter. Ironically in "The Veldt," Ray, often lambasted by science fiction purists for inaccurate technology, had envisioned what would ultimately become virtual reality.

In "Kaleidoscope," a rocket explodes in deep space, catapulting its crew out of the destroyed vessel and off into the void. As the astronauts drift apart in the vacuum of outer space, they continue to communicate with each other over their spacesuit radios, each man coming to terms with his own fate.

In "The Other Foot," African Americans have colonized Mars. After the Earth is destroyed by atomic war, a small number of white survivors arrive by rocket on the Red Planet, and the colonists must decide what to do with the newcomers. In this science-fictional tale of role reversal, Ray asks if centuries of racial intolerance, injustice, and hatred continue to persist in a new planetary milieu.

As ever, Don Congdon was steadfastly working on Ray's behalf.

Along with Maggie, Congdon was Ray's most loyal partner. He was a thorough editor, working to help shape Ray's stories. Congdon was also a tremendous personal influence. When he got a crew cut, so did Ray. Congdon was an avowed liberal Democrat and his political leanings certainly reinforced Ray's own beliefs. He also knew that Ray had a keen ability to pitch stories; when Ray would make his periodic trips to New York, Congdon would take Ray to magazine offices to meet editors. It was an unusual sales strategy, eschewing the traditional manuscript and cover letter submission. But Congdon knew full well that Ray's infectious energy and enthusiasm would often sell his own stories.

As Ray put his new short-story collection together, Congdon sold "The Illustrated Man," a tragic tale of a carnival freak, to *Esquire*. In 1948, Ray had envisioned it as a title story for a collection of short stories. But when he took this idea to his editor in 1950, Walter Bradbury wasn't quite sold on the idea. The editor felt the story didn't fit with the science fiction motif of the rest of the collection. However, Walter Bradbury liked the title and the two men agreed to consider it as a name for Ray's new collection. Another possibility was taken from a recently penned short story, "Perhaps We Are Going Away."

As Ray worked on the new book of short stories, the Bradburys were experiencing growing pains. The apartment in Venice was too small, so Ray and Maggie began searching for a house, and found one they loved in a rolling, quiet nook of West Los Angeles. It was a white single-story tract home, located at 10750 Clarkson Road, and had three bedrooms and one bathroom. It had a putting-green backyard and a detached garage—a perfect office space for Ray. Ray and Maggie borrowed the down-payment money from their parents and bought the home for twelve thousand dollars. They moved in on August 3, 1950.

A few weeks later, Christopher Isherwood's review ran in the premiere issue of *Tomorrow* magazine and it was a glowing tribute. Until then, *The Martian Chronicles* had received only a smattering of reviews, and none from the powerhouse publications. Now this high praise from a highbrow critic signaled that perhaps there would be a paradigm shift in the way the intelligentsia handled genre fiction. Ray certainly hoped this was the case.

"Poe's name comes up," wrote Isherwood on Bradbury, "almost in-

evitably in any discussion of Mr. Bradbury's work; not because he is an imitator (though he is certainly a disciple) but because he already deserves to be measured against the greatest master of his particular genre."

It was perhaps the most important and salient distinction in Isherwood's review that vindicated Ray from the trappings of the science-fictional pigeonhole. Isherwood stated in no uncertain terms that Bradbury transcended genre: "His brilliant, shameless fantasy makes, and needs, no excuses for its wild jumps from the possible to the impossible. His interest in machines seems to be limited to their symbolic and aesthetic aspects. I doubt if he could pilot a rocket ship, much less design one."

As *The Illustrated Man* neared publication, a final element was added to the book. "Somewhere along the line," said Ray, "Walter Bradbury said, 'We've disguised *The Martian Chronicles* as a novel, do you think we can somehow do the same thing with *The Illustrated Man*?'" Ray thought long and hard about his editor's words. While Walter Bradbury had passed on the eponymous short story "The Illustrated Man," Ray had an inkling of how it might loosely tie his entire new story collection together. Just before sending his editor the manuscript, Ray devised a clever narrative frame that incorporated the character of the illustrated man, even though it had been decided that the story by the same name would not be included in the book. Ray wrote a haunting prologue for his new collection of short stories that began with a young man—the story's narrator—walking the back roads of Wisconsin. It is a hot and humid summer day, late in the afternoon, when the narrator meets another wanderer—a former carnival freak, out of work and out of luck. He is an "illustrated man," a sideshow spectacle bearing tattoos from head to toe. And, ironically, that is why this tragic figure cannot find work. His tattoos are somehow different: They come alive at night, swirling in colorful smears of water-colored fright, predicting dark and dreadful futures.

As Ray wrote the prologue story, each tattoo on the body of the illustrated man represented a short story in the book. It was a stroke of creative inspiration. Ray wrote a few more interludes between the first few stories in the collection, setting the tone, showing the tattoos chang-

ing shape, blurring, becoming different visions of the future. Ray ended the book with an epilogue in which the narrator, lying beside a campfire with his fellow drifter, at long last peers at "that empty space upon the illustrated man's back, that area of jumbled colors and shapes." The book ends with one more vision of the future—the final tattoo morphs and bleeds into a coherent work of skin art. It shows the illustrated man strangling the narrator.

Ray turned in the manuscript for *The Illustrated Man* on August 19, 1950, and continued to correspond with Walter Bradbury as they polished the book for publication early the following year. Ray had won a small victory in convincing his editor to remove the words "science fiction" from the cover of the new book, but he still wasn't satisfied. Walter Bradbury wanted the Doubleday Science Fiction logo at least to appear on the book's title page, and Ray rebelled. It was a symbolic battle for Ray Bradbury, a quiet struggle against being tagged a genre writer that he had been fighting since his high school days. Ray wrote to Walter Bradbury on September 29, 1950, asking him once more to remove the science fiction tag altogether.

> . . . *May I ask now, very humbly, that we remove it from the title page also? I think we could have gotten more reviews from the big people on CHRONICLES if it hadn't been for that science-fiction label. . . . Can't we do something about this, please, Brad? Must the light remain under the bushel-basket? I realize your financial position on books of short stories, but there's no reason one kind of advertising won't work on book-store-managers, and another, devoid of the s-f shadow for the general public and the critics. My name is known well enough among s-f readers now so they'll investigate the book, with or without a special label, don't you agree? You have been a good friend to me on so many details, and I hate to plagge [sic] you again about this, but the Isherwood review only brings it to the surface once more. If he likes the book, then why wouldn't the reviewers at Atlantic, Harper's, SRL, and the other big sources? Haven't we lost at least a thousand sales, to put it mildly, by not getting the CHRONICLES to certain reviewers without the s-f label? I have admired [Aldous] Huxley for years,*

*but never heard him referred to as a science-fiction writer. Or
George Orwell. I do not mean to sound conceited, but I only want
a certain amount of recognition among people I admire and look
up to. . . .*

Ever the hands-on author, after wrangling over the science fiction
cover label, Ray had strong opinions on the cover art for his new collec-
tion. He envisioned a very loose and abstract rendering of a man, with
primitive symbols stamped all over his body: symbols that resembled
age-old cave etchings, drawings of suns and moons, snakes and human
figures. Down to the orange and red color scheme, the design was all Ray
Bradbury. Luckily, Walter Bradbury liked Ray's jacket-art concept and
forwarded the idea to the Doubleday art department, and they liked it,
too. "The Art Department tells me to pass along to you their feeling that
you are an excellent jacket designer," Walter Bradbury wrote Ray on Oc-
tober 10, 1950.

As Doubleday prepped *The Illustrated Man* for its impending re-
lease, Ray and Maggie settled into the new house on Clarkson Road. Af-
ter living in the tight confines of the one-bedroom apartment in Venice,
the three-bedroom home afforded them room to breathe. And they were
going to need it: Maggie was expecting again.

ONE AFTERNOON Christopher Isherwood telephoned Ray and asked if
he could stop by for a visit. He wanted to bring a friend, the noted au-
thor and philosopher Gerald Heard. Heard was a distinguished intellec-
tual, sixty years of age at the time, a former Oxford University lecturer,
BBC science commentator, as well as the author of dozens of books,
most notably on the evolution of human consciousness. Heard had
asked Isherwood specifically to introduce him to Ray Bradbury. Ray was
incredulous. He couldn't fathom that a man of his repute, an intellec-
tual held in such high regard, wanted to meet him.

"We'd only been in the house a few weeks and we had no furniture,"

said Ray. "In the living room we only had a sofa but no other chairs. I told Christopher, 'You can't bring him over if we have nowhere to sit.' And Christopher said, 'He'll sit on the floor.' I said, 'No, I'll sit on the floor!'"

On a still Los Angeles evening, twilight settling over Clarkson Road, there was a rap at the front door. It was Christopher Isherwood and Gerald Heard, standing on the front steps of Ray and Maggie Bradbury's new home. Heard was given a seat on the sofa, alongside Maggie, and Ray and Christopher Isherwood sat on the floor. As they conversed, Heard asked many questions of Ray. He wanted to know Ray's background, and he asked how *The Martian Chronicles* came to be, attempting to understand the cogs and machinations that made Ray Bradbury tick. As Ray recalled, Heard had the ability "of making you feel as if you were the intellectual, you were the one with the IQ, you were the one who deserved attention rather than himself. There are not many intellectuals who have this gift. They're so busy talking and listening to themselves, they don't want to pay attention to you. But Heard, for the first time, I really think for the first time, made me feel that I was worthwhile to myself."

A few weeks after the meeting, Heard called Ray with an invitation for tea at his house. "I was really frightened," said Ray, "and I said to my wife, 'What am I going to say to him? I'm going to go down there and I'm going to spend two hours at tea. What do we have to talk about? I have no education. I've never been to college. I haven't read any of the books that this man has read and my career is just beginning. What could he possibly want to talk about?'"

Despite his trepidation, Ray went to see Heard at his Pacific Palisades home, a small rented cottage behind a larger house. "He put me at ease immediately," said Ray, "and we talked about life on other worlds and space travel and things I felt comfortable about. I found we got on fine, and I dared to say many foolish, or what I thought were foolish, things about life and myself and creativity, and I found that he felt this way, too—this whole thing about fun in writing, and enjoying and loving your work."

Ray dined periodically with Isherwood and Heard, and Ray's friend Sid Stebel occasionally joined them. Stebel had met Ray in 1948 while putting a literary magazine together called *Copy*. Stebel and another

friend paid a visit to Ray's apartment on Venice Boulevard one afternoon to ask if he might contribute to their magazine. He did, giving them the story "The Highway." Ray and Sid Stebel remained close friends from then on. The two pals shared all sorts of grand times, including evenings spent with Gerald Heard.

"Gerald Heard was a charming man. He was very wizened," professed Stebel. "He had a little pointed goatee, a Van Dyke, I think they called it, and very mischievous eyes." One evening while Ray and Stebel were visiting, turmoil ensued when a moth fluttered into the house, prompting Isherwood and Heard into action. "There was quite a to-do over this moth," Stebel said. "My instinct would have been to kill it and their instinct was to shepherd it out because it was a life."

Soon, Christopher Isherwood and Gerald Heard introduced Ray to another member of their intellectual clique, Aldous Huxley. Ray had read and admired Huxley's work, particularly *A Brave New World*, in his late teens and early twenties, during his imitative period, just before he began publishing and prior to discovering his own voice as a writer. "I tried to be artsy-fartsy like him," Ray said, "including science and aesthetics and anthropology and archeology and all those things, which of course I couldn't do."

On an afternoon late in 1950, Heard invited Ray to his home for tea with Huxley. Of course, Ray didn't have a car and even if he did, he never learned to drive, so, as he often did, he asked a friend to give him a lift. Ray Harryhausen obliged, driving Ray to Heard's home. Even as Ray had been uniformly accepted by this esteemed group of intellectuals, he learned that as cordial and accepting as Heard and Huxley were, there were still the underpinnings of snobbery. "Ray Harryhausen brought me to Heard's house on a Sunday afternoon and they didn't invite him in," remembered Ray. "He had to sit outside and I was so embarrassed. He waited an hour for me to come out and I apologized to him. I said, 'Those people are so impolite.' Of course, he was nobody then. He hadn't made any films. He was unknown. If he'd been famous, they'd have asked him in, of course."

Through Isherwood, Heard, and Huxley, Ray had infiltrated the inner sanctum of a well-regarded trio of intellectuals. He also recognized, however, that as kind as these great writers, philosophers, and thinking

men were, they still wore the armor and attitude of the intellectual elite. But he had been invited into an arena that had been, until that point, largely off-limits to a perceived writer of science fiction and fantasy. It was a turning point for him, as his insecurities over being categorized as a genre writer continued to haunt him. Isherwood, Heard, and Huxley reassured Ray. They listened to him. They told the young writer that he had talent and ought to relax and enjoy the long and splendid ride. They predicted that the name Ray Bradbury would be etched in the annals of literary history. Most important, they reassured Ray that he wasn't a science fiction writer at all. "You're a *writer*," they said. One afternoon, Heard took the praise a notch higher. "You're not a writer, you're a poet," he said. To prove his point, Heard opened his copy of *The Martian Chronicles* and read aloud a sampling of the book's passages.

"It was the first time a group of intellectuals said, 'This guy's a great writer,'" said Sid Stebel. "Sci-fi was considered a kind of trashy form and a lot of sci-fi writers were trying to achieve respectability. Isherwood and his friends said, 'Forget what genre Ray Bradbury is writing in. He's a fabulous writer.' They saw all kinds of psychological and philosophical things in Ray's work."

The psychedelic drug movement wouldn't take flight until the sixties, but in the early to mid-1950s, Gerald Heard and Aldous Huxley, ever the philosophers of alternative consciousness, were already trying mescaline, a natural chemical that prompted hours-long, colorful hallucinations. Heard and Huxley were not interested in experimenting with mind-dulling drugs, but rather with psychoactive stimulants that heightened perception, so they took mescaline, a legal substance at the time, under the watchful supervision of a doctor. One day, they asked Ray to participate. Heard and Huxley must have been tremendously curious to know how mescaline would interact with a mind like Ray Bradbury's. "They offered me mescaline because Huxley had done several books, one called *The Doors of Perception,* that all had to do with drugs and getting a heightened perception by using them. They looked at it all very scientifically," Ray explained. He declined their offer, puzzling them. "I told them, 'No, I can't do that.' They said, 'Why not? We'll have a doctor in attendance.' And I said, 'Yes, but what if the top of my head comes off and the doctor can't put it back on?' And of course, they had no answer,

because a lot of people went insane in those days taking drugs. I told them, 'I don't want to have a lot of perceptions, I want to have one at a time. When I write a short story, I open the trapdoor on the top of my head, take out one lizard, shut the trapdoor, skin the lizard, and pin it up on the wall.'" Ray was afraid that if he took mescaline, he would be unable to, as he put it, "shut the trapdoor and all my lizards would escape."

DOUBLEDAY WAS pleased with its prolific young author, but had to take care—Ray was in demand. Bantam Books had approached Don Congdon about the possibility of Ray serving as an anthologist for a fantasy collection, and offered an advance of $500. Congdon countered, asking for $1,000, and with classic negotiation protocol, the two parties settled on the fee of $750, payable upon publication. Ray set out to pick a book's worth of tales—stories of terror, magical realism, dark fantasy, hope, and promise. Ray endeavored to find stories by authors not generally associated with the fantasy genre; he also looked for material that hadn't appeared in other fantasy anthologies. "They were stories that I had read over the years that I loved," Ray said. "And so it was very easy to, in a single day, decide the contents of the book." Ray chose a wide-ranging group of tales, by authors as diverse and unexpected as John Steinbeck, E. B. White, Franz Kafka, Shirley Jackson, and John Cheever, to name but a few. In many ways, the list reflected something few people knew about Ray Bradbury: He did not read exclusively within his own field. In high school, he had expanded his reading list to include nongenre literature, and shortly thereafter he began reading both contemporary and mainstream work as well as the classics. He stopped reading science fiction, fantasy, and horror altogether, except for works by his personal friends in the field. "Instinctively," Ray said, "I knew that if I read within my own field that I'd never develop. I'd be stealing ideas from other writers or imitating them or else I'd discover that someone in the field was doing a story similar to mine and I'd become discouraged and I wouldn't finish my own story. You must not read in

your field. Read everything else." With his table of contents selected, the first anthology of fantasy selected by Ray Bradbury, *Timeless Stories of Today and Tomorrow,* was scheduled for publication in the fall of 1952.

In February 1951, advance copies of *The Illustrated Man* arrived in the mail. Ray had recently signed on with Famous Artists, the renowned Hollywood talent agency, to market his stories to the movie industry. His agents, Ben Benjamin and Ray Stark, had connections to John Huston, and at long last Ray felt ready to meet his hero. It had been a year since Ray had encountered him at one of Norman Corwin's United Nations radio broadcasts, but he hadn't felt up to meeting the larger-than-life film director then. He now had *Dark Carnival, The Martian Chronicles,* and *The Illustrated Man* to show for himself, not to mention his recent radio work, his inclusion in *The Best American Short Stories of the Year* anthologies, and his O. Henry Prize stories. "After I had published three books, and I could prove my love to John Huston," said Ray, "I called my agent, Ray Stark, and asked him to arrange a meeting."

In early 1951, Ray met Huston at Mike Romanoff's restaurant, a posh Hollywood eatery that was a favorite of the 1950s Tinsel Town elite. Minutes after being introduced to Huston, Ray expressed his admiration for Huston and his work, and followed it by boldly declaring that he believed they were destined to work together. It was yet another towering proclamation made with Bradburian bravado. He then slid his three books across the table and told Huston that if he liked the books, to give him a call. Through it all, John Huston listened with keen interest, taking the books in his hands and admiring them with curiosity. The dinner lasted an hour and as it wound down, Huston invited Ray to a screening of his latest film, an adaptation of the Stephen Crane classic *The Red Badge of Courage,* the following evening at the Pickwick Theater.

"I went to the theater the next night and John Huston was there with his girlfriend, Olivia de Havilland. He had left his wife somewhere," Ray said with a laugh. "I went in and sat by myself. John sat in back with his friends and they ran the preview of *The Red Badge of Courage* and by the time the film was half over, the theater was almost empty. People were leaving and they were bored and they didn't like the film. And I sat there

in despair and thought, 'Oh my God! Here's my hero with a flop on his hands, because the film was far too long and needed cutting.'"

Dore Schary, then vice president in charge of production at MGM, the studio behind the film, described the preview debacle as "disastrous. . . . The audience began to file out toward the end of the first hour, the pace of exodus increasing as the second hour wore on." By the end of the screening, Huston knew his film was doomed, and he made haste to travel overseas to begin work on his next picture. Ray wandered out into the lobby, where Huston spotted him and told him that he was traveling to England and then to Africa to make the film *The African Queen*. "I'll write you," promised the director.

As Ray recalled, it was a week later that he received a handwritten note from the director thanking him for the books. Huston went on to give Ray high praise. "Impressed is hardly the word for my state of mind," he wrote. He cited the stories "The Tombstone," "The Traveler," and "The Other Foot" as just a few of his favorites. John Huston ended his letter with a sentence that caused Ray to do a double take: ". . . [T]here's nothing I'd rather do than work with you on a picture."

IN THE days, even weeks, after reading the director's missive, Ray was walking at least a few inches off the ground. John Huston had told him that he was a great writer. He had also said in no uncertain terms that there was a good chance that someday Ray Bradbury would be writing a screenplay for a John Huston film.

THE GOLDEN APPLES OF THE SUN

Ray Bradbury has been one of my idols since I first came upon The Martian Chronicles *while I was still in high school, and I fell hopelessly in love with both his stories and his storytelling. Ray challenges the imagination—indeed all the senses—in the simplest way of all—by finding the inner truths about humanity. From Mars to East Los Angeles, from the lilt of Ireland to a grim place where books are burned, from October Country to the magic of a new pair of tennis shoes . . . Ray knew who we all were, and where we came from, and most of all he knew all the secret places where we—and he—wanted to travel to.*

—ROY E. DISNEY, *former vice chairman of the board of directors of Walt Disney Productions*

THE ILLUSTRATED Man was published on February 23, 1951. Ray was all of thirty years old. More and more of Ray's work was appearing on the radio, as Don Congdon sold Ray's stories to several dramatic programs. Ray's story "Mars is Heaven!" (titled "The Third Expedition" in *The Martian Chronicles*) aired on the National Broadcasting Company radio program *Dimension X.* "Mars is Heaven!" followed a group of American astronauts who landed on Mars only to discover the green grass, Victorian homes, and front porches of their own childhoods. More startling, they also found all of their dearly departed loved ones—grandfathers, grandmothers, mothers, fathers, brothers, and sisters—apparently alive once again. It was a nostalgic/futurist vision that could only come from the mind of Ray Douglas Bradbury. The story crackled over radio speakers across the nation, in New York tenements, Iowa farmhouses, California bungalows, Texas ranch homes. And, in Portland, Maine, a boy

named Stephen King placed his small fingers on the radio dial and tuned in to listen.

"My first experience with real horror came at the hands of Ray Bradbury—it was an adaptation of his story 'Mars Is Heaven!' on *Dimension X*," King recalled years later in his book *Danse Macabre*. "This would have been broadcast in 1951, which would have made me four at the time. I asked to listen, and was denied permission by my mother. 'It's on too late,' she said, 'and it would be too upsetting for a little boy of your age.' I crept down to listen anyway, and she was right: it was plenty upsetting. . . . I didn't sleep that night; that night I slept in the doorway, where the real and rational light of the bathroom bulb could shine on my face."

Ray's work was moving beyond books, and his influence was starting to permeate the outer reaches of popular culture. At the same time, his family was growing. On May 17, 1951, a second daughter, Ramona Anne, was born. Once again, neighbors were called upon to bring Maggie to the hospital, as the Bradburys still had no car. And this time out, unlike the long labor Maggie endured with the birth of Susan, the arrival of little Ramona was relatively quick and easy. The new parents had assumed that their newborn would be a boy, and had chosen the name "Ray Jr." for their new child. But when their second daughter arrived, they quickly improvised, adapting the name Ray into a feminine version.

Ray's career continued to go well, too. Along with the increasing sales of his story rights to dramatic radio, which expanded his audience exponentially, Ray moved into television, a medium in its infancy. While Ray had cautioned his readers about the potential threat of a television-reliant culture in his short story "The Veldt," he also recognized that for a writer with a wife and two baby girls to support, TV opened up an entirely new arena of financial opportunity. Some might say this made Ray Bradbury a hypocrite. However, Ray recognized the potential power of the burgeoning cultural medium and determined to put it to good use.

Over the course of his long career, Ray Bradbury was often perceived as a technophobe. He never learned to drive a car; he didn't fly on an airplane until the age of sixty-two; he owned a computer for only a short time later in life but never bothered to learn how to use it. When his stories began appearing on television in the early 1950s, the Brad-

bury family didn't even own a television upon which they could watch the adaptations of his grand creations. Ray always felt there were more imaginative ways in which a family could spend its time. He believed that the overuse of television would surely signify the beginning of the "dumbing down" of America. However, this didn't mean he disapproved of the technology, or didn't recognize its great potential. With this in mind, Ray sold the rights to "Zero Hour," from *The Illustrated Man,* to the NBC program *Lights Out.* The program aired on July 23, 1951.

As Ray's reach was expanding beyond books into other media, he continued to move beyond the boundaries of North American publishing. Like *Dark Carnival, The Martian Chronicles* was published in the United Kingdom in September 1951, this time by publisher Rupert Hart-Davis. But Hart-Davis wasn't so keen on the title; the term "Martian" had hardly entered the global lexicon. Ray wrote Hart-Davis in wholehearted agreement:

> The Martian Chronicles . . . *dropped into a conversation causes people to blink and say, "What?" or "I beg your pardon?" Then I have to spell it.*
>
> *"M..A..R..T..I..A..N. You know what I mean?" They blink again. "You know the planet Mars. Martians." They nod sagely, "Oh, yes!" I'm getting a bit tired of explaining my title to people. In any event, once they learn it's about Martians, they sidle away from me and apprehensively change the conversation. So . . .*
>
> *May I suggest* The Silver Locusts *might not be bad at all. I hope you'll think it over. Either that or* Way in the Middle of the Air *will probably have to do.*

In addition to changing the title for the British edition, Ray took the opportunity to make changes to the book itself. He was highly critical of his work, even after it had been published. As was his wont, he fine-tuned his published stories whenever given the chance. Ray removed "Way in the Middle of the Air" from the British edition of *The Martian Chronicles,* published as *The Silver Locusts.* It told the story of an exodus of African-American settlers leaving the Deep South of the United States for a new life on Mars, free from discrimination, hatred, and

racial injustice. It was groundbreaking social commentary, written at the dawn of the American civil rights movement. But in hindsight, Ray felt the story simply didn't fit in with the rest of the book. "The blacks appear in that one story and then they don't appear again," he said. Ray always felt that "Way in the Middle of the Air" was more appropriately paired with its sequel, "The Other Foot," which was published in *The Illustrated Man*. The latter story was so strong, in fact, that it earned Ray yet another spot in *The Best American Short Stories of the Year* anthology for 1952.

As Ray readied the British edition of his book, he also excised a short story he dearly loved, the macabre and chimerical "Usher II." It was about a man obsessed with tales of fantasy and horror—in particular those of Edgar Allan Poe—which had long been banned on Earth. In an act of defiance, the man builds a second "House of Usher" with which he lures the people who brought about censorship on Earth, and murders them one by one, employing all of Poe's deliciously dark and violent devices. Ray loved the tale but, even as he was preparing the original *Martian Chronicles* manuscript, there were doubts about the role of this story of dark fantasy within the larger pioneering allegory. His editor, Walter Bradbury, had stated in no uncertain terms that he did not feel "Usher II" fit into the larger picture of *The Martian Chronicles*, but Ray battled to keep the story in the book. The author won out, and it was only after *The Martian Chronicles* was published by Doubleday that Ray recognized the errors of his ways. "Brad," Ray wrote Walter Bradbury, "you were right about Usher II. I should have followed your advice and cut it out of *The Martian Chronicles*. It is a good story, but time and again people have mentioned it to me as the lump in the cake frosting. I let my love for the story blind me to its position in relation to the whole. I should have taken advantage of your more objective view."

Now with a second chance at publishing *The Martian Chronicles* across the Atlantic, Ray removed the story from the book. Ironically, he would later lament this decision, as "Usher II" was a story near and dear to him. It also dealt with the theme of censorship, which would later become the foundation for *Fahrenheit 451*, a book that many would call his masterpiece.

This proclivity to tinker with previously published work was at odds

with the philosophy Ray would assume later in life. "A writer shouldn't interfere with his younger self," he proclaimed. His early, constant retooling would eventually lead him to repackaging, and in some cases rewriting, stories he was displeased with from *Dark Carnival*, rereleasing it as the 1955 book *The October Country*.

The Silver Locusts (a reference to the silver Earth rocket ships landing on Mars) was released in Britain in September 1951. Ray sent a copy of the book, in its new incarnation, to John Huston, who responded in a letter dated December 27, 1951, in which he thanked Ray for the copy of "The Silver Locust" [*sic*], and said, ". . . There is no doubt in my mind it would make a great picture. . . . I will try my best to get some studio to let me make your book, providing you still desire that and that there is still such a thing as motion pictures."

It was the second flattering note from Huston in less than a year. And now the director was expressing interest in not only working with Ray but also adapting *The Martian Chronicles* for the screen. When this might occur, Ray didn't know, but he felt that his dream of working with John Huston would soon become a reality.

RAY BRADBURY lived his life in a race against time. He had so many things to do and to say, and he felt he did not have enough time in which to accomplish them all. Perhaps that was why he so often wrote of time machines. With devices to travel back to the past and forward to the future, he was able to right the wrongs of yesteryear and to prevent the seemingly inevitable mistakes of tomorrow. To Ray, time represented mortality, an end to his creative output. He did not fear death itself; instead, he was frightened of being unable to write. And so Ray Bradbury wrote as if he were making up for tomorrow's lost time. Even with the demands of a growing family and a new house, he continued to write a short story a week, or its equivalent in novel pages. He never worked on only a single project, preferring instead to juggle various endeavors in different stages of development. Early on, Ray developed a filing system

for his story starts. Often, he would concoct a title or a story concept, begin the story, then slip it into his filing cabinet for a future day. Days, weeks, months, years, sometimes decades later, he would slide open the metal drawer of his filing cabinet and pull out a folder containing a short-story title, or perhaps a half-started tale born of some long-ago inspiration. In this way, he felt, he would always be able to "hotwire his idea machine." Ray believed that, with each completed creation, he bolstered his quest for immortality; he strove to live up to the words of Mr. Electrico and, through his works, to live forever.

As he was working on *The Martian Chronicles* and *The Illustrated Man*, Ray consistently wrote, submitted, and published new tales in magazines. In high school, Ray had written a story about the ravine that ran through his hometown of Waukegan. Since writing "The Lake" in 1942 and discovering how his youthful memories could generate story ideas, Ray had intermittently written more Illinois stories, in the hope that he was building a novel in the same manner he had used with *The Martian Chronicles*. It was a novel that his agent, Don Congdon, very much wanted him to write, and a novel that his editor, Walter Bradbury, wanted to publish. After finishing *The Illustrated Man*, Ray planned to, at long last, complete his Illinois novel that, over the years, had various working titles: *The Small Assassins, The Wind of Time, The Blue Remembered Hills,* and, by 1951, *Summer Morning, Summer Night*. After *The Illustrated Man* was published, Ray signed a contract for the book, which was scheduled for publication late in 1952.

IN APRIL 1952, Ray and Maggie stumbled upon a piece of art they loved. While on an evening stroll through Beverly Hills, they passed an art gallery. Ray glanced through the storefront window and saw a dramatic lithograph that was, in his mind, the pen-and-ink embodiment of his writing. He felt as if he had discovered a twin—a doppelgänger who had chosen pens and brushes instead of an Underwood typewriter and paper for his creations. The artist's name was Joe Mugnaini. The piece in

the gallery window was a lithograph of a gothic house, a dwelling that Ray's vampire family might live in, tall and spindly and ominous. But it also evoked an urban aura, with a graffiti-scrawled billboard on a cement wall beneath the house. Standing in the shadows was a dark figure. As Ray said, it was the "sort of place a beast like myself might want to live in." Ray entered the store and inquired about the price of the art. "The lithograph of the house was seventy-five dollars," remembered Ray, "and I couldn't afford that. I asked if I could pay for it on time because I was only making eighty or ninety dollars a week at the time. So I bought the lithograph on time and paid it off over a period of three months. The lady who sold the lithograph to me said, 'If you like that, there's an oil painting of that same house in the next room.'"

Ray and Maggie stepped into the adjacent room and saw a larger painting titled *Modern Gothic*. After studying the painting for a while, Ray realized that he recognized the grotesque structure. It was the house that had stood across the street from the tenement owned by the mother of his former friend Grant Beach. In love with the painting, Ray desperately wanted to buy it, but Maggie would not hear of plunking down $250 for it. Dejected, Ray spun on his heel and then, on the opposite wall, he spotted yet another dark, haunting oil painting. Again by Joe Mugnaini, this work portrayed a carnival train traveling late at night over a towering, gothic trestle. Aboard the train were dozens of faceless, colorfully dressed celebrants hoisting flags and banners into the night sky. Most bizarre, the bridge on which the train ran abruptly ended at either side. The carnival train was going nowhere. Titled *The Caravan*, the painting stirred Ray Bradbury's imagination. It reminded him of his own carnival-inspired stories, in particular "The Black Ferris," which would a decade later inspire the novel *Something Wicked This Way Comes*.

"It was a spooky moment when I saw that Joe's mind and my mind met somewhere out in space," Ray said. He wanted to buy the artist's pieces right there on the spot, but that was impossible. Ray asked the gallery saleswoman for Mugnaini's phone number. "I called Joe and a friend drove me out to his house in Altadena and I saw all of his beautiful stuff and I said, 'Mr. Mugnaini, I can't afford to pay the gallery prices, but you split it fifty-fifty with them, don't you?' He said, 'Yes, that's right. The gallery keeps half the money.' I said, 'I'll tell you what, I

can't afford to pay the gallery price, but if those paintings don't sell, I'll buy them from you for the price you would have got. So therefore, I'm not cheating you, you see. I don't mind cheating the gallery because they're rich, and to hell with them.'"

Two weeks later, Joe Mugnaini called Ray to inform him that neither of the paintings had sold. If Ray was still interested, they were his and he could pick them up and pay when he was able.

Joe Mugnaini was an Italian-born artist who immigrated with his family to the United States as an infant. Eight years older than Ray, Mugnaini remarked that they were "joined at the hip." Like Ray, Mugnaini was a Depression kid. He was in his late teens the day the stock market crashed, and he worked menial jobs throughout the thirties, like a lot of people, to survive. But he had lofty ambitions and enrolled as a student in the Otis Art Institute in Los Angeles, where he studied painting and drawing. California artist Mary Anderson, who studied under Mugnaini in the late 1950s, described him as "enthusiastic, skeptical, vulgar, exhortative, Italian, dedicated. He was an energetic wild man." It was this energy that made him the perfect collaborative partner for Ray Bradbury: Joe Mugnaini painted like Ray Bradbury wrote.

"I had heard of [Ray Bradbury]," said Mugnaini, in a 1990 interview in *Outré* magazine, two years before his death, "because he was a very popular guy. I think a lot of GIs who came out of the Army were reading his books." Mugnaini recalled the day Ray first visited his house: "He got very excited and told me I was doing graphically what he was doing literally."

Ray made arrangements to pay the artist on an installment basis. "Years later," said Ray, "I found out that he pulled the paintings from the show to give them to me. That's the kind of guy he was." A lifelong friendship and partnership was born.

The same month Ray met Joe Mugnaini, he began a correspondence with Bill Gaines, managing editor and publisher of Entertaining Comics, more commonly known as EC. The comic book company had recently risen to prominence as a leading publisher of horror, science fiction, and fantasy titles. Ray discovered that EC, without permission, had taken two of his stories from *The Illustrated Man,* "Kaleidoscope" and "Rocket Man," and combined them into the story "Home to Stay." (Unbeknownst

to Ray at the time, EC had lifted two more of his tales: "The Handler"
ran as "A Strange Undertaking," and "The Emissary" had been published
as "What the Dog Dragged In.") Ray wrote Gaines, but he didn't admon-
ish EC for its trespass.

"I pretended they had taken my stories inadvertently; they had read
them, and then subconsciously stolen them," Ray recalled. He requested
modest compensation for the plagiarism (a meager fifty dollars), but it
was more important for Ray to open up a dialogue with the popular
comic book publishing house, for he had an ulterior motive. Gaines re-
sponded to Ray, and while denying any plagiarism, he readily agreed to
pay the author fifty dollars for the trouble. Ray, in turn, wrote back,
thanking Gaines, and proposed the idea of working together on "official"
Bradbury comic book adaptations. Gaines, excited, wholeheartedly
agreed to Ray's proposal. EC Comics began adapting the stories of Ray
Bradbury in an official capacity later that year. The stories were adapted
by some of the top artists in the field, including Wally Wood, Jack Ka-
men, Joe Orlando, and Al Williamson. The EC adaptations introduced
Ray to a younger group of comic book fans, thousands strong, who
picked up the Bantam paperback editions of *The Martian Chronicles*
and *The Illustrated Man*.

As the summer of 1952 neared, Ray had done much work on his Illi-
nois novel, but it was still far from completion. Ray was feeling pres-
sured, but Walter Bradbury was agreeable. The editor had read drafts of
Ray's Illinois manuscript and had a sense that it could well be Ray's ma-
jor literary breakthrough. Ray simply needed more time. Walter Brad-
bury released Ray from his contract to complete the midwestern
childhood-inspired novel and, instead, agreed to publish another Brad-
bury short-story collection. In turn, Ray promised to wrap up the Illinois
book as quickly as possible. So Ray began pulling together *The Golden
Apples of the Sun,* but this time the book would be a collection of mixed
fiction that well represented Ray's continuing inroads into the major
market literary magazines. While Walter Bradbury had kept Ray within
the confines of science fiction with *The Illustrated Man,* with this next
book the editor agreed to a collection comprising not only science fiction
and fantasy but also contemporary and literary fiction. Included would
be four of Ray's realistic tales that had been published in the slicks to

critical acclaim in the 1940s. The first of these was "I See You Never," originally published in *The New Yorker*. The story marked Ray's sole appearance in the magazine over the course of his career. "I probably submitted three or four hundred short stories to them over the years and this is the only one that ever sold," Ray lamented.

The other three mainstream stories Ray included in *The Golden Apples* were "The Big Black and White Game," Ray's first tale about race relations; "Powerhouse," a story about a woman coming to terms with mortality and spirituality as she travels to visit her dying mother; and "Invisible Boy," a tale of a boy convinced he has turned invisible by the make-believe magic of an old woman.

Alongside these realistic stories, Ray included his lovesick dinosaur tale, "The Beast from 20,000 Fathoms" (published in the June 23, 1951, issue of the *Saturday Evening Post* and later retitled "The Fog Horn"), and "The April Witch," from his long-in-the-works vampire family novel, a fanciful story based on a character who was a thinly disguised incarnation of Ray's beloved aunt Neva. Rounding out the collection were five new, as yet unpublished tales: "The Flying Machine," "The Murderer," "The Meadow" (a short-story adaptation of his radio script of the same name), "The Garbage Collector," and the title story, a science-fictional Promethean quest, "The Golden Apples of the Sun," the title of which was taken from a poem by W. B. Yeats.

Of all the stories in *The Golden Apples of the Sun,* only one, "Embroidery," had appeared in the pulps. With *The Golden Apples of the Sun,* Ray was assembling his first true book of mixed fiction. He had signed with Doubleday to write for its new science fiction line, but Ray's latest collection reached well beyond science fiction, offering fantasy and contemporary tales alongside stories of the far future.

As his friendship with Joe Mugnaini blossomed, Ray became more determined than ever to work with the artist. "We got drunk a lot," Ray recalled with a laugh. But well beyond being drinking buddies, they respected each other's art. "Ray has always been a very open, very enthusiastic sort of guy," said Mugnaini. "It's impossible to talk to him without becoming enthused yourself."

Ray and Mugnaini discussed a picture book based on Ray's concept of a malevolent carnival arriving in a midwestern town. The book, as they

envisioned it, was a precursor to the modern graphic novel. But the two men had other projects. Ray recommended Mugnaini to Walter Bradbury, and the artist was commissioned to illustrate the cover of *The Golden Apples of the Sun*. "I told Joe what the book was about and showed him some of the stories and asked him if he could do the cover for me. Maybe come up with one or two samples," explained Ray. "He came back with twelve samples. He was that energetic. That was Joe. All the cover designs were so beautiful I couldn't pick one, but I finally selected the art that you see on the cover of the first edition."

Walter Bradbury and the design department at Doubleday were equally impressed. Ray had high hopes to have Mugnaini do individual black-and-white illustrations for each story, and Doubleday agreed. While *The Golden Apples of the Sun* did not have a unified narrative thread like *The Martian Chronicles* and *The Illustrated Man*, it did have a visual uniformity through Mugnaini's stunning pen-and-ink line drawings; each story in the book opened with a black-and-white interpretation. As the artist recalled, he did all the work for $250. With this one book, the distinctive visual art of Joe Mugnaini became synonymous with the unique literary art of Ray Bradbury.

During the summer of 1952, Ray received a call from film producer Hal Chester to come for a meeting at Warner Brothers studio. Chester had a screenplay in development and had procured the talents of Ray's friend Ray Harryhausen to supervise the stop-motion animation effects. Like Ray Bradbury, Ray Harryhausen had been making dramatic career inroads, fast becoming a legend in the field of visual effects. From the beginning of their friendship, Ray Bradbury wanted nothing more than to work with his dear friend and best man, Ray Harryhausen. "We could talk for hours over the telephone," recalled Harryhausen about the early days of their friendship. "We wanted to make a great dinosaur movie together. We would sort of pitch ideas back and forth. I was going to animate them and he was going to write the script. The ideas never matured, but it was fun."

Ray now had an opportunity to work with his friend. He was eager to meet with Hal Chester and, on the day of their meeting, Chester handed Ray the screenplay and asked him to read it on the spot. He told Ray that if he liked the script, he could revise it or even rewrite the entire thing.

Chester wanted Ray Bradbury in on his project, and Ray Bradbury wanted to team up with Ray Harryhausen. Ray agreed to read the screenplay immediately, and was shown to an adjacent room. After reading the first twenty pages, Ray was incredulous. The script featured a dinosaur encountering a lighthouse. It was straight out of his short story "The Beast from 20,000 Fathoms," which had run in the *Saturday Evening Post* a year earlier. The screenplay had plagiarized Ray Bradbury. "After reading the script," Ray said, "I went out and Hal Chester said, 'What do you think? Would you be interested in working on this screenplay?' I said, 'Yeah, I would, but, incidentally, there's a slight resemblance to my story 'The Beast from 20,000 Fathoms.'" Hal Chester was mortified. "His jaw dropped, his eyes bugged, his wig turned around three times, and then I realized that someone in the studio had 'borrowed' my idea and written the script. Then they had called me in, forgetting where they had borrowed the idea, and asked me to rewrite it."

Ray agreed to consider the offer to work on the script, even with the apparent lifting of his idea. As with his experience with EC Comics, at first Ray chalked up the entire incident to inadvertent plagiarism and let the matter slide. If anything, it showed that his stories were being noticed by other creators. Ray told Chester to be in touch, and left. "The next day I got a telegram from them asking to buy the rights to my story," said Ray. "I didn't have to threaten them or anything. They got the hint when I dropped the safe on them."

On July 3, 1952, Hal Chester's company, Mutual Pictures of California, bought the rights to "The Beast from 20,000 Fathoms" for $750. Oddly, after selling the story rights, Ray had no further involvement with the production of the film. After making the initial offer, Chester never hired Ray to rewrite the script, and Ray never asked why he was passed over. "I think they called me in that day to test me, I guess," conjectured Ray, "to see if I realized that there was plagiarism. I just don't know." While he lost the opportunity to work on a motion picture with Ray Harryhausen, the two friends would still be linked in the credits of the film: *The Beast from 20,000 Fathoms*—Story by Ray Bradbury, Animation Effects by Ray Harryhausen.

While one cinematic opportunity slipped away, another presented itself. Ray was approached by Universal Pictures in the summer of 1952

to develop a monster movie. Ray, however, had loftier ambitions. It is no surprise that the young man who had brought mainstream respectability to the fields of science fiction and fantasy with *The Martian Chronicles* had high hopes of crafting an outline that elevated beyond the ghetto of the kitschy 1950s monster spectacle. Ray offered to write two different versions of the film, tentatively titled, as he recalled, *The Meteor*. One would be an outline in keeping with the studio's wishes—a stereotypical story of a malevolent space creature attacking Earth. But he would also proffer an alternative. "I wanted to treat the invaders as beings who were not dangerous, and that was very unusual," Ray said. "The only other film like it was *The Day the Earth Stood Still,* two years before. These two films stand out as treating creatures who understand humanity. The studio picked the right concept and I stayed on."

Ray went to work at Universal in late August, earning three hundred dollars a week. Monday through Friday, he took the morning bus from his home in West Los Angeles to the Universal lot, on the other side of the hills in Universal City. It was an hour-long commute each way. "I was used to riding the bus back then," Ray said. "So I filled the time writing stories inside my head." At Universal, Ray shared bungalow 10, a modest two-office cottage, with screenwriter Sam Rolfe, who in 1954 would receive an Oscar nomination for his work on the western *The Naked Spur.*

In the six weeks Ray spent at Universal, he drafted several outlines—richly detailed screen treatments—that quickly became the story *It Came from Outer Space.* "I got carried away by my emotions," Ray said of his explosion of prolificacy while at Universal. Original working titles for the film were *The Meteor* and *Atomic Monster.*

At noon each day, Ray took his sack lunch, walked the back lot of the film studio, and stopped at the faux Main Street, America. The set of quaint, charming houses conjured warm memories of his Illinois childhood. "There was an entire street, just like the street in Waukegan where I was born," Ray recalled. "And there was a house very much like my grandparents' house, and I sat on the front steps of the porch and had my lunch."

During his time at Universal, Ray wrote four drafts of film treatments. "I basically wrote a screenplay," he recalled. His writing went far beyond the parameters of the normal, present-tense, narrative film treat-

ment. The final 111-page outline, completed in early October, was heavy
on dialogue and camera direction, and it featured his own unmistakable
language and "Bradburian" description. It was a point-by-point, scene-
by-scene blueprint for a writer to adapt into script form. According to
Ray, because he had no screenwriting experience, the studio decision
makers had little confidence in him actually writing the script, but he
had conceptualized and produced a detailed outline. Writer Harry Essex
was hired to write the final script. Given the level of detail in Bradbury's
treatment, the job was a simple one for Essex. "Harry just retyped my
treatment. He added things, of course, because it wasn't complete, but
he was very open," said Ray. "He told people this. He said, 'Ray Bradbury
wrote a screenplay and called it a treatment.'"

It Came from Outer Space was not released until May 25, 1953.
When it finally reached the silver screen, it was immediately recognized
as a groundbreaking work of 1950s science fiction paranoia, echoing the
burgeoning national obsession with Martians, flying saucers, and inci-
dents like the alleged 1947 crash of an alien craft in the desert outside
Roswell, New Mexico. Ray Bradbury's story capitalized on the waxing
cultural interest in little green men. But instead of rehashing the tired
cliché of an intergalactic monster set to devour civilization, he flipped
the space-invader genre on its collective ear by portraying human beings
as the real villains of the story.

By 1952, Ray Bradbury had grown increasingly disenchanted with the
American political climate. While Norman Corwin, Sid Stebel, and
many of Ray's other friends at the time did not recall having regular po-
litical discussions with Ray, he was a steadfast liberal Democrat in the
early 1950s. In 1952, he even volunteered for the Adlai Stevenson pres-
idential campaign, going door-to-door, handing out political literature,
shaking hands, attempting to persuade strangers to vote Democrat. Over
the years, Ray's political leanings had led to more than one heated ex-
change with his father, whose own ideology landed somewhere on the

other end of the spectrum. Throughout the war years, Ray had been an ardent supporter of President Roosevelt. Leo Bradbury, on the other hand, disparaged FDR. When World War Two ended and the 1940s wound to a close, an alarming new political trend reared its ugly head and it concerned Ray Bradbury very much. As the Communist-governed Soviet Union switched from wartime ally to postconflict adversary over the newly drawn boundaries of Germany, a witch hunt was under way in the United States, spearheaded by an as yet little-known U.S. government entity, the House Un-American Activities Committee.

First established in 1938 to identify subversive individuals and organizations, after the Second World War the committee was given increased authority by President Truman, FBI director J. Edgar Hoover, and Attorney General Tom Clark. A "Red Scare" was sweeping America. It was the dawn of the Cold War, and in 1947 the House Un-American Activities Committee set its sights on Hollywood, probing for Communist influences in the motion picture industry. Led by Chairman J. Parnell Thomas, the committee stopped at nothing to expose alleged Communists lurking within film studio walls. Fearing for their careers, looking to backstab old enemies, or simply surrendering to national hysteria, many tongues in the film industry began wagging to government investigators. With no proof whatsoever, fingers were pointed in the direction of suspected Communist sympathizers. Not everyone in Hollywood was intimidated. Prominent cinematic luminaries such as Humphrey Bogart, Jane Wyatt, Billy Wilder, Gene Kelly, Judy Garland, and Burt Lancaster decried the committee's goon-squad tactics. Many took out ads in Hollywood trade magazines in opposition to the government's activities. John Huston, then vice president of the Screen Directors Guild, was also a vocal opponent of the government's Communist-trawling expedition.

"In my estimation," said Huston, "Communism was nothing as compared to the evil done by the witch hunters. They were the real enemies of this country. And what made it so bizarre, so unbelievable, was the fact that the worst offenders against all that this country stands for were members of a committee of the Congress of the United States, who had sworn an oath to protect and defend the Constitution."

Yet even as Hollywood's elite stood up to the bullying tactics of the

committee, the end result of the shakedown was a blacklisting that reverberated throughout the film industry. Nineteen writers, directors, and actors found their careers in tatters. Many more were forced to work under pseudonyms or to move overseas to find employment. In a country in which free speech was a celebrated constitutional right, many Communist sympathizers, and many more who were unjustly accused, instantly lost their civil rights. In addition to the destruction of many notable careers, the damage left in the path of the investigation made for a less daring, less confrontational Hollywood. At the onset of the 1950s, the film industry was producing far fewer socially conscious pictures. Intimidated, Hollywood took no chances.

Along with Chairman J. Parnell Thomas, among those politicians who championed the cause of "protecting" America from the alleged Red scourge, were California congressman Richard M. Nixon, Nevada senator Patrick A. McCarran, and Wisconsin senator Joseph McCarthy. In 1950, the McCarran Act was signed, mandating that all Communist-affiliated organizations register with the office of the United States attorney general. Anyone associated with these organizations was denied a passport and forbidden to work for the government. Practically overnight, America found itself in the throes of mass hysteria. By the time Joseph McCarthy entered the scene, the finger-pointing had reached its peak. Neighbors accused neighbors of being Communists; friends accused friends; even families were antagonistic toward their own. The question "Are you, or have you ever been, a member of the Communist Party?" had become an everyday part of the national discourse.

Ray Bradbury hoped that his choice for the presidency, Governor Adlai Stevenson of Illinois, would win the 1952 election and reverse the climate of fear that had consumed the country, but Stevenson lost the election by a sizable percentage. General Dwight D. Eisenhower garnered more than fifty-five percent of the vote to Stevenson's forty-four.

"I was disappointed in Stevenson," Ray remarked. "He had no courage. He didn't speak out against McCarthy during the campaign and that's why he lost. It was terrible. Nobody spoke up. Nobody."

Days after the election, on November 7, 1952, Ray was invited to speak before the Los Angeles chapter of the National Women's Com-

mittee of Brandeis University. Influenced by the recent election results, and the years of censorship and Communist witch hunts, Ray's speech was a rallying cry extolling the virtues of free speech, the power of the written word, and the necessity of libraries courageous enough to house books encompassing all ideologies and all faiths from far left to far right. Titled "No Man Is an Island," the speech was a rousing and moving manifesto; it was such a success that the National Women's Committee printed it in booklet form, a twelve-page pamphlet given to members of another chapter within the organization.

"I was on a roll," said Ray. Refusing to stop with one speech delivered to a private audience, he took his opposition to the current political climate a step further.

Incensed by Stevenson's loss, disappointed by the candidate, and infuriated by the censorship that gripped the country, Ray paid for a full-page ad in *Daily Variety*, a widely read Hollywood trade magazine. On November 10, 1952, the publication ran Ray Bradbury's highly charged missive:

Letter to the Republican Party

You have won and the Democrats are now the opposition. And so it is time for someone to remind you of a few words that you yourselves spoke during the campaign concerning fear of losing the two-party system.

I remind you now that the two-party system exists and will continue to exist for the next four years. Every attempt that you make to identify the Republican Party as the American Party, I will resist. Every attempt that you make to identify the Democratic Party as the party of Communism, as the "left-wing" or "subversive" party, I will attack with all my heart and soul.

I have seen too much fear in a country that has no right to be afraid. I have seen too many campaigns in California, as well as in other states, won on the issue of fear itself, and not on the facts. I do not want to hear any more of this claptrap and nonsense from you. I will not welcome it from McCarthy or McCarran, from Mr. Nixon, Donald Jackson, or a man named Sparkman. I do not want any more lies, any more prejudice, any more smears. I do not want

intimations, hear-say, or rumor. I do not want unsigned letters or nameless telephone calls from either side, or from anyone.

I say this to you then: do your work and do it well. We will be watching you, we, the more than 25,000,000 Americans who voted without fear and who voted Democratic. We are not afraid of you and you will not intimidate us. We will not be sloughed aside, put away, turned under, or "labeled." We are a strong and free force in this country and we will continue to be the other half of that wonderful two-party system you wailed so much about losing.

Leave that system alone, then, leave our individual rights alone; protect our Constitution, find us a way to Peace, and we will be friends. But God help you if you lay a hand on any one of us again, or try to twist the Constitution and the Bill of Rights to your purposes. We Democrats intend to remain as powerful and thoughtful four years from now as we are today, and that is powerful and thoughtful indeed, and, given provocation, we will vote you out the door in '56, with the majority next time, behind us.

Get to work now, remembering that you have good men in your party if you put them to work. But in the name of all that is right and good and fair, let us send McCarthy and his friends back to Salem and the 17th Century. And then let us all settle down to the job of moving ahead together, in our time, without fear, one of the other, and with the good of everyone, each lonely individual in our country, firmly held in mind.

Ray Bradbury

"I was sick and tired of all the terrible things being said back and forth, the Communist talk, the anti-Catholic talk, the anti-Jewish talk, that everybody was spouting," Ray declared. "I had to say something."

The day his letter was published, Ray was visiting the office of his Hollywood agents, Ben Benjamin and Ray Stark, when Benjamin emerged from his office clutching the issue of *Daily Variety*. He shook it at Ray Bradbury.

"You'll never work in Hollywood again!" he shot at his young client.

"Yes, I will," Ray responded, "because I'm not a Communist."

Furious with Ray Bradbury, Benjamin was certain that Ray was call-

ing undue attention to himself in a time when so many had decided to keep their mouths shut and heads down. And he was right. The U.S. government would investigate Ray, but not for several more years.

Ben Benjamin slammed his office door in Ray Bradbury's face. But Ray was certain of what he had done. It is telling that the two people he trusted most, his wife, Maggie, and his literary agent, Don Congdon, supported him implicitly.

"I was proud of Ray for writing that letter," said Maggie Bradbury. "I was behind him one hundred percent."

Added Congdon, "I was all for it."

It was a tempestuous time to live and be free in America—especially as an artist. However, as Ray rallied against government censorship, he was unwittingly storing away the components for his next book—his much-anticipated first novel.

As that time neared, Ray's latest short-story collection, his first book of mixed fiction, was released. Published in March 1953, *The Golden Apples of the Sun* was dedicated to the one person who had influenced Ray more than anyone else:

AND THIS ONE, WITH LOVE, IS FOR NEVA
DAUGHTER OF GLINDA
THE GOOD WITCH OF THE SOUTH

FAHRENHEIT 451

Ray was one of my heroes when I started publishing Playboy.

—HUGH HEFNER, *publisher*

WHEN RAY was nine years old, he learned of the cataclysmic fires that destroyed the Alexandrian library of ancient Egypt. Untold numbers of books, letters, and archival documents were reduced to cinders. At a young age, Ray had embarked upon his singular lifelong love affair with the library; he regularly visited the old Carnegie Athenaeum in Waukegan, Illinois. The very fact that the greatest and most storied library in history—the library at Alexandria—had gone up in flames pained him to his core.

In the autumn of 1932, when the Bradbury family—Leo, Esther, Skip, and Ray—made the trek across the country, along Route 66, through Depression-era America, at dusk, road-wearied, they often stopped to rest at a bungalow-court motel. "I hit the ground running to the nearest library," said Ray. "That was my way of sustaining myself on the journey. When I got in the library, the first thing I looked for were the Oz books. They weren't there. The second thing I looked for were the Edgar Rice Burroughs *Tarzan* books or his Martian books. They weren't there. That was my education to the fact that certain kinds of books, at least when I was a kid, were not allowed in libraries. It wasn't censorship. It was taste. The librarians looked down their noses at these books—which were not 'literature.'" It was Ray's first exposure to the literary snobbery that would one day plague his own career as an author.

In 1934, when Ray was living in Los Angeles and watching at least a dozen movies a week, he was shocked at the newsreel footage that rolled

before each motion picture feature. Grainy black-and-white images of Nazi soldiers hurling books into fiery blazes flashed before him, singeing his subconscious. Ray sat bathed in projector light, flames reflecting in his round spectacles, and he cried. During the Depression, books—particularly free books from the public library—were his one great solace. "When Hitler burned a book," Ray wrote in 1966 in an introduction to *Fahrenheit 451,* "I felt it as keenly, please forgive me, as his killing a human, for in the long sum of history they are one and the same flesh."

As Ray watched the House Un-American Activities Committee ignite a Communist witch hunt in Hollywood in 1947, the seeds of a masterpiece—*Fahrenheit 451*—swirled within his subconscious. It was a mad inquisition that reminded him of his own long-lost relative, Mary Bradbury, convicted of witchcraft at the Salem Witch Trials.

During this period in the late 1940s, Ray wrote what he would later call "five ladyfinger firecrackers," which led to the "explosion" of *Fahrenheit 451.* Each of the stories—"The Bonfire," "Bright Phoenix," "The Exiles," "Usher II," and "The Pedestrian"—addressed themes of censorship, banned books, book burning, the power of the individual, or the salvation of art from the clutches of those who might destroy it. They were stories of social satire, addressing issues dear to Ray Bradbury. "The Pedestrian," the final story in the buildup to *Fahrenheit 451,* sprang from a personal, if bizarre, experience.

As Ray often told the story, it was a late, windy autumn night in Los Angeles, the Santa Ana breeze carrying the scent of cinders. Ray and a friend (Ray does not recall who this particular friend was) had finished dinner at a restaurant in the mid-Wilshire district of Los Angeles and were walking to the bus stop, deep in conversation. (Neither man owned an automobile.) As he walked, Ray munched on some soda crackers, a box of which, in his typically eccentric fashion, he had brought with him to and from the restaurant. A police car wheeled up beside them. The officer stepped out and approached the two men. He asked what they were doing.

"Putting one foot in front of the other," said Ray, his mouth full of crackers.

Displeased, the officer asked again what they were doing.

"Breathing the air," said Ray, "talking, conversing, walking."

As he spoke, bits of cracker flew from his mouth, dusting the police officer's uniform. The officer flicked the crumbs from his chest and shoulders.

"It's illogical, your stopping us," Ray continued. "If we wanted to burgle a joint or rob a shop, we would have driven up in a car, burgled or robbed, and driven away. As you see, we have no car, only our feet."

As Ray recalled it, the police officer was dumbfounded to see two pedestrians out late walking in a city not known for foot traffic. He also took Ray Bradbury as a smart-ass. (In actuality, Ray was just being Ray: innocently impudent, a little naïve.)

"Walking, eh?" said the officer. "Just walking?"

Ray and his friend nodded, wondering if they were the victims of some strange joke.

"Well," the officer said, "don't do it again!"

The officer returned to his patrol car and drove off into the night.

Incensed, Ray went home and wrote "The Pedestrian," a story about a future society in which walking was forbidden and all pedestrians were treated as criminals. The tale follows one man, a writer, in the year 2053 who still enjoys the lost pastime of late-night walks, while others sit inside their little homes watching television. Ray's agent, Don Congdon, sent the story to countless magazines, from the top slicks to the science fiction pulp magazines, but it did not sell. "Probably because it was too political," Ray surmised. Finally, in August 1951, the story was published in *The Reporter,* a liberal political magazine put out by Max Ascoli; later, "The Pedestrian" appeared in *The Golden Apples of the Sun*; and in 1952, it was included in the *Best Science Fiction Stories* anthology.

" 'The Pedestrian'—even though it's not dealing with censorship—resulted in *Fahrenheit,*'" said Ray. "Because later, I took the pedestrian out for a walk one night again, and when he turned a corner, he bumped into this young girl named Clarisse McClellan and she took a sniff and she said, 'I smell kerosene, I know who you are,' and the man she bumped into said, 'Who am I?' and she said, 'You're the fireman who lives up the block who burns books.' "

By 1949, the "five ladyfinger firecracker" tales were written. In 1950, Ray set out to write "the explosion," as he referred to it, that would later evolve into *Fahrenheit 451*. The earliest draft of this formative novella

was titled *Long After Midnight*, and was written shortly after Ray and Maggie had moved into the Clarkson Road house. Ray had yet to transform the garage into a workable space. One afternoon, as he was roaming the UCLA library stacks, he discovered the perfect spot in which to write.

"I found the best way to inspire myself," he said, "was to go to the library in Los Angeles and rove about, pulling books from shelves, reading a line here, a paragraph there, snatching, devouring, moving on, and then suddenly writing on any handy piece of paper."

One day he heard the clatter of typewriter keys emanating from a stairwell; he went down the stairs to investigate. In the library basement, he discovered a typing room with rows of desks topped with well-oiled typewriters. Each typewriter had a timer, and could be rented for a dime for each half hour. Ray had found his new office.

He went to work. In a flourish, he set out to draft the story "Long After Midnight," soon to be retitled "The Fireman." Ray made a quick outline for himself, a series of plot points he wanted to touch upon, then commenced writing madly. By the end of the first day in his new "office," he found it difficult to leave the library and ride the bus home.

In the days that followed, the writer woke at seven in the morning, took the bus to the library, and wrote until dusk. "I cannot possibly tell you what an exciting adventure it was," he recalled in the 1993 introduction to the fortieth-anniversary edition of *Fahrenheit 451*. "Day after day, attacking that rentable machine, shoving dimes, pounding away like a crazed chimp, rushing upstairs to fetch more dimes, running in and out of the stacks, pulling books, scanning pages, breathing the finest pollen in the world, book dust, with which to develop literary allergies. Then racing back down blushing with love, having found some quote here, another there to shove or tuck into my burgeoning myth."

Nine days after he had started, at a total cost of $9.80 (forty-nine hours of typewriter time), Ray Bradbury had written a 25,000-word novella; it was the story of a fireman named Montag in a distant future in which firemen, instead of putting out blazes, started them. They burned books.

As with some of his other politically charged tales, such as "The Pedestrian" and "The Other Foot," many editors rejected "The Fireman."

Don Congdon shopped the story to magazines such as *Harper's* and *Esquire*, but none of the major literary publications was interested. Finally, "The Fireman" sold for three hundred dollars to Horace Gold, the editor of *Galaxy* magazine, a science fiction pulp publication, and was published in February 1951. It was the same month that Ray's third book, *The Illustrated Man*, was published. Other stories, other books, myriad film and radio projects then took hold of his attention, and Ray set "The Fireman" down for two years. He had initially hoped to include it in *The Illustrated Man* and then in *The Golden Apples of the Sun*, but decided to cut the lengthy story from both when editor Walter Bradbury thought "The Fireman" unfit for both collections. *Fahrenheit 451* would have to wait two more years before it would come to life.

IN 1953, in Los Angeles—and all across America, for that matter—it appeared as if economically prosperous Americans had forgotten the war years. The horrors of Nazi Germany had been largely brushed aside in favor of a Kodachrome culture, a new society of tract homes with white picket fences. Senator Joseph McCarthy's voice had become background noise on suburban-living-room television sets.

But not everyone was wearing red, white, and blue blinders. Despite the relative prosperity of the nation, Ray feared for the future of his two towheaded daughters. He was frightened by the new atomic world and the potential consequences of what society would do with modern technology. In addition, the "Red Scare" moved Ray to explore the alarming possibilities of a dark, dystopian future.

With *The Martian Chronicles*, Ray had cleverly unified a series of his Mars-themed short stories, written in the late 1940s, into a thinly veiled novel. While widely acknowledged for his mastery of the short-story form, as well as for his poetic, luminous style, Ray Bradbury had yet to prove himself with a work of longer fiction. And this posed the question: Could he do it? Could Ray Bradbury's inspiration-fueled writing process be sustained over the course of creating a novel-length work?

"Being hit and run over by a short story is exhilarating," Ray re-marked in his 1966 introduction to the book. "But how does one get hit and run over and exhilarated by such a long thing as a novel? How does one stay exhilarated day after day so the whole damn thing stays honest, so one does not begin to rationalize and spoil the process, become self-conscious and ruin the whole?"

In *The Martian Chronicles,* Ray had explored issues at that time un-common to the science fiction genre. While the book was set fifty years in the future on the planet Mars, the stories actually confronted con-temporary concerns such as racism, the anti-Communist witch hunt, environmental pollution, and nuclear war. Ray's examination of these hot-button topics would lead to the writing of *Fahrenheit 451.*

By the summer of 1952, the publishing industry was abuzz with the news about publisher Ian Ballantine and his new endeavor, Bal-lantine Books. Ballantine and editor Stanley Kauffmann had left posi-tions at Bantam Books, publisher of the paperback reprint editions of *The Martian Chronicles* and *The Illustrated Man.* Because of their af-fordability, the Bantam paperbacks had managed to do what had thus far eluded Doubleday's hardcover Bradbury titles—bring Ray Brad-bury to a larger, mainstream audience. "Certainly the paperbacks and library-bound hardback editions became the way that the younger generation learned to love Bradbury and to see him as an American master," said Jonathan R. Eller, coauthor (with William F. Touponce) of *Ray Bradbury: The Life of Fiction,* a scholarly survey of Ray's pub-lishing history.

Ray's prominence in the literary landscape was growing, and while he loved his editor, Walter Bradbury, and owed much to his creative in-sights, Ray was still frustrated by Doubleday's myopic vision. The pub-lisher was insistent on marketing Ray as a science fiction writer to a science fiction audience. Ian Ballantine recognized not only the growing popularity of science fiction, but also its literary potential.

Walter Bradbury passed on "The Fireman" and agreed to allow Ray to publish it elsewhere, so long as it was not published as a novel, but within a collection of stories. Walter Bradbury did not want his prized author to write his first novel for another publisher.

In the meantime, Don Congdon spoke with Ballantine, to see if

there was any interest in a new Bradbury collection. In the early 1950s, Ray Bradbury, while not yet a household name, was one of the top players in the science fiction field; he was a celebrity to fans of science fiction, horror, and fantasy. *The Martian Chronicles* and *The Illustrated Man*—thanks in large part to healthy paperback sales—had sold respectably. Ray's first book of mixed fiction, *The Golden Apples of the Sun,* had received more reviews than all of his previous three books combined. And the reviews were largely glowing. The *New York Times* stated, "He writes in a style that seems to have been nourished on poets and fabulists of the Irish Literary Renaissance. And he is wonderfully adept at getting to the heart of his story without talking all day long about it and around it."

In Bradbury, publisher Ian Ballantine recognized the potential for much more. Ballantine wanted Ray Bradbury to write a book for his company—a company that would break new ground in publishing by offering, simultaneously, both paperback and hardcover books. After discussions, in late 1952, Ray signed with Ballantine to write a collection that would include the novella "The Fireman," to be rewritten with an additional 25,000 words. All parties involved agreed that the story could be elaborated on. The advance for this new book was five thousand dollars. Though his stature as an American writer had grown dramatically, Ray was still financially strapped, and the advance from Ballantine was welcome.

By now, the two Bradbury girls, Susan and Ramona, were aged three and two, respectively. Full of toddler energy, they liked to romp about the three-bedroom home on Clarkson Road and play in the backyard, where there was a man-made pond. The girls especially adored watching the tadpoles in the pond, and inside the garage, which Ray had finally converted into an office, Ray tried to work as the girls called to him from outside the window. The girls threw pebbles at the garage window and their father giggled as he typed. A playful man, easily distracted and ever the child at heart, Ray could hardly ignore the pleas of his kids, so he almost always gave in and ran outside to play. But he had a book to write, and he needed a real office. However, with a meager annual income and monthly mortgage payments, the Bradburys could ill afford it. In addition, they had bought a dishwasher and a dining-room

set on installment. When Ray Bradbury opened the first dishwasher bill and saw the amount going to interest, he was alarmed and swore to finish the payments quickly. So, he again returned to UCLA, this time to finish his book for Ballantine.

Another round of days and dimes ensued. Ray Bradbury joined the typists in the typewriter rental room to add 25,000 new words to "The Fireman." In revising his novella, he knew he had to consult his original story, "The Fireman," but at the same time, he didn't want to overintellectualize his approach to writing; it ran counter to his usual style.

"I feared for refiring the book and rebaking the characters," noted Ray. "I am a passionate, not intellectual writer, which means my characters must plunge ahead of me to live the story. If my intellect caught up with them too swiftly, the whole adventure might mire down in self-doubt and endless mind play."

Despite these concerns, Ray Bradbury was determined to turn "The Fireman" into a short novel. However, the story would be just a centerpiece, surrounded by other stories, to adhere to his agreement with Doubleday.

As he wrote the book, he determined not to consult the original story. "I just let the characters talk to me," he said, remembering his first hours writing *Fahrenheit 451* and invoking the age-old writer's cliché. "I didn't write *Fahrenheit 451,* it wrote me." The plot line was still the same, the characters still in place: Fireman Montag; his pill-popping wife, Mildred; Clarisse McClellan who told Montag about the power of the books that he burned each night. There were some minor changes: Fire Chief Leahy became Fire Chief Beatty, certain scenes were tossed out, others were fleshed out, the language waxed more poetic, and the story expanded as Ray wrote. Additionally, he hyped up the fire and sun symbolism. Once again, in just nine days, he finished, this time producing the first draft of the book.

In January 1953, Ray returned to his garage office to revise the draft. He was still without a title for the book; he sought a particularly powerful, symbolic title. On the afternoon of January 22, as sunlight streamed in through the garage windows, he had a revelation.

"I decided I might well use the temperature at which book paper catches fire," Ray recalled. "I telephoned the chemistry department at

several universities and found no one who could tell me the right temperature. I made inquiries, also, of several physics professors.

"Then, still ignorant, I slapped my forehead and muttered, 'Fool! Why not ask the fire department!'"

After a quick phone call to the downtown Los Angeles firehouse, Ray Bradbury had his answer: The temperature at which books burn is 451 degrees Fahrenheit. "I never bothered to check to see if that was right," Ray said, with a laugh, many years later. "The fireman told me that book paper ignited at 451 degrees Fahrenheit. I reversed it to *Fahrenheit 451* because I liked the sound of it."

While he was obsessively cleaning and polishing *Fahrenheit 451,* the editors of the eminent magazine *The Nation* contacted Ray. As science fiction gained global prominence and popularity, the genre was also drawing detractors, and Ray was asked to write an article in defense of the field. The editors asked Ray to explain why he wrote science fiction. The resulting article, titled "Day After Tomorrow: Why Science Fiction?," was published in *The Nation* in May 1953.

In June, Ray opened his mailbox to find a letter addressed in a spidery handwriting from B. Berenson, I Tatti, Settignano, Italia.

Ray turned to Maggie.

"Good Lord," Ray said. "This can't be from *the* Berenson, can it?"

"For God's sake," said Maggie. "Open it!"

Ray tore open the envelope and unfolded the letter. Indeed, the note, dated May 29, 1953, was from renowned Renaissance scholar and author Bernard Berenson. The nearly illegible handwriting was ornate and spindly, and written on the stationery of the Italian hotel Grand Hôtel Des Etrangers. It was, in Berenson's words, his "first fan letter," written in reaction to Ray's article "Day After Tomorrow" in *The Nation.* ". . . It is the first time I have encountered the statement by an artist in any field, that to work creatively he must put flesh into it, and enjoy it as a lark, or as a fascinating adventure. How different from the workers in the heavy industry much professional writing has become! If you ever touch Florence come to see me."

Ray and Maggie were delighted, if not flabbergasted. It was a most unlikely fan letter, from an eminent intellectual and an esteemed scholar of the arts. "The letter terrified me," said Ray. The words "come

to see me" rang in his head. Come to see me. But it was impossible. There was no money for travel and certainly no money for Europe.

Ray recalled watching a film with Maggie and "looking at far places—Rome and Paris and London and Egypt—with tears streaming down my cheeks. I turned to my wife and said, 'My God, when will we ever have enough money to travel [to] all these far, wonderful places?'"

Not only did the Bradburys have no money to travel and meet Berenson, but if they did, what would Ray say to a man of such stature? He had felt the same when Gerald Heard and Aldous Huxley invited him for tea. "And so I put off writing Berenson," said Ray.

Ray continued working on *Fahrenheit 451*. The book was set for publication in October, and by mid-June, Ray was still toiling away. He sent the first half of the unfinished manuscript to Ballantine's editor in chief, Stanley Kauffmann, who acted as Ray's editor on the novel. The two agreed that Kauffmann would travel to Los Angeles in August to review the proofs with Ray. "We did that," said Kauffmann, "so Ray would have a final deadline and so that he wouldn't continue to polish it forever." After nearly fifty years, Kauffmann's memory of the editing process was blurry, but he was adamant about one thing: "Every single word in *Fahrenheit 451* is Ray Bradbury's."

After Ray posted the unfinished manuscript to New York on June 15, Kauffmann recalled making some structural changes and suggested shifting some scenes, with which Ray agreed. Ray continued to send pages to his editor throughout the summer, and, as promised, Kauffmann flew to Los Angeles on August 10 with the typeset proofs of the book in hand.

Despite the anti-McCarthy sentiment of the book, Kauffmann claimed he was unaware of what he had on his hands. "None of us at Ballantine had any idea how political the book was," remembered Kauffmann. "You must recall, World War Two had just ended and we all thought the story was a response to Hitler."

Kauffmann stayed in a hotel on Wilshire Boulevard about a mile from the Bradbury home, and he and Ray spent long days in the hotel room editing the proofs of *Fahrenheit 451*. There, Ray paced back and forth anxiously. "Ray's attention span has always been short," said

Maggie Bradbury, citing *Fahrenheit 451* as her personal favorite of her husband's canon. "So when it came time to edit proofs, it drove him crazy because he had to do it; he had no choice if he wanted the book to get published."

Kauffmann remembered one more detail: Ray was constantly asking him to go out for ice cream—his one lifelong vice. "Some people are addicted to cocaine. Others choose marijuana. Ray is addicted to ice cream," said Maggie dryly.

Kauffmann and Ray walked to a nearby soda fountain at least once, sometimes several times, a day. "I've never eaten more ice cream in my entire life," Kauffmann exclaimed. By the end of the week, after strenuous work and many pints of vanilla, the editing process was complete and *Fahrenheit 451* was done. "We knew it was brilliant," remembered Kauffmann, "but we had no idea what it would become."

In mid-August 1953, Kauffmann flew back to New York City; in his luggage was a classic. To fulfill his agreement with Doubleday that the book be a collection rather than a novel, the first edition of *Fahrenheit 451* included two additional short stories—"The Playground" and "And the Rock Cried Out." (The original plan was to include eight stories plus *Fahrenheit 451,* but Ray didn't have time to revise all the tales.) "The Playground" and "And the Rock Cried Out" were removed in much later printings; in the meantime, Ray had met his contractual obligation with the first edition. *Fahrenheit 451* was a short novel, but it was also a part of a collection.

Upon its publication on October 19, 1953, *Fahrenheit 451* earned high praise from critics across the nation. Noted *New York Times* critic Orville Prescott lauded the book: "Mr. Bradbury's account of this insane world, which bears many alarming resemblances to our own, is fascinating. His story of the revolt of his fireman, who refused to burn any more books and actually wanted to read them, is engrossing. Some of his imaginative tricks are startling and ingenious. But his basic message is a plea for direct, personal experience rather than perpetual, synthetic entertainment; for individual thought, action and responsibility; for the great tradition of independent thinking and artistic achievement symbolized in books."

Though not immediately, *Fahrenheit 451* went on to be Ray's best-selling book. The first hardcover printing was 4,250 copies, while 250,000 paperback copies were simultaneously released. Sales were steady over the decades, gradually building as the book gained cultural prominence. By the end of the 1980s, the novel was in its seventy-ninth printing, with four and a half million copies in print. "I could retire on the royalties of that one book alone," Ray revealed in a 2002 interview. Beyond its enduring sales figures (both Ray and Don Congdon contended that they were unaware of the total worldwide sales of *Fahrenheit 451*, and added that sales numbers were unimportant), *Fahrenheit 451*, perhaps more than any other Bradbury title, has become a literary classic. It is comfortably couched next to other dystopian masterworks, such as Orwell's *1984* and Huxley's *Brave New World*. And it is just as easily situated on high school reading lists alongside Hemingway, Faulkner, Harper Lee, and F. Scott Fitzgerald.

While Ray Bradbury has always considered himself a fantasy writer rather than a science fiction author ("Science fiction," Ray stated, "is the art of the possible. Fantasy is the art of the impossible"), *Fahrenheit 451* helped establish its author as a visionary. A half century after it was written, it may be seen that Ray's impassioned story of social commentary predicted much of the future in striking detail. Certainly, the book's main book-burning premise is pure Bradburian metaphor—that is, a rendering of an imagined world that explores problems vexing our own. Ray succeeded in addressing Hitler's wave of book burnings during the Second World War, while at the same time examining the growing rash of censorship on the home front led by Senator Joseph McCarthy and the House Un-American Activities Committee. But some of the uncanny details of *Fahrenheit 451* suggest that Ray had somehow looked into a crystal ball and seen the future. The book predicts, among other things, society's reliance upon television, plasma-screen wall televisions, the invention of stereo headphones (the seashell radio has long been rumored to be the inspiration behind the invention of the Sony Walkman), and even live media coverage of sensationalistic news events. *Fahrenheit 451*'s climactic finale, in which the story's hero, Guy Montag, is being chased by media helicopters as the event is broadcast into millions of

homes, was an eerie precursor to the real-life events surrounding O. J. Simpson and the now-infamous slow-speed Ford Bronco chase on a Los Angeles freeway.

The monumental week Ray finished *Fahrenheit 451,* he heard that John Huston was in Los Angeles for a brief visit. Since his dinner meeting with the film director two and a half years earlier in February 1951, the two men had exchanged more than just cordial pleasantries. Huston had made it quite clear that he wanted to work with Ray and that he would consider adapting *The Martian Chronicles* for the screen. Ray was hopeful that while Huston was in Los Angeles the director would contact him, perhaps even with a firm offer to write a screenplay. However, with each passing day, Huston neither called nor sent a postcard, and Ray grew more discouraged.

On Tuesday, August 18, feeling restless, Ray decided to visit one of his favorite bookstores, Acres of Books in Long Beach, with Ray Harryhausen. As usual, the two childhood chums were looking for dinosaur books. It was a pleasant reprieve for Ray, who was spent from his last-minute work on *Fahrenheit 451* and the subsequent days of fervently hoping for a message from Huston. That evening, after Harryhausen drove him home, Ray learned that his wait was over. Maggie had taken a message from John Huston: Ray was to call him the next morning before 10:30.

The next morning, Ray phoned John Huston and plans were made to meet that evening for cocktails at a suite at the Beverly Hills Hotel, where Huston was staying. Recounting the fateful meeting was one of Ray Bradbury's favorite stories to tell. In fact, over the years, he had recalled the events of the meeting with scripted precision, and when he told the story, Ray always donned a gruff baritone when imitating John Huston. "I walked into his room. He put a drink in my hand. He sat me down and he leaned over and said, 'Ray, what are you doing during the next year?'

"I said, 'Not much, Mr. Huston. Not much.' And he said, 'Well, Ray, how would you like to come live in Ireland and write the screenplay of *Moby-Dick*?' And I said, 'Gee, Mr. Huston, I've never been able to read the damn thing.'

"He'd never heard that before and he thought for a moment and then said, 'Well, I'll tell you what, Ray. Why don't you go home tonight, read as much as you can, and come back tomorrow and tell me if you'll help me kill a white whale.'"

Stunned, Ray left the hotel. "Later," Ray said, "when John Huston described the moment when he made the offer to me, he said my jaw dropped ten feet to the floor." On his way home, Ray stopped in a bookstore to buy a copy of *Moby-Dick,* though he already owned the book. His edition was unwieldy and slip-cased, and Ray wanted a smaller, more portable copy. In the bookstore, he mentioned to someone in the shop, possibly a clerk, that he had been offered the job to go to Ireland and write the screenplay based on *Moby-Dick* for John Huston. A woman browsing in the shop overheard Ray and approached him.

"Don't go on the trip," she said adamantly.

Ray was completely taken aback. "Why?"

"Because he is a son of a bitch."

The woman was screenwriter Peter Viertel's estranged wife, Jigee. Viertel had known John Huston since childhood and was Huston's co-writer on the 1949 film *We Were Strangers;* Viertel had also worked as an uncredited script doctor on the Huston film *The African Queen.* "John Huston will destroy you if you go on that trip," she warned Ray, and identified herself.

Surprised, Ray pondered his response. "Well," he said finally, and perhaps too cavalierly, "he's never met anyone quite like me. Maybe I'm different. Maybe he won't try to destroy me. I'll make do."

With that, Ray left the bookstore and headed home.

"I went home that night," Ray fondly recalled, "and I said to my wife, 'Pray for me.' She said, 'Why?' I said, 'Because I've got to read a book tonight and do a book report tomorrow.'"

Ray was nervous. Of course he wanted to accept Huston's offer. But Herman Melville's book was infamously daunting, and Ray wanted to make certain he was up to the task. He hunkered down in his living room and read all night, but instead of reading from beginning to end, he leapfrogged through it, diving into the middle of the book, skipping to a chapter here, a passage there, absorbing the metaphorical components of the

Melville classic. "It's an ocean of fantastic bits and pieces," said Ray, in a 1972 interview. "It's Shakespearean pageant with flags and pennants and fleets of ships and whales. One minute you're examining the various colors of nightmare, panics, terrors, and the next you're studying whiteness. The whiteness of the Arctic and the Antarctic, the things born beneath the sea, that surface without eyes, and on and on. I finally got back to the scene where Ahab is at the rail, saying, 'It's a mild-looking day and a mild-looking sky and the wind smells as if it blew from the shadow of the Andes where the mowers have lain down their scythes,' and I turned back to the beginning and read, 'Call me Ishmael,' and I was hooked!"

The next day, over lunch at the Beverly Hills Hotel, Ray enthusiastically accepted John Huston's offer. For Huston, it was a gutsy move to ask Ray Bradbury to adapt this monumental piece of nineteenth-century literature for the screen. It would be a Herculean task. And Huston had offered it to a man whose reputation had been made on rocket ships, tattooed freaks, vampires, and dinosaurs. In fact, though, it was Ray's lifelong love of dinosaurs that landed him the job. When Ray had sent a copy of *The Golden Apples of the Sun* to John Huston, the film director opened the book and read the first story, "The Fog Horn," which had appeared in the *Saturday Evening Post* under the title "The Beast from 20,000 Fathoms."

"I had read a number of short stories by Ray Bradbury," Huston wrote in his 1980 autobiography, *Open Book,* "and saw something of Melville's elusive quality in his work. Ray had indicated that he would like to collaborate with me, so when it came time to do the screenplay, I asked him to join me in Ireland."

It was a staggering week for Ray Bradbury. No sooner had he finished work on *Fahrenheit 451* than Huston called with the offer to write the screenplay for *Moby-Dick*. But there was little time to celebrate. Huston wanted Ray, along with Maggie, Susan, and Ramona, in Ireland in three weeks. The problem was that Ray would not fly; instead, he would travel to Europe by boat.

Ray's contract for the film work on *Moby-Dick* was drafted on September 2, 1953. He would be paid $12,500 for the screenplay; six hundred a week for seventeen weeks, and an additional two hundred a week for expenses. He and his family would be put up in a Dublin hotel. Ray's parents, Leonard and Esther, who now lived in an apartment five min-

utes from the Bradbury house on Clarkson Road, offered to house-sit
while Ray, Maggie, and the kids were overseas.

Before the Bradburys' departure, Ray's father, Leo, stopped by the
house to say good-bye. Leo Bradbury had aged gracefully. At sixty-three,
he was still svelte, with silver hair combed straight back and perfectly
bronzed skin, a result of his afternoon passion—18 holes of golf. He and
his wife had never been particularly emotional parents to Ray and Skip;
after all, they were products of a more staid generation, but they loved
their boys in their own quiet way.

So it was a sentimental moment when Leo said good-bye to Ray. Leo
was carrying something small in his hand, and as his fingers opened, Ray
recognized it immediately. It was a gold pocketwatch that had belonged
to Leo's father, Ray's beloved grandfather, Samuel Hinkston Bradbury. It
had a round, white face bearing Roman numerals and in the middle of
the dial were the words "Waukegan, Illinois." "I want you to have this,"
Leo said, placing the watch in his son's hand.

"I looked in my dad's eyes," Ray recalled, "and they were filled with
tears and I suddenly realized, he was going to miss me." It was a quiet,
loving moment between father and son. In a matter of days, Ray and
Maggie and their children would be across the Atlantic, where they
would stay for more than half a year.

19

THE WHITE WHALE

*I have been in awe of Ray Bradbury ever since my brother intro-
duced me to his books when I was a young boy. I remember distinctly the joy of
reading* Fahrenheit 451 *and* The Martian Chronicles *at that time in my life. In
1973, I had the pleasure of doing one of his plays,* The Wonderful Ice Cream
Suit, *a production that turned out to be a major touchstone for my career. The cir-*

cle completed itself when twenty-five years later I was able to reprise my role of Gomez in that piece for our filming of Ice Cream Suit *for Disney. My idol as an author had now become a friend and an associate. Of all the joys my career has afforded me, my relation to Ray Bradbury will stand as one of the most shining aspects of it.*

—JOE MANTEGNA, *actor*

ON SATURDAY, September 12, 1953, Ray, Maggie, and their two girls, Susan and Ramona, boarded a Union Pacific train bound for New York City. Joining them was a young woman, twenty-five-year-old Regina Ferguson, Susan's preschool teacher in Los Angeles, whom Ray and Maggie had asked to be the girls' nanny for the trip to Europe. Eager for change, Ferguson readily accepted. "It took me all of about an hour and a half to make the decision," she recalled.

So the five set off on their European adventure. As the train cut through Utah, Ray wrote the opening scene of the film *Moby Dick*. He was exhilarated. After sending his books to John Huston over the last few years, and exchanging letters with him, they were at long last working on a motion picture together. Two days later, the train arrived at Chicago's Union Station. Maggie took advantage of the Chicago stop-off to remedy a major packing faux pas. "We forgot to pack diapers for Ramona," Maggie recalled with a laugh, "so we all walked to the Marshall Field's department store on State Street to buy a fresh supply." The Bradbury family also visited Ray's favorite museum, the Art Institute of Chicago; Ray had always loved the 1884 Georges Seurat impressionistic piece *A Sunday on La Grande Jatte*.

With disaster narrowly averted and a quick afternoon visit to the art museum, the Bradburys returned to the train and continued the journey eastward. When they arrived in New York City, they checked into the Plaza Hotel. That evening, Ray and Maggie joined Ray's publisher, Ian Ballantine, and his wife, Betty, along with editor Stanley Kauffmann, at Don Congdon's Brooklyn apartment for a celebratory dinner to mark the completion of *Fahrenheit 451* and to toast Ray's new cinematic en-

deavor. While they were in New York, the family also did some sightseeing. Watching his girls' excitement as they had their first glimpse of the Statue of Liberty, and knowing that he'd provided this trip for his family, Ray felt that his hard work was finally yielding dividends.

Two days later, they left for Europe. The Bradburys boarded the SS *United States,* a five-star, 990-foot luxury liner that had made its maiden voyage a year earlier; at the time, it was the fastest ocean liner in the world. The family stayed in two second-class cabins, one for Ray and Maggie and one for Regina and the girls. The ship was bound for Le Havre, France, where the Bradburys would then travel by rail to Paris to meet up with John Huston before heading to London and then, finally, to Ireland.

One day during the Atlantic voyage, the skies darkened, the seas turned rough, vast green swells rose and fell, and the ship heaved with the waves. The SS *United States* was headed straight into a hurricane. Regina Ferguson had been on ships before, but this was something else altogether. She feared for her life. Maggie and the girls were fine thus far, but Ray was on the edge of nausea. "It was a very strong storm," recalled Ferguson. "There were sixty- or seventy-mile-per-hour winds. The first night, a steward came into the room and put pillows along the side of the mattresses where the children were so, as the ship went from side to side, they wouldn't fall out. He told me to take everything off the dressertop. It was a godawful storm."

"There were lots of bumps and bruises," among the 1,500 aboard, reported the ship's surgeon, Dr. John E. Sheedy. The master of the *United States,* Commodore John Anderson, held the stately ship steady; even through the mountainous swells, the *United States* did not take on any water.

Ever one to put a positive spin on a dire situation, Ray looked at the tumultuous start to their voyage as the perfect occasion to reread *Moby-Dick,* the story of obsession and vengeance on the high seas. Ray curled up with the book on the ship's afterdeck and began devouring it, and with each passing page, he was more and more convinced of its power. It was a book of pure metaphor, which excited him, since this was how he viewed his own work. It was also a book, as Ray put it, "with two mid-

wives—Shakespeare and the Old Testament." After years of self-education in the library, Ray was more than well versed in both. "My midwives were also Shakespeare and the Old Testament—along with dinosaurs," he proclaimed.

Ray finished rereading the book at three in the morning in the midst of the hurricane. "There was no better way to read it," he said. In the coming months, he would read the Melville classic at least eight more times.

As the ship powered east, the hurricane grew in strength, lasting three days without reprieve. By the time the skies cleared, the SS *United States* arrived at port in Le Havre, France, on September 22, 1953. There, the Bradbury family caught a train to Paris. It was late afternoon when the passenger train arrived in the city, and Paris shone in the golden light of the setting sun. With his face pressed up to the window, Ray stared out. He had, at long last, made it to Paris. He cried.

"Looking out the window," remembered Ray, "and seeing Sacré Coeur for the first time, oh God! I was in Paris. As I looked out the window, there were men on bicycles riding by with big loaves of bread under their arms. How French! It was right out of the movies. The whole landscape, everything about Paris in those days was right out of the movies."

Ray, Maggie, the girls, and Regina checked into the Hôtel St. James D'Albany, and that evening, Ray and Maggie strolled the streets, hand in hand, through a light rain. In five days, they would celebrate their fifth wedding anniversary. It was a moment he wished to cherish forever. In the decades to follow, Paris, the City of Lights, would become the favorite vacation destination for Ray and Maggie. They both adored the city, its art, opera, food, and wine. In the 2000 essay "Beautiful Bad Weather," Ray wrote about his love affair with the city, his frequent visits there with Maggie, and taking long strolls in the rain. Together, Ray and Maggie Bradbury would visit Paris twenty times, and each time would fall ever more enamored with their adopted hometown.

A few days later, John Huston arrived. Ray and Huston walked along the Champs-Elysées and discussed the work that lay ahead. "The first thing I learned," said Ray, "was that John didn't know any more about *Moby-Dick* than I did. It was the blind leading the blind." Ray was eager to please his hero, but he was uncertain about the kind of script Huston

envisioned. "I asked John, 'Do you want the Melville Society's version of *Moby-Dick,* or the Jungian version, or the Freudian version?' And John looked at me and said, 'I want Ray Bradbury's version.'" This instantly put Ray at ease. Huston, agreeable and respectful, agreed to let Ray write the first fifty pages of the script without seeing any of it.

That evening, Ray dined with Huston, writer Art Buchwald, actress Suzanne Flon, and writer Peter Viertel (whose estranged wife had warned Ray to turn down the offer to write the *Moby Dick* screenplay), along with several others. As she often did, Maggie opted out of the social gathering. She was the introvert, the quiet one, satisfied with staying behind and reading a book (and curling up with her cats when she was home), and sipping wine. Her husband, on the other hand, was gregarious, a talker, a man who fed on the energy of crowds. Much later in life, Ray lamented how much Maggie missed. But had they both been wildly bombastic and extroverted, the marriage very likely would have imploded.

THE BRADBURYS left Paris and headed to London, following Huston, who was traveling there to take care of last-minute details for his latest film, *Beat the Devil.* By sheer coincidence, it was the same week that *The Beast from 20,000 Fathoms* was opening in London. While there, Ray happened upon a theater in Piccadilly Circus. Posters advertising the film were plastered all over the front of the movie house. Ray had already seen the film, months earlier, at its premiere in Los Angeles. It was a campy 1950s B movie, fun and innocuous, with noteworthy Ray Harryhausen effects, but it was little more than kitsch. It was a film that Ray had nothing to do with, except that it had been loosely based on his story of the same name; one scene in particular, in which the dinosaur lumbered up from the depths of the sea and destroyed the lighthouse, had been pulled intact from his short story. As Ray stood in Piccadilly Circus, he was shocked to see his name prominently displayed on the posters and lobby cards. He was panic-stricken. What if Huston saw it?

Ray was worried Huston would think he had hired a mere B-grade sci-fi scribe to adapt what many deemed the great American novel. Ray knew that Huston hired him because he believed he was a worthy writer, but in his heart of hearts he also understood that a part of Huston's decision to hire him was born of sheer perversion. Huston reveled in the shock value of having hired a writer who had made his name in the fantasy and science fiction pulp magazines, and whom he had charged with adapting Herman Melville's great *Moby-Dick*. Fortunately, Huston never mentioned that he had seen the ads. Ray's fears were unfounded.

While the Bradburys were in London, Huston invited Ray to Elstree Studio for a screening of *Beat the Devil*, which starred Humphrey Bogart, Jennifer Jones, and Gina Lollobrigida. From the beginning, production on *Beat the Devil* had been troubled. Peter Viertel and Tony Veiller had written the original draft of the screenplay, an adaptation of the Claud Cockburn novel (written under the pseudonym James Kelvick). But the writers had a terrible time adapting the story. Struggling with the plot, they turned to Huston for guidance. But Huston, Viertel felt, was preoccupied with another project—*Moby-Dick*. "Left to our devices," said Viertel, "Veiller and I worked relentlessly on the Cockburn story, but the longer we persisted in our efforts, the more apparent it became to us that the material was flimsy despite its bright dialogue."

The screenplay they presented Huston was not up to his standards, and he threatened to scrap the project. Frustrated, Viertel and Veiller resigned. Luckily for Huston, he was able to bring in author Truman Capote, who happened to be in Rome at the time, to write a new script; coincidentally, shooting was to take place in Rome. Yet even with the last-minute heroics of the twenty-eight-year-old Capote, *Beat the Devil* was a failure for John Huston. After the Elstree screening, Ray went to the theater rest room and stood at the urinals side by side with director William Wyler and Peter Viertel, who had remained friends with Huston. No one said a thing. The film was dreadful.

Days later, the Bradburys traveled by overnight train from London to the town of Fishguard, Wales. As the train sped through the dark and unfamiliar countryside, the Bradbury girls prepared for bed. Outside, it was snowing, and Susan and Ramona peered through a window, which was broken, and watched the snowflakes. Never having seen snow in

Southern California, the girls were alarmed. "There was snow every-where," recalled Susan years later. "It was so bloody cold that we all slept in our clothes and our overcoats that night."

After arriving in Fishguard, they boarded a ferry for the final leg of the trip to Dublin. At customs, the agents searched Ray's luggage and pulled out his copy of *Moby-Dick*. In the midst of a political crackdown, Ireland had banned certain books, and Meville's masterpiece was one of them. Ray was unaware of this ban, and he found it terribly ironic, given the fact that he was in Ireland to adapt the book into a screenplay, and that he had just finished writing *Fahrenheit 451*, an anticensorship novel. After a brief holdup and an explanation of why he was carrying *Moby-Dick*, the customs agents moved Ray and his family along. Ray was allowed to keep his book.

In Dublin, the Bradburys checked into the old yet opulent Royal Hibernian Hotel on Dawson Street and were given two rooms. Ray and Maggie's room—number 77—had a fireplace, and in this room Ray would do much of his work on the screenplay. Regina and the girls were placed in a separate room, with a coin-operated heater into which Regina continually fed money to keep the room warm. Regina Ferguson was the ideal nanny; she was attentive and patient with the nearly four-year-old Susan and two-year-old Ramona, nicknamed "Monie." "I was really very fond of the kids," Ferguson recalled, decades later. "I loved Susan and I adored Ramona." Ferguson's recollections of Ray Bradbury, the young father, were equally fond. "He was a super dad. The kids just adored him. He was just a lovely man. He was kind and compassionate, sort of a spiritual hemophiliac. He was very gentle and very thoughtful."

From the lift operator to the hotel manager, the staff of the Royal Hibernian Hotel treated the Bradburys as family. Exhausted from travel, the Bradburys planned on relaxing their first day in Dublin. But as Ray was reading the *Irish Times*, he discovered this ad: TODAY, ONE DAY ONLY—STAN LAUREL AND OLIVER HARDY. The famous comedy duo was making a rare appearance that night at the Olympia Theatre in a benefit show for Irish orphans. While Maggie, Regina, and the girls rested, Ray went to the Olympia and bought the last available ticket. His seat was front-row center.

That night, Ray felt as if he was fourteen again. "When the curtain

went up," he recalled, "Stan and Ollie did all their great routines. When it was over, I went backstage, and I stood by their dressing room door and I watched all their friends going in and out. I didn't bother them. I didn't introduce myself. I just wanted to be in their ambience."

Ray and his family settled into their new home at the Royal Hibernian. Soon after, he joined John Huston and his wife, Ricki, for dinner at their rented manor house in the countryside. Over dinner, Ray made his first script suggestion to Huston, to remove Melville's Parcee Fedallah character from the film. Ray deemed the character unnecessary, and, instead, wanted to give Fedallah's good lines to Ahab. Huston wholeheartedly concurred. But from that point on, the dinner degenerated rapidly. The subject of Spain came up, and Huston's young and beautiful wife stiffened. Huston raved about Spain—the bullfights and Hemingway, the colorful cities, the wonderful people. Huston explained that he and Ricki had visited Spain a month earlier when a little mishap occurred. When Huston mentioned this, Ricki stood up. Huston told his wife to sit down, to tell the story to Ray. Puzzled, Ray sensed a palpable tension in the room. Ricki dutifully sat. They had been crossing the border by automobile, she said, when a Spaniard without proper papers pleaded with them to smuggle him across the border. Spain's political climate was volatile, and Huston wanted to assist the man. But Ricki protested. It was illegal to smuggle someone out of the country. What if they were caught? She had children to worry about and could not risk landing in jail.

"Very simply," said Huston to Ricki, "you were a coward."

Ricki protested, but Huston refused to back down. Ricki said they would have been breaking the law, and Huston upbraided her for being a coward. The director then turned to Ray. "Wouldn't you hate to have a wife who's yellow, Ray?" Of course, Ray could hardly reply. Sympathizing with Ricki and horribly uncomfortable, Ray looked at her. Her eyes were welling with tears.

John Huston and Enrica Soma had married less than three years earlier, after Ricki had become pregnant with their son, Walter Anthony. Huston was married at the time to his third wife, actress Evelyn Keyes. He filed for a hasty divorce and, one day after receiving the decree, married the seven-months-pregnant Ricki. She was nineteen years of age to his forty-three.

With Ricki in tears, Ray sat saucer-eyed and appalled, naïvely as-
suming that Huston's malicious behavior indicated some sort of marital
strife. Huston would never zero in on him like that, would he? In 1992,
thirty-nine years after the fact, Ray would finally document the entire
Huston/*Moby Dick* melodrama in the book *Green Shadows, White
Whale*. But then, as John Huston was belittling his wife, Ray had no idea
of what was to come. He could only hope that Huston's mean-spirited
machismo would never be turned in his direction.

IRELAND. JOHN Huston had fallen in love with the cold, rugged land-
scape and the kindhearted people. A tall, tough man, Huston was a
sportsman—a prize-winning boxer, an amateur bullfighter, a globe-
trotting big-game hunter, a reputed womanizer. Lately, Huston had been
charmed by the ritual of the Irish foxhunt. "I had hunted the fox in the
States," he said in his 1980 autobiography, "in England and on the Con-
tinent, but Irish hunting came as a new and joyful experience. It had lit-
tle of the formality of the other hunts. You heard laughter and shouting
as the hunt went on; there was a festive feeling about it all. Everyone was
in high spirits."

Seduced by the allure and magic of the Emerald Isle, Huston had,
earlier in the year, rented an old, spacious country house near the town
of Kilcock, in County Kildare. Called Courtown, the gray-stone house
came replete with a staff of servants and sat on a patchwork quilt of
green—three hundred acres of meadow and forest, and, as Ray said, be-
yond that "more meadow and more forest." In the coming months, Ray
took many cab trips from Dublin to Courtown, a thirty-mile ride through
the lush Irish countryside, to discuss the screenplay's outline and
progress with the director. The reason Ray had been summoned to Ire-
land to work on a screenplay for a film that was to be shot largely in the
Canary Islands was so Huston could make the foxhunting season.

Ray found the first weeks of writing the screenplay nerve-wracking
and the novel almost insurmountable. He read passages over and over,

some hundreds of times. He worked twelve-hour days, seven days a week, which was foreign for Ray, who had always worked on multiple projects simultaneously, to skirt boredom and frustration. Once he began the *Moby Dick* screenplay, it was all white whale, all Ireland, all John Huston. He had no time for creative respite. In his limited free time, Ray occasionally accompanied Huston to the horse-racing tracks, another world foreign to Ray. Sometimes, he would catch an occasional movie, take weekend walks with his family in the countryside, or down a pint of Guinness at Heeber Finn's Pub in Kilcock. Ray and Maggie had met an American couple, Len Probst and his wife, Beth, and become friendly with them. Len was the head of the United Press International office in Dublin, and coincidentally was working on a story about John Huston. The two couples met once a week for dinner. But these joyful moments were fleeting. Ray was consumed by two towering American icons: Herman Melville and John Huston.

Making matters more grim, there was no autumn in Ireland. The days turned short and gray; the weather turned cold, damp, and dreary; and fog and rain descended upon Dublin. With each day, Ray sank further into depression, which he had never before battled. As a child, he had bouts of feeling blue, but those waves of emotion were nothing compared to his frame of mind in Ireland. "I was suicidal," he said, "for the first time in my life."

Maggie was helpless—she could do nothing except watch her husband sink deeper into the *Moby Dick*–induced doldrums. Ray was overwhelmed; mostly, he was beleaguered by the idea that he might disappoint his hero. What if Huston despised his work? What then? The pressure was nearly unbearable, and by early November, the moment arrived to present John Huston with the first fifty pages. Ray took the long, lonely cab ride out to Courtown.

When Ray arrived at the house, he put the pages in John Huston's hands. "John," Ray said, "if you don't like what you read here today, I want you to fire me. I want you to send me home. Because I will not take money under false pretenses."

"Okay, Ray," Huston said, holding the stack of pages in his rugged hands. "Go upstairs and lie down and take a nap while I read the script."

Ray was flabbergasted. Take a nap! "I was thinking to myself, 'You're

kidding! I'll go upstairs and roil around on the bed waiting for you to read the script.'" So Ray went upstairs and did just that. "I roiled around on the bed, waiting for word from him, because I meant it, I didn't want to go on working if it wasn't right."

Nearly an hour later, Ray heard Huston calling from the bottom of the staircase. Ray went to the top of the stairs and looked down. Huston was standing with drink in hand. "Ray," he said, "come down and finish the screenplay."

"I came down the stairs weeping," recalled Ray. "I so loved that man, I so loved that project. At that point, the burden was lifted from my shoulders. Up until then, I was suicidal. But after that day, it was gone."

Though Huston approved of the work Ray had given him, the director began preying on the young writer. Huston had a reputation as a vicious practical joker, and he loved a good laugh at another's expense. He had derided Ray for his fear of flying. At first, the jesting was gentle, but it soon turned malicious. Huston knew Ray desperately sought his acknowledgment and affirmation, and began ridiculing his screenwriter in public.

One afternoon Huston, Ray, and two of Huston's associates were in a cab, on the way to lunch, when Huston turned to one of his friends— a former assistant of Charlie Chaplin's—and said, "I don't think our friend Ray here has put his heart into writing the screenplay of *Moby Dick*."

"I sat there stunned, in the back of the cab," said Ray. He was mortified and could not understand why Huston would say such a thing. Did Huston really feel that way? When they arrived at the restaurant, Ray sat at the table, poking at his lunch, unable to speak, unable to eat a bite. In the meantime, John talked amiably with his friends, laughed, and enjoyed his lunch. Apparently, he had dropped the topic of Ray and the screenplay. "He noticed that I was quiet, but he didn't say anything," recalled Ray.

Later that afternoon at the Royal Hibernian Hotel, Ray and Huston sat down to discuss details of a scene Ray was tinkering with, and, as Ray remained rather quiet, Huston asked about his uncharacteristic silence.

"John," Ray said, "did you really mean it when you said that I wasn't

putting my heart into writing the script? That I didn't care?" The ever-emotional, easily wounded writer was on the verge of tears.

"Ray!" Huston chortled, putting his arm around his screenwriter. "Ray, I was only joking!"

Ray tried to laugh and disguise his hurt. But this episode marked the beginning of Huston's bad treatment of Ray. In the next months, their relationship grew ever more strained.

Maggie Bradbury, fiercely protective of her husband, did not approve of Huston's behavior or his attitude toward Ray. "He was weird," Maggie said, decades later. "And he took a strange attitude toward me." Maggie remembered one morning when she was breakfasting with Peter Viertel in the living room of Huston's home in Kilcock. "Peter was a very intelligent man, and one morning, we were having such fun talking, and Peter said, 'You know how John is always asking people what they're talking about? When he comes down the stairs today, I'll say "transcendentalism."' Well, a short time later, down the stairs comes John Huston. Peter and I were laughing and quieted down when Huston appeared." Maggie remembered that Huston instantly inquired, as if on cue: "What are you two talking about?" "Peter responded," Maggie recalled, "'Transcendentalism.' Well, Huston was no intellectual, he could tell a good story, but he was no intellectual: He asked Peter what transcendentalism was; Peter gave him some made-up answer, some rigmarole, and Huston said, 'Oh, I understand,' and walked away. Peter and I had a great laugh over that. Huston couldn't have understood it because Peter's explanation made no sense!"

By Christmas, Ray had written nearly a hundred pages of the screenplay. To celebrate the season, he and Maggie visited Courtown together. Huston had bought Ricki a new horse, a beautiful chestnut, as Ray and Maggie recalled, for Christmas, and all the holiday guests were outside admiring the horse, which had a wreath around its neck. To properly show off her husband's gift, Ricki climbed upon the horse, but no sooner was she in the saddle than the horse threw her off. As Ray and Maggie recalled the scene, Ricki Huston landed on her head. "The normal reaction to something like this," said Maggie, "is horror, and then to go see if you can help. You know what Huston said? 'Goddammit, Ricki! Get back on that horse! If you had done

what I'd told you, you wouldn't have been thrown.' He said it in that icy-cold voice."

"He didn't check her out first, to see if she was hurt," added Ray. "She could have broken her neck. She could have been killed."

Ray began seeing Huston in a new light, but just as Ray was thinking poorly of his hero, Huston ensnared him time and again with considerate words and encouragement. The two were such opposites: Huston was a gruff, macho, often mean-spirited man, while Ray Bradbury was acutely sensitive, easily brought to tears, and forever seeking love and attention.

Ray tried to be congenial and play along with Huston. For instance, when Huston told Ray that he had received an urgent telegram from studio head Jack Warner, insisting that a female love interest be inserted into the screenplay, Ray was livid and stomped around the room. He was attempting to remain as faithful to the tone and spirit of Melville as possible and to add a romantic female lead was absurd, but after Huston broke out in laughter and revealed it was another of his many gags, though Ray was still miffed, he laughed with Huston. By January, Maggie had had enough and asked to leave. She could not continue to stand by as Huston victimized her husband with his malicious humor, though she never confronted Huston, fearing that it could jeopardize her husband's position.

Wearied of witnessing the abuse and enduring Ireland's foul weather, Maggie told Ray she needed to leave with the girls and go somewhere warm. Ray suggested she phone a travel agency and ask them to pull out a map and locate the southernmost tip of Europe, and when Maggie complied, Ray booked them passage to Italy.

Even decades later, Maggie rarely ever discussed John Huston, and when she did, it was not with fondness. With Maggie and the girls gone, Ray was more vulnerable than ever to Huston's antics as he grappled with the rest of the *Moby Dick* screenplay. When the director found out that Ray was on his own, Huston actually worried for Ray; he knew that the sensitive writer would be lonely. Huston himself suffered from loneliness and constantly surrounded himself with people, so he recommended that Ray move out to the house at Kilcock. "Fortunately for me," said Ray, "I turned down John's offer."

In late January 1954, Ray assumed he was nearing the end of the script. But there was still much work to be done. "Huston very wisely, very prudently, very intelligently, hadn't told me the extent of the revisions that would be necessary," said Ray. "I give him credit for having good intuition on this sort of thing." Trying to bolster his spirits, Ray telephoned his family nearly every day, but he was exhausted and lonely. By March, Huston was ready to cast *Moby Dick,* and suggested to Ray that they relocate to London to finish the screenplay. However, Huston could not resist another perverse stab. He gave Ray two options: He could fly to England with him or stay in Dublin on his own. Again, Huston was preying on Ray's fear of flying. In response, Ray agreed to go to London, but not by air; instead, he would take the ferry across the Irish Sea, traveling at night and meeting Huston in the morning, prepared to work.

John Huston would have none of it and told Ray that if he did not get on an airplane, he could just stay in Ireland. Ray's nerves were fraying quickly. Peter Viertel advised Ray to let it slide and not fret. It was just another of Huston's vicious jokes. "John had a rough way of kidding," said Viertel. "[Ray] was much more naïve than the rest of us. Because he'd never been out of the States. But he was always very sweet, a little bewildered by working with John. John was difficult to work with for a writer. And they had their ups and downs.

"Huston was really a somewhat frustrated writer. He had always had his input to whatever script was being prepared, but writing didn't come easily to him. Doesn't come easy to me, or anybody, I guess, except for a few lucky guys. I think that his personality was so different than Ray's, and I think when you work closely with someone, there are always little tensions that come up," Viertel said, explaining the relationship between writer and director. "But John was very satisfied with Ray's adaptation for most of the time that they were together. I think, maybe, they were just together too much."

Taking Viertel's advice, Ray bought a ferry ticket, intending to head to London. On the day of his departure, Huston showed up at the Royal Hibernian Hotel and joined Ray with his friends Len and Beth Probst. "The subject of horses came up," said Ray, "and John asked Len Probst what he knew about them. When Len replied, 'I don't know anything

about horses,' John said, 'How can you be head of United Press here in Ireland and not know anything about horseflesh?' And Len had no answer."

To Huston, Ireland was horse country. He made Len Probst appear obtuse. "It was such a typical thing for John to insult Len in front of me. John was angry at me for not flying, so he made fun of Len," Ray mused.

The relationship between Ray and Huston was splintering by the day. When Ray arrived in London, Huston barely spoke to him. To John Huston, Ray Bradbury was blemished; he was not living according to the Hemingway code.

"This man," wrote Huston in his autobiography, "who sent people on exploratory flights to the distant stars, was terrified of airplanes. You could hardly coax him into a car."

After Ray was in London for a few days, John Huston turned more genial; they were just a few weeks away from a completed script. Huston also cast several parts for the film—Leo Genn as Starbuck, Robert Morley as Bildad, and surprisingly, Gregory Peck as Captain Ahab. Huston had originally hoped to cast his father, actor Walter Huston, as Ahab, but his father died in 1950. Later, Fredric March and Orson Welles were mentioned, and Ray suggested Laurence Olivier. Ultimately, Huston tapped Gregory Peck to play the one-legged sea captain. Huston and Warner Brothers liked Peck, but even the actor himself was bewildered by the casting. Author Gary Fishgall, in his biography of Peck, commented that "[w]hen Huston said he wanted him for Ahab, Peck was stunned; he really couldn't see himself in the role." Huston, however, had a proven track record with actors; if anyone could help Peck channel Ahab, it was John Huston.

In just a few more weeks, Ray would be done and could join his wife and girls in sunny Italy. One evening, Ray dined with Huston, Peter Viertel, Huston's assistant, Jack Clayton, and others, when Huston once again assailed Ray and his choice of friends. Huston brought up the subject of horses and insulted Ray's United Press friends. This time, Ray Bradbury did not humor Huston or remain silent.

"John," Ray said as Huston turned to face him. "Fuck you."

"What?" Huston asked.

"John, fuck you," Ray said once again. "You have very peculiar friends,

but I wouldn't dream of discussing your friends with anyone, and here you are in front of ten people here, insulting my friends at dinner. Fuck you."

No one spoke for a few moments. Ray rarely swore; in fact, he loathed the word "fuck." A part of him was actually pleased he had said it, but another was anxious of the repercussions. "Everyone froze," Ray said. "Here was this upstart cricket criticizing the lion in front of everyone."

Dinner was abruptly adjourned, and everyone stood up to leave. Outside the restaurant, after some scuffling and jostling, Huston grabbed Ray by the lapels, hoisting him in the air, and cocked his fist. Turning to Peter Viertel, Huston asked if he should let Ray have it.

"Yes, John," Ray said, hanging in the air. "Let me have it. But fire me first." Ray knew Huston would not fire him; John Huston needed him to finish the script. Huston lowered Ray to the pavement.

Distressed, Ray walked away toward his hotel. Viertel followed, attempting to calm him. They walked quite a distance that night, while Viertel once again assured Ray that Huston was merely joking. "Joking?" Ray said, tears streaming down his cheeks. "Look where we are now! Some joke!" The screenplay needed to be finished, and Ray was in no state to contemplate the remaining days working with Huston after the night's humiliating scene. Viertel assured Ray that he would talk with Huston and wangle an apology; he said that if Huston did not call the next morning, Ray should leave and head to Sicily to join Maggie and the kids.

The next morning, Huston's secretary phoned and apologized on behalf of her boss; she also invited Ray to Huston's hotel. Ray thought it over and went. When he met Huston, the director proffered his hand and asked if they could just forget the entire sordid affair and move on with their business; Huston also assured Ray it would never happen again.

THOUGH RAY was enduring some difficult days in Europe, back home, Ray's literary agent, Don Congdon, had heartening news. After months of hawking *Fahrenheit 451* serial rights to the magazine market, Congdon had succeeded. Although Ian Ballantine had published the book

without trepidation, as Congdon said, "because he was politically very liberal. He was a real Democrat," few magazines wanted to touch the scathing cultural commentary; the country was still gripped by McCarthy-era paranoia. Luckily, Don Congdon heard of a new magazine, run by a daring young editor from Chicago who was committed to pushing boundaries. The editor's name? Hugh Hefner.

Hugh Marston Hefner had much in common with Ray Bradbury. Both were Depression-era boys; both grew up in Illinois (Hefner was a born-and-bred Chicagoan). As children, both read comic books voraciously, watched movies incessantly, and read, with vigor, Arthur Conan Doyle, H. G. Wells, and Edgar Allan Poe. As adults, the two gravitated toward F. Scott Fitzgerald. And at one point in their young lives, each had also published his own fanzine.

When *Fahrenheit 451* was published in October 1953, Ray was in Ireland. Hefner read it and thought it a seamless fit for his new publication, *Playboy* magazine. "I felt that fiction had become increasingly character-driven rather than plot-driven," said Hefner, "so I was looking for plot-driven stories."

The first issue of *Playboy* was published in December 1953; forty-eight pages long, it featured a nude center-spread photograph of Marilyn Monroe. As Ray had done with *Fahrenheit 451,* Hefner had published his magazine in a censorship-driven culture. Readying the second issue of *Playboy* from his Chicago apartment, Hefner bought the fifty-thousand-word *Fahrenheit 451* for five hundred dollars. He planned on serializing it in *Playboy* issues 2, 3, and 4.

"The story seemed, of course, perfect for me," said Hefner, "coming as it did in fifty-three in a time of McCarthyism. That's what it was all about for me. *Fahrenheit 451.* The temperature at which book paper burns. What a perfect story for my fledgling magazine."

The second issue of *Playboy* appeared on newsstands in March 1954 as Ray was having a devil of a time with the devil himself, John Huston. "Finally," said Ray, "after seven months of hard work, a day of great passionate relaxation came to me. I got out of bed one morning in London, and I looked in the mirror and I said, 'I am Herman Melville!'" On April 14, 1954, Ray sat down at his typewriter and in eight hours wrote the final forty pages of the screenplay. After reading the pages, Huston told

Ray that the script was completed. Ray's last blaze of inspiration had produced his best work yet on the screenplay. Production on *Moby Dick* would begin that summer.

Practical jokes, bouts of tears, and street scuffles aside, Ray Bradbury and John Huston parted on good terms. The two men hugged and Ray thanked him for the singular experience. As Ray remembered it, "The last thing I said to John was, 'John, I'm so indebted to you for this opportunity to work on a screenplay that has changed my life, if you want, we'll put your name on the screenplay too.' John said, 'No, Ray, it's your screenplay.' I offered that to John because I was so filled with gratitude. He changed my life forever, and only for the better. Ever since, I never had to pick up the phone, looking for work."

Ray left London on April 16, 1954. He traveled by boat to Paris, then by train to Italy. While Ray's experience working on the script had proved thorny, complex, and vexing, he was done, and proud of his accomplishment. But Huston's problems were only just beginning. The director would later call the film "the most difficult picture I ever made." Frightful weather plagued the production; the crew wrestled endlessly and sometimes fruitlessly with the ninety-foot, thirty-ton mechanical whale; and Huston, it turned out, was a disappointment to some of the actors. Gregory Peck acknowledged that he would have liked more artistic guidance. "Huston was not that good with actors," Peck said. "When people were perfectly cast . . . he was great with them. But he was not very good at helping actors to find a performance."

Huston finished *Moby Dick* over budget; he was given three million dollars, but overshot it by one and a half million. Released on June 27, 1956, *Moby Dick* performed respectably at the box office, making more than five million dollars and placing ninth among the ten top-grossing films of 1956.

Before the movie's release, Ray had a final fracas with John Huston. The first ads appearing for the film listed Ray Bradbury as the sole screenwriter, but then Ray noticed that John Huston's name was appearing next to his on mimeographed copies of the script, which were made by Huston's secretaries. After that, Huston's name appeared as co-writer on promotional materials. "He should have just accepted my offer for credit when I gave it to him," said Ray. Huston had certainly assisted Ray with

decisions on the script, and Ray often consulted with him. But according
to Ray, he wrote none of it. Ray fumed and complained to the Screenwrit-
ers Guild; he protested the billing and handed over the entirety of his
work—all pages, notes, and outlines—1,200 pages in all. Initially, the guild
ruled in his favor. He had shown ample evidence that the script was his
and his alone, but John Huston had Hollywood clout. At some point, Ray
said, Huston returned to Hollywood with a copy of the *Moby Dick* screen-
play. The copy included Huston's notes, which the director used to argue
his contribution. The guild reversed its ruling, and co-screenwriting credit
was returned to John Huston. "The people at the Writers Guild told me,"
said Ray, "you deserve complete credit." He demanded to see the letters by
the ruling judges at the guild. "In every single letter, it said, 'If it weren't for
the fact that Huston is a well-known personality and influence in our time,
we would probably, just on the facts, on the evidence, give it to Bradbury.'"

The judges at the guild had surrendered to Huston's stature in Hol-
lywood and assumed that, given the director's experience, he probably
taught Ray Bradbury a great deal. Even if Ray had written the actual
script, Huston's supervision and guidance was most certainly an influ-
ence. Ray agreed that Huston unquestionably offered much advice, but,
he argued, that made him a good producer and director—not a screen-
writer. However, John Huston prevailed and his name remained as co-
author of the *Moby Dick* screenplay.

On Saturday, April 17, 1954, Ray arrived by train in Rome and contin-
ued on to Sicily. On Easter Sunday, he reunited with his wife and daugh-
ters. "It was as if a terrific burden had been lifted off Ray's shoulders,"
said Regina Ferguson. "He was a different man when he arrived in Italy."

Before leaving for Europe, Ray had written Renaissance scholar
Bernard Berenson to arrange a meeting. Ray, responding to Berenson's
invitation to visit, was thrilled yet apprehensive. After his troubles with
John Huston, Ray feared that another renowned man would make a fool
of him. A respected intellect and noted author of art history, Berenson

held court with world leaders and film stars; Ray was intimidated. Honest about his own limitations, Ray was the first to admit that he was not an intellectual. If anything, Maggie Bradbury, cultured, well read, and fluent in four languages, was the intellectual in the Bradbury household. Despite Ray's insecurities, he decided to meet Berenson, and traveled with Maggie to Berenson's villa, I Tatti, in Florence.

The sixteenth-century home sat on a lush estate, with ornate gardens surrounded by palm and cypress trees. When Ray and Maggie arrived, Berenson's secretary-assistant, Nicky Mariano, welcomed them and asked that they wait in the library. Shortly thereafter, Berenson appeared in the doorway. He was a slight man and, at eighty-eight years old, quite frail. But Berenson was full of energy. He approached Ray and, in his accented English, pointed and said, "Mr. Bradbury, when you answer this next question, we will be friends or we will not be friends."

Ray once again found himself facing a man he greatly admired, feeling insecure. "Ask the question," Ray said, nervously.

"When I wrote you last year, you didn't answer me immediately. Is it because you didn't know who Bernard Berenson was, or you found out later, and then you wrote to me?"

Ray hesitated, unsure of how to answer. "Mr. Berenson," he said at last, "I've never had a letter like yours in my life. It scared the hell out of me. We had no money to travel. At the end of your letter you said, 'If you're ever in Italy, be in touch.' But we had no money and no prospects for travel. We were very poor, and I didn't know what to say to you. So I delayed writing, and then suddenly John Huston came along and gave me the job writing *Moby Dick,* and when I got to Ireland, I wrote to you because I knew there was a chance I could come down and see you."

To that, Berenson replied, "Accepted! We shall be friends."

His relationship with Berenson was of paramount importance to Ray. After Huston and *Moby Dick,* he felt wholly beleaguered, and Berenson's kind offer of friendship appeared at the exact moment he needed it most. Like Christopher Isherwood, Gerald Heard, and Aldous Huxley a few years earlier, Berenson, a revered intellectual, was heaping praise on a writer known primarily for science fiction.

"We were welcomed into his household," said Maggie, "and we became his children. He always called us his 'children.'" For the next few

days, Ray and Maggie dined with Berenson. Berenson marveled at Ray's prose mastery, but emphasized that Ray need not write with the ornate decorations of science fiction and fantasy. He hoped that one day Ray might write a book with characters outside the realm of the fantastic.

Berenson also recommended Renaissance art stops for Ray and Maggie to make throughout the region. In turn, Ray and Maggie reported back their thoughts and viewpoints. Both neophytes to Renaissance art, Ray and Maggie learned much from Berenson, who reveled in teaching them. "When you go to museums," he cautioned Ray and Maggie, "only stay for an hour at a time! Don't exhaust the body so as to exhaust the eye and tire the mind." For Ray and Maggie Bradbury, the days in Florence with Berenson, who had become very dear to them, were some of their happiest.

20

RETURN TO GREEN TOWN

Ray is known best for his science fiction, but to me his most moving things are his midwestern, rural remembrances of things past. I loved Dandelion Wine.

—STUDS TERKEL, *Pulitzer Prize–winning author*

AFTER THE Bradburys returned to the United States in May 1954, Ray was inundated with proposals to write screenplays. He was offered *Good Morning, Miss Dove; Anatomy of a Murder; Les Diaboliques; Friendly Persuasion;* and *The Man with the Golden Arm,* but refused them all. "I remember walking down Hollywood Boulevard," he said, "and three films I had turned down were playing at theaters at the same time." Ray, fa-

tigued from his overseas sojourn and Huston experience, was not about to embark on another script misadventure. And, he said, "I wanted to spend time with my family."

While Ray was most certainly a career man, he was faithfully devoted to his family. As a father, he loved nothing more than telling bedtime stories to his daughters. He invented adventures starring himself as Blackstone the Magician's sidekick—tales that took him as a young boy all across the globe. His girls listened, mesmerized, to these fables about their father and the world's greatest illusionist; they believed every word. Naturally, Ray and Maggie emphasized storytelling and books. In an unusual nod to their importance, when the girls were infants, Ray placed books in their cribs—to get them accustomed to the shape, feel, and smell. Books were always of the utmost importance to Ray.

And this is why, even after considering a slew of lucrative screenwriting offers after he returned home from Ireland, Ray refused them. He would rather write novels and short stories. "No one ever remembers screenwriters," he claimed. "I would have been rich if I had done those scripts, but no one would have remembered me." Fortune was never a motivating factor behind Ray's singular drive; his ego needed to be fueled and he wanted adoration and recognition for his creations, and he was the first to admit this personality trait.

A few weeks after his return home, Ray attended a special meeting of the Screenwriters Guild, held in the Crystal Room at the Beverly Hills Hotel. The McCarthy hearings were gripping Hollywood, and the guild convened for a vote on screenwriters who had invoked the Fifth Amendment. Should they remove these writers' names from screen credits for refusing to testify before a U.S. government body?

"It was ridiculous!" recalled Ray. "You can't play politics that way. You either write a screenplay or you don't. If you wrote it, it's yours. Your name appears on it."

Nearly eight hundred guild members appeared for the vote, and a secret ballot, to ensure anonymity and safety for the voters, was distributed in the Crystal Room.

"We voted it down," said Ray. "I was so proud of my fellow guild members." But, as Ray recalled, not everyone was as pleased. Screenwriter Borden Chase, who was helping to facilitate the vote, decried the

decision of the guild that night and warned his fellow members that the newspapers the next morning, particularly the conservative publications, would label them all "Commies" and "pinkos" if they did not reverse their decision.

"He insisted on an open vote," Ray recalled fifty years later, still filled with outrage. "That was against the law." At Chase's urging, a new, open vote was cast, and almost everyone in the room reversed his or her original vote. The secret ballot was overturned. "There were eight hundred cowards in that room," said Ray. Only a dozen or so members stood alongside Ray Bradbury, including author Leon Uris. "My understanding was that there were some finks in the room reporting back to the studio," Uris opined in a letter to Ray in 2001, "and a cruddy character from the *Reporter* wanting to get the list of names of those who voted against taking the oath."

With the vote reversed, Ray Bradbury spoke out harshly. "Cowards! McCarthyites!" he cried, his finger raised in the air.

"Throw that man out!" Borden Chase retorted.

Ray was indignant and defiant. "I'm ashamed of all of you!" With those final words, Ray stormed out of the room and skipped guild meetings for the next year. "I was sickened," he said.

As for Leon Uris, his final words, as he told Ray in his 2001 letter, were, "I'll never attend another Guild meeting again." Uris kept his pledge.

On July 22, 1955, Maggie gave birth to their third daughter, Bettina Francion Bradbury. Her name reflected the Bradburys' recent world travels and new friendships. Both Ray and Maggie loved the name of Peter Viertel's elegant girlfriend, Paris model Bettina Graziani. Francion was the name of their dear friend Madame Man'Ha Garreau-Dombasle's daughter.

A new daughter, more books published—the period following their return from Europe was a boon for Ray and his family. After six years of

being shopped to various publishing houses, Ray's children's book, *Switch on the Night,* sold to Pantheon Books. The story of a child over-coming his fear of the dark, *Switch on the Night* won the Boys Club of America Book Award a year after publication. Ray's second book with Ballantine, *The October Country,* was also released. It was a repackaging of Ray's first book, *Dark Carnival,* which after nearly a decade had finally sold out of its first print run of just over three thousand copies. Because Ray constantly tinkered with his literary past (something he later lamented), *The October Country* featured fifteen of the original tales from *Dark Carnival,* along with four new, unpublished short stories: "The Dwarf," "The Watchful Poker Chip of H. Matisse," "Touched with Fire," and "The Wonderful Death of Dudley Stone." As ever, Ray was particularly critical of his own work, and as a result he rewrote or edited all the *Dark Carnival* stories, with different levels of effort given to each one. Some stories, such as "Homecoming," were given a minor polish. Other tales, "Jack-in-the-Box" and "The Emissary," for example, included wholesale rewrites. These tales were among the last Ray had written for *Dark Carnival* prior to its publication in 1947, and unlike many of the stories in Ray's first book, had not appeared in magazines before the book was published. As a result, they did not go through the same level of editing as stories that had appeared previously in magazines.

Editor Stanley Kauffmann, who worked with Ray on *Fahrenheit 451,* suggested that, since this book included new stories and new tellings of old tales, Ray consider giving the book a new title. It was far from simply a second printing of *Dark Carnival.* After ruminating, Ray decided upon *The October Country.* In the opening pages of the book, he described his spectral landscape:

OCTOBER COUNTRY

. . . that country where it is always turning late in the year. That country where the hills are fog and the rivers are mist; where noons go quickly, dusks and twilights linger, and midnights stay. That country composed in the main of cellars, sub-cellars, coal-bins, closets, attics, and pantries faced away from the sun. That country whose people are autumn people, thinking only autumn thoughts. Whose people passing at night on the empty sound like rain. . . .

One last feature would set *The October Country* apart from its early incarnation, *Dark Carnival*. This new book would feature illustrations, including the cover art, by Ray's friend, artist Joe Mugnaini, who had furnished the cover and interior illustrations for *The Golden Apples of the Sun,* as well as the striking cover art for *Fahrenheit 451*.

Even as Ray had taken a self-imposed hiatus "for at least three years" from working on another motion picture, he did continue to sell story rights to dramatic radio. Throughout the early to mid-1950s, Ray's stories were adapted by other writers for shows such as *Dimension X, ABC Radio Workshop,* and the CBS program *Suspense*. In 1955, Ray began a relationship with the television program *Alfred Hitchcock Presents*. "I'd loved Hitchcock forever," Ray said, "and I saw his show and realized that we were similar spirits." Ray wrote his first script for *Alfred Hitchcock Presents,* "Shopping for Death," which was based on "Touched With Fire," from *The October Country*. He was paid $2,250 for the script. The episode aired January 29, 1956. "I wrote one or two things a year for them," said Ray. He worked closely with Norman Lloyd, one of the program's producers and directors, as well as with producer Joan Harrison. "I would go to the studio and tell them my idea or give them a short story, and if they liked it, they'd say, 'Hey, that's good, go home and write that.' I would write the script and send it over. I would go back to lunch the next week and they'd tell me what was wrong with it or what was right. If I agreed, I'd make changes. If I didn't agree I'd tell them why and I didn't have to make any changes. It was a wonderful relationship."

Alfred Hitchcock left the day-to-day business of running his television program to Lloyd, Harrison, and the rest of his staff. The producers would send initial plot summaries of each and every episode to the director for his approval, and Hitchcock's word was final. If he liked it, the episode was good to go. If he didn't like it, the concept was stopped dead in its tracks. Alfred Hitchcock liked Ray's ideas. The director, according to Norman Lloyd, felt privileged to have an author of Ray's literary stature contributing to the program. "Ray's strength," said Norman Lloyd, "above all, was a great sense of story—of plot—which is not given to many."

On occasion, Ray would meet with Hitchcock, "a very kind, gentle man, with a good sense of humor." Ray would also visit the set of several

Hitchcock film productions. One afternoon, Ray even brought his child-hood pal Donald Harkins to the set. Ray had first met Harkins in 1934, outside the walls of a film studio, where they were both collecting auto-graphs. Now they were inside the walls, by invitation, watching one of the masters at work.

Ray had a solid partnership with Alfred Hitchcock. It was a good collaboration, based on professionalism and without the psycho-antics involved in writing the screenplay for John Huston. Between 1955 and 1964, Ray would go on to write seven scripts for Hitchcock. Because of his commitment to Hitchcock's television show, he was forced to take a pass on an enticing film offer. Alfred Hitchcock gave Ray a copy of a story by Daphne Du Maurier, the celebrated author of *Rebecca*. The story was called "The Birds," and Hitchcock planned on making it into a motion picture. Ray took the story home, read it, and met with Hitchcock again to discuss it. "He asked me if I'd do the screenplay," recalled Ray. He told Hitchcock that he'd do it. "If you can wait two weeks for me."

"Why do I have to wait two weeks?" Hitchcock asked.

"Because I'm doing a teleplay right now."

"For who?"

"For Hitchcock."

Hitchcock was confused.

"I'm working for you already," Ray explained. "Doing a teleplay for your television show. If you'll just wait two weeks, I'll write *The Birds*."

Unfortunately, Hitchcock could not wait the two weeks for Ray to finish a teleplay for his own series. "I should have done it," Ray said re-gretfully, years later. "The film is full of holes. It's too long. Still, I often wonder what would have happened if I had written it. The ending of the film as it stands is very unsatisfactory."

Moby Dick premiered in Hollywood in June 1956. The gala opening was held at the Pantages Theatre on Hollywood Boulevard. Once again, Ray had come full circle. As a teenager growing up in Hollywood, he had stood outside the old Uptown Theatre on countless film opening nights, clutching his autograph book and pen to his chest, watching as the pa-rade of stars climbed out of their limousines and strolled into the the-ater. And tonight he was in the parade.

The opening night of *Moby Dick* was a glitzy Hollywood affair. The cast of the film, including Gregory Peck, was all there. John Huston's limousine rolled up, and Ray saw him for the first time since leaving Ireland two years earlier. They spoke for a few minutes, exchanging pleasantries, despite the flap over screen credit. But Ray couldn't enjoy the film that night. He was too nervous. He was too close to the film to take it all in for its entertainment value. The following night, Ray purchased seventy tickets, and invited all of his family and friends: Leo and Esther Bradbury; Aunt Neva; his uncle Inar; his brother, Skip, and his wife, Sonnie; his pals Sid Stebel and Bill Nolan. Ray even invited his high school writing teacher, Jennet Johnson. It was always important for Ray to show the people who had helped him along the way that he had made it. However, even that night, surrounded by his loving inner circle, Ray did not enjoy himself. He was too worried about what everyone else thought of the picture.

"The following Saturday," Ray said, "I brought my two daughters, Susan and Ramona, and we sat in the front row, the three of us, and I finally saw *Moby Dick*. With my kids. They relaxed me so I could look at the film and say, 'Goddammit, it's good! It's a good film.'" Ray sat there in the dark theater, with his two daughters by his side, and as he often did during euphoric moments, he cried.

RAY WAS always one for nostalgia—a sentimental fool, as the saying goes. He was even feeling nostalgic for Ireland, where he had spent some of the hardest months of his life, feeling suicidal, working for a man who played him for all of his boyish, small-town, by-golly naiveté. But as painful as many of the memories were, there was something undeniably romantic about the loneliness he had felt there. Loneliness was a theme that at once frightened Ray and, at the same time, invigorated him. Ireland had that allure—the inclement weather, good, decent people, the boys at Heeber Finn's Pub, and the Royal Hibernian Hotel and its staff who became family. Returning to Ireland in his imagination, Ray wrote his first Ireland story (one of many to follow), "The First Night of

Lent." The tale was, as Ray described it, the entirely true story of his taxi driver, the man who brought him day in, day out, from Dublin to Kilcock and back to Dublin again in the late hours of the night. "My Irish cab-driver was a human being when drunk, but as soon as he sobered up for Lent he was a demon-monster. My only advice to him was: Stay drunk . . . I love you that way."

"The First Night of Lent" sold to *Playboy* and was published in the March 1956 issue. Ray wrote to his book editor, Walter Bradbury, to share his enthusiasm for writing about Ireland: "All of the months of walking the Dublin rains is now beginning to simmer up in me. I lay in bed the other night until five in the morning thinking of Ireland and got so many damn fine ideas I got up gibbering to put them down on paper." But Ray wasn't just feeling nostalgic for Ireland; as always, he was nostalgic for his childhood and his young adulthood. Given the tone and themes of many of his science fiction tales, with their rocket ships straight out of H. G. Wells, one might say that Ray Bradbury was even nostalgic for the future. And he was unashamed of it. Over the years, he was taken to task by some literary critics for being overly sentimental, and his response to that criticism was, "You're Goddamned right!"

But perhaps more than any other time or place he visited in his fiction, Ray regularly conjured Green Town. He had long been writing short stories about his childhood in Waukegan, Illinois, and had sold many, including "The Season of Sitting" (*Charm,* August 1951); "The Lawns of Summer" (*Nation's Business,* May 1952); "The Swan" (*Cosmopolitan,* September 1954); and "Summer in the Air," which appeared in the February 1956 issue of the *Saturday Evening Post*. This simple summer tale, about a boy and his new tennis shoes, would later be retitled "The Sound of Summer Running." It would one day become a staple of junior high school reading lists, a favorite of students and teachers alike. It, too, as with so many Bradbury tales, had its origins in a real-life experience.

Ray had been riding on a Los Angeles city bus when he noticed a young boy with an unmistakable spring to his step. Ray looked down at the boy's feet. He was wearing a brand-new pair of sneakers, white, perfect, able to leap tall buildings in a single bound (or at least, Ray imagined, the owner of the shoes thought so). This one image sparked in Ray memories of a rite of passage from the summers of his own youth, when

his mother would take him to Genesee Street to buy new tennis shoes every June. After Ray got off the bus, he went right home and wrote "The Sound of Summer Running":

> *Somehow the people who made tennis shoes knew what boys needed and wanted. They put marshmallows and coiled springs in the soles and they wove the rest out of grasses bleached and fired in the wilderness. Somewhere deep in the soft loam of the shoes the thin hard sinews of the buck deer were hidden. The people that made the shoes must have watched a lot of winds blow the trees and a lot of rivers going down to lakes. Whatever it was, it was in the shoes, and it was summer.*

What Ray had been doing all along, at his own pace—which was important to him, because he didn't like to feel pressured—was assembling a pastiche of Illinois stories that he hoped one day to combine into a novel. He'd had the idea for a long time, since the mid-1940s, when he told Don Congdon, who was then still an editor at Simon & Schuster, about the concept. Congdon had always been enthusiastic about the idea, and over the years had gently prodded Ray to finish it. It had always been assumed that Ray's first novel would be his Illinois book. But then a little book called *Fahrenheit 451* ignited Ray's imagination, so to speak, and it became the first.

Now, in 1956, the Illinois book was finally coming together. Walter Bradbury even suggested to Ray that he write and send him a chapter a week so that the book would finally be completed. Walter Bradbury certainly did not hound him, but he let Ray know that he wanted the book. Ray assured his editor that he would do his best; he was, at the very least, making slow and steady progress toward finishing it. He had written another story, "The Last, the Very Last," first published in *Reporter,* in June 1955 (later retitled "The Time Machine" in the Bradbury collection *Classic Stories 1*). It told of an elderly Civil War veteran, Colonel Freeleigh, who had bottled up inside of him all the memories of famous magicians of yesteryear, buffalo stampedes on the wild plains of 1875, and the smell of gunpowder drifting in the air of the battlefields at Bull Run, Shiloh, and Antietam. In this story, Ray wasn't writing a tale of fantasy, he was

writing about a real-life, honest-to-goodness time machine—an old man who had lived, nearly died a hundred times, and carried on to the summer of 1928 to share his tales of time-traveling adventure with a group of appreciative boys. The character was a composite of the Civil War veterans Ray recalled marching in Waukegan parades when he was a child; himself, now an adult, looking back on his younger self; and, most important, a "time machine" he had recently encountered in an Italian villa not far from Florence, eighty-eight-year-old Bernard Berenson.

As was his wont, Ray wrote about magic in his Illinois stories. This time, however, magic had to do with neither rocket ships nor circus freaks; the magic of this novel was the magic of *memory*. Ray conjured Summer 1928, sitting on the porch with his grandfather lighting his pipe as dusk settled, a boy wearing new tennis shoes, listening to the first lawn mowing of the season. And, of course, the family ritual of making dandelion wine during the height of Prohibition. Each bottle of sun-kissed elixir was labeled with a date, stoppered in an empty ketchup bottle, and stored in the cellar to be opened some far-off winter day for a taste of summer. It was vintage Bradbury metaphor: memories stored away to be tapped at a later date. After several years of working sporadically on the stories of Summer 1928, Ray was nearly done with the book.

By August 1956, Ray had sent his editor a table of contents listing the tales to be included in the Illinois novel-in-stories, now officially titled *Dandelion Wine,* after one of the stories. The nearly completed book, as it stood, followed young Douglas Spaulding (a thinly veiled young Ray Bradbury: Douglas was Ray's middle name; Spaulding was his paternal grandmother's maiden name) from the summer of 1928 to the summer of 1929.

When Walter Bradbury saw the manuscript of loosely connected short stories, he had an idea. He told Ray that he saw two books within the manuscript. "If you just take hold of this book by the ears and rip it apart, it will fall into two halves. Every other chapter should go out, and the remaining chapters will fall back into place. They will be your first book, and every other chapter will be your sequel," Ray recalled his editor counseling him.

Ray heeded Walter Bradbury's advice and removed half the stories from his manuscript. The half that remained was still titled *Dandelion*

Wine; the half that was removed would become its sequel, still unpublished as of 2005, a book Ray would title *Farewell, Summer.* To smooth over the gaps left by the extracted stories, Ray wrote bridge chapters as he had done for *The Martian Chronicles. Dandelion Wine* emerged as a string of short stories about a young boy, Douglas Spaulding, who, with his brother Tom, comes to terms with time and mortality. As well as writing bridge passages to unify the narrative, Ray removed the short-story titles from each chapter, to further lend the appearance of a novel. Had the titles remained, the table of contents of *Dandelion Wine* would have run as follows:

Ray sent the new version of the *Dandelion Wine* manuscript to Walter Bradbury at the end of 1956, though he continued to edit the book over the next few months. Ray, of course, was fastidious as ever about the rewriting process, honing and polishing, until the manuscript had to be pried out of his hands and sent to the printer.

Meanwhile, in February 1957, Ray accepted an offer from the production company Hecht-Hill-Lancaster to serve as a script consultant and writer on the film *White Hunter, Black Heart*. He would collaborate with film and television screenwriter John Gay, who was under contract with the company. *White Hunter, Black Heart* was based on the Peter Viertel book about the making of the John Huston film *The African Queen*. Ray's tumultuous tenure with Huston made him the perfect candidate to work on the film; he had invaluable insight to share.

As Gay recalled, the two writers sat together at the Hecht-Hill-Lancaster office and Ray would tell his John Huston stories, and then they'd look at the Viertel book, but they found themselves spending whole days doing just that and not much more. "Ray was a most unusual character," Gay recalled. "He could talk your arm off. He was full of ideas, he had more ideas in that brain than anybody." As Ray remembered, they were able to outline the book to a degree and write about

1. Samuel Irving Bradbury, Ray's great-grandfather, the man who brought the Bradbury family to Waukegan, Illinois. Date of photograph unknown.

2. The Samuel Hinkston Bradbury family, c. 1911–12. *Left to right, bottom row:* Minnie Davis Bradbury [Ray's grandmother], Samuel Hinkston Bradbury [Ray's grandfather], Nevada M. Bradbury [Aunt Neva], Bion E. Bradbury [Uncle Bion]. *Standing, left to right:* Leonard Spaulding Bradbury [Ray's father], and Samuel Hinkston Bradbury, Jr. [Ray's Uncle Sam].

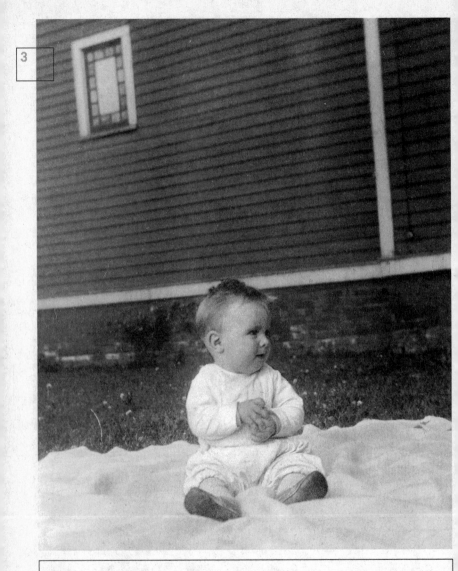

3. Ray Bradbury, c. 1921, on his grandparents' lawn. Note the stained glass window in the background that would later play a prominent role in the story "The Man Upstairs." **4.** The only car Ray Bradbury ever drove, 1923. **5.** Ray and Skip Bradbury, c. 1923–24. **6.** Ray Bradbury, just roused from a nap, age three, summer 1924.

4

5

6

7. The future Mrs. Ray Douglas Bradbury. Marguerite Susan McClure, age three, c. 1925.
8. Leonard, Jr.; Esther; and Ray; traveling across the dust bowl during the Great Depression, c. 1932. 9. An advertisement for an appearance by Blackstone the Magician that ran in the December 31, 1931, *Waukegan News-Sun*. [Courtesy of the *Waukegan News-Sun*] 10. A family outing to the beach, c. 1934. From left, Skip Bradbury, Leonard Bradbury, Esther Bradbury, and Ray. 11. Ray's Aunt Neva, c. 1927–28.

7

11

8

9

10

12. Ray with actress Ida Lupino outside of Paramount, c. 1935. **13.** George Burns and Ray Bradbury, c. 1935, standing outside the famous Brown Derby restaurant, a favorite stomping ground of Hollywood's elite. **14.** The handwritten original of Ray Bradbury's first published work, the poem "In Memory to Will Rogers," which ran August 18, 1936, in the *Waukegan News-Sun*.

The man who jested through his life
And chased away all care and strife.
The man who we called, "JUST-PLAIN
BILL".
Our Ambassador of Good Will,
Has laid away his ink and pen
to see his Maker once again.
No more the cheerful smile, the grin
That warmed a nation's heart within
No more the homely humor of
the simple man we grew to love,
Who won his way into our heart,
And now when time comes to part,
No effort made to shield our tears
For our true friendship through
the years.
Upon your tomb we place this
wreath.
Upon your head we this bequeath
that you will not forgotten be,
You'll live throughout eternity,
A monument to all mankind,
To poor, to sick, to mute, and blind.
~~Stilled are our voices on this day,~~
~~For our friend "Will" has passed away~~

R.D.B.

15. Ray Bradbury selling newspapers on the corner of Olympic and Norton, c. 1938.
16. The Los Angeles Science Fiction Society, c. 1939. Ray Bradbury is seated, second from left. Seated next to him on the left is Leslyn Heinlein. To the immediate right are Forrest J Ackerman and Ray Harryhausen. Standing against the wall, center rear in tie, is writer Jack Williamson and to the right in tie, Edmond Hamilton. Robert Heinlein is seated, sporting glasses and mustache, to the right of Hamilton. **17.** Photo booth portrait of Marguerite McClure and Ray Bradbury taken during their courtship, c. 1946. **18.** Ray Bradbury's friend Forrest J Ackerman at the First World Science Fiction convention, July 1939. [Courtesy of Forrest J Ackerman]

16

17

M. McCLURE —
+ R BRADBURY

18

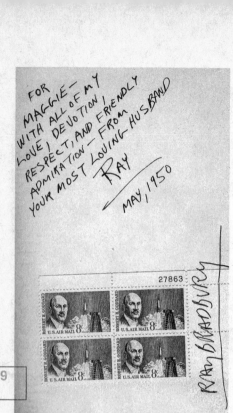

FOR
MAGGIE—
WITH ALL OF MY
LOVE, DEVOTION,
RESPECT, AND FRIENDLY
ADMIRATION — FROM
YOUR MOST LOVING HUSBAND
RAY
MAY, 1950

RAY BRADBURY

27863

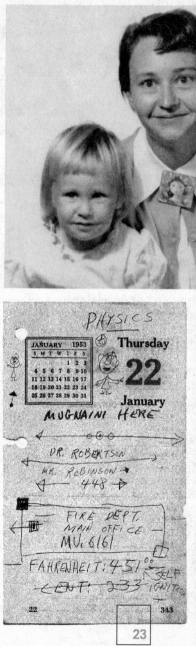

19. Ray's inscription to Maggie, first edition of *The Martian Chronicles*. **20.** Ramona, Maggie, and Susan Bradbury, c. 1953. **21.** Publicity photograph, c. 1952. [Photo by Morris Dollens/Courtesy of Ray Bradbury] **22.** John Huston and Ray Bradbury working on the screenplay of *Moby Dick*, Ireland, January 1954. **23.** The birth of a title: The handwritten notes in Ray Bradbury's personal day planner, dated January 22, 1953. After calling the UCLA physics and chemistry departments, Ray finally dialed the Los Angeles Fire Department and found out the temperature at which paper bursts into flame.

PHYSICS
Thursday
22
January

JANUARY 1953
S M T W T F S
1 2 3
4 5 6 7 8 9 10
11 12 13 14 15 16 17
18 19 20 21 22 23 24
25 26 27 28 29 30 31

MUGNAINI HERE

DR. ROBERTSON
MR. ROBINSON →
448 →

FIRE DEPT.
MAIN OFFICE
MU. 6161

FAHRENHEIT: 451°°
← ENT: 233 → SELF IGNITION

22

343

24. Ray and Maggie celebrating aboard the SS *United States,* returning from Europe after completing work on *Moby Dick,* May 1954.
25. Ray Bradbury, September 1957, at the Hotel St. James D'Albany in Paris, France.
26. The Bradbury family, c. 1962, or, as Ray called this portrait, "the wax museum people." *Bottom row:* Bettina, Alexandra, Maggie; *top row:* Susan, Ramona, Ray. **27.** Ray putting the finishing touches on the *Halloween Tree* painting that would later inspire his book of the same name, c. 1960. **28.** Ray with his childhood hero, Blackstone the Magician, c. 1968.

25

26

27

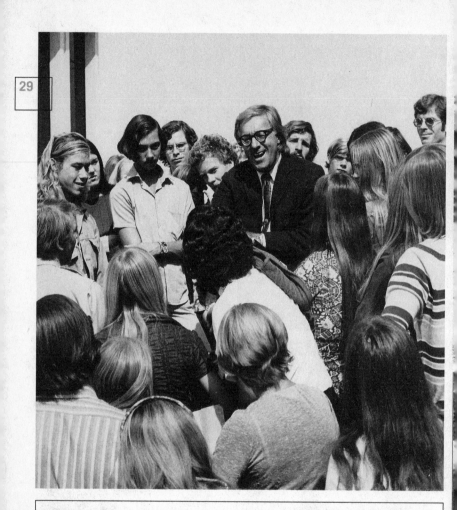

29. Ray talking to students at Irvine, California, 1971. [Photograph by Marci Mauthe, courtesy of Ray Bradbury] **30.** Ray Bradbury and Ray Harryhausen on the set of *Something Wicked This Way Comes*, c. 1982. [Courtesy Walt Disney Pictures] **31.** Ray with his beloved Aunt Neva at his seventy-fifth birthday party, August 22, 1985. [Photograph by Arnold Kunert, courtesy of Arnold Kunert] **32.** Skip and Ray Bradbury, c. 1971, at Skip's retirement party. [Courtesy of Leonard Bradbury III] **33**. Ray at the dedication of "Ray Bradbury Park" in Waukegan, Illinois, June 1990. [Photograph by Barry Brecheisen, courtesy of Barry Brecheisen]

RAY BRADBURY PARK
WAUKEGAN PARK DISTRICT

34. Hugh Hefner and Ray Bradbury, October 2002. [Photograph © 2005 by Playboy. Reproduced by special permission of Playboy. Photograph by Elayne Lodge.] **35.** Ray Bradbury with President and Mrs. Bush, upon receiving the 2004 National Medal of Arts for "his incomparable contributions to American fiction as one of its great storytellers who, through his explorations of science and space, has illuminated the human condition." [White House photo by Susan Sterner]

thirty pages of material. But that was all. Ray had not collaborated on anything since his attempt to do so with Henry Hasse back in the early 1940s. "God knows," said Gay, "I wasn't made for collaboration, but I said to Ray, 'You definitely were not made for collaboration.' This was the most impossible combination ever brought together." Even though Ray was being paid a thousand dollars a week, he realized that he and Gay were going in circles. The two writers decided it was best to tell producers Harold Hecht and Jim Hill that the collaboration had failed. "They were fine with it," said Gay. "They said, 'Well, we tried.'"

As ever, as Ray was endeavoring to work on *White Hunter, Black Heart,* and as *Dandelion Wine* was in the prepublication stages, he continued to craft new short stories.

Ever since Ray and Maggie had visited Bernard Berenson in the spring of 1954 at his Italian villa, Ray had remained in touch with the aged Renaissance scholar. The two men corresponded often, writing each other letters touching upon any number of subjects, from space travel to the aesthetic hurdles that confronted artists. It was a tender relationship, a father-and-son bond that Ray never had with his own father. Leo Bradbury was a tough guy, a blue-collar man, never one to wear his emotions on his shirtsleeves, though he had a terrific sense of humor, and he loved his son, but he was never able to relate fully to his sensitive imaginative, anomalous offspring. In Bernard Berenson, Ray had found a man who shared his enthusiasm for the love of the creative process. In Ray Bradbury, Berenson had found a young man who shared his passion for the arts, and for creating. What Berenson found most remarkable about Ray was his ability to articulate this love concisely. "All my life I have been trying to say what the artist does to us and I have never succeeded in doing it better or half so well as you," he wrote Ray.

With each letter from Berenson that arrived in Ray's mailbox, he continually pointed out that his time on Earth was nearing its end. With each letter, Berenson expressed his desire to see Ray and Maggie soon, for it could be their last visit. This pained Ray no end. Even as his star had risen dramatically since working on *Moby Dick,* he and Maggie still did not have enough money for a return trip to Europe. The occasional television work helped, but with three little girls to support, they had just

enough money to live comfortably, but had nothing left for luxury. A trip to Europe was out of the question, and Ray feared that he might never see Bernard Berenson again.

But in the summer of 1957, fate intervened. Writer Graham Greene had read Ray's short story "And the Rock Cried Out" and brought it to the attention of film director Sir Carol Reed. The director was looking for a new project, and one afternoon, as Ray recalled, Reed happened to be on the telephone with Harold Hecht, for whom Ray had been working on *White Hunter, Black Heart*. Ray was in Hecht's office when the call came in. Reed asked Hecht if he had ever heard of this young writer named Ray Bradbury, as Reed was interested in working with him on a film adaptation of "And the Rock Cried Out." "As a matter of fact," Harold Hecht told Reed, "he's standing here right this minute. Would you like to talk to him?"

Ray, Maggie, and the girls were soon off to London, where Ray would adapt his own short story into a screenplay for Sir Carol Reed. It was a stroke of serendipity and, most important to Ray, the opportunity allowed him to visit Bernard Berenson one last time. Around this time, Ray learned that his work on *White Hunter, Black Heart* would be all for naught. Hecht-Hill-Lancaster was unable to find a studio to back the picture. The film would have to wait several more decades, when new writers would adapt the novel for director Clint Eastwood.

Ray spent that summer in London, writing the screenplay, which turned out to be an exhilarating creative experience. Carol Reed was no John Huston. He encouraged Ray, reading the screenplay's completed pages and telling him to just "keep doing what you're doing." In a matter of weeks, Ray finished the script, but his work was in vain. Once again, Hecht-Hill-Lancaster, the producers of *And the Rock Cried Out,* was unable to procure funding. To this day, according to those who have read the script, it is Ray Bradbury's best unproduced screenplay.

When Ray had completed work on *And the Rock Cried Out* in August, he and his family traveled south to Italy to meet with Bernard Berenson. "We were reunited in joy," Ray wrote in the essay "The Renaissance Prince and the Baptist Martian," "as if three years had not passed since our last fireworks. B. B. was, of course, even more the trem-

bling gray moth now: the bones had thinned within the mother-of-pearl, crushed-flower flesh, but his spirits were good and his mind clean."

Ray and Maggie shared sumptuous lunches and exquisite late-afternoon teas with "B.B." It was their last visit with this extraordinary man, who was a kindred spirit, a father figure, and an unlikely fan of Ray's. Although Bernard Berenson lived two more years after this visit, Ray and Maggie would not return to Europe in time to see him again. He died October 6, 1959.

WHILE IN Italy, the Bradburys visited Rome. It was on a golden after-noon, with the city spreading out before their hotel balcony window, that Maggie turned to Ray and told him that she no longer loved him. She wanted a divorce. Ray was dumbfounded; he had never sensed any such feelings in Maggie before, and decades later, he maintained that he was unaware that Maggie was unhappy. He was a faithful husband, a loving father, and a hard worker. Ray could hardly understand why she would ask for a divorce, but she told him that she was through.

"I suppose she was tired of raising four children," Ray surmised, counting himself as the fourth child. In the Bradbury household, Maggie did most of the parenting. She was the disciplinarian; she helped the girls with their homework; she attended all the parent-teacher confer-ences. Ray, of course, did his share: He was the enthusiast, always will-ing to cart the girls off to the movies, to play games, to paint, to tell bedtime stories. But apparently Maggie carried the brunt of parenting. At least, this was how Ray perceived it when confronted by Maggie's dis-satisfaction. Somehow, Ray didn't remember how, he managed to talk Maggie out of leaving and, many years later, when he asked her why she had asked for a divorce, why she had said what she did in Rome, Maggie replied that she recalled none of it.

THE BRADBURYS arrived stateside and, upon their return home, Ray learned that his father had been admitted to the hospital with a burst appendix. The initial prognosis had looked good, so Esther Bradbury refrained from telling Ray, fearing that he would worry too much and that his vacation would be spoiled. Unbeknownst to anyone, Leo had been misdiagnosed. He did not simply have a burst appendix; he was in fact suffering from peritonitis, an acute inflammation of the inner lining of the abdominal cavity. "Had they operated immediately, they might have saved his life," Ray lamented.

Before Ray left for Europe, he had given his father an advance copy of *Dandelion Wine*. Leo Bradbury loved it. Ray had given copies of all of his books to his parents upon publication (he even dedicated *The Illustrated Man* to "Father, Mother, and Skip"), but this book was different. After all, it poetically evoked Leo Bradbury's hometown, too. *Dandelion Wine* was published in September 1957 as Ray's father was hospitalized.

During this time, Ray remembered, Maggie again asked for a divorce. He was heartbroken. But with an indefatigable spirit, he determined to set things straight. First, he had to tend to his father. Ray wanted him moved. Leo had been admitted to a veterans' hospital where he had to share a room with several other patients; Ray wanted his father to have his own room. In recent years, Ray had come to love and appreciate his father, particularly since the tear-filled turning point when Leo Bradbury had given him Samuel Hinkston's gold pocketwatch.

Ray managed to move his father to Santa Monica Hospital, but two days later, Leo suffered a massive stroke. After this, Ray visited his father twice a day, every day, for two weeks. Each time, Ray told him that he loved him. But Leo never recovered. On October 20, 1957, he passed away.

The funeral for Leonard Spaulding Bradbury was held two days after his death, at the Kingsley and Gates Funeral Home in Santa Monica. This devastating day for Ray was made heartwarming only by a huge turnout of Leonard Bradbury's coworkers, people Ray had never known. "I never knew so many people cared about my dad," he said.

After Leonard Bradbury was buried, Ray set out to salvage his disin-

tegrating marriage. He still claimed to be befuddled by Maggie's unhappiness and dissatisfaction. He went to Maggie the only way he knew: "I suppose I just cried," Ray recalled. It worked. Maggie agreed to stay, "like so many spouses do," said Ray, "for the children."

21

SOMETHING WICKED

When I visit schools, kids always ask me, "What's the scariest book you've ever read?" and I always tell them Something Wicked This Way Comes. *I still remember how creepy it was. It really struck a chord with me.*

—R. L. STINE, *author*

DESPITE FISSURES in their marriage, Bradbury baby number four—Alexandra Allison—arrived on August 13, 1958. Like her three elder siblings, "Zana," as friends and family called her, did not share the supranatal proclivity of her father; none of the Bradbury girls recalled their own births.

The ranch house at 10750 Clarkson Road was now too small for the family, prompting Ray and Maggie to look for a new home. The first place the couple saw was a sprawling three-bedroom house, not far from where they had been living, in the Cheviot Hills enclave of West Los Angeles. Cheviot Hills was, and remains, a junior Beverly Hills; the houses are not nearly as ostentatiously large, but still reasonably sized by Los Angeles standards. The streets are rolling, with well-manicured lawns fringing the sidewalks; and rows of mature palm trees reach to the sky. Ray and Maggie loved the split-level stucco house, which had been built in 1937. It was nestled into a cozy embankment of grass and tall green

shrubbery. It had an attached garage beneath the kitchen and, most important for Ray, it had a basement where he could put his office. The Bradburys found the sliver of a backyard perfectly charming; it was just big enough for Ray and the girls to play badminton at twilight—one of the family's favorite nightly rituals. (Many years later, with his daughters grown and out of the house, Ray had the gutters cleaned. When the serviceman climbed onto the roof, he discovered an old badminton birdie among the leaves. Ray noticed the serviceman holding the shuttlecock in his hand, and he told him to return it to its nest. Ever the sentimentalist, Ray wanted to leave the fond memories of nightly badminton games undisturbed. The utility man returned the birdie to the gutter, where it sits to this day.)

Ray and Maggie purchased their new home in the autumn of 1958. They moved in on Thanksgiving Day because, as Maggie said, with her usual sarcasm, "I was trying to get out of cooking Thanksgiving dinner!" It took two moving trucks to relocate all the Bradbury belongings, the first vehicle for furniture, clothes, and household goods. Ray was a packrat; he threw nothing out, and many of the boxes were stuffed with his collection of toys, old autograph books, and movie and theater ticket stubs spanning the decades. A second moving truck was called into duty just for the books. The Bradburys packed things where they could squeeze them. Ray even placed an obstreperous cat into a trash can for the short drive over to the new house. In the new house, Susan and Ramona shared a bedroom, with their own bathroom, while Bettina had her own room on the west side of the house. Baby Alexandra slept with her parents.

Not long after the Bradburys moved into their new home, screenwriter John Gay, who had briefly collaborated with Ray on *White Hunter, Black Heart,* introduced Ray to his friend Rod Serling. Serling, a three-time Emmy Award–winning writer, was in the midst of developing a new fantasy and science fiction series for CBS. The show's title was *The Twilight Zone.*

According to Don Presnell and Marty McGee, authors of *A Critical History of Television's The Twilight Zone, 1959–1964,* Serling had "helped define television as a dramatic art form," beginning with a teleplay that aired on the *Kraft Television Theater* in January 1955. Some

would proffer that Rod Serling was to dramatic television in the 1950s what Norman Corwin was to radio in the 1940s; Serling was known for addressing social issues and writing "serious" stories. And so, when he announced his intentions to develop a dark fantasy television series, it came as a surprise to many. Furthermore, according to Ray Bradbury, Serling was out of his element with a genre television program and he needed help. Soon after meeting Rod Serling, Ray and Maggie attended an awards banquet sponsored by the Writers Guild. Serling was there and he approached Ray, who by 1959 was hailed as one of the undisputed masters of fantasy and science fiction.

"Rod told me that he was starting a fantasy series," recalled Ray, "but he didn't really know what he was doing. I invited him over to the house that night." Serling accepted the invitation and, as Ray recalled it, he took Serling down to his basement office and put a pile of books in his arms, by Charles Beaumont, Richard Matheson (both friends and acolytes of Ray's), Roald Dahl, and John Collier. Ray placed a few of his own books on top for good measure.

"I told Rod," Ray said, "'After you read these books you will have a complete idea of what your show should be like. Buy some of these stories or hire some of these authors to work for you, because you can't do the whole thing by yourself.'" Ray then sent Serling off.

After that, Rod and his wife, Carol, would have Ray and Maggie over for dinner occasionally. As their friendship progressed, Ray agreed to be a regular contributor to Serling's television program.

Meanwhile, Ray landed a short story in *The Best American Short Stories* anthology of 1958. "The Day It Rained Forever" would mark his last appearance in the respected literary collection. He had also readied another short-story collection, *A Medicine for Melancholy,* which featured twenty-two newly collected Bradbury short stories, including such reader favorites as "The Dragon," "The Wonderful Ice Cream Suit," "In a Season of Calm Weather," and the widely anthologized "All Summer in a Day." The latter story told of a group of vicious schoolchildren on Venus who lock a little girl in a classroom closet just as the sun is preparing to make its brief, once-every-seven-years appearance. "More people ask me about that one story than any other," Ray said, reflecting on his prolific

output of short stories. "That story reveals the dark side in all of us. And it makes us feel ashamed." Doubleday published *A Medicine for Melancholy* in February 1959.

At the same time, Ray's film agents offered him free use of an office space in a gleaming white building located at 9441 Wilshire Boulevard, in Beverly Hills. Ray's agents were moving to another office, but had prepaid a year's lease at the Wilshire location. Ray readily accepted the generous offer. Each morning, he took the bus, or a cab, or asked Maggie to drive him to the office (the family had, at long last, given in and bought an aqua blue station wagon). Ray was working diligently on a new novel, and the Wilshire Boulevard office provided him a quiet respite from the tapping of little feet above his basement office at home.

At this time, unbeknownst to Ray, the Federal Bureau of Investigation began looking into his possible involvement with the Communist Party. According to the FBI file, recently declassified through the Freedom of Information Act, the bureau began investigating Ray on April 2, 1959. Over the years, some of Ray's works—stories in *The Martian Chronicles* and *The Illustrated Man,* and, of course, *Fahrenheit 451*—had strong antigovernment overtones; Ray's public criticism of the House Un-American Activities Committee and of the McCarthy hearings also made him a target. It is worth noting, however, that in the FBI report, the bureau, like many journalists over the years, spelled Ray's name incorrectly: He is listed as "Raymond" Douglas Bradbury. The FBI's investigation, which included surveillance of the Bradbury house in Cheviot Hills, combed through Ray's past, searching for evidence that he was a member of the Communist Party. One anonymous informant advised the investigators that writers such as Ray were reaching a large audience through mass paperbacks and, consequently, were "in a position to spread poison concerning political institutions in general and American institutions in particular." The report cited several public speeches Ray had delivered in recent years that included comments critical of the U.S. government. It also took note of the November 1952 advertisement decrying the Republican Party that Ray had taken out in the *Daily Variety*. In the end, while the bureau had suspicions that Ray was a Communist sympathizer, the report concluded that "no evidences have

been developed which indicate he was ever a member of the CP." On June 3, 1959, the FBI closed its case on Ray.

Just a few months later, in the fall of 1959, Rod Serling's program, *The Twilight Zone,* premiered on CBS. The pilot episode, "Where Is Everybody?" aired on October 2. The plotline followed a confused astronaut who, after enduring isolation training on Earth in preparation for orbital space flight, finds himself inexplicably wandering through a desolate town, an amnesiac looking for any sign of life or even a sign of his own identity. After watching the program, Ray was shocked. "Where Is Everybody?," bore an uncanny resemblance, at least in his mind, to one of his own stories, published almost a decade earlier in *The Martian Chronicles.* In Ray's tale, "The Silent Towns," a reclusive man living in the blue hills of Mars emerges from his shack to find the planet completely evacuated. All the recent settlers had rocketed back to Earth to assist in the great atomic war raging back home. As the man walks the desolate streets of a Martian town, he is desperate to learn if he is truly the last person on Mars.

"When I saw the pilot episode of *The Twilight Zone,*" said Ray, "I thought, 'That looks a little bit like a story from *The Martian Chronicles.*' I didn't say anything to Rod. I was embarrassed." He assumed that it was an unintentional lifting of his concept.

A month later, remembered Ray, Rod Serling called him. "He said, 'Why didn't you tell me?' and I said, 'Tell you what?'" Ray related the phone conversation. "Rod said, 'That my pilot script was based partially on a story of yours in *The Martian Chronicles.*'" Serling told Ray that the previous night he had been reading in bed when his wife, Carol, who was immersed in *The Martian Chronicles,* turned to him and pointed out the similarities between "Where Is Everybody?" and "The Silent Towns."

According to Ray, Serling admitted over the telephone that he had inadvertently used Ray's concept—at least in part. He was calling to right the wrong. Ray said that Serling offered to buy the rights to "The Silent Towns," as an act of good faith. "I told him," said Ray, "'The very fact you called me and recognized what happened, that's it. Let's let it go.'"

Two weeks later, according to Ray, Serling called him again. "He

said, 'I can't stand it. I've got to buy your story. My lawyers will call you.'
Rod hung up and his lawyers never called," Ray said. "He shouldn't have
made the second call. He was off the hook. I let him off the hook. And
then he called and talked about his lawyers and they never called."

Shortly thereafter, on October 30, 1959, Ray noticed more narrative
similarities to his own work in the fifth episode of *The Twilight Zone,*
"Walking Distance." The nostalgic story followed a man who travels back
in time to visit his childhood town. The story at once evoked the mood
and imagery of *Dandelion Wine,* but, as *Twilight Zone* aficionados would
note, Ray Bradbury does not have a monopoly on tales of nostalgic
Americana. The episode even included the mention of a character, "Dr.
Bradbury," an apparent nod of appreciation from Serling. But Ray was
frustrated, feeling that Serling was liberally borrowing ideas, themes,
and concepts from his canon.

"On one level," wrote Christopher Conlon in the December
2000–January 2001 issue of *Filmfax* magazine, "Bradbury's frustration
with what he saw broadcast each week on *Twilight Zone* is perfectly un-
derstandable. The *Zone* is in fact drenched in Bradburian notions and
plot devices, and from the onset Serling himself was well aware of Brad-
bury's central place in mid-century fantasy fiction."

Even so, Ray wrote three teleplays for *The Twilight Zone*. The first
teleplay he submitted to Serling's Cayuga Productions was an adaptation
of his short story "Here There Be Tygers," first published in the 1951 sci-
ence fiction anthology *New Tales of Space and Time*. The story follows a
rocket crew to the distant Planet 7 in Star System 84 (a rare instance of
a Bradbury story set on a world outside of our own solar system). Planet
7 is Eden in outer space: beautiful, expansive, green, untouched. The
rocket crew soon discovers that the planet rewards their respect of its
ecology, by fulfilling their every thought: A creek flows with white wine;
the wind flies an astronaut like a drifting kite. But when one crew mem-
ber endeavors to exploit the planet for its rich natural resources, Planet
7, a living, breathing entity, decides to lash out. Thematically, "Here
There Be Tygers" was a perfect fit for *The Twilight Zone*. Serling was in-
tent on his show addressing social issues, and in his teleplay Ray was ex-
amining modern ecological concerns (well before the ecology movement
of the late 1960s and early 1970s). There was one problem with "Here

There Be Tygers." It would cost too much to produce; consequently, it was rejected.

The next script Ray presented for *The Twilight Zone* was "A Miracle of Rare Device," an adaptation of a short story that wouldn't appear in print for a few more years, in the January 1962 issue of *Playboy*. This time, Ray's script sold to *The Twilight Zone*. The tale followed two drifters, driving through the desert down an Arizona highway, who eye a stunning mirage in the far distance—a city rising out of the shimmering heat and the parched mountains. The two men decide to set up a viewing station, charging passersby twenty-five cents for a glimpse of the uncanny urban mirage. They soon discover that each viewer sees a different city: Paris, New York, Rome, even the mythical city of Xanadu. But one patron sees nothing at all and becomes intent on spoiling this place of vision and imagination for everyone.

"A Miracle of Rare Device" was scheduled for production but was never made. *Twilight Zone* scholars Presnell and McGee theorize that, once again, production costs likely played a role. The authors also present another theory, quoting Rod Serling: "Ray Bradbury is a very difficult guy to dramatize, because that which reads so beautifully on the printed page doesn't fit in the mouth—it fits in the head."

While Ray's difficulties with *The Twilight Zone* persisted, he was also, after a decade, seriously contemplating a change of publishers. Over the years, Ray had grown disenchanted with Doubleday, and he was having doubts whether the publisher should get his new book. He was truly fond of his editor, Walter Bradbury, who was instrumental in shaping *The Martian Chronicles* and *Dandelion Wine,* but he had never been impressed by Doubleday's marketing efforts and, as his agent, Don Congdon, complained, the company did not pay enough for Ray's books. These were the reasons, according to Congdon, that he and Ray were eager to sign a deal with Ian Ballantine for *Fahrenheit 451* and *The October Country*. Ballantine showed enthusiasm and an understanding that Ray's work far exceeded the science fiction genre.

The space race was blasting off, Sputnik had circled the globe, and it had ignited the collective imagination of people young and old around the world. People dreamed of traveling beyond the boundaries of our own little blue marble. Ray was confounded to learn that in a time when

periodicals like *Life, Newsweek, U.S. News & World Report,* and *Time* were all covering space exploration, one of the great paeans to pioneering outer space, *The Martian Chronicles,* was no longer available. Doubleday had let the book go out of print and Ray was livid. When he raised his grievances, the ever-agreeable Walter Bradbury made haste to put *The Martian Chronicles* back into print with a new introduction by writer Clifton Fadiman. Walter Bradbury had always tried his best to keep Ray appeased, but he was only one man. In 1959, when Walter Bradbury left Doubleday for an editor's post at Henry Holt and Company, Ray's relationship with Doubleday, after more than a decade, was in jeopardy. Ray expressed his concerns with his new editor at Doubleday, Tim Seldes, in a letter that reflected his acute awareness of the status of his career and also that of his growing popularity. Ray was lecturing on college campuses, and his work was beginning to be assigned and read in high school literature classes throughout the country. Ray knew full well that he was a name entity for Doubleday, and he took Seldes to task for his company's lack of support.

> . . . *As you know, I've been under contract to you people now for 11 years, as of this month. And while Walter Bradbury in his time, and you in yours, have been warmly responsive to my work, I have never felt the same enthusiasm existed throughout the Doubleday organization.*
>
> *So may I ask this of all of you—some time in the coming four weeks, at an editorial meeting, as a joint effort, I want you to think of my past books and my possible value at Doubleday in the next few years. I think a group decision has to be made now as to whether you find my books lacking and bid me goodbye.*
>
> *I have felt lonely at Doubleday, and often neglected, and want some of the individual attention and promotion given to other authors at smaller publishing houses. I have waited patiently, these eleven years, for Doubleday to exert influence in my behalf in many places in the book trade where I could use your good offices.*
>
> *My anxiety and un-ease have increased because of one simple fact: the Space Age is here. And Doubleday, I feel, has yet to realize that they own the leading writer in the field. In colleges and high*

schools throughout the country my name gets fantastic attention. Operas, one-act plays, and films are being made of my work everywhere. Immodest of me to mention this, but the enthusiasm is there, and must be noted.

What do I ask of Doubleday, in the light of all this? A blueprint of my future, set down in detail, jointly, by you people . . .

While Ray felt that Seldes wanted him to remain at Doubleday, he believed the other decision makers at the New York publishing house did not. He felt they did not understand or care about the value of the nascent Space Age. They were being myopic and could not connect Ray on a marketing level to the new race against the Russians to break the bonds of Earth's atmosphere, to challenge the laws of Mother Nature, to explore the great unknown. Ray Bradbury saw himself, perhaps immodestly, as a spokesperson for this new era.

Ray consulted with his one great confidant, Don Congdon. "In all his years as an agent," Ray said in a 2004 interview, "he never steered me wrong." After discussions with Congdon and Maggie, Ray wrote Seldes with a decision.

After eleven years, I think it is time for me to leave Doubleday and to try to find a new publisher who will see me and this fantastic and exciting new Space Age with the same high-spirits in which I approach it. I feel very much like a person who, throwing confetti, serpentines, and my hat to the sky, finds he is the lone celebrant at a party. I need a whole company of people to celebrate and be really excited with me about an age I believe is the greatest man ever lived in.

And with that, Ray Bradbury left the publishing house that he had joined, with just one book to his credit, in 1949.

A new novel was fast taking shape, its origins, like a lot of Bradbury tales, going back several years. Ray was crafting a classic tale of good versus evil, a story, he said, that he "wanted to take place almost entirely at night, in the shadows." The book was *Something Wicked This Way Comes.*

As with many Bradbury tales, the inspiration for *Something Wicked This Way Comes* dated back to Ray's formative years in Waukegan, Illinois. Mining his childhood was a time-tested technique for generating stories. The concept for this new novel was no different. It began with Ray's recollections of running with his brother, Skip, near the shoreline of Lake Michigan. They loved to watch as the circuses and carnivals came into town; before dawn locomotives and trucks lumbered down the streets toward the lake and, more than once, the brothers witnessed the arrival of these night caravans.

"We used to run down Washington Street," recalled Skip, "clear down to almost the beach, and we used to watch the trains come in and the men would unload the elephants and the zebras and the other animals. Sometimes we'd do chores, help carry things or unload things, and we'd get free tickets."

Sometime in the mid-1940s, Ray began writing about late-night freight trains, trucks, and dusty canvas tents pitched before sunrise. It was an enigmatic world of magic, amusement rides, and freak show characters lurking in the shadows; a world of flashing lights, moaning calliopes, and sweet-smelling candy and popcorn. It was a world that Ray Bradbury loved.

As Ray recalled, he had initially planned a short story for his first collection, *Dark Carnival,* titled "Carnival," but it was cut from the final manuscript of the book. Even before the collection *Dark Carnival* was published by Arkham House, Ray had conceptualized a novel titled *Dark Carnival,* about a carousel that sent its riders back in time. The story fragments of *Something Wicked This Way Comes* were taking shape more than fifteen years before the book would finally be published.

The wicked carnival concept appeared again, in the 1948 *Weird Tales* short story "Black Ferris," the last story Julius Schwartz sold for Ray. "Black Ferris" followed a sinister carnival worker riding a Ferris wheel backward in time to become a boy once more—a little boy with malicious intentions who could later climb back on the amusement ride, run it forward, and return to adulthood and anonymity, safe from his youthful indiscretions.

The primordial fragments of *Something Wicked This Way Comes* continued to coalesce when, in 1952, Ray spied Joe Mugnaini's rendition of

a shadowy Renaissance circus train in a Beverly Hills gallery. The two men discussed turning the evil carnival concept into an illustrated book, but it never came to fruition.

In 1954, as Don Congdon was selling more Bradbury story rights to the growing television market, producer Sam Goldwyn Jr. purchased "Black Ferris" for six hundred dollars. The episode aired as a series pilot for the NBC television program *Sneak Preview* on July 10, 1956, under the less foreboding title "Merry-Go-Round." But before the program aired, Ray read the teleplay that Goldwyn had contracted out to another writer, and became inspired. He suggested to Goldwyn that the concept had legs, that he could easily expand it into a feature-length screenplay. Purely on spec, for no money, Ray drafted a script titled *Long After Midnight*, about an evil carnival rolling into a small American town. As with his Mars stories of the 1940s, which evolved into *The Martian Chronicles;* as with the "five ladyfinger firecracker" short stories that set the stage for *Fahrenheit 451,* the various pieces of Ray's carnival premise were coming together. He was unconsciously bringing *Something Wicked This Way Comes* to life.

The final, major catalyst for the novel occurred during the summer of 1955 when Ray and Maggie attended a preview of a new Gene Kelly film, *Invitation to the Dance*. Ray had met the actor through writer Sy Gomberg, who was working at Universal as Ray was writing *It Came from Outer Space*. Ray was an avid Kelly fan and considered *Singin' in the Rain* among the greatest films ever made. Likewise, Kelly was a Bradbury fan and had asked Gomberg to arrange a meeting. By 1955, Ray and Kelly, though not friends, were good acquaintances, and Kelly invited Ray and Maggie to a preview of *Invitation to the Dance* at the MGM Studios in Culver City, which was a few miles from their house. Ray found the film flawed, but its ending reminded him of the unrequited love themes in the Lon Chaney films he had loved as a boy.

After watching the picture, Ray left, inspired. He and Maggie waited at a nearby bus stop for the trip home, but the bus never arrived. They decided to walk, and along the way, Ray talked excitedly about working with Gene Kelly, writing a screenplay for him. Maggie suggested to Ray that when they arrived home, he head straight downstairs to his filing cabinets. Certainly there was a story buried in there that Ray

could adapt into a Gene Kelly vehicle. When Maggie said this, Ray knew right away what story that was—his screenplay *Dark Carnival*.

The next day, Ray sent the script to Gene Kelly, who was enthusiastic about the idea of working together. He liked the script as both a potential acting and directing project. "Gene was moving more into directing at that stage," recalled Ray. Realizing that the script was too "off-trail" for a Hollywood studio, Kelly decided to find financial backing for the film overseas; he flew to Europe. The renowned actor, director, and dancer promised Ray that he would get back to him in short order. In a few weeks, he would know whether he could secure the funds to produce the motion picture. By September 1955, Kelly returned stateside without the financial backing to produce Ray's carnival concept. He was disappointed and apologetic. "I was flattered that Gene even tried," said Ray.

Of course, the genesis of *Something Wicked This Way Comes* evolved, even though Kelly failed to find funding to make the film. By the late 1950s, the idea had developed from "The Black Ferris" short story into the feature-length script *Dark Carnival,* and at this point Ray set out to turn it into a novel. Early on, he wrote the book in the first person. It told the story of two boys living in a small Illinois town who are the only ones to comprehend that a recently arrived carnival is more than it appears.

Along with the other misgivings Ray and Congdon had about Doubleday, editor Tim Seldes had expressed only lukewarm interest in Ray's new book. It was the final step in pushing Ray to leave. After Ray parted company with Doubleday in 1960, Congdon began shopping *Something Wicked This Way Comes* to new publishers. It took him no time to interest Simon & Schuster, the company he was with when he first met Ray Bradbury. By the end of 1960, Ray Bradbury had signed on with Simon & Schuster to publish his next book. While Ballantine Books (publisher of *Fahrenheit 451* and *The October Country*) had always been supportive, they didn't have the financial muscle to market Ray that Simon & Schuster did. His new editor was Bob Gottlieb, and from the beginning, Ray felt renewed. His editor was energetic, and the publishing house showed excitement at the notion

of bringing Ray Bradbury to a much larger, more mainstream audience.

On the home front, he and Maggie enrolled in an evening adult education course at the University of California. Two nights a week, they went to the Westwood campus to study the history of Renaissance arts, politics, and culture. Their appreciation of the Renaissance era had been fueled by their friendship with Bernard Berenson. Ray and Maggie, in their spare time, loved nothing more than to pontificate about these subjects, and during these years and the decades to come, despite Ray's grueling work schedule or any personal matter between them, the two would indulge in these kinds of activities, whether it was an evening course or a European trip, always enriching themselves.

Meanwhile, Ray's relationship with Rod Serling and *The Twilight Zone* continued to spiral ever downward. The third and final teleplay Ray wrote for the series, "I Sing the Body Electric!," had actually sold and gone into production. The story followed a family of children who had recently lost their mother, and their father, looking to find a surrogate, purchases a robotic grandmother.

"I was very excited about it," Ray said in a 1972 interview. "I asked Mr. Serling if I could count on it being filmed exactly as I had written it, as had always been the case with Hitchcock, and he assured me that it would be."

But when Ray watched the episode the night it aired on May 18, 1962, he found that Rod Serling had not kept his word. "They cut out the most important part of the story," said Ray. "The moment of truth in the story when the grandmother tells them that she is a robot."

Ray was livid, but he said nothing to Serling. Trying to move beyond the negativity, he turned his attention to his forthcoming novel. At least he had that to celebrate. Simon & Schuster published *Something Wicked This Way Comes* in September 1962. With its origins as a screenplay, this new book reflected the influence of cinema on his writing. *Something Wicked This Way Comes* was a tale of good versus evil, encompassing themes of age and mortality, told through a cinematic narrative. And just as the book's structure and gothic descriptions showed Ray's love of film, the very premise of an evil carnival arriving at the end of October,

carrying with it the mysterious "autumn people," highlighted Ray's life-long love affair with circuses and carnivals.

In an unpublished *Paris Review* interview, Ray summed up the popular culture influences on his life: "A conglomerate heap of trash, that's what I am," he said with a laugh. "But it burns with a high flame."

22

THE AMERICAN JOURNEY

> *His gift of provocative thought on the human condition through the medium of science fiction stands as a beacon of light for writers of the genre. No wonder Gene Roddenberry held him in such high regard . . . and named a Starship the USS* Bradbury *in his honor.*
>
> —NICHELLE NICHOLS, *original* Star Trek *cast member*

"IN 1962, two men appeared at the front door," said Ray. "I answered the door and they introduced themselves. They represented the United States Pavilion at the New York World's Fair, which was beginning to be built and was going to open in two years. They said, 'Mr. Bradbury, we're here to give you a fifty-million-dollar building.' I said, 'Come in, come in!'"

It was yet another full-circle opportunity for Ray Bradbury, who had wandered the pavilions of the Chicago World's Fair as a boy. It also portended a new, burgeoning role for Ray—as cultural consultant for the rocket age. In 1933 and again in 1934, when he was just a boy, Ray had visited the Century of Progress World's Fair along the lakefront in Chicago. During these trips, a lifelong, passionate interest in architecture developed. "[I] walked among the cities of the future," he said, "with

all the wonderful colors and shapes and sizes and when it came time to go home that night . . . I didn't want to leave. My mother and father had to drag me out of the fair and they were taking me away from the buildings of the future. So I went home and I started to build those buildings in the backyard. Very dreadful cardboard cutouts. But I began to make outlines for cities of the future when I was fourteen. And I began to write. Because I discovered a remarkable and terrible thing about the Chicago World's Fair, that after two years, they were going to tear most of it down, and I thought—how stupid, not to leave the future up and build toward it. So, since they were going to tear down the future, I began to write about it."

In the summer of 1939, when Ray visited the New York World's Fair and saw its marvelous constructions, he found his "beliefs in architecture and the buildings of the future reaffirmed again." It was the night of July 4, 1939, and World War Two would soon begin. "I was afraid for the future," he recalled. "I was afraid that none of us would live to inhabit those buildings."

Now, in 1962, two men stood in the foyer of the Bradbury house in Cheviot Hills with a firm offer. They wanted Ray to serve as a consultant for the United States government exhibit at the upcoming World's Fair, to be held in New York. In just under thirty years, Ray had gone from little boy, awestruck by world's fairs, to American icon, consultant for world's fairs.

Ray had also become an unwitting armchair astronaut. Prior to his leaving Doubleday in 1960, he had agreed to assemble two collections of his previously published tales of fantasy and science fiction that would appeal to the young adult market. They would serve as "greatest hits" packages for kids. The majority of the stories, given the new cultural interest in all things outer space, would be Ray's fanciful tales of rocket ships and space travel, with a few dinosaur tales and childhood memoir yarns thrown in for good measure. The first of this two-book agreement, *R Is for Rocket,* was released in October 1962. The timing of the book was perfect, arriving just as the space race between America and the Soviet Union was heating up. The second book—Ray's last with Doubleday—was another "Best of" collection, entitled *S Is for Space.* It would be published later, in August 1966. Both books, it is worth noting, were

targeted to the juvenile market but, as a result of the strength of the stories, reached a much broader audience.

Even as *R Is for Rocket* was being readied for publication, Ray wrote an acclaimed essay for *Life* magazine about the Space Age, titled "Cry the Cosmos." Ray had become an unofficial spokesperson for this new, exciting era of space exploration.

Meanwhile, the power brokers planning the U.S. Pavilion for the 1964 World's Fair had read Ray's introduction, "The Ardent Blasphemers," to a new edition of the Jules Verne classic *20,000 Leagues Under the Sea*. In the piece, Ray compared two mad sea captains, Herman Melville's Ahab (about whom Ray knew a thing or two) and Jules Verne's Nemo. Within the essay, said Ray, "I described the history of the United States in terms of a certain kind of wildness and blasphemy." Because of this introduction, Ray was asked to write a short program for the top floor of the U.S. Pavilion. He readily accepted the assignment, agreeing to write the script for the educational display, about the history of the United States, titled *The American Journey*. Spectators were carried along a moving platform through the darkened pavilion, past movie screens of various sizes. The story was told through film, with Ray's narrative, and augmented by three-dimensional props. *The American Journey* was accompanied by a recording of a full symphony orchestra. The entire thing was a big, bold precursor to Walt Disney's EPCOT Center, and Ray had envisioned it all: the visuals, music cues, the narration.

Ray was venturing into yet another province of popular Americana, but he didn't stop there. He began working in the world of animated films. Writer George Clayton Johnson, a friend of Ray's who was just beginning as a writer for *The Twilight Zone*, had read Ray's short story "Icarus Montgolfier Wright," about humankind's dream of flight. The story was first published in the *Magazine of Science Fiction and Fantasy* in May 1956, and collected shortly thereafter in *A Medicine for Melancholy*. Johnson approached Ray with the idea of adapting the story into a short animated film. Ray loved the idea, Johnson wrote the script, and Ray polished it.

Ray and Johnson shopped the short screenplay and quickly got backing from Format Films, an animation studio run by Joel Engel, formally of Disney, along with his partner Herb Klynn, an animation pio-

neer who had worked on *Mr. Magoo* and *Madeline,* among others. Ray tapped his longtime friend and illustrator Joe Mugnaini to work on the art. Mugnaini, working pro bono, spent a year animating the twenty-minute film, creating hundreds of colorful watercolor paintings.

Meanwhile, Johnson had written a teleplay for *The Twilight Zone,* which he titled "Nothing in the Dark." Once again, Ray felt that the story smacked of one of his own tales, "Death and the Maiden," which had run in the March 1960 issue of the *Magazine of Fantasy and Science Fiction.* Ray's work with Johnson on *Icarus Montgolfier Wright* had concluded, but he was convinced that Johnson had adapted "Death and the Maiden" without giving him proper credit. Both stories dealt with Death disguising himself and paying a call on a suspicious woman. According to Ray, Johnson denied any plagiarism charges; their friendship, not surprisingly, was irrevocably damaged. In an interview for Gordon F. Sander's 1992 biography of Rod Serling, *Rod Serling: The Rise and Fall of Television's Last Angry Man,* Johnson acknowledged the author's profound influence on him and *The Twilight Zone* series, going so far as to admit stealing from Bradbury.

"I think that a lot of Bradbury was used in *The Twilight Zone,*" Johnson said. "A lot of his most unique and most Bradburian ideas were common property. The field was so heavily marked by Bradbury there was no way Serling could walk across it without stepping in some of Bradbury's footprints. I stole from Bradbury. . . . We all stole from him. Bradbury was the seminal influence."

To this day, Serling and Bradbury fans disagree over what truly occurred. Serling's supporters maintain that the similarities between Ray's stories and *The Twilight Zone* episodes he claims were plagiarized are nothing more than tenuous at best. There is the theory that Ray Bradbury, the recognized master of dark fantasy, was having trouble getting his scripts produced while younger writers, some of them friends of Ray's, were having great success with the program. Some theorize that this upset Ray's ego. Ray's fans see otherwise. Ray, when asked how to counter the naysayers, pointed back to the conversation he had with Serling after the airing of *The Twilight Zone* pilot: Serling admitted that he had inadvertently stolen from *The Martian Chronicles* and offered to pay Ray for rights.

WHEN OSCAR nominations were handed out for 1962, *Icarus Montgolfier Wright,* the film Ray cowrote with George Clayton Johnson, was named to the list for best animated short subject. Ultimately, the film lost to *The Hole,* a short film about two New York construction workers pondering the subject of nuclear proliferation.

BECAUSE RAY was an efficient creator, he was able to work on several projects simultaneously and still have time for his wife and children. As Maggie adored warm weather, the Bradburys took their annual summer vacations on Coronado Island, near San Diego, where they stayed at the Hotel Del Coronado, an old, opulent Victorian retreat. The four blond Bradbury girls loved running barefoot across the warm white sand beaches, across the dew-covered patches of Bermuda grass that surrounded the hotel, and under the shadows of the dozens of palm trees on the property. These were unforgettable days, filled with laughter and a robust sense of family. Ray was an energetic, doting father, even if he left most daily parenting responsibilities to Maggie.

Halloween was always another special time in the Bradbury house. Ever since he was eight years old, Ray had loved it. His aunt Neva would often pile him and his brother, Skip, into her Tin Lizzie, a Model T Ford. With Neva behind the wheel and the two boys in the backseat, the car would rumble west of Waukegan into farm country. The trio would collect pumpkins and sheaves of corn from the October fields and come home to decorate Ray's grandparents' house. Indeed, Halloween was almost better than Christmas in many ways in the Bradbury house, and because Susan's birthday was on November 5, Ray and Maggie often combined the two events, throwing boisterous parties with a Halloween theme in her honor. Ray would also take his daughters out trick-or-treating, frequently donning a mask of his own. They would tirelessly

roam their neighborhood, occasionally knocking on a door of a Holly-wood celebrity like Barbara Billingsley, the mother in the television program *Leave It to Beaver*. The morning after Halloween, the girls would often find that their father had raided their candy stashes, absconding with his favorites.

More than anything, Ray loved taking his girls to the movies. They watched everything: Westerns, Saturday matinee horror films, Japanese movies with badly dubbed dialogue (Ray was especially fond of the films of director Akira Kurosawa). They saw *House of Wax* at Graumann's Chinese Theater; *One Million Years* at the Picwood; *Camelot* at the Cinerama Dome. "Often after," remembered Bettina Bradbury, "we would go out for ice cream at Baskin-Robbins or hit one of the magazine stands in Hollywood and Dad would let me buy all the *Archie* and *Little Lotta* comics I wanted. We'd ride home in a yellow cab and I remember leaning on his shoulder and thinking to myself: Life doesn't get much better than this."

The taxicab was a ubiquitous fixture of growing up a Bradbury. On days when Maggie could not drive the girls to school, Ray called for a cab and rode with his daughters. Embarrassed, the girls demanded to be dropped off blocks from school so that classmates did not see their mode of transportation.

One afternoon in the early 1960s, Ray was walking his daughters down Hollywood Boulevard when they passed a magic shop; through the storefront window Ray spotted a ghost from his past—Blackstone the Magician. The Bradbury girls were, of course, well familiar with Blackstone, having heard bedtime stories of their father's fictional childhood adventures with the magician. But the girls believed the stories to be true, and so Ray told them to wait outside the magic shop for a moment. He walked in and approached the nearly eighty-year-old magician.

"Mr. Blackstone," Ray said, "the last time we met was when I stumbled onstage at the Orpheum Theatre in 1937, to help you with your canary cage. My daughters think I know you better than I really do, because I've told them stories about you for the last two thousand nights. Can I bring them in?"

Blackstone laughed and said of course, but before Ray ushered his girls inside, the old magician asked Ray his name. Ray then shepherded the girls into the magic shop.

"Ray!" cried Blackstone. "It's been so long! Great to see you again!" The Bradbury girls were awestruck. For the next thirty minutes, they watched with wonder as the elderly illusionist vanished cards and made handkerchiefs dance on air.

While it couldn't have been easy for Maggie to have a husband running wild with much the same mind-set as the children, in her later years, she was always very proud of her husband's relationship with their daughters. "Ray was a terrific father and the girls just adored him," Maggie said.

RAY PREPARED another short-story collection for release in February 1964. *The Machineries of Joy,* published by Simon & Schuster, featured twenty-one stories, including "Death and the Maiden," as well as "To the Chicago Abyss," "Tyrannosaurus Rex," and the Ireland-inspired tales "The Beggar at O'Connell Bridge" and "The Anthem Sprinters."

In April, the 1964 World's Fair opened to much fanfare. The theme of the global celebration was the Space Age. The slogan of the fair was "Man in a Shrinking Globe in an Expanding Universe." The fair featured 140 pavilions, built on the site of the 1939 celebration in Flushing Meadows, New York. For the grand opening, Ray traveled once again across the country by passenger train. This time, his two youngest daughters, Bettina and Alexandra, accompanied him. Maggie would join them later, choosing to fly with Susan and Ramona. One night, as the train sped through the woods of Pennsylvania, Ray looked out the window and couldn't believe his eyes. Beyond the window was a solid river of flowing green phosphor, moving, twisting, headed somewhere, nowhere, anywhere far into the night. It was a river of hundreds of thousands—perhaps millions—of fireflies. He shook Tina and Zana awake.

"Girls, you have to see this," he said.

The sleepy little girls in their pajamas rubbed sleep from their eyes and looked out the window.

"I was just five, but I still remember it clearly," said Alexandra Brad-

bury. "There must have been millions of fireflies. How could you forget something like that? It was just amazing." It was a special, beautiful memory for father and daughters.

At the fair, the family was reunited. Stan Freberg, the popular satirist, whom Ray had met two years earlier at a Hollywood party, also met up with the family. Ray and Freberg had become fast friends and would remain so for the rest of their days.

While the World's Fair, with all of its technology and gleaming architecture of the future, was wondrous to behold, in Ray's estimation nothing would ever compare to the late-night light show provided by a sea of fireflies somewhere in Pennsylvania.

SHORT STORIES. Novels. Radio. Television. Movies. Comic books. Animated films. World's Fair exhibits. What was left to do?

Theater.

Ray's relationship with the theater world had begun on a Tucson, Arizona, school stage in 1932 when he was twelve. That was when Ray realized that he loved the glare of the spotlight. From that point forward, he was as comfortable in front of an audience as he was in front of his typewriter—a natural-born ham, as he would describe himself. In 1939, he had barnstormed his way into Laraine Day's theater group, the Wilshire Players, and his love of theater deepened.

Ray's next venture into the theater began in the summer of 1955, when Broadway producer Paul Gregory and actor Charles Laughton approached him to write a stage version of *Fahrenheit 451*. Ray was a big Laughton fan, and was eager to tackle writing for the stage, but by year's end, with a completed script in hand, Gregory and Laughton took their writer for drinks with some bad news. With Ray sufficiently liquored up, the two men kindly informed him that the *Fahrenheit 451* script was dreadful. Ray, musing years later, felt that he adapted the book too literally for the stage, and it obviously failed. However, Ray had forged a

close friendship with Charles Laughton, one that would continue until the actor's death in 1962.

A few years later, Ray decided to try writing for the stage again, this time adapting his Irish stories into one-act plays. He wrote "The First Night of Lent," a story of the Irish cabdriver who drove him between Dublin and Kilcock as he was writing the *Moby Dick* screenplay. Ray also drafted "The Anthem Sprinters," about the Irish who, under British rule, madly flee movie theaters at the ends of films before the English national anthem strikes up. In 1959, Ray's friend writer and producer Sy Gomberg approached Ray about the scripts. Gomberg invited him over to his house for an informal reading, to see if Ray's new theatrical endeavors were any good. When Ray arrived at Gomberg's home, actors James Whitmore (who had acted in Ray's first radio drama, "The Meadow"), Strother Martin, and a few others were there to read Ray's scripts. If these fine actors, who were reading his work for the first time, could not make the plays sound good, they would all know it immediately. To Ray's amazement, as the actors who had gathered in Gomberg's living room started to read his plays, the group was laughing and having a grand time. Ray's confidence soared, and he continued to write the occasional play. Whitmore reprised his radio role in "The Meadow," as part of three one-act plays titled *Three for Today*, staged at the Huntington Hartford Theatre, a small space in Hollywood.

Ray held more informal readings with local actors and friends, and he joined an amateur theater group that convened at the Desilu Theater, owned by Lucille Ball. As Ray remembered it, Ball rented the space to the theater group free of charge. Ray had recently written an adaptation of his "The Pedestrian," but the group found the script a difficult one to bring to the stage. The task was given to a young actor/director named Charles Rome Smith, an original cast member during the seven-year Broadway run of the popular show *The Threepenny Opera*. Smith knew Ray's work and accepted the challenge. In June 1963, the group staged a run-through of "The Pedestrian," and Ray loved it. More important, he loved that Smith hadn't flinched from adapting work that had been deemed difficult to stage. Ray and Smith staged more of his plays at Desilu. And then, in 1964, they decided to form a partnership, The Pandemonium Theatre Company. Ray would fund the operation and write all

the plays, and Smith would serve as producer and director. By October 1964, they had leased the Coronet Theatre in Los Angeles and opened *The World of Ray Bradbury*, which included dramatizations of "The Veldt," "The Pedestrian," and "To the Chicago Abyss." The play premiered on October 8 and received resounding reviews by local theater critics. It was the beginning of The Pandemonium Theatre Company, a passion of Ray's for the rest of his life. It was also the beginning of a close friendship and partnership with Smith, who would continue to direct many of Ray's plays over the course of the coming decades.

THE 1964 CHRISTMAS holiday season was in full swing in Beverly Hills—palm trees and twinkling lights, Santa Claus and Santa Ana winds—and Ray was shopping for gifts for his family. He was cutting through a department store crowd when, through the hustle and bustle, he saw Walt Disney. To Ray it was as if, for a brief moment, time slowly ground to a halt; he considered Disney to be one of the great imaginative men of the twentieth century. In 1929, seeing *The Skeleton Dance* at the Genesee Theater in Waukegan, Ray had marveled at Disney's talent. Then, in the summer of 1940, Ray's opinion of Disney was magnified tenfold when he and Neva saw *Fantasia,* a film that would be counted as one of his favorites.

Disney was holding boxes of Christmas gifts, one stacked upon another, piled up to his chin. He was dressed, as ever, in a classic 1960s tailored suit and skinny tie and sported his famous pencil-thin mustache.

Ray rushed up to him to introduce himself.

"I know your books," Disney responded, matter-of-factly. Ray was thunderstruck. Walt Disney knew his work!

"Thank God," Ray said, finally.

"Why?" Disney said.

"Because," Ray replied, "someday soon I want to take you to lunch." Disney smiled. "Tomorrow?" he offered.

The next day, Ray visited Walt Disney's office at the Disney studio in Burbank. For a child of imagination, nurtured in part by the animated films of Walt Disney, it was like visiting Saint Nick at the North Pole. At Disney's office, the keeper of the gate, his secretary, gave Ray a stern warning. Ray had one hour, after which he had to leave. Disney was a busy man and there would be no monopolizing his time. The first meeting between Ray Bradbury and Walt Disney was wonderfully understated—soup and sandwiches served atop a card table in Walt's office. The two men talked about their work, their ideas, and then discovered that they shared a common sorrow. In discussing the history of world's fairs (just like Ray, Disney had contributed to the 1964 fair), they both lamented the tragic, even ridiculous fact that when these global celebrations closed, all the wonderful buildings, all the architecture of tomorrow, all the pavilions, transports, amusement rides—*everything*—was demolished. Walt Disney had an idea for a cure to this pain that he shared with Ray: a year-round world's fair that, once built, would never be torn down. (To the contrary, it would never be completed.) Ray loved the idea. But for Walt Disney, it was a long way from becoming a reality. His concept of a year-round world's fair was, at this juncture, still just a vision. When realized, it would feature all sorts of pavilions, fusing education and entertainment, and comprise exhibits from cultures spanning the globe. This grand dream of Walt Disney's would be called the Experimental Prototype Community of Tomorrow: EPCOT.

When Ray's hour was up, he stood, ready to leave, but Disney said, "Wait! I have something to show you." Disney took Ray out to the studio lot, and gave him a walking tour. Inside a vast workshop, he showed Ray a series of unrecognizable spare robot parts, built for a display that would feature the world's first audioanimatron, a perfect, fully functioning likeness of Abraham Lincoln that could sit, stand, and speak. Of course this concept sent Ray's imagination into hyperdrive. He wondered aloud what would happen if an assassin came in and murdered the robotic Abraham Lincoln. Disney liked Ray's idea so much that he told him to go home and write a short story, right away. (Ray did just that; the result was "Downwind from Gettysburg.")

By the time the tour was over, Ray had stayed with Disney well beyond the time allotted him by the secretary. She looked at Ray accusingly,

tapping her wrist. Ray pointed at Disney and cried, "He did it!" It was an incredible afternoon. After all, it was not every day one is given a personal tour of the Disney studio by none other than Walter Elias Disney himself.

Ray never visited Disney at home, and they never met socially. But every so often, the two men got together for a meeting of their mutual admiration society. In what would be one of their last lunches together, Disney expressed his gratitude to his comrade-in-all-things-fantastic. Sitting at the card table in his office, Disney leaned forward and asked if he could do anything for Ray. Ray only hesitated for a moment. He knew what he wanted: an original piece of Disney memorabilia. When he asked Disney to "open the vaults," Disney certainly did, for Ray left the studio that afternoon with an armful of original animation cels—frame-by-frame paintings from some of Disney's greatest cinematic achievements, including *Dumbo, Bambi,* and *Sleeping Beauty.* In the mid-1960s, there was certainly no market for animation cels; very few people cared about them. Ray Bradbury did, not for their monetary value, but out of love for Walt Disney and his genius. The two men remained friends until Disney's death on December 15, 1966.

Many decades later, in the living room of the Bradbury house in Cheviot Hills, one of Ray's framed acetate cels rests on a bookcase shelf. It is a beautiful painting, rendered on clear acetate, with Walt Disney's stamp of approval visible in the lower right-hand corner. It depicts a timeless scene from *Snow White and the Seven Dwarfs,* the moment the wicked stepmother hands the poison apple to Snow White.

ON THURSDAY, January 13, 1966, production began on François Truffaut's adaptation of *Fahrenheit 451.* The French director had purchased the rights to the Bradbury novel four years earlier, on July 19, 1962. It would be the director's first English-language picture, his first color film, and it would star Oskar Werner and Julie Christie. Briefly, Paul Newman had agreed to play fireman Guy Montag, but the star, citing "creative

differences," withdrew from the project; he felt that the novel's social and political commentary should have been heightened in the screenplay.

Truffaut had initially considered changing the title from *Fahrenheit 451* to *Phoenix,* to give it a more international appeal, but in the end he remained faithful to Ray's title. From the beginning, it was a troubled and difficult project. Due to the exorbitant costs required to make a film of this nature, there were at least six producers attached to the film before it finally got made. Four screenwriters wrote four different drafts of screenplays. Casting disagreements persisted throughout the planning of the film. For a time, Terence Stamp was set to play Montag, with Jane Fonda as Montag's wife; both Max von Sydow and Peter O'Toole were considered for the role of Captain Beatty.

Truffaut decided to cast actress Julie Christie in the dual roles of Clarisse McClellan and Montag's wife, Mildred (renamed Linda for the film). "Using Julie Christie," the director wrote in a letter to actor Terence Stamp, "allows me to solve the eternal problem of the thankless part versus the glamorous part, show two aspects of the same woman, and also prove visually that for most men, wife and mistress are the same." It was a risky artistic decision, one that Ray Bradbury criticized later on. "Clarisse needed to be much younger," Ray said, adding that the casting was just plain confusing. Furthermore, Truffaut's interpretation of Clarisse McClellan was far from the author's. Truffaut envisioned the character of Clarisse as being older and more seductive, which irked Ray, who never intended any sexual tension between his characters Clarisse and Montag.

When François Truffaut first read the Bradbury book in 1960, he was immediately moved by it. During production, he maintained that if he accomplished anything, he wanted his film to bring more attention to the book. The director even declined two offers from writers looking to publish books on the making of *Fahrenheit 451*. "[W]henever I work from a novel," the director wrote in 1966 in his journal, "I feel a certain responsibility toward the author. Whether it comes off or not, whether it is faithful to the book or not, the film of *Fahrenheit 451* should only favor the sales of one book, the book from which it was taken. A book about the making of the film would only create confusion with Bradbury's."

Because of logistical and financial turmoil, it took three and a half

years for cameras to begin rolling on *Fahrenheit 451*. Principal photography on *Fahrenheit 451* lasted three and a half months. Throughout, the relationship between Truffaut and actor Oskar Werner degenerated dramatically. Tensions began two weeks into the shoot. Werner had felt that a flamethrower used for a scene had been dangerously mishandled behind his back, and an argument ensued between lead actor and director. The relationship never recovered. Both men held widely divergent opinions on how the character of Guy Montag should be portrayed. Werner championed playing the lead character as a classic movie hero, while the director clearly was uninterested in heroics. "I'll never be able to film courage," he is quoted as saying in Antoine de Baecque and Serge Toubiana's book, *Truffaut: A Biography*, "probably because it doesn't interest me." Truffaut felt that Werner was being a prima donna. By the end of shooting, Truffaut and Werner were barely on speaking terms. "We must put up with each other until the end of April," Truffaut told the actor. "It isn't the film you envisioned and it isn't the film I envisioned, it's somewhere in between, and that's the way things are. Now if you don't like the scene the way I'm filming it, you can just stay in your dressing room and I'll shoot without you or use your stand-in."

As production came to a close, the icy relations between Truffaut and Werner had frozen solid. Werner went so far with his disdain of Truffaut and his vision that he had his hair cut to destroy continuity in the film. Werner claimed he had fallen asleep in the barber's chair, but Truffaut suspected otherwise.

On November 2, 1966, *Fahrenheit 451* opened in New York. *New York Times* writer Bosley Crowther summed up the opinion of most critics in this November 15, 1966, review:

> If François Truffaut were trying to make literature seem dull and the whole hideous practice of book-burning seem no more shocking then putting a blow-torch to a pile of leaves, he could not have accomplished his purpose much better than he unintentionally has in his first motion picture made in English, Fahrenheit 451.
>
> Holy smoke! What a pretentious production he has made of Ray Bradbury's futuristic story. . . .

FURTHER ESTABLISHING Ray's role as unofficial spokesperson for the Space Age, *Life* magazine assigned him to write a story on the Apollo program, the astronauts, and the uncharted territories of outer space. On the morning of January 13, 1967, Ray arrived in Houston, Texas (ironically and predictably by passenger train), to witness firsthand where humankind, with all of its chutzpah, was headed. After Ray checked into the Nassau Bay Motor Lodge, a representative from the National Aeronautics and Space Administration came to drive him to the nearby Johnson Space Center. Right from the start, Ray encountered fans. One of the first NASA administrators Ray met told him that his favorite book was *Dandelion Wine*. Ray spent the afternoon touring the NASA facilities, taking in the vast technologies: flight simulators, lasers, flight suits, and the centrifuge, in which astronauts were exposed to g-forces.

That evening, Ray dined in Houston with astronauts Jim Lovell and John Young, Richard Gordon and Pete Conrad and their wives. "Gordon and Young have qualities of Buck Jones, Bob Steele, Tom Mix about them," Ray wrote in his notes. "They are short, compact men, economically built. Young is shy, Gordon more direct, but there is the familiar echo of the intellectual cowpuncher here. Something out of my own memory perhaps. Conrad is the clown of the bunch, much fun to watch and listen to. Lovell very friendly and easy and the proverbial host."

In the days that followed, while visiting the Johnson Space Center, Ray attended a press briefing. He sat in the back of the conference room as one by one the young horses were trotted out—nearly sixty Apollo astronauts, as Ray recalled, the primary teams and the alternates. They were all present: Armstrong, Aldrin, Grissom, Lovell. They were clean-cut kids, all-American types, with blindingly white smiles and military crew cuts, and courage taller and mightier than the Saturn rockets they would ride on. When someone in the room announced that Ray Bradbury was present—Ray Bradbury, the author—at least half of the astronauts looked up, alert, scanning the room excitedly. Several of them approached Ray after the conference. As young dreamers with imagina-

tions fixed squarely on the stars, many of them credited Ray, and specifically *The Martian Chronicles,* as an early inspiration. Ray suddenly found himself surrounded by American heroes, who were worshiping him. The kid from Green Town—Buck Rogers, as so many in the literary community had disparagingly deemed him—had done good. As Ray shook hands with all the astronauts, a line from one of Ray's favorite films, *Things to Come,* based on the H. G. Wells story of the same name, came to him: "Which shall it be, the stars or the grave?"

Ray spent a week in Houston, touring mission control and chatting it up with John Glenn. When the week was up, Glenn even offered to personally fly Ray Bradbury home in a private jet. Of course, afraid to fly, Ray declined. Glenn shrugged. "Stagecoach leaves for Tombstone in the morning," he said, with a good-natured smile. "What a fool I was!" said Ray, looking back on it. "I could have had my first flight with one of the most famous astronauts in history."

During his visit with the astronauts, Ray was invited to Gus Grissom's house, where he met the astronaut's wife and children. Everyone was so accommodating. The final frontier, Ray felt, would be well served.

When Ray returned home to Los Angeles, he sat down to write his article, but he was overwhelmed. He had hours and hours of taped interviews and reams of notes. Where was the forest through the trees? Ray was horribly out of his element. "I called my editor at *Life* and told him to fire me," Ray recalled. "I had seen too much. I had too many quotes. Done too many interviews. I told him, 'I'm not an article writer. I'm not a researcher. I don't know what in the hell I've got. I've been all over the place, met all these wonderful people, but I can't make sense of it. It's terrible.'"

Life editor David Maness told Ray he had no choice. He had to write the article. Even worse, it was due in four days. Ray went to bed that night in a fit of anxiety. "I couldn't find the metaphor," he said. But sometime over the course of the next sleepless hours, it hit him. "I got to thinking," said Ray, "I'm looking at a theater. I've been watching all these actors, I've been meeting all these directors, they have scripts for what they are going to do, they're rehearsing every day, hour after hour, and once I got that, I was off and running on the article the next day."

Ray filed the story, "An Impatient Gulliver Above Our Roofs," with

Maness and heard back almost immediately. The *Life* magazine staff loved the article. "If he hadn't pushed me," Ray said, "I wouldn't have done the piece." That afternoon, exhausted after filing his story, Ray was taking his daily nap when Maggie walked into the bedroom and woke him.

"Come look at the television," she said with urgency.

Ray got out of bed and went to look at the TV. He had a sinking feeling. A tragedy had occurred at NASA. During a preflight test, a fire had ignited and enveloped the command module, taking the lives of the three-man *Apollo 1* crew—Virgil "Gus" Grissom, Edward White, and Roger Chaffee. Ray stood and stared blankly at the television screen and began to cry. These three American heroes had sacrificed it all. They had died so those who might go after them could live.

23

REMEMBERING THE FUTURE

My father was a big fan of Ray Bradbury's and he had me reading him when I was 9 or 10 years old. We had this tradition in our family that on holidays or when we took road trips we would all read stories to one another. Of course, Ray Bradbury had a story for every occasion so we read him a lot. My favorites were the short story "The Emissary" and the novel Something Wicked This Way Comes. *Those stories still creep me out when I read them.*

—THOMAS STEINBECK, *author and son of John Steinbeck*

FOLLOWING THE tragedy of *Apollo 1,* Ray's article on the space program was shelved for several months to give the nation time to heal. It finally ran in the November 24, 1967, issue of *Life* magazine. The next year, Ray was given the Aviation-Space Writers Robert Ball Memorial Award

for his story—the highest honor for writing of its kind. "Here is a boy who never flew," said Ray. "I got the award from all the aviators of America for the best article of the year."

Ray was invited to Cape Canaveral to accept his award. In an ironic twist, the ceremony was just days away, and there would be no time for Ray to take the train across country. "I called them," said Ray, "and said, 'I don't fly.' They said, 'You don't fly!?' You get the aviation award and you don't fly!?'" Ray's editor, David Maness, went to the Cape to accept the award on Ray's behalf. "I was especially proud of the aviation award," said Ray, "because I had never flown."

But Ray's tethers to Earth were about to be loosened. He was invited to fly aboard the Goodyear blimp and, to everyone's utter amazement— even Ray's—he accepted. On a magnificent California day, at the age of forty-eight, Ray Bradbury lifted off from terra firma and flew for the first time. The blimp launched from Long Beach, and soared out over the shimmering Pacific, toward Catalina Island. The captain of the blimp spotted a whale and flew in quietly over it. "It was like three whales," said Ray. "There was the whale coming to the surface, and then the shadow of the blimp, another whale, coming down over it, and then there was the blimp itself. All these whales came together. The blimp seemed like it was just ten feet from the surface. It was spectacular."

THE YEAR 1969 marked the release of two more Bradbury movie adaptations—*The Illustrated Man* and *Picasso Summer*. Ray had sold the story rights to *The Illustrated Man* two years earlier, in December 1967, for the tidy sum of $85,000. Ray's fee was increasing, along with his international stature. As conceptual as *The Illustrated Man* was, Ray had never sold the film rights to the 1951 book. Even with the memorable idea of the tattooed outcast whose skin illustrations come alive to predict the future, the book was, in the end, a short-story collection and not an easy narrative to adapt. This hardly frightened director Jack Smight, who planned on bringing *The Illustrated Man* to the screen. Smight was

known primarily for his work in television, directing episodes of *Route 66, The Defenders,* and *The Alfred Hitchcock Hour,* among others, and in 1966, he directed the film *Harper,* which starred Paul Newman and Lauren Bacall.

Smight intended to use the carnival sideshow freak, just as Ray had done in the prologue and epilogue of his book, as the primary narrative thread throughout his film. But it would be impossible to adapt all eighteen stories from *The Illustrated Man,* so Smight settled on three: "The Veldt," "The Long Rain," and "The Last Night of the World." Smight cast Rod Steiger in the title role.

Ray Bradbury and Rod Steiger had been acquaintances since the late 1950s when they had met, as Ray remembered, at their mutual friend Sy Gomberg's house. The two men had had a grand time talking and laughing well into the morning. "Rod drove me home at two in the morning," said Ray, "and that was the beginning of our friendship." Ray recalled another time after Steiger had purchased an expensive, new Jaguar automobile. "He drove up to the house one day and yelled for us. Maggie and I came out and Rod looked at us and yelled, 'Eat your heart out!' and drove off." It was all in fun, and was pure Rod Steiger.

Despite Ray and Steiger's friendship, *The Illustrated Man* was both a critical and financial failure. Once he sold his story, Ray had no creative input into the film. He occasionally visited the set, took publicity photos with Steiger in his tattooed incarnation, and waited, with the now-growing army of Bradbury fans around the world, to see the motion picture upon its release in March 1969. After an early screening, as the audience left the theater, Ray noticed a teenage boy, a fan, staring at him.

"Mr. Bradbury," the teenager said, woefully. "What happened?"

Equally disappointed in the film, Ray, too, was befuddled and could hardly reply. "The script was bad and the film, as a result, wasn't any better," Ray concluded, years later.

If *The Illustrated Man* was a flop, *The Picasso Summer* was a travesty from start to finish. Ray had sold the rights to "In a Season of Calm Weather," a short story from *Medicine for Melancholy,* in the autumn of 1967. He agreed to write the screenplay, based on the tale of a husband and wife who, while vacationing in a coastal community in France, have

a magical encounter with Pablo Picasso. The short story, first published in *Playboy* in January 1957, was an odd choice for a film adaptation. It was a tight and concise narrative, the epitome of a short story. Because of this, Ray always believed that it would make for a better half-hour live-action film, incorporating Picassoesque animation. But given Ray's unyielding confidence in his own abilities, he agreed to a write a feature-length script for the film, which would be given the more straightforward title *The Picasso Summer*. The response to Ray's screenplay was fantastic. Producers Bruce Campbell, Roy Silver, and comedian Bill Cosby were all enthusiastic. So, too, was director Serge Bourguignon. Actor Albert Finney signed on, and arrangements had been made for renowned artist Pablo Picasso to make a cameo appearance. But Picasso's involvement with the motion picture would quickly fall apart in a comedy of errors that would portend further production problems. As Ray recalled the bizarre scenario, Dominguín, the Spanish bullfighter—a close, personal friend of Picasso's—had agreed to act as a liaison between the film's producers and the artist. Dominguín assured the filmmakers that he would secure Pablo Picasso for the movie. But then Dominguín, Ray said, slept with actor Yul Brynner's wife. Brynner was a friend of Picasso and his wife, Jacqueline Roque. "When Picasso's wife found out what Dominguín had done, she fired Dominguín out of their life. End of friendship," said Ray. And, as Dominguín had been the middleman between Picasso and Campbell-Silver-Cosby, it was the end of the artist's involvement in *The Picasso Summer*. Many years later, Ray laughed boisterously at the absurdity of the whole situation. Making matters worse, when director Serge Bourguignon cast a Picasso look-alike to play the artist, "Dominguín fled Madrid," recalled Ray, "and took with him the Picasso double that we were going to use!"

The trouble with the bullfighter and the painter did not mark the end of problems for *The Picasso Summer*. In fact, they worsened. When Ray saw an early screening of the film in a Hollywood projection room before its scheduled release, he felt angry and betrayed. Before Bourguignon had even left for Europe to shoot the feature, he had gushed with superlatives over Ray's screenplay. However, when Ray saw the finished film, his script was nowhere to be found. Bourguignon had detoured from the screenplay, deciding to ad-lib the story, to give it a more

"natural" narrative flow. It was a crazy artistic decision with disastrous results. Bourguignon was in the projection room that day with Ray. When the film was over, and the lights came up, Ray turned and pointed at the director. "Fire that man," Ray said.

"Bourguignon jumped to his feet and started after me to hit me," Ray said, recalling the resulting scene. "People had to get between us so we wouldn't come to blows."

Producer Bill Cosby, who, as Ray recalled, had very little to do with the day-to-day logistics of the film, was incredulous at how the production had degenerated. "He said to us," recalled Ray, "'I don't need you people to waste my money, I'm going to go waste my money myself!'"

The Picasso Summer was dreadful. "There was one minute in that film that you could look at. That's it," said Ray. The film's only redeemable attribute, in Ray's opinion, was the beautiful score by Michel Legrand with vocals by Barbra Streisand. Ray was so ashamed of the film, he demanded to use the pseudonym "Douglas Spaulding" in the credits. *The Picasso Summer* was never released to theaters.

In July 1969, Ray vacationed in London with Maggie and their four daughters (again they crossed the Atlantic by ship). They were there to take in the Wimbledon tennis tournament—as the Bradburys enjoyed tennis as a spectator sport—and to witness the national celebration of the investiture of Charles, Prince of Wales. On the evening of July 20, Ray was asked to appear on two television programs, one with journalist David Frost, a second with CBS newsman Mike Wallace. It was a monumental night in world history. Neil Armstrong, Edwin "Buzz" Aldrin, and Michael Collins—the crew of *Apollo 11*—were headed for the moon. Armstrong and Aldrin would be the first human beings, if the mission succeeded, to step foot on the lunar surface. The entire world was on the edge of its seat. In his newfound role as layman color commentator for the space program, Ray had been asked to appear on the television programs to discuss the moon mission. Ray was at the David Frost studio when, at 9:17 P.M. London time, Neil Armstrong took "one small step," becoming the first person to step foot on a celestial body other than the Earth. Ever emotional, Ray watched with everyone else in the studio that night and cried. It was a moment beyond words. He had waited his entire life for this. The television lights went on as the show

began airing. But immediately, Ray realized that something was amiss. Frost had Engelbert Humperdinck on the program that night, along with Sammy Davis Jr. "I love Sammy," said Ray, "but come on! It was not the right night for that." Ray stood off-camera, watching the campy spectacle, realizing that David Frost and his staff were not recognizing the magnitude of the evening. Ray stormed out of the studio, walking away from his scheduled interview with Frost. As Ray crossed the parking lot, one of the show's producers chased him, insisting that he return for the interview with David Frost. "You can't leave," the producer said.

"Yes, I can," Ray shot back. "That idiot in there doesn't give a Goddamn about space, and he's ruining the whole evening. He's terrible!"

Ray hailed a taxi and went to the CBS studio, where he sat down with Mike Wallace for a taped interview that would air later that night, via satellite, in the United States. Having sufficiently simmered down from what he deemed the inappropriate extravaganza of the David Frost program, Ray waxed poetic on the events of the evening. "This is an effort to become immortal," he said. "At the center of all of our religions, all of our sciences, all of our thinking over a good period of years has been the question of death. And if we stay here on Earth we are all of us doomed, because someday the sun will either explode or go out. So in order to ensure the entire race existing a million years from today, a billion years from today, we're going to take our seed out into space and we're going to plant it on other worlds and then we won't have to ask ourselves the question of death ever again."

BACK HOME by October 1969, Ray had moved beyond his recent cinematic disappointments and published another short-story collection, *I Sing the Body Electric!*, released by publishing house Alfred A. Knopf. (Ray's Simon & Schuster editor, Bob Gottlieb, had moved to Knopf, and Ray had followed him there. Gottlieb was a staunch supporter of Ray and his work, and Ray wanted to stay with him.) *I Sing the Body Electric!* featured seventeen stories, most written during the period 1964 to 1969,

although the title story had earlier origins as Ray's only produced tele-play on *The Twilight Zone*. The new book was Ray's only collection of short stories released in the 1960s, and it represented nearly all of his published short stories during the decade. This certainly wasn't a sign that Ray's output had tapered off. To the contrary, he was as busy as ever. He had merely refocused his energies away from the short-story form—arguably his best medium—choosing to concentrate on World's Fair consultation, the lecture circuit, the theater, and film. Ray added an-other role to his repertoire. At the recommendation of Norman Corwin, he joined his friend on the Documentary Awards Committee for the Academy of Motion Picture Arts and Sciences. Ray was now part of the "Oscar" voting. That same year, before the decade was out, in September Ray's oldest daughter, Susan, married Morgan Cavett, a Los Angeles record producer and songwriter who had worked with singer Johnny Mercer, as well as the rock band Steppenwolf, among others. Just as Ray and Maggie had done twenty-two years before, Morgan and Susan mar-ried in a private ceremony, without their parents. Days later, Ray and Maggie threw a postnuptial dinner reception to celebrate the marriage of their firstborn child.

IT IS not every day that an author's reach extends beyond the planet Earth. In the case of Ray Bradbury, in July 1971, that is precisely what happened. The crew of *Apollo 15*, David R. Scott, Alfred M. Worden, and James B. Irwin, helped Ray footprint the moon. It was an Apollo tra-dition for astronauts to christen the craters in the vicinity of the lunar module touchdown location. Accordingly, a small crater was given the name "Dandelion" for Ray's book *Dandelion Wine*. It was a resounding declaration of the profound impact Ray Bradbury had on the culture of his times. Sales figures of his books only supported the notion that Ray was an iconic figure on the international literary landscape. By 1971, the Bantam paperback editions of *The Martian Chronicles* had sold more

than 1.1 million copies; *The Illustrated Man* paperback sales were approaching one million.

In August 1972, Ray's book *The Halloween Tree* was published by Knopf. While it was marketed as a Young Adult title, Ray never set out to write something targeted to just one demographic. If anything, he was frustrated that Knopf refused to market it as a book for all readers. Like so much of his work, it was a book that appealed to children of all ages.

The origins of *The Halloween Tree* went back five years to the fall of 1966. Ray had been at home, watching a television special, *It's the Great Pumpkin, Charlie Brown,* with his children. Ray, an admirer of *Peanuts* creator Charles Schulz, had met the cartoonist on several occasions. But as much as Ray loved Schulz and his beloved characters, he was deeply disappointed by the *Peanuts* Halloween special. "I hated it," he stated. "After it was over, my children ran over and kicked the television set. They promised the Great Pumpkin was going to come and he never did. You can't do that to people. It's like shooting Santa Claus as he comes down the chimney. Myths should not be touched. We all know they're not true. You don't have to prove that they're untrue."

The day after *It's the Great Pumpkin, Charlie Brown* aired, Ray received a telephone call from his friend animator Chuck Jones. Jones was the godfather of the Golden Age of animation at Warner Brothers. He had worked on all the Warner cartoon classics, including Bugs Bunny, Porky Pig, and Daffy Duck; Jones himself created the Road Runner, Wile E. Coyote, Marvin Martian, and Pepe le Pew. Decades after the fact, his work is still a key chapter in twentieth-century popular culture. After leaving Warner Brothers, Jones went on to direct the Dr. Seuss holiday television mainstay *How the Grinch Stole Christmas*. Ray Bradbury met Chuck Jones early in 1966, the same year the *Grinch* ran on television, the same year *It's the Great Pumpkin, Charlie Brown* aired for the first time. Chuck Jones was an excitable guy, an idea machine just like Ray Bradbury; they hit it off immediately. "As soon as I met Chuck, it was instant love," declared Ray.

After seeing the Charles Schulz holiday special, Jones felt the same disappointment that Ray did. The two men grumbled about the *Peanuts* Halloween special and how the Great Pumpkin never appeared. Schulz

was a master—there was no doubt of that. But they both felt his Halloween program had done a great disservice to children, and to the myth of the holiday. Jones believed he could do better; he could do justice to Halloween. And so he called Ray, the gatekeeper to *The October Country,* the man who wrote of evil autumn carnivals, of ghosts in graveyards, and of whimsical vampire family reunions. Jones suggested to Ray that they do their own Halloween film.

The suggestion triggered an idea. Ray had done a painting that he thought Jones might like. On occasion, Ray enjoyed taking out his tubes of oil paints and gathering his daughters to go down to the basement, where they created personal masterworks. In 1960, Ray had finished a large oil painting on a piece of smooth plywood, which he titled "The Halloween Tree." As with all of Ray's artwork—from his doodles to his more elaborate paintings—"The Halloween Tree" had a childlike quality to it. It was a primitive work, cartoonish, yet at the same time highly evocative. The painting was done in all the earthy tones—umber, burnt sienna, gold, orange, red, and yellow—of autumn. In the background was a small house, with a single upstairs light aglow and whirls of smoke rising from the chimney. In the foreground was a vast, looming tree, its foliage blazing October orange. Hanging from the limbs and branches were dozens and dozens of carved jack-o'-lanterns. This Halloween Tree was in full bloom.

When Ray showed his painting to Chuck Jones, the animator loved it. Jones suggested that it could be the focal point of their film, the metaphor, as they told the entire sweeping history of Halloween through the ages. Excited, Ray agreed to work with his friend on the idea. He began haunting the library, seeking the history of Halloween in other cultures. At the time, Chuck Jones was employed by the animation department of MGM, so the duo instantly had a studio behind them. Ray began writing the screenplay, which took, as he remembered, nearly two months to complete. During that time, he met with Jones once a week, late in the afternoon, at Jones's office on Sunset and Vine in Hollywood. There, the two men would discuss Ray's progress on the script, and enjoy happy-hour martinis and finger sandwiches at the upstairs bar in Jones's office building. It was a splendid, exhilarating collaboration. When Ray had completed his script, Jones read and loved it. The story centered upon a group of children on a quest for the origin of Halloween.

But now that they had the screenplay in hand, the money behind the project disappeared. MGM dismantled its animation unit, dismissing all its employees, including Chuck Jones. Throughout the late 1960s and early 1970s, Ray and Jones shopped their script, but could not drum up interest. Ray recalled that they even optioned the screenplay, selling the rights to the story, but it was not made and the rights reverted back to them. Frustrated, Ray decided to adapt his own screenplay into a book, *The Halloween Tree* (as he had done with *Something Wicked This Way Comes*).

Knopf would publish *The Halloween Tree,* and, as Ray wrote it, he brought in his longtime friend Joe Mugnaini to illustrate it. Upon seeing the artwork, Ray's editor, Bob Gottlieb, was awed by Mugnaini's talent. Just as Ray had done with so many of his books, he had envisioned a look to *The Halloween Tree* that Mugnaini, through his series of black-and-white illustrations, brought to life. "I've got to hand it to you," Gottlieb wrote Ray in late 1971, "you are a great art director."

By January 1972, Ray had submitted his manuscript of *The Halloween Tree* to Knopf. The story, Ray said, "was much richer than the original screenplay. I added a lot of new material to the book."

"One of the main things I added to the book," said Ray, "was the idea at the end of the story where Moundshroud says to the boys, 'You can save your friend, if you each give a year from the end of your life.' They all give up a year. They go to Pip's house, they look up and he's home and he's well. And they all stand out on the sidewalk and they cry. That humanized the whole concept."

Gottlieb liked the first draft of Ray's manuscript, but felt that the balance of the story was somehow off-kilter. He sent Ray specific but minor editorial suggestions on January 10, 1972. A few passages were too long, the opening section on Egypt was too didactic, a section on witches was "impersonal and unlived."

By most accounts, Ray took editorial suggestions extremely well. If he disagreed, he argued his cause. Norman Lloyd, Ray's producer during his tenure writing for Alfred Hitchcock, went so far as to call Ray "a dream to work with." Of course, Lloyd added he had heard rumors in Hollywood circles that Ray Bradbury did not like to cut his own work (rumors that possibly surfaced from Ray's rocky relationship with *The*

Twilight Zone), but Lloyd said that he had never personally experienced such a problem.

Within two months of receiving Bob Gottlieb's editorial remarks on *The Halloween Tree,* Ray had made all the requested changes. Gottlieb was elated. There were a few line-edit suggestions left to be made, but mostly the hurry now was to get the illustrations and cover art from Joe Mugnaini. When the artist submitted his work, some of his best ever done in collaboration with Ray Bradbury, *The Halloween Tree* was complete. The book was published in August 1972, in time to celebrate All Hallows' Eve.

THERE WAS a great dichotomy to Ray Bradbury. He was, all at once, gregarious, approachable, loud, hilarious, and full of philosophies he was eager to share with everyone and anyone who would lend an ear. Ray loved being the center of attention. But Ray Bradbury was also a very private man. There was a guarded side to him—he was hesitant to discuss matters of health, familial troubles, or marital woes. He grew up in a household in which one did not discuss such subjects. "It's boring to talk about those things," he often said. Instead, Ray preferred discussing his work. "Just get your work done" was his credo. But Ray Bradbury, like all of us, was human.

And so, beginning in 1968, throughout much of the creation of *The Halloween Tree* first as a screenplay, then as a book, the difficulties in his marriage to Maggie began again. Since Maggie first professed her discontent with their marriage in 1957, the couple managed to hold things together for the family's sake. They even went on to have another child, the beloved baby of the brood, Alexandra. But ever since Maggie had asked for a divorce, Ray felt tentative and insecure in the relationship. Ray always feared that Maggie might again decide that she wanted to leave. "I couldn't trust her anymore," Ray said with a heavy sigh. In Maggie's defense, many years later, she claimed no memory of ever asking for a divorce. And after Maggie Bradbury passed away in November 2003,

Ray was protective of her when discussing the cracks in their union. "She's no longer here to defend herself," he said, sadly. "It's not fair to her to talk about it."

In 1968, while lecturing in California, Ray met an attractive woman, nearly twenty years his junior. "I knew right away," Ray said, "that she wanted to have an affair with me." She was married, and at first the signals were subtle. When Ray lectured in Los Angeles, she often showed up, along with her husband. Ray sometimes dined with the couple, and all the while, there was the unspoken undercurrent of passion between the woman and Ray. Ironically enough, Ray liked her husband very much. "My admiration for him was fantastic. Here I am in the middle of this situation," said Ray, "and I love the husband. He was a nice man." A few years went by, but Ray never acted upon his feelings. Ray even wrote her letters, telling her, "My body says yes, but my mind says no." Then, one day, she appeared at Ray's office on Wilshire Boulevard, alone. They both had strong feelings. They both felt desirous. Even then, Ray recommended that it would be best if she left.

The following year, she again visited Ray's Beverly Hills office. The temptation was too much. Ray went out and bought a bottle of wine and food and she stayed. But after two years, Ray's mistress, as he called her, began having remorse. Her husband had begun to lavish her with romantic gifts. "She began feeling guilty about him treating her so beautifully," Ray said. In 1974, the affair ended.

During much of Lyndon Johnson's administration, Ray watched the war in Vietnam unfold and swell, and he balked at the thought of more American soldiers being shipped to the Southeast Asian country, only to die. As Johnson deepened the United States' involvement in the war, Ray became thoroughly disenchanted with the Democratic Party. His daughters Susan and Ramona even protested when Johnson was in Los Angeles giving a speech. Even after the president announced that he would not seek reelection in 1968, Ray determined not to vote Democrat—this from a man who had taken out an ad in defense of the party during the McCarthy hearings. For the first time, Ray voted Republican, and did so thereafter, in all but the 1976 election. Then Jimmy Carter's inept handling of the economy, he explained, pushed him permanently away from the Democrats.

In the midst of the Vietnam conflict, in January 1970, Ray met Italian film director Federico Fellini, who would eventually become a good friend. Fellini was visiting Los Angeles, promoting his latest work, *Satyricon*. As Ray was an ardent fan of the director, he attended a Hollywood screening of the movie. Afterward, Ray walked up to Fellini to introduce himself; when he proffered his hand and said his name to the director, Fellini did not recognize Ray. "I went away desolated," said Ray. "I wanted Fellini to know my name. I wanted him to know that I loved him."

The next evening, the director spoke in a seminar held in Beverly Hills by the American Film Institute. Naturally, Ray was in the audience, packed with the institute's students and Hollywood luminaries such as Jack Lemmon and Billy Wilder. At one point, Fellini commented that he never looked at film rushes—the raw footage after a day of shooting. This intrigued Ray, who, when the discussion opened to the audience, engaged the director in dialogue. "I asked him," recalled Ray, "'How can you make an entire film without looking at it as you go along?' and he said, 'I don't want to know what I'm doing.'" Ray thought how much like his writing process this approach was. Trust the subconscious, Ray always believed; in thought comes analysis and second-guessing. "An artist must never do that," Ray cautioned.

After the discussion had ended, Ray approached Fellini again, this time armed with an Italian edition of *The Martian Chronicles*. When he handed the book to the director, Fellini's face brightened. "He said in his thick, Italian accent, 'Oh! Ray Bradbury!'" Ray went home that night feeling much better.

As he crossed over into modern cultural mediums that had helped foster his own imagination—and met people he had worshiped as a boy—there was still much that Ray wanted to do. In fact, Ray Bradbury always kept a mental "to-do" list of countless ideas. One of his dreams was to direct a short film. When he mentioned this wish to the noted film director King Vidor, the filmmaker remarked, simply, "Let me know when, and I'll carry the camera." Of course, the renowned filmmaker was just paying Ray a compliment; the project remained a dream.

Another of Ray's dreams was to design a library, with a children's library in a subbasement accessible by a slide (as well as a more practical elevator for those unwilling or unable to slide in). Masks would hang on

the sides of the tall stacks of books. When touched, they would light up and speak the subjects in that aisle: "Aisle 7: Dinosaurs to Egypt," for example. Ray believed that the modern library had lost its mystery, forgotten its imagination. New libraries were too cold, too bright, too impersonal. He maintained that a library should have pools of good light for reading, but they should also have shadowy areas in which the mind and body could wander and get lost.

Architecture and design had always been his one unfulfilled passion. Ever since his visit to the 1933 World's Fair, he had dreamed of designing and building. In 1970, he wrote an essay on urban design in Los Angeles, titled "The Girls Walk This Way; the Boys Walk That Way—A Dream for Los Angeles." It was first published on April 5, 1970, in *West*, the magazine of the *Los Angeles Times*. The essay lamented the demise of the town plaza as a central gathering point in American culture, and it was vintage Bradbury. He was being nostalgic for the past, while offering solutions for our future. In his essay, he spoke of the countless outdoor cafés lining the rain-slicked streets in Paris where people congregated late into the night. He wrote of town plazas in Mexico, hubs of community, family, and friends. It was through these time-honored urban success stories that Ray prescribed his vision for the future of Los Angeles.

When Ray's essay was published in 1970, a thirty-year-old L.A. architect named Jon Jerde read it with piqued interest. Jerde was on a career path that would eventually find him crowned king of the stigmatized architectural subspecies known as shopping-plaza design. In the decades that followed, Jon Jerde would become the controversial yet celebrated architect of shopping centers and dramatic public spaces around the world. His goal: "To get people to come back to the core of the city." It was this vision that prompted a *Los Angeles Times* architecture critic to state that Jerde "reached beyond the cultural elite to tap into the public imagination. And that public has flocked to his projects."

Jon Jerde was never interested in designing structures to dazzle other architects. His visions were about people. The architect wanted to design spaces that would entice the public's imagination and draw them in. "My interests have always been the ordinary, common man, not the elitists which are all the other architects," he said.

Jon Jerde's hero in all of this was none other than Ray Bradbury, who

was certainly an unlikely influence for an architect. Jerde had first read *The Martian Chronicles* when he was a teenager growing up in 1950s America. When he read *Dandelion Wine,* he was bowled over by the story "The Lawns of Summer." "Anybody who would think to write a story about the scent of cut grass," said Jerde, "that's a brilliant thinker."

After Jerde read Ray's essay in *West,* a mutual friend arranged a lunch between the architect and the author. Jerde had recently designed the Glendale Galleria shopping center and, at that first meeting, he asked Ray Bradbury if he had seen it.

"Yes," Ray said.

"What do you think of it?" Jerde inquired.

"It's nice," Ray said.

"That's yours," Jerde told him.

Ray was uncertain what the young architect was getting at. And then Jerde explained. He told Ray that he had read his essay "The Girls Walk This Way; the Boys Walk That Way" and had been inspired by Ray's visionary plan to revitalize depressed retail districts. Jerde had imitated all the things Ray Bradbury had spelled out in his urban-planning blueprint. The Glendale Galleria was based on the concepts of Ray Bradbury.

Ray was incredulous. And proud. He told Jon Jerde that if it was okay with him, he wanted to claim to the world that he was his "bastard son."

From that point forward, the two men forged a tight working relationship. "I went to work for Jon as a part-time consultant," Ray said. Ray went to Jerde's office, an old Los Angeles power plant turned design studio. As both men had myriad outside projects going on, they met once a week, very early, around seven-thirty in the morning.

"Very slowly," said Jerde, "I discovered my really great friend. We did a lot of explorations together, from the very trivial to the very profound, without even knowing so."

During their weekly meetings, the two visionaries plotted all sorts of design concepts for malls that Jerde's firm, the Jerde Partnership International, was developing. One of these malls was a new, $140 million center called Horton Plaza, to be built in downtown San Diego. Ray wrote a conceptual design essay, expressing his vision for this urban mecca, titled "The Aesthetics of Lostness." In it, he extolled the virtues of getting "safely lost" as adults. To wander the side streets of Paris, Lon-

don, or New York, getting lost in the fray, he posited, was divine. Ray suggested that shopping plazas should offer the same retreat. "[E]ven in our interior malls," he wrote, "we can plan in such a way that, for a brief if not lengthy time, we can enjoy sensations of lostness. To build into these arcades twists and turns, and upper levels that by their mysteriousness draw the eye and attract the soul: That can be the subliminal lure of all future architectures."

When Horton Plaza finally opened, with four staggered floors boasting balconies and hidden alcoves, it was a direct interpretation of Ray Bradbury's essay. "Ray's influence on the design was total," said Jerde.

Even as Ray's influence was extending into architecture, on Ray's favorite holiday, Halloween, his first collection of poetry was published. *When Elephants Last in the Dooryard Bloomed* was released on October 31, 1973. It had taken Ray a long time to gain confidence as a poet. He had deemed his first forays into the form, back in his high school days, as complete and utter failures. Ray made a silent pledge then not to return to verse until he had achieved a certain level of maturity and skill. *Elephants* symbolized Ray's newfound confidence that he had finally reached that goal. The book contained fifty-one poems, ranging in subject from the very personal, to the profoundly spiritual, to visions of the future and nostalgic sojourns into the past. In many ways, it was his most personal work to date, the clearest window yet, unoccluded by the ornate décor of fantasy, into Ray Bradbury the man, the writer, husband, father, son, child of the universe. It was the book's opening poem that, perhaps, said most about this sensitive man, an unabashed celebrant of sentimentality, but also a steadfast proponent of looking ahead to the future. In "Remembrance," Ray recalled a visit he had made to his childhood hometown of Waukegan, Illinois, sometime in the 1960s. He walked by the old house at 11 South St. James. He wandered down into the ravine, where he used to play some forty-odd years earlier. And then he remembered. Standing there alone in the ravine deeps, golden sunlight filtering through a leafy green canopy, he looked up at a tree and he started to climb. In his poem, Ray recalled the incident, the silly forty-something-year-old man climbing a tree trunk as high as he could go. He found an old squirrel's nest and reached inside. His fingers played around until they landed on something. A note, a message written decades before.

I opened it. For now I had to know.
I opened it, and wept. I clung then to the tree
And let the tears flow out and down my chin.
Dear boy, strange child, who must have known the years
And reckoned time and smelled sweet death from flowers
In the far churchyard.
It was a message to the future, to myself.
Knowing one day I must arrive, come, seek, return.
From the young one to the old. From the me that was small
And fresh to me that was large and no longer new.
What did it say that made me weep?
I remember you.
I remember you.

24

WICKED REDUX

> *I think it's fair to say that somebody as distinct an individual as Ray Bradbury was never meant to succeed in mainstream Hollywood. Hollywood thrives on people who conform in one way or another—conform to popular taste, conform to current trends, conform to formula, to box office mandates, or bend to a director's or producer's wish. None of those things describes Ray. In a way, it makes sense that he doesn't have a longer list of movie credentials.*
>
> —LEONARD MALTIN, *film critic, author*

SOON AFTER Ray's first extramarital relationship had ended in 1974, late in the afternoon one day, the phone rang in his office. A woman's voice was on the other end of the line.

"Mr. Bradbury?" the woman asked.

"Yes?"

"It's your birthday," she said. "Your wife has forgotten it. Your children have forgotten it. Your friends have forgotten it, but I haven't forgotten it. Happy birthday."

Though it's hard to believe that his wife and loving children would have forgotten his fifty-fourth birthday, Ray claimed that, indeed, they did. He must have been lonely, if they had done so, and when he picked up the telephone and heard the woman wishing him a happy birthday (this was not yet the era of stalkers, and Ray was always generous to anyone who expressed appreciation), he reached out to her. The woman was calling, it turned out, from a nearby pay phone, so Ray invited her up to his office. She was an aspiring writer in her early thirties. They chatted for a while, and the more they talked, the more Ray grew attracted to her. A week later, the woman invited him to her home in the Hollywood Hills and Ray's second affair began. It was a passionate and exciting relationship that lasted four years. Ray was fairly certain that Maggie was unaware of his infidelities, even though his daughter Ramona had seen him in a Beverly Hills delicatessen with his first mistress (his daughter acted as if she had not seen him or his companion). If Maggie knew, at this point, she neither acknowledged his straying nor confronted him about it.

One evening, as the sun set in Los Angeles and lights were starting to come on in the houses that dotted the hills of the Silver Lake neighborhood, Ray and his new love visited the famous staircase where, in 1932, Laurel and Hardy had filmed *The Music Box*. The scene in which Stan Laurel and Oliver Hardy struggle to move a piano up 133 steps is now a classic of cinematic history. That night, Ray and his new mistress, as he liked to call her, snapped photographs of each other. In the pictures, Ray twiddles his tie, and she tousles her hair—an homage to Laurel and Hardy. It was a special, simple night, an evening that Ray would later fictionalize in the short story "The Laurel and Hardy Love Affair," from 1988's *The Toynbee Convector*.

But as the secret relationship progressed, Ray became careless. One day he left a credit card receipt for flowers lying about the house and Maggie found it. Suspicious, she asked Ray for whom he bought the flowers. Not wanting to lie, Ray simply admitted his affair. Maggie was

furious. She immediately tossed her husband out of the house. That night, dejected, Ray checked into a Beverly Hills hotel and wondered if he had lost his family for good. But after a few days, Maggie called him. "You're a son of a bitch," she said, "but I love you." Ray was allowed to return home. But was he chastened? Ray had never intended to hurt Maggie, but he felt hugely insecure in their marriage from the time Maggie had asked for a divorce. From his perspective, the fact that she even contemplated such an idea meant that she was no longer vested in their relationship. He believed that she could leave him at any moment, and so he turned to other women. This was how he rationalized his affairs. Had he discussed his feelings openly with Maggie, he would not have felt any more assured. He continued to see his mistress.

THROUGHOUT THE 1970s, Ray's reputation as a master of the imagination soared. By 1974, his stories had been collected in more than two thousand anthologies, from *The Best American Short Stories of the Year,* to numerous science fiction and fantasy collections, to high school and college literature textbooks around the world. Renowned writer William F. Nolan wrote in 1975's *The Ray Bradbury Companion* that "it is doubtful that the work of any American author has approached the remarkable anthology exposure achieved by Bradbury."

As he was being read in schools all around the world and becoming a household name, he continued his forays into different media. Without doubt, Ray Bradbury had become a modern-day Renaissance man. Ever since his work on the United States Pavilion at the 1964 New York World's Fair, Ray had been on the radar screen of the design and development team for the Walt Disney company, Disney Imagineering. Headquartered in Glendale, California, at the foot of the Verdugo Mountains, in the San Fernando Valley, Disney Imagineering was the think tank behind the Mouse, responsible for turning ideas—from theme park rides to audio-animatrons to real estate development—into reality. As the Disney company was moving toward bringing to life Walt Disney's vision of an

Experimental Prototype Community of Tomorrow, one of the names that was first bandied about as a potential creative contributor was Ray Bradbury. Executives Jon Hench and Marty Sklar could think of no other person who better reflected the ideals of the past in harmony with the concepts of the future: Ray's fond attachment to the small-town Americana of yesteryear, combined with his hopes and dreams for a better tomorrow, was a perfect match for Disney. Walt Disney had created "Main Street USA," as well as "Tomorrowland." But even before that, Ray had authored *Dandelion Wine* and *The Martian Chronicles*, odes to those very two concepts.

Ray was hired by Disney Imagineering in 1976—the year of the American Bicentennial—to consult on EPCOT Center. Just as he had done with the United States Pavilion at the World's Fair, he was asked to conceptualize and write the script for the interiors of EPCOT's centerpiece, the geodesic sphere known as "Spaceship Earth." Ray worked at the Imagineering offices for a period of weeks late in 1976, four or five days a week. His hours were flexible. "They didn't care when I got there or when I left," said Ray. "It was very relaxed." The final result of Ray's efforts was a seventeen-page script for Spaceship Earth, an amusement ride that moved through the inside of the 180-foot-tall, eighteen-story geodesic sphere. Spaceship Earth would be the grand focal point of EPCOT Center, the largest geodesic sphere ever constructed. It was a 16,000-ton structure, comprising more than 11,000 interlocking aluminum and plastic-alloy triangles. While some would disparage the building as "the world's largest golf ball," Spaceship Earth was unquestionably a bold futuristic concept brought to life. It also stood as the visual symbol of Walt Disney's grand dream—a year-round world's fair, one that would never be destroyed, one that would be in a constant state of change and modification.

Ray characterized his efforts as giving voice to "the interior metaphors" of the daring structure. The result was a journey through the history of our planet—the great spaceship, Mother Earth, on her voyage through space and time. Ray's script charted the story of communication through the ages, and humankind's quest for knowledge. The ride traveled from the time of the earliest cave etchings, to sun-scorched pyramids of ancient Egypt, to Michelangelo's paintings in the Sistine

Chapel, and onward to the rocket age and beyond. Ray was exhilarated by the work, and in early 1977, turned in his final script.

As Ray was writing the script for the interiors of Spaceship Earth, he was also assembling yet another collection of short stories. Knopf published *Long After Midnight* in October 1976. The title of the book, taken from a short story within the collection, was actually the earliest working title of what had become *Fahrenheit 451*. The new short story was unrelated to Ray's magnum opus, but he liked the title enough to "recycle" it. William F. Nolan, who had recently published a comprehensive Bradbury bibliography and biographical timeline, *The Ray Bradbury Companion,* had unearthed several stories published in magazines over the decades but never collected. Two of these stories, "One Timeless Spring" and "The Miracles of Jamie," were among the trio of tales that Ray sold in August 1945, marking his entrée into the slick-magazine market. So why did Ray Bradbury sit on these two stories for more than thirty years? "I got busy with other things," he said, in a grandiose understatement. "Then I forgot about the stories."

Twelve of the stories in *Long After Midnight* had been written and published before—printed in various publications between 1946 and 1962—but, with Nolan's help, they made their first appearance in a Bradbury collection. Ten new tales rounded out the book. Ray dedicated the book to Nolan, calling him an "amazing collector, fantastic researcher, dear friend." More than anything, *Long After Midnight* represented the way Ray would assemble future short-story collections. For example, 1988's *The Toynbee Convector,* 1996's *Quicker Than the Eye,* 1997's *Driving Blind,* 2002's *One More for the Road,* and 2004's *The Cat's Pajamas* would all include new Ray Bradbury compositions side by side with at least one older tale culled from the voluminous filing cabinets in Ray's storied basement office.

ON NOVEMBER 27, 1977, Ray reviewed the photographic book *Fellini's Films* for the *Los Angeles Times Book Review*. His article was at once cel-

ebratory, explosive, and brimming over with enthusiasm for the works of the Italian film director. "In *Fellini's Films*," wrote Ray, "the author put his entire cartoon-oriented, vaudeville-circus-carnival-church-Roman-sweatbath mythology on full display." The contents of the book, he continued, were "photographed from the walls and ceilings inside Fellini's magic lantern head."

Two months after his review was published, in February 1978, Ray received a letter from Federico Fellini, forwarded to him by the editors of the *Los Angeles Times*, in which the great director said, in part: ". . . I admire you very much, dear Bradbury. And, knowing you like what I do and seeing it expressed with such fervor is one of those things that's good for the heart and makes one want to go back to work right away . . ."

As his letter continued, the great director inquired if Ray would be in Rome in the near future. By coincidence, Ray, Maggie, and Alexandra planned to travel to Italy later that year, to celebrate Zana's twentieth birthday. The initial meeting between Ray and Fellini would mark the beginning of a friendship that would last until the Italian director's death in 1993. Their common connection: passion for creativity. "Federico Fellini," offered Alexandra Bradbury, "was an Italian version of Dad."

ON JULY 19, 1979, ABC television aired a special program, *Infinite Horizons: Space Beyond Apollo*, commemorating the tenth anniversary of the moon landing. Ray Bradbury was the show's host. It was filmed on location at Cape Canaveral, Florida, and the NASA facilities in Houston. Ray quickly realized he wasn't cut out for the role of the television host, at least according to industry standards. Ray didn't believe in preparing lectures and speeches, and he cautioned against overthinking the writing process. He was a skilled extemporaneous orator, able to speak eloquently from the heart on numerous topics. But "the director insisted that everything be written on idiot boards," Ray said, referring to the cue cards that are held off-camera from which a host reads a pre-

pared script. "I had to read my dialogue," Ray recalled, "and I hated it. I told them, 'Just put me in front of the camera and tell me what you want. Let me ad-lib. Trust me.' But they wouldn't do that."

Ray recalled one scene at the NASA vehicle assembly building that required twenty takes. "I flubbed it each time. By the time we were on the twenty-first take, I was in tears because I felt so stupid." A crew member consoled Ray, telling him that everything would be okay if he'd just relax. But standing before the camera, reading a prepared script, was too deliberate for Ray. It smacked of inauthenticity and went against his credo of trusting the subconscious. Ray felt stiff on camera.

At the Cape, Ray was brought to the old launch pads from which the Apollo rockets had blasted off to the moon. "The launch sites were abandoned," Ray remembered with sadness. "The very spot where the rockets lifted off. Abandoned in place. In other words, we had given up on the moon." Ray was so moved by the desolation of the historic sites, and the symbolism of our abandoned hopes and aspirations, that he wrote three poems right there, on the spot where humankind had only a decade earlier reached for the cosmos.

Ray felt beleaguered by the entire experience of working on *Infinite Horizons*. And at that time, his personal life was in disarray: His second mistress phoned him while he was working on the television special to tell him she wanted to end the affair. She had joined the Catholic Church and could no longer continue the affair in good conscience. Ray was devastated. But he didn't try to woo her back, for he felt it was noble that she had found religion.

OVER THE years, many attempts had been made to bring *The Martian Chronicles* to the screen. Director Fritz Lang had expressed interest; John Huston had once stated in no uncertain terms that he wanted to turn the science fiction classic into a motion picture, although ultimately Huston decided against it, following his experiences with Ray on *Moby Dick*. In 1953, writer Alan Jay Lerner and composer Frederick

Loewe approached Ray about making a musical-theater version of *The Martian Chronicles*. "They wined me and dined me and danced me," said Ray, "and took me out to fancy restaurants, and I finally said, 'No, I don't think it would make a good stage musical.' They left and nothing ever happened to them except *My Fair Lady* and *Camelot!*" For several months in 1957, Ray had met regularly with producer David Susskind, who also wanted to make a musical of *The Martian Chronicles*. Susskind envisioned a musical comedy; Ray's interest was piqued this time. But he told Susskind he wanted something darker, more operatic, in the tradition of the Rodgers and Hammerstein musical *Carousel*. In the end, the two men were unable to see eye to eye and parted company.

Finally, in 1980, *The Martian Chronicles* was brought to television. The much-anticipated NBC miniseries adaptation of *The Martian Chronicles* aired in three consecutive nightly installments on January 27, 28, and 29. The television movie featured an ensemble cast, including actors Rock Hudson, Roddy McDowall, and Darren McGavin. Richard Matheson, the noted science fiction and fantasy author, screenwriter, and contributor to the original *Twilight Zone* television series, wrote the script for the miniseries. As was the case with so many of his media adaptations, Ray had nothing to do with its production.

The first time Ray saw the miniseries was at a preview the year before at the NBC studio in Burbank. Afterward, a press conference was held to promote several of the network's upcoming programs and specials. Ray sat next to boxing legend Muhammad Ali, who was also there to promote a program. When a reporter asked Ray what he thought of *The Martian Chronicles* miniseries, Ray summed up his reaction in one word, delivered with his typical to-hell-with-it honesty: "Boring." Later, at a cocktail reception, the head of NBC, Fred Silverman, approached Ray and asked him if what he said about the miniseries was true.

"Haven't you seen it?" Ray asked the network chief.

Silverman admitted he hadn't.

"Well," Ray continued, "you better see it because you've got a boring miniseries on your hands." Ray had even told friends that his "idea of hell" was sitting through NBC's *The Martian Chronicles*. As a result of Ray's words, the network reconsidered the three-part series. "They shelved it for a few months," Ray said. "They tinkered with it a little bit,

but not much." When the program finally aired, Ray and several friends and family members gathered at his house to watch it. Again his assessment of it was, "It was just boring."

Two years later, in January 1982, NBC got it right. The network had hired Ray to write a teleplay for the series *NBC Peacock Theater*. The story the producers selected to adapt was "I Sing the Body Electric!" from the book of the same name. It was a story Ray had brought to the screen before, with results he didn't care for, in a 1962 episode of *The Twilight Zone*. This time, Ray was overjoyed with the adaptation of his script. The episode was given the more television-friendly title "The Electric Grandmother," and it starred Maureen Stapleton as a robotic grandmother called into service to assist a family who is grieving the death of their mother. It was a tender story that belied the widespread impression that Ray Bradbury only wrote antitechnology tales. "It was a beautiful adaptation," Ray said. "It was very touching." Later that year "The Electric Grandmother" was nominated for an Emmy Award for "Outstanding Children's Production."

In October 1982, Ray traveled to Orlando, Florida, for the opening of EPCOT Center. He took the train, of course. From the start, his voyage was a traveler's nightmare. Ray first stopped in New Orleans to give a lecture at a local college. While there, he learned that he couldn't get continuing rail service to Orlando, and so he hired a limousine driver to take him on the five-hundred-mile trek. The driver was a courtly southern African-American gentleman in his midseventies with whom Ray enjoyed talking as they headed across swamp and 'gator country toward the city that Disney had built.

Somewhere outside of Tallahassee, Florida, the limousine blew a tire. "We're out on the highway," said Ray, "repairing a ruptured tire, with cars going by us at eighty miles an hour. Of course, the spare was no good, and could just barely run on a rim of rubber." So Ray and the driver went to buy a new spare. "It took us two hours to find one going all around Tallahassee," Ray recalled. "All the while, God was whispering to me, 'Fly, dummy! Fly!'"

A hundred and fifty miles farther down the Florida interstate, the limousine engine blew. "The limousine was going to hell!" Ray said. The old car drifted off the highway, coasting slower and slower, finally lurch-

ing into the parking lot of a Howard Johnson motor lodge. Ray and the old driver both got rooms and called it a day. The next morning, Ray called a taxi company to take him the remaining distance to Orlando. "Smokey and the Bandit showed up," said Ray, referencing the 1977 film starring Burt Reynolds and Jackie Gleason. When the taxi rolled up, Ray noted that the driver was a dead ringer for Gleason. To top it all off, Ray learned that the driver was the town sheriff, who moonlighted as the town cabbie. The sheriff-cabbie drove Ray the remaining distance to Orlando, pontificating the entire way, acting as tour director, pointing out various Sunshine State sights. "The taxi trip must have cost me two hundred dollars," said Ray. "But it was a great trip because he was a great guy."

Ray's twenty-seven-year-old daughter Bettina joined her father for the grand opening of EPCOT, a three-day, multimillion-dollar extravaganza. Unlike her father, however, Bettina flew from Los Angeles to Florida for the gala event. One evening, as father and daughter were strolling through the park's World Showcase—a series of re-created international streets and buildings—it stormed. Ray recalled with awe that the EPCOT staff appeared almost instantaneously with complimentary umbrellas for the thousands of guests. "We marched down the streets of Paris and Rome like a parade of *parapluies,*" remembered Bettina.

While at the opening of EPCOT, Ray appeared as a guest on the *Larry King* television show. He was interviewed from the lobby of the Contemporary Hotel as a large crowd of bystanders assembled. Bettina looked on with pride, thinking, "Two amazing visionaries who created amazing tomorrows by looking backward—Walt Disney and Ray Bradbury. If you only have two heroes in your life, you could do a lot worse."

On the last night of their visit, as fireworks exploded in the sky over EPCOT, Ray thought of the 1939 World's Fair, when he had looked up at the sky with tears in his eyes, realizing that World War Two was inevitable. This time, at age sixty-two, Ray watched the fireworks with tears of joy in his eyes, thrilled to have helped Walt Disney's vision of a never-ending world's fair become a reality.

When the EPCOT celebration was over and it was time to go home, Ray's travel woes worsened. There was still no direct rail service from Orlando to Los Angeles; he would have to travel through Washington,

D.C., to get to California. "I went to the Disney people and told them that I had a little problem. I think God's been whispering to me for two days now. 'Fly, dummy! Fly!'" It was time to confront and overcome his fear of flying; and so Ray made a monumental decision and asked the Disney people to book him on a flight.

To survive his first flight, Ray decided he needed to get liquored up. So, before boarding, he drank three double martinis and "they poured me on a Delta airliner," said Ray. The occasion was important enough that *Time* magazine sent a photographer to snap the Martian Chronicler taking his first flight. In the photo, Ray, white-haired, in suit and tie, is gritting his teeth and gripping his armrests.

"I took my first flight and I didn't panic," he confessed. "I discovered that I wasn't afraid of flying, I was afraid of me. I was afraid that I would run up and down the aisles screaming for them to stop the plane." When that didn't happen, Ray's fear of flying abated and he began flying regularly from then on. In fact, he and Maggie began making annual trips to their beloved second home, Paris, on the Concorde. And he was able to accept more and distant lecture invitations.

ONE OF Ray's long-held dreams was to see *Something Wicked This Way Comes* adapted for the big screen. In 1982, Disney purchased the film rights to the book. This was just the latest chapter in a long saga—the tortuous trip from page to screen.

It began in 1950. A knock came at the door of Ray and Maggie's tiny apartment. Thirty-year-old Ray opened the door to find an even younger man, a USC film student, calling. The young man's name was Sam Peckinpah, and he was an aspiring director. He was also a huge Ray Bradbury fan, and had come by simply to meet Ray. The two chatted briefly, both unaware that their career paths would cross two decades later.

In 1955, Ray wrote a screenplay of *Something Wicked This Way Comes* for Gene Kelly, but that project was shelved when no backing could be found. Then, in 1971, Peckinpah, now a renowned director

(most notably for his paean to the waning days of the American West, 1969's *The Wild Bunch*), approached Ray again, this time about adapting *Something Wicked This Way Comes*. While Ray felt that the director's work was strikingly violent, he was convinced of his talent and was enthusiastic about the idea of working with Peckinpah.

"I asked Sam," recalled Ray, "'How would you make the film?'"

"Take the book and shove the pages into the camera," Peckinpah replied. And that was all Ray Bradbury needed to hear.

"If you look at the average page of any of my novels or short stories," said Ray, "it's a shooting script. You can shoot the paragraphs—the close-ups, the long shots, what have you. This has to do with my background and seeing films and collecting comic strips, because Buck Rogers, Flash Gordon, Tarzan—those are all storyboards for films, aren't they?"

Ray and Peckinpah had several meetings about the project as Peckinpah sought financial backing for the picture. The director, as Ray recalled, was a heavy drinker, and when he was drunk he was lovable and charming. At their meetings, usually happy-hour gatherings during which Peckinpah would pour gin in Ray's beer to keep him on equally inebriated footing, the two men had a grand time. But Peckinpah took months seeking funding, which he ultimately never found. Because it was taking so long, Ray believed that Peckinpah was "dragging his feet," and that the director was not truly committed to the project. As a gesture of his confidence and desire to work with Peckinpah, Ray offered to sell him the option rights to the novel for one dollar. But Peckinpah wouldn't take it.

Finally, in 1977, Ray turned to Paramount, selling the studio the rights to *Something Wicked This Way Comes*. Ray would be writing the script.

That week, as word about the sale of the novel made the rounds, a delivery arrived at the front door of the Bradburys' Cheviot Hills home: a small, spiky cactus and a jar of Vaseline. Attached was a note from Sam Peckinpah. Ray recalled the message: "It said, 'Cut this cactus in three parts—one for you, one for your director, and one for your producer. And use the Vaseline as directed.'" Ray was bewildered; he believed that Peckinpah had been afforded more than enough time to secure financial backing for a production. "When he had a few drinks in him," said Ray,

"Sam loved me. Then, when he was sober, he wasn't interested." But the cactus amused Ray, so he placed it on the front porch until Maggie finally threw it out a year later.

The saga of *Something Wicked This Way Comes* didn't end with the sale of the novel rights to Paramount. Jack Clayton was the producer on the project. Ray had known Clayton since working with him on *Moby Dick* from 1953 to 1954, when Clayton had served as associate producer on the film (he had also served in this capacity on the 1952 Huston film, *Moulin Rouge,* as well as on Huston's 1953 picture, *Beat the Devil*). Despite the turmoil between Ray and Huston throughout the making of *Moby Dick,* Ray had always liked and admired Jack Clayton. Since then, Clayton had become a respected director in his own right, with the 1974 adaptation of the F. Scott Fitzgerald classic *The Great Gatsby,* starring Robert Redford in the title role. The film was a favorite of Ray's and Maggie's. "It was a beautiful film," raved Maggie. "We saw it several times over the years on television."

In 1977, Ray began writing a new screenplay for Paramount Pictures. "The first script I handed in to Jack was 220 pages," said Ray—one hundred pages longer than the average two-hour film screenplay. "He made me cut it and cut it and cut it," said Ray. Initially, Ray cut the screenplay to 170 pages. Clayton then asked him to edit it to 150 pages. Ray went back to the typewriter and trimmed the script. Then Clayton told him that he had to get down to 120 pages. "'I can't cut anymore,' I told him," recalled Ray. Nonetheless, in the end, Ray did it. "We had a nice script of 120 pages. Perfect. And it was perfect because Jack was patient with me. He was a very bright guy." But when Clayton delivered the screenplay to the two top decision makers at the studio, president Michael Eisner and chairman Barry Diller, there was an argument. "One liked it, and the other didn't," said Ray. "I never found out which one didn't like the screenplay." The differing opinions between the studio executives led to an impasse, and according to Ray, they argued about it for weeks. "Jack and I finally picked up our baggage and left. The whole project fell through."

The film rights reverted back to Ray, and years passed without any studio interest in *Something Wicked This Way Comes* until in 1982, when Disney purchased the film rights. At long last, it appeared as if this

wonderfully cinematic novel would finally make it to the big screen. When the powers at Disney asked Ray if he had a director in mind, Ray was quick to recommend his friend Jack Clayton. After all, they had worked hard on the project while at Paramount, and Ray trusted that Clayton understood what it took to make a good adaptation of a Ray Bradbury book. "The secret is no secret at all," Ray exclaimed. "Follow the book! It's what Sam Peckinpah said. Stuff the book in the camera and shoot the damned thing!" However, when Ray suggested Clayton to the Disney people, according to Ray, they were less than enthusiastic. Clayton was an old-fashioned director and the Disney people, in this new era of the big-budget special-effects film, wanted more of a young gun who could draw a younger audience. Ray asked if they had seen any of Clayton's films, *The Bespoke Overcoat,* or *Room at the Top,* or *The Great Gatsby.* "I told them," said Ray, "'It's very simple, if you don't use him, I won't sell you the script.'" Faced with Ray's ultimatum, the studio acquiesced. Jack Clayton was hired to direct *Something Wicked This Way Comes.*

Ray would soon realize that he had made a big mistake. In 1983, the day before filming began, Ray met with Clayton. "I sat across the table from him," Ray recalled, "and he handed me the script."

"Jack said, 'We've got a new script for the film.'" Ray was incredulous. *He* had written the screenplay based on *his* novel, a screenplay that he had meticulously honed according to Clayton's detailed instructions in 1977. Who had written a new screenplay? *Why* had someone written a new screenplay? Ray didn't understand. Jack Clayton explained. He had hired John Mortimer, the English screenwriter who had recently written the script for the television miniseries *Brideshead Revisited,* to rewrite Ray's script. "We knew you were busy," Ray recalled Clayton saying.

"Busy, hell!" Ray blurted out. "All you had to do was ask me and I would have revised the script if I agreed with the changes."

Jack Clayton told Ray to take the screenplay home and read it. He told him to report back if he found things in the script that he disagreed with. The screenplay, according to Ray, no longer even had his name on it. It now belonged to Mortimer. "He was a fine writer," said Ray, "but he didn't know fantasy."

"The next day," Ray recalled, "old naïve Ray comes in with a list of twelve things in the first twenty pages of the script that didn't work." Clayton took a few moments to review Ray's list, and then "he tossed the notes back at me across the desk," recalled Ray, "and said, 'Completely unacceptable.'"

"End of the friendship," said Ray, reflecting back on the incident. "And I got him the job! Could you imagine? I was stabbed right in the heart."

Dan Kolsrud, Clayton's assistant director and the associate producer of the film, had a different take on the dramatic events. While Kolsrud was not privy to the closed-door meeting between Ray and Clayton, he said that Clayton's hiring of screenwriter John Mortimer was more a reflection of Jack Clayton's insecurities than a statement on Ray Bradbury's writing prowess.

"Jack brought John Mortimer in on other films he did," said Kolsrud. "Whether it was for credit or not, I don't know." It was Kolsrud's opinion that Jack Clayton simply felt more assured with Mortimer adding a final, minor polish; it certainly wasn't because Ray's script was weak.

"We'd all read Ray Bradbury and all loved his writing, so we sort of all sat at his feet," added Kolsrud. "To everyone on the set, and it might have been different with Jack, but Ray Bradbury was this sort of old-world gentleman. He was extremely charming."

Something Wicked This Way Comes went into production at the Disney studios in Burbank, California. Casting included Jason Robards as Charles Halloway, the father in the novel, and Jonathan Pryce in the coveted role of Mr. Dark, the proprietor of the sinister carnival that descends upon a small, innocent midwestern town looking to make people's dreams come true for a price.

Although it was one of the great betrayals of his long and illustrious career, "I couldn't stay away from the set, no matter what," Ray said. After decades of trying to get the novel produced, *Something Wicked* was finally getting made. The entire experience had been tarnished, but Ray was still hopeful that, in the end, a good film would be made of his book. Sad and hurt, Ray's spirits were lifted somewhat by the numerous beautiful and elaborate sets built for the film on the Disney back lot. Every day for two weeks, Ray visited the set and admired the detailed re-

creation of Green Town—the houses, the town plaza, and, most of all, the old, dark library with its jungle-green reading lamps and tall stacks of books in which Mr. Dark and Charles Halloway face their moment of truth.

"It was still my film," said Ray. "It was my book. And here we had a case where a man who had double-crossed me was directing it. The whole time on the set, Jack wouldn't talk to me." Ray recalled how Clayton's secretary explained the director's silence: Jack Clayton was unhappy with Ray because he hadn't supported the John Mortimer script. Clayton, the secretary explained, even felt that Ray should have written a letter of praise to Mortimer, complimenting his script.

"Get me his address!" Ray said. "I'll write a lying letter!" Ray simply wanted Clayton to talk to him. Indeed, Ray wrote John Mortimer, praising his fine screenplay for *Something Wicked This Way Comes*. After that, Jack Clayton resumed communications with Ray. "Throughout the entire ordeal, I kept warning Ron Miller, the head of the studio who was Walt Disney's son-in-law. But he didn't really know what to do. He didn't have the touch," said Ray.

When production on the film had wrapped, and an early preview was arranged, Ray and Maggie and his four grown daughters all attended. As Ray expected, the film was terrible. In his estimation, everything about it was wrong—from the editing, to the ending, to the score. The preview audience was completely silent. A few days later, Ray's telephone rang. It was Disney chief Ron Miller calling. He wanted Ray to come to his office right away. "I walked into his office," Ray remembered, "and he said, 'I hope you're not going to say, "I told you so." ' I said, 'I'm not. There's no time for that. Rebuild the sets. Rehire the actors. I'll rewrite the script. I'll make a new ending. I'll time the ending because the editing is all wrong. I'll write a narration for the film. You need a new score.' " Because the project had been a fiasco, Ron Miller followed Ray's advice. The actors were called back in and shooting resumed in an attempt to salvage the production. "Jack was there," said Ray, "but he was mainly on the side. It was all a very strange situation.

"In the end we spent five million dollars redoing everything that Jack Clayton did wrong. Unofficially, I became the director of the film. I tried to pretend that I wasn't the director, but I was."

In April 1983, *Something Wicked This Way Comes* was released in the United States. It received mixed reviews. Prominent *Chicago Tribune* film critic and television personality Gene Siskel summed up the sentiments of many a national reviewer: "The beginning couldn't be more promising; the climax couldn't be more disappointing."

25

CATHODE RAY

I think Ray's style upsets the followers of life, while the leaders allow him to perpetuate new algorithms, new DNA, new forms of expression and new forms of omission. His art is to deconstruct, to move freely and embrace nuance and allegory and paradox through the tapestry of life, the distilling membrane of Ray Bradbury.

—LARRY WILCOX, *producer,* The Ray Bradbury Theater

"PEOPLE ASK, 'Where do you get your ideas?' Well, right here. All this is my Martian landscape. Somewhere in this room is an African veldt. Just beyond, perhaps, is a small Illinois town where I grew up. And I'm surrounded on every side by my magician's toyshop. I'll never starve here. I just look around, find what I need, and begin. I'm Ray Bradbury, and this is *The Ray Bradbury Theater*."

So began the opening sequence to each and every episode of Ray's new cable television program, *The Ray Bradbury Theater,* which premiered on HBO on May 21, 1985.

The idea for Ray's television series began in 1984 when Larry Wilcox (perhaps best known as a California highway patrolman on the television series *ChiPs*) and his business partner, Mark Massari, began courting

Ray. They imagined a series with episodes based on his short stories; Ray would be the host, introducing each program. Ray was flattered, but declined the offer. "I'd seen the way the studios treated Hitchcock," he said. "When he needed extra money to reshoot some scenes, like we did on the episode I wrote, 'The Life Work of Juan Diaz,' the studio wouldn't give it to him. At the time, I thought, If I ever have a series, I'm not going to be in a position where that happens to me, so help me God."

Offers did come Ray's way. In the 1970s, NBC approached him about doing a television series. "Various others approached me over the years, including Universal," he said, "and I turned them all down."

But Larry Wilcox and Mark Massari were Bradbury fans. They loved and respected Ray's work. As "baby boomers," they had grown up reading his books. "They took me out to lunch and to dinner and bought me wine and met Maggie and took us both out and they spent a year combing my hair and fixing my feathers until they convinced me they really meant it," said Ray. "They would respect my rights and my tastes and I would control and write the whole thing. When they convinced me of that, I signed the contract."

It was an ideal situation. Ray would serve as sole writer and executive producer, and all the episodes would be based on his stories. Ray was given complete creative control. He would also host the program, à la Alfred Hitchcock and Rod Serling. The opening sequence for the episodes, showing Ray's office—a sort of laboratory of the imagination, jammed from floor to ceiling with toy dinosaurs and rocket ships and books—was shot, in part, in Ray's Beverly Hills office. Other shots, showing Ray arriving at his office in an old, hand-operated, wrought-iron elevator, were photographed in, ironically enough, the Bradbury Building at 304 South Broadway, in downtown Los Angeles. The name was purely coincidental. The Bradbury Building was constructed in the late 1800s and had a remarkable open lobby with a lacework of iron railings and stairs; it had been used as a location in many films over the years, and, in another coincidence, Forrest J Ackerman's grandfather, George H. Wyman, designed it.

The shoot of the opening sequence of *The Ray Bradbury Theater* took place at the Bradbury Building. Shortly before midnight Ray arrived on location. He had been, however, suffering from the flu and decided to

go home. "When you see *The Ray Bradbury Theater*," said Ray, "and the elevator comes up, supposedly I get off the elevator, but that isn't me." After Ray had left, producer Mark Massari was tapped as a body double for Ray, donning a sports jacket and slacks similar to what Ray might wear. With clever camera angles, Massari was a passable stand-in.

The major networks all passed on *The Ray Bradbury Theater*, but the fledgling cable channel Home Box Office was interested. "HBO nibbled, as the marquee of Ray Bradbury helped market their fledgling brand," recalled Wilcox. But HBO, newly launched, was unable to fund the entire series. Martin Leeds, an attorney for Wilcox Productions, sought out deficit spending and secured backing from the Canadian-based company Atlantis Films, a trend Wilcox referred to as "the beginning of the Canadian 'drain' on American production through Canadian government subsidy programs. This allowed Bradbury to be filmed under what are called the Treaty Deals with England, France, Canada, and New Zealand."

The first season of *The Ray Bradbury Theater* included six episodes, starring a wide range of Hollywood actors, including Drew Barrymore, William Shatner, Leslie Nielsen, Jeff Goldblum, and Peter O'Toole in the final episode of the season, "Banshee," an autobiographical fantasy about Ray's tumultuous tenure in Ireland working for John Huston. In the story, Ray finally exacted revenge on the film director for all of his wicked and manipulative games. Looking back on the series, this episode would stand as one of Ray's favorites.

"[W]e spent many late evenings," wrote Ray in the introduction to 2003's *Bradbury Stories*, "sitting by the fire, drinking Irish whiskey, which I did not much care for, but only drank because he loved it. And sometimes Huston would pause in the middle of drinking and talking and close his eyes to listen to the wind wailing outside the house. Then his eyes would snap open and he would point a finger at me and cry that the banshees were out in the Irish weather and maybe I should go outdoors and see if it was true and bring them in.

"He did this so often to scare me that it lodged in my mind and when I got home to America I finally wrote a story in response to his antics."

"Banshee" was, as Ray liked to put it, "comeuppance time" for John

Huston. In the story, Ray (renamed Douglas Rogers) goes into the dark Irish woods to encounter the lonely, wailing wraith. But it isn't Douglas whom she desires. She wants Douglas to send the director (named John Hampton in the episode) out to her so she can have her way with him. This was vintage Bradbury, finding closure to real-life events through fiction. As Ray often advised aspiring writers: "Make a list of ten things you love and celebrate them. Make a list of ten things you hate and kill them."

After the first six episodes, *The Ray Bradbury Theater* moved to the USA Network. According to Wilcox, HBO, in its infancy, did not truly recognize the stature of the Ray Bradbury name, particularly in the international market, and they let the series go. It was an odd decision, likely based on production costs. During the first season on HBO, the series received six Cable Ace Award nominations—the top honors in cable television—and won three, including one award given to Ray for best writing on a dramatic series.

The Ray Bradbury Theater stayed at USA for the remainder of its seven-year run, until 1992. In total, Ray wrote and served as executive producer on all sixty-five episodes, and the program was nominated for thirty-one Cable Ace Awards. It won twelve. But beyond attaining industry accolades, the television show introduced Ray to a whole new audience—the MTV generation. *The Ray Bradbury Theater* began just as MTV and cable television were exploding in popularity on the national landscape. For the first time, kids discovered Ray Bradbury not through reading, but on the television screen. And this caused many of them to rush out to libraries and bookstores to find his books.

Ray was fully involved with his new television show, regularly visiting the sets on location where they were filmed in Canada, New Zealand, and France. But as ever, he wrote every day, and in October 1985, his first mystery novel was published by Knopf. It was an excursion into yet another genre by a man who had so often been labeled as "just a science fiction writer."

The only book of his own that Ray considered science fiction was *Fahrenheit 451*. If he was to be labeled at all, he much preferred another tag: "teller of tales." And so, in 1985, the teller of tales made his first sojourn into the shadowy narrative labyrinth known as the detective novel.

Ray had written mystery short stories before, selling them to the detective pulp magazines in the 1940s. But this was his first mystery novel, albeit very different from the standard detective yarn. In *Death Is a Lonely Business,* Ray abandoned many of the hard-boiled clichés of the genre and, instead, opted to write a highly nostalgic narrative about his days living in Venice, California, in the late 1940s. Absent was the steely voice so familiar to readers of mystery-noir. Instead, the story's narrator was a thinly veiled young Ray Bradbury, a sentimental and sensitive science fiction and fantasy pulp writer living in Venice who is grappling with writing a novel. When the young author discovers a body trapped in an old circus lion's cage that has been dumped in one of Venice's dark, polluted canals, he becomes embroiled in a murder mystery. The novel nostalgically conjures many important places and incidents from Ray's past as a struggling pulp writer. *Death Is a Lonely Business* was Ray's first novel since *Something Wicked This Way Comes,* published twenty-three years earlier. And, along with *Dandelion Wine,* it is Ray Bradbury's most autobiographical work of fiction.

IN MAY 1988, as *The Ray Bradbury Theater* was clipping right along, Ray gathered still another short-story collection. This new one, titled *The Toynbee Convector,* included twenty-three stories, eight of which were older tales that had been unearthed in Ray's files by his friends Bill Nolan and Donn Albright, an art professor at New York's Pratt Institute who also functioned as Ray's bibliographer. "The Tombstone" had first appeared in *Weird Tales* in March 1945 and in the now long-out-of-print Dark Carnival. "At Midnight in the Month of June" ran in the June 1954 issue of *Ellery Queen's Mystery Magazine; The Toynbee Convector* marked the first time the story had been collected in book form. Six more stories were culled from Ray's voluminous files, all in various states of completion. These tales included "West of October," which was originally titled "Trip to Cranamockett" and cut from Ray's first book, *Dark Carnival,* prior to publication. Ray "ran a damp rag" over the old stories,

editing and rewriting them for inclusion with fifteen new compositions in *The Toynbee Convector*.

THROUGHOUT THE remaining seasons of *The Ray Bradbury Theater*, some of Hollywood's finest actors appeared in a few of Ray's short-story adaptations—Donald Pleasence in "Punishment Without Crime," Robert Vaughn in "The Fruit at the Bottom of the Bowl," Hal Linden in "Mars Is Heaven," James Whitmore in "The Toynbee Convector," and Tyne Daly in "The Great Wide World Over There." All the while, Ray Bradbury continued to turn out more books. *Zen in the Art of Writing*, a collection of essays on creativity and the writing process, was published in 1989. That year Ray's essays on architecture, design, his past, and our future were collected in *Yestermorrow. A Graveyard for Lunatics*, a sequel to *Death Is a Lonely Business*, was published in July 1990. Ray wrote much of the book in Paris, late at night while Maggie slept, in their room at the Hôtel Normandie, where he and Maggie stayed every year. Ray never learned to use a computer, but he did own a small electric typewriter that had silent keystrokes.

On the home front, Maggie was now working part time, tutoring students in technical French at the University of Southern California. Susan, Ray's oldest daughter, had divorced and remarried, to Tommy Nixon, the road manager for the rock band the Eagles. Ramona was married to architect Andrew Handleman, while Bettina married graphic design artist and interior designer Gary Karapetian. Bettina and Gary had met on Halloween night in 1985 at Ray's annual Halloween party, held at the Cheviot Hills house. It was always a gala affair, partygoers spilling out the front door and into the backyard as a raucous Dixieland jazz band played well into the night. A hired magician moved through the home, performing illusions. But the annual Halloween party was never of interest to Maggie, who over the years had become more and more reclusive. Maggie never liked crowds. Though she reveled in one-on-one conversation, she avoided bawdy and clamorous events like the annual Bradbury

Halloween party. She often retreated to the master bedroom during these costumed soirées, curling up with a cat and a good book.

In May 1992, Ray published *Green Shadows, White Whale,* a book detailing his experiences working on the screenplay for *Moby Dick* in Ireland for John Huston. For years, people had suggested to Ray that he chronicle his Huston era, but he resisted. However, when he read Katharine Hepburn's account of working for John Huston, *The Making of the African Queen: Or How I Went to Africa With Bogart, Bacall and Huston and Almost Lost My Mind,* he decided it was time to do his own novel. While Katharine Hepburn's book was entertaining, Ray felt it was too thin. And as he had done with *The Illustrated Man* and other works, Ray designed the cover of *Green Shadows, White Whales,* sketching a writer standing atop a slain whale, clutching a giant fountain pen in place of a harpoon, for jacket artist Edward Sorel.

As the novel on his Ireland experiences was released, *The Ray Bradbury Theater* was winding down its successful run. But this hardly marked the end of Ray's television success. That same year, almost twenty-five years after Ray had first envisioned it as a film, *The Halloween Tree* was made. David Kirschner, the president of Hanna-Barbera and creative force behind such cartoons as *The Flintstones, The Jetsons,* and *Scooby-Doo,* purchased the rights to *The Halloween Tree* and hired Ray to freshen up the script he had peddled in Hollywood in the late 1960s and early 1970s. The result: *The Halloween Tree,* an animated film narrated by Ray Bradbury and starring the voice of *Star Trek's* Leonard Nimoy as "Moundshroud." A rousing success, it won the Emmy Award for "Best Animated Children's Program" of 1992. Beginning with *The Ray Bradbury Theater* and ending with the highest award given in the television industry, for *The Halloween Tree,* Ray Bradbury had moved effortlessly into the realm of television. And to think—all from a man who had issued a stern warning of the dangers of television, in his short story "The Veldt" and his novel *Fahrenheit 451.*

THE TIME OF GOING AWAY

Ray has been a father to us . . . guiding and inspiring us, encouraging us at our best, chiding us at our worst, his work always deeply felt, deeply human, and deeply poetic. In fact, I've always thought of him as a poet . . . a poet of the Rocket Age. And I don't mean rockets with boosters and O-rings, I'm talking about rockets with tail fins that look like art deco sculptures. These aren't rockets that carry cargoes of scientific hardware, they carry cargoes of deep and compelling human truth.

—FRANK DARABONT, *Academy Award–nominated*
screenwriter and filmmaker

THE *Los Angeles Times* called him "a giant." The *Washington Post* proclaimed, "Almost no one can imagine a time or place without the fiction of Ray Bradbury." The *St. Louis Post-Dispatch* declared, "Bradbury's talents are immortal." *Time* stated, "Bradbury is an authentic original."

Throughout the 1990s, Ray secured his rightful place on the bookshelf alongside his childhood literary heroes. The books of Ray Bradbury were now ensconced alongside the works of L. Frank Baum, Jules Verne, Edgar Rice Burroughs, and Edgar Allan Poe. But they also sat cozily next to Hemingway, Welty, Steinbeck, and Fitzgerald. By the 1990s, Bradbury's stories were as widely assigned in junior high schools and high schools as those of all the other "literary" writers. He had been translated into more than twenty foreign languages; Ray Bradbury was a household name.

One afternoon in the early 1990s, after giving a lecture, Ray, now into his seventies, visited the town of Sausalito and stumbled upon an old-fashioned toy store. He walked inside and found stuffed animals, ju-

nior laboratories, plastic dinosaurs, Tinkertoys, action figures, and magic sets. When he left the shop, he saw a group of boys, aged twelve and thirteen, pressing their noses to the toy store's window. When they were ready to leave, one boy remained with his hands pressed to the storefront glass, transfixed.

"Go in," Ray said under his breath, looking on from a distance. "Go in."

"Come on!" cried the other children to the boy.

"Hurry up," one said.

"That's kid's stuff!" another child said. "Come on!"

The boy snapped to and he spun on his feet. In an instant, to Ray's chagrin, he was off and running with his friends.

"Grow up?" said Ray. "What does that mean? What does that mean! I'll tell you: It doesn't mean anything." When he saw that boy take off with his friends instead of going into the toy store, he remembered the moment he buckled under his own friends' ridicule and peer pressure and destroyed his beloved *Buck Rogers* comic strip collection. Ray wrote of this childhood memory and his *Buck Rogers* experience in the introductory essay to *Zen in the Art of Writing*.

> *Where did that judgment and strength come from? What sort of process did I experience to enable me to say: I am as good as dead. Who is killing me? What do I suffer from? What's the cure?*
>
> *I was able, obviously, to answer all of the above. I named the sickness: my tearing up the strips. I found the cure: go back to collecting, no matter what.*
>
> *I did. And was made well.*
>
> *But still. At that age? When we are accustomed to responding to peer pressure?*
>
> *Where did I find the courage to rebel, change my life, live alone?*
>
> *I don't want to over-estimate all this, but damn it, I love that nine-year-old, whoever in hell he was.*

After *Green Shadows, White Whale* was published in 1992, Ray ended his long partnership with his publisher, Alfred A. Knopf. His first editor, Bob Gottlieb, had moved on to edit *The New Yorker*. His second Knopf editor, Nancy Nicholas, had left for Simon & Schuster. His current Knopf editor, Kathy Hourigan, had in Ray's opinion done a splendid job with his books; he credited her with bringing *Green Shadows, White Whale* to life. Ray dedicated the book, in part, to Hourigan. However, he was displeased that Knopf had allowed *The Halloween Tree* to go out of print; furthermore, many of his classics were no longer available in hard cover. The final blow came when Ray handed in his manuscript for a new children's fable, *Ahmed and the Oblivion Machines*. The book sat with Knopf for a year, and Ray was not told whether the publisher wanted it or not. Hourigan hoped to publish it, for certain, but she had to report to higher-ups. Exasperated and hurt that his publisher had dragged its feet for so long, Ray and his longtime agent, Don Congdon, arranged to leave Knopf. Avon Books publisher Lou Aronica made an enticing offer, promising to keep Ray's backlist in print. Ray also felt genuine love from Avon and Aronica; he signed with the publisher and never looked back. Ray said in a 2002 interview that Avon was the best publishing house of his storied career.

As his stature as a great American icon burgeoned, Ray continued to release books through his new publisher. In 1996, *Quicker Than the Eye,* a new short-story collection featuring new and old stories (recently unearthed by Bradbury friend, fan, and researcher Donn Albright), was published.

The following year, Ray assembled another collection by the same means, and released *Driving Blind*. Both books received high praise from many national critics. They showed Ray's leaner, more dialogue-driven prose. His work had become far more minimalistic. "Much of the text is dialogue," wrote a *Publishers Weekly* reviewer, "and it works because Bradbury excels at portraying the robust textures of American speech." Susan Hamburger of *Library Journal* said of the collection, "[Ray Bradbury] paints vivid word pictures of people and small towns in a kind of skewed Norman Rockwell way."

"Most authors peak at some point," remarked Maggie Bradbury. "They can't sustain it much past their sixties. But not Ray. It amazes me. He only gets better with time."

As he had done since he was twelve, Ray still wrote virtually every day. Several times a week, he traveled to the family's second home in Palm Springs, about two hours by car from L.A., where he kept an office. The house, a low-slung testament to midcentury modernism, had a small, rectangular swimming pool in which Ray would take a dip or would sit beside in a reclining chair. He used a spare bedroom as an office, where he kept an IBM Selectric typewriter, just like the one in the Cheviot Hills house.

From the early fifties, Ray and Maggie had regularly visited Palm Springs, and in 1980 they had purchased the vacation house. They also thought that since there was so little room in Cheviot Hills for Ray's collection of, for lack of a better term, *stuff,* it could become something of a repository. "I've been a great saver and I still am," Ray said in a 1961 interview. "It's very hard for me to throw out. Practically the whole texture of my life is put away somewhere in the house."

The second home was now bursting at the rafters, like the first. Original paintings by Joseph Mugnaini lined the walls and shelves; beside them were numerous trophies and placards. In a side bedroom, every square inch of every wall was covered in family photos and old letters, including an early rejection slip from original *Esquire* magazine editor Arnold Gingrich that called his ideas "unoriginal." A letter written home to his mother from the First World Science Fiction Convention in New York City in 1939 declared: "The one thing I miss is tomato soup." The walls were also papered with playbills from the many stage adaptations of his work and with memorabilia from the movie versions of his stories. One item taped to the wall summed up Ray's collecting habits better than any other: It was a white envelope stuffed with a lock of hair from his daughter Ramona, presented to her father when she was a little girl:

Dad—I know you love to save things. So here is some hair from my head. Love, Mona.

Ray liked retreating to his midcentury home in the desert. At this point, he was drinking more than usual, by his own admission. He loved cold Coors beer out of the can and confessed that a six-pack a day "went down like water." The beer consumption, coupled with a diet high in fatty foods and lots of sweets, caused Ray to gain considerable weight.

For lunch, he would often head into town to a Mexican restaurant—Las Casuelas—where he had been dining since it opened in 1958. He always ordered the same thing: the number one combination—a chile relleno with a cheese enchilada.

On November 4, 1999, Ray went to the Palm Springs house. He rarely took cabs anymore, as he had in the old days. Now he had a full-time limousine driver, forty-six-year-old Patrick Kachurka, whom Ray referred to as "the son I never had." Kachurka had dropped him off and headed back to Los Angeles, where he owned and ran a limousine business. Ray was at his desk in the air-conditioned house, working on a short story, when he suddenly went numb all over. Talking with him on the telephone from Los Angeles, Maggie noticed that Ray's speech was slightly slurred. Alarmed, she called their youngest daughter, Alexandra, who had worked as his assistant since 1988. Zana immediately called her father from her home outside of Phoenix, Arizona, and could tell that something was wrong as well. Was Dad drinking? Maggie then called Kachurka, who intuitively sensed things were askew. After twelve years of driving Ray and effectively functioning as his personal assistant, Kachurka knew "Mr. B.," as he called him, better than anyone except Maggie. He slipped into his midnight blue Cadillac Town Car and sped back to the desert house. He drove at over ninety miles per hour much of the way. When Kachurka arrived, he realized right away that Ray had had a stroke. But since his father's death in the hospital, Ray was terrified of hospitals and wanted nothing to do with them. Ray refused to go to the emergency room, and instead demanded that Kachurka take him home. Kachurka insisted and Ray grew angry. When provoked, Ray had a temper that most people danced around. But not Patrick Kachurka. He insisted that they head to the emergency room. Ray threatened to fire Kachurka.

"That's fine, Mr. B.," Kachurka said. "You can fire me. But you're still going to the hospital."

Kachurka helped Ray into the car, drove to a local hospital, the Eisenhower Clinic, and checked him in. "I got there and they ran all the tests," said Ray, "and sure enough I had had a stroke. Patrick saved my life."

Ray was transported back to Los Angeles, where he was admitted to St. John's Hospital in Santa Monica. "I was completely immobilized for about a month," said Ray. "I talked to my foot and it wouldn't move. I

talked to my arm, it wouldn't move. And you lie there and you shout at yourself, 'Okay! Let's move!' And you don't move. It's very awful."

But Ray Bradbury was, if anything, a fighter.

Now, bedridden in a Los Angeles hospital, he was not about to stop fighting. He summoned Alexandra to his hospital room. He needed to work. While lying in his hospital bed, Ray set out to finish a novel he had been working on in recent years, *Let's All Kill Constance,* the book that would complete his mystery trilogy. His spirit was indefatigable.

After a month, Ray was released from the hospital. He had lost sixty-two pounds. "The whole experience has been good for me," he said. "My blood pressure is normal again after years. I did all this to myself. I have no one else to blame. Lots of beer. Lots of wine. Overweight by seventy pounds. And it was time to take it off."

Slowly, Ray regained his strength, moving from wheelchair to walker to a four-pronged cane. And through it all, he never stopped writing. He thundered forward on *Let's All Kill Constance.* And, at the gentle prodding of his editor, Jennifer Brehl, he went to his basement file cabinets, blew away spider webs and cellar dust, and set out to complete his decades-in-the-making vampire family novel, *From the Dust Returned.* From the on-set, Brehl hoped to surprise Ray by locating Charles Addams's original painting, which had accompanied the story "Homecoming" in the October 1946 issue of *Mademoiselle.* "Homecoming" was always intended as the cornerstone story in Ray's vampire novel, and Addams's autumnal artwork was the obvious choice to adorn its cover. There was one major problem: Brehl had no idea where the painting was. The Addams estate was also at a loss. A fevered treasure hunt ensued: Phone calls were placed, archives searched, the Internet combed over, but nothing. Defeated, Brehl finally telephoned Ray to tell him of her intentions, and her disappointment.

"But, darling, you should have asked me!" he told her. "The painting's on my living-room wall. Charlie gave it to me back in 1946." The Addams painting was eventually used on the cover of *From the Dust Returned,* just one more title to add to Ray's ever-growing oeuvre.

Ray Bradbury was in a conscious race against death, knowing full well that with each newly published book, his place in immortality was further solidified. But in November 2000, just one year after his stroke, perhaps the greatest honor of his career occurred. Ray was given the

Medal for Distinguished Contribution to American Letters from the National Book Foundation. This governing board runs the annual National Book Award ceremony—the literary equivalent of Hollywood's Oscars. What was so special about this acknowledgment, to Ray, was that the award was not for fantasy. It was not for science fiction. It was not for any genre. The medal was awarded for *Literature*.

In conferring the award, the National Book Foundation issued the statement "Mr. Bradbury's life work has proclaimed the incalculable value of reading; the perils of censorship; and the vital importance of building a better, more beautiful future for ourselves and our children through self-knowledge, education, and creative, life-affirming attentiveness and risk-taking."

And so, in November 2000, Ray arrived in New York. He was getting around again, lecturing at colleges, universities, and corporations across the country. He made the trip to New York alone. Maggie, at seventy-six, was even more reclusive than ever, opting to stay home with her four beloved cats, her cigarettes, her fine French coffee, and her seven thousand–plus books. Ray's daughters had their own lives to tend to. There were now eight grandchildren, four girls, four boys. Patrick Kachurka, on Jennifer Brehl's suggestion, had offered to accompany him, but Ray liked doing things on his own. When people offered to help him after his stroke to climb stairs, he fended them off. But the one man who had been with him for nearly his entire career in books was there at the awards ceremony by his side—Ray's agent, Don Congdon. And his "date" was his editor, Brehl. That evening, near the end of the ceremony, host Steve Martin introduced Ray, summing up a lifetime of literary achievement nonpareil.

"Novelist, short-story writer, essayist, playwright, screenwriter, and poet . . . how can we even begin to count all of the ways in which Ray Bradbury has etched his indelible impressions upon the American literary landscape? There are few modern authors who can claim such a wide and varied provenance for their work, spanning from the secret inner-worlds of childhood dreams, to the magic realism of everyday life, to the infinite expanses of outer space."

Ray moved slowly to the stage, aided by others. No one but Brehl and Congdon knew it, but less than a week earlier, he had suffered yet another ministroke, losing the vision in his left eye. He had briefly pondered

canceling his appearance at the awards but, decided against it. He had finally been accepted and acknowledged by the New York literary establishment as a literary writer. No, this was not to be missed. When Ray took the podium, in an instant, everyone in the packed auditorium forgot that this man was eighty years old and in declining health. He was the Ray Bradbury he had always been: entertaining, energetic, and hilarious.

"Well, here I am," he said, after taking the stage. He wore a black suit that looked like a tuxedo (he hated wearing tuxes) with a red bow tie. "I have one good eye, one good ear, one good leg, and there's other things missing but I'm afraid to look."

From the start, the audience in the vast room at the Times Square Marriott was captivated. Ray's speech was a rousing, epic survey of his entire career, centered upon his lifelong love of libraries and books.

"[W]ho you're honoring tonight is not only myself but the ghost of a lot of your favorite writers," he continued. "And I wouldn't be here except that they spoke to me in the library. The library's been the center of my life. I never made it to college. I started going to the library when I graduated from high school. I went to the library every day for three or four days a week for ten years and I graduated from the library when I was twenty-eight."

Ray's speech, like all of his speeches since the late 1940s, was completely extemporaneous: fifteen minutes of love, joy, and inspiration. That night, Ray Bradbury jumped off the cliff and built his wings on the way down.

When it was all over, Ray received a standing ovation. He stood looking out at the crowd, unable to see much because of the glare of the lights, the cacophony of the audience overwhelming his one good ear. But standing there, as he was so often prone to be, he was touched. He wanted to cry. As the big banquet room roared with gratitude, generations young and old cheering him on, thanking him, Ray Bradbury relished the moment. He was loved.

It was one of the great highlights of his career. And, just as his first story, "Hollerbochen's Dilemma," published in 1938, had given him the energy and confidence to continue writing, the National Book Foundation medal fueled Ray on. He continued prepping his forthcoming novel, *From the Dust Returned*. He worked on his mystery novel, *Let's All Kill*

Constance. And, as he had done for six decades, Ray was still writing a short story a week.

"Every time I've completed a new short story or novel," he said, "and mailed it off to Don Congdon, I say to the mailbox, 'There, Death, again one up on you!'"

Yet even as Ray found life and immortality in his work, as the new millennium began, many of his inner circle were vanishing forever. Sitting in his large leather chair in the television room of the Cheviot Hills house, Ray often sadly noted that most of the names in his brown leather telephone directory were of friends who had died.

On an early January morning in 2001, Ray Bradbury was walking slowly up a concrete pathway of his Palm Springs home. He was on a mission. After his stroke, he used a four-pronged cane, but gradually he relied more heavily on the walker he was now using. If he had long walks ahead of him, Ray acquiesced to a wheelchair. Despite these physical hindrances, his spirits were high.

Ray had always approached life in this manner. Though he lamented that his impatience kept him from writing his astounding experiences in a daily journal, a rare diary entry written in 1939, when he was eighteen, confirmed this outlook on life: January 21, Saturday: "It rained glorious rain all day. . . ."

Now, more than sixty years later, when he walked, he chuckled and talked as he dragged his feet behind the walker. He sank his thick fingers into the pocket of his white tennis shorts (a uniform of comfort he began adopting in the early seventies), and withdrew a set of keys. The key chain had attached to it a small pewter fish, a gift from film director John Huston, given in 1953 when Ray was in Ireland working on the *Moby Dick* screenplay. He unlocked the door. The curtains and shutters were closed. The stout, white-haired man wearing the white tennis shoes, white socks, white shorts, white Oxford shirt, and a tie emblazoned with a colorful pattern of Easter eggs, stood at the doorway and peered into the darkness.

Ray slid his walker down the front hallway and threw wide the white shuttered doors of the coat closet. More boxes, more books, more toys. For a moment, Ray looked about until he located a cardboard box. He moved to a table near the living room, next to a sliding glass door that overlooked the small backyard and the swimming pool, and began to

rummage through the box. He took out a stack of old newspaper clippings—yellowed cartoon strips torn from the funny pages of a bygone era. They were from his childhood hometown newspaper, the *Waukegan News-Sun;* the dates along the top read "1929," and dozens of clips made up the pile. They were his *Buck Rogers* comic strips.

As Ray sat gingerly leafing through these old remnants, he grew quiet. He looked at the pieces of newsprint with a bittersweet mix of nostalgia and wonder. He had traveled two hours so that he could find these mementos of his past.

On March 16, 2001, Ray's beloved aunt Neva died at the age of ninety-two. The great inspirer, "Glinda the Good," was gone. Ray, Patrick Kachurka, and Neva's longtime partner, Anne Anthony, were the only ones who gathered for a private memorial service. Neva was laid out peacefully, her long, gray tresses fanning out beneath her. Afterward, Ray arranged to have her remains cremated. When he received the tin with his beloved aunt's ashes, he placed them on a small card table in his dining room, with two old photographs of Neva placed nearby, alongside a small painting that Neva had done in the 1920s. It was a shrine to the one person who had most profoundly influenced him.

After that, he put together yet another collection of short stories, *One More for the Road,* published in 2002. His murder mystery, *Let's All Kill Constance,* the third book in his mystery-noir trilogy, begun in a hospital bed shortly after his stroke, was released in 2003. That year also, one hundred of his "Most Celebrated Stories" were collected and published with *Bradbury Stories.* He raced to publish 2004's *The Cat's Pajamas,* another collection of short stories old and new, spanning his entire career.

Though Ray was lecturing occasionally in the Los Angeles area, his primary passion these days had become the theater. His own troupe, the Pandemonium Theatre Company, was mounting several productions a year. As ever, Ray's longtime theatrical partner, the soft-spoken Charles Rome Smith, handled the director's duties on the majority of the productions. Ray was still very active, dining regularly with his friends, attempting to eat better, and limiting his drinking to one glass of wine with each meal. And, of course, he spent his mornings writing. Since his strokes, he had tried to type, but he could barely move his left hand. And so in 2001, he took to dictating almost all of his stories by telephone to his daughter

Alexandra. It was a difficult way to write, and Ray never quite felt the same rhythm as he had as a prolific and fast typist, but it was his only recourse. On rare occasions, he jotted stories down by hand, usually with a thick Sharpie, or he attempted to type on his trusty Selectric.

Late mornings and afternoons usually consisted of opening mail. Ray received, on average, three hundred letters a week from fans in China, Argentina, Japan, everywhere. He did his best to answer them all. "If it's a love letter, you have to answer it," he asserted. By midafternoon, as he had done for his entire life, Ray was napping. A good part of the remainder of the day, postnap, was spent in front of the television with Maggie. They were there, like the majority of the nation, staring in shock as the events of September 11, 2001, unfolded. Ray called the terrorist attacks "the darkest day in American history." And, ever the oracle, when asked how the world's problems might be solved, he was quick to insist that everyone was ignoring the real problem, the relationship between Palestine and Israel. "When that is solved, only then will we have real peace," Ray said.

On Saturday, February 1, 2003, he and Maggie were watching television, as usual, when reports of the space shuttle *Columbia* burning up on reentry, killing the seven astronauts on board, aired on all the news channels. Ray was sitting in much the same spot as he had been, thirty-six years earlier, watching in horror the coverage of the *Apollo 1* tragedy. As the *Columbia* space shuttle debris streaked across the blue Texas sky, Ray sat in disbelief. This tragedy was eerily reminiscent of his own story "Kaleidoscope," in which an astronaut, falling from the sky, was thought to be a falling star. Ray did the only thing he could to keep from despairing—he began another short story that morning. "Work is the only answer," he said.

By early 2003, Maggie was growing increasingly and markedly wearied. She rarely left the house anymore. When she made appointments with friends, the hairdresser, the doctor, she'd inevitably cancel them. She spent her days reading and talking to her four cats, Jack, Win-Win, Dingo, and her favorite, Ditzy. From the sofa in the TV room in which she sat, Maggie could look out the screen door and marvel at her glorious rose garden, reports of which she'd rattle off to friends on the telephone.

On Halloween night, 2003, Ray and his daughter Alexandra sat at the small table in the breakfast room, carving pumpkins. As he had done over decades, Ray stood at the front door with a large bowl of candy and a Po-

laroid camera to snap photos of young trick-or-treaters in their elaborate costumes. That evening, Maggie was noticeably tired, noticeably frail, and didn't come to the door to hand out treats. Two weeks later, when she could not climb out of bed, Ray dialed 911 for the paramedics, though Maggie refused to go to the hospital. When the paramedic crew arrived, they took her to Brotman Medical Center in nearby Culver City, where she was admitted. Because Maggie had skipped all her doctor's appointments in the last few years, the diagnosis came as a shock to everyone. She had advanced lung cancer. In the days that followed, her daughters visited her at the hospital, Patrick Kachurka kept a regular vigil by her bedside, and Ray and Maggie's dear friends, bookstore owners Craig and Patty Graham, came by with flowers and laughter. Ray stopped in each afternoon and sat by her side and held her hand and cried. "I love you, Mama," he mustered, choking back tears. "I love you." To the end, Maggie's sense of humor remained. Even when she could no longer speak through the tangle of feeding tubes and the oxygen mask, if someone in the room cracked a joke to cheer her up, she chuckled, her spirit unbreakable.

On November 24, 2003, at 3:15 in the afternoon, Marguerite Susan McClure Bradbury passed away. She and Ray had been married for fifty-seven years. Like all married couples, Ray and Maggie had shared their ups and downs, but through it all Maggie had been Ray's adviser, his staunch supporter, the love of his life, the woman who "took a vow of poverty" when she married a relatively unknown pulp writer who had nothing more than big dreams. He told her he wanted to go to the moon and he wanted to take her with him. And she went.

The funeral service, kept simple and intimate, was held on Friday, November 28, at Westwood Memorial Park Chapel. On that day, the sun was bright and the sky was blue, the requisite L.A. smog on temporary hiatus. Ray had chosen that particular cemetery to bury Maggie because it was small, close to home, and practically a Who's Who of twentieth-century entertainment—there lie Marilyn Monroe, Burt Lancaster, Dean Martin, the original "Odd Couple," Walter Matthau and Jack Lemmon; singers Peggy Lee, Roy Orbison, and Mel Tormé. He had purchased a plot for himself, as well.

Inside the A-frame chapel, family and friends gathered—the Bradbury daughters and grandchildren, Forrest J Ackerman, Norman Corwin,

Sid Stebel, Bill Nolan, Stan Freberg, and dozens more. Maggie lay at rest in her casket, a stuffed animal—a black cat—and a comic-book adaptation of Marcel Proust's *Remembrance of Things Past,* which Ray had slipped in, nestled by her side. Eschewing the traditional standard service, since they'd only attended church a handful of times over the decades, Ray invited those in attendance to share their memories of Maggie. Forrest Ackerman spoke, reminding Ray that Maggie, his wife of fifty-six years, had always "looked out" for him and was now watching from above. After a few more brief, respectful remarks from others, Ray stood to offer his own reflections. He began at the beginning, recalling his courtship with Maggie and the early days of their marriage. Those were the days he most cherished. "We were so in love and it was so wonderful," he said.

With Maggie's passing, Ray was left all alone in the big house in Cheviot Hills. However, he carried on and continued writing. Loss, though, seemed to be all around him. On Sunday, February 8, 2004, Ray's longtime friend and his first agent, Julius Schwartz, died at Winthrop Hospital in New York from complications due to pneumonia. He was eighty-eight years old.

On the afternoon of April 3, 2004, Ray spoke by telephone to his brother, Skip, just as he did every Wednesday and Saturday. The last thing Ray said to his older brother was, "I love you." Later that night, Leonard "Skip" Bradbury Jr. passed away in his sleep at his home in La Pine, Oregon. He was eighty-seven.

"Everyone around me is dying," Ray said. Sitting in the breakfast room of his house, sunlight falling through the slats of the white wooden window shutters, Ray pondered the future. His future. Our future. He had long been respected as a visionary and he was often asked where humankind was headed next.

"We're going to make it. We're going to be all right. First, we're going back to the moon. Then, we're going to Mars. After that, we're headed to Alpha Centauri," Ray said, pausing for a moment to reflect. "And you know what? I'm going with you."

And he was right. Mr. Electrico had been right, too. Ray would live forever. Through his work. As so many around him were departing, Ray found solace in the fact that he would be here long after his physical self was gone, buried at Westwood Memorial Park next to Maggie.

"The thing that makes me happy," he said, "is that I know that on Mars, two hundred years from now, my books are going to be read. They'll be up on dead Mars with no atmosphere. And late at night, with a flashlight, some little boy is going to peek under the covers and read *The Martian Chronicles* on Mars."

For certain, this child of modern popular culture had earned his own rightful place as a central figure in the annals of twentieth-century Americana. Even the language of this multimedia Renaissance man had entered the national lexicon. In May 2004, Academy Award–winning documentary filmmaker Michael Moore premiered his politically charged motion picture *Fahrenheit 9/11* at the Cannes Film Festival. The movie skewered the policies of President George W. Bush that led the United States to war in Iraq in 2003. The documentary film title was an obvious homage to Ray's seminal novel of social commentary, *Fahrenheit 451*. Like so many, Michael Moore had grown up on the works of Ray Bradbury. In the post–September 11 world, many readers—Moore included—believed that *Fahrenheit 451,* with its themes of censorship, individual empowerment, and looming government control, was now more relevant than ever before. Moore even felt that his title was carrying on a proud Bradbury tradition, of respectfully borrowing lines from classic literature for titles, just as Ray had done with Shakespeare's "Something wicked this way comes," Yeats's "The golden apples of the sun," and Whitman's "I Sing the Body Electric." But when Ray caught wind of Michael Moore's intentions, he was upset and tried in vain to reach Moore by telephone, to ask him to drop the title. Ray wished that Moore had at least asked him for permission; Ray also worried that his novel would somehow be confused with Moore's film. Academy Award–nominated screenwriter and director Frank Darabont (*The Shawshank Redemption*) had recently completed a much-anticipated new screenplay of *Fahrenheit 451* with the hopes of releasing the film in 2005. Ray worried that some might confuse Moore's film with the Darabont movie. Ray was vocal to the press about his displeasure with Moore. "Give me my title back," he stated in numerous television and print interviews. On the afternoon of Saturday, June 5, 2004, Moore finally called. The U.S. release of his film was just two weeks away. Ray was sitting in his oversized leather chair in his television room when Moore phoned. The filmmaker was soft-spoken

331 THE TIME OF GOING AWAY

and gentle. Ray responded in kind and suggested that they hold a joint press conference, in which Moore would hand a copy of *Fahrenheit 451* back to him as a metaphorical gesture. During the proposed conference, Moore would announce that he was changing the film's title. But when Ray presented this idea, Moore said that the film and all of its marketing had been set into motion long ago. It was too late to change the title, and Moore was apologetic that it had come to this.

When Ray's feelings on *Fahrenheit 9/11* hit the news, a firestorm ensued. Many noted the irony of Ray Bradbury attempting to censor Michael Moore. After all, *Fahrenheit 451* was one of the great emblematic works of anticensorship. Ray insisted that politics had nothing to do with his feelings. He steadfastly maintained that he had no party affiliation, was not offended on behalf of the Republican Party; in fact, he said that if he were to be classified at all, he was an Independent. Ray argued that it was a matter of principle, if only Moore had called him before he had chosen the title. Ray defended himself and his use of titles from Shakespeare, Yeats, and Whitman; in each instance, in the front of Ray's books, he had credited the respective quotes from the original authors.

Upon its release, *Fahrenheit 9/11* broke records, becoming the first documentary ever to open at number one at the box office; the film grossed $23.9 million during its opening weekend alone. *Fahrenheit 9/11* well illustrated just how profoundly Ray Bradbury had imprinted popular culture. In November 2004, his influence became ever clearer. On November 17, Ray received the highest national honor given to artists by the United States government. Accompanied by three of his four daughters—Susan, Bettina, and Alexandra—and Patrick Kachurka, Ray flew to Washington, D.C., to accept the National Medal of Arts from President George W. Bush, presented under the auspices of the National Endowment for the Arts.

It was a crisp, sunny autumn day. As Ray got ready to go to the White House, he couldn't help but think of Maggie, and wish that she could be with him to enjoy this unprecedented honor. He thought, too, of his mother and father, and how proud they would have been to see how far he'd come—all the way to the White House!—from the little house in Waukegan.

Upon their arrival, Ray and his guests were escorted to the Roosevelt Room in the West Wing, just off the Oval Office, where they were asked

to wait. Moments later, a door opened, and a Marine Corps captain pushed Ray's wheelchair across a short hallway and into the office of President George W. Bush. Standing alongside the commander-in-chief was First Lady Laura Bush, along with Dana Gioia, chairman of the National Endowment for the Arts, and several others. Like so many people, Gioia, a renowned poet in his own right, had grown up on the words of Ray Bradbury. Gioia had personally recommended to the President that Bradbury be awarded the Medal of Arts.

"The author of *The Martian Chronicles* and *Fahrenheit 451*," wrote Gioia in the official NEA announcement, "Ray Bradbury is the greatest living American writer of science fiction. His singular achievement in this genre is rooted in the imaginative originality of his works, his gift for language, his insights into the human condition, and his commitment to the freedom of the individual."

President Bush placed the heavy medal around Ray's neck and shook his hand. Ray smiled broadly, savoring the exhilarating moment, the apex of his decades-long career. Since his earliest days in "Green Town," Illinois, he had always believed the future to be full of promise. And, from the Great Depression through to the Space Age, as he dreamed of the future—imagined it, wrote about, embraced it—he had inspired some of the most renowned individuals of several generations, from filmmakers to musicians to politicians to astronauts to writers. Many of them would go on to leave their own marks, to establish their own legacies, and many of them owed a debt of sincere gratitude to Ray Bradbury for being an early inspiration. Ever since he walked out of a dark movie theater in the winter of 1924, his mother by his side, Lon Chaney in his heart and his mind, Ray Bradbury was forever forged of popular culture. Now, eighty years later, he claimed the same influence on others. His impact was widespread. From a crater on the moon, to a classroom in Tokyo, to an instantly recognizable amusement park ride rising out of the Florida swampland, to a small park in Waukegan, Illinois, named in 1990 "Ray Bradbury Park," he was everywhere. And even if he wouldn't be a part of the future he so eloquently envisioned, he was all around us.

ACKNOWLEDGMENTS

MANY PEOPLE assisted me in unraveling the secrets of Ray Bradbury's magic over the course of writing and researching this biography. First and foremost, the man himself, who, against the magician's oath, brought me backstage and showed me all the props and blueprints to his grand illusions, and explained the tricks of his literary sleight of hand. His generosity and patience were nothing short of amazing. His willingness to field questions at all hours of the day, to open up his file cabinets, his bureau drawers, his closets—*his life*—made this book possible. For this, I am eternally grateful. Thank you for this honor, for your friendship, for a lifetime of literature.

I am equally indebted to Marguerite Bradbury. A fiercely private woman, I was always acutely aware of the privilege I had during our hundreds of hours of conversations. Maggie's humor, candor, knowledge of books, generosity with wine, and unconditional acceptance of me will never be forgotten.

I would also like to thank Ray's four wonderful and gracious daughters, Susan, Ramona, Bettina, and Alexandra, along with their lovely families, who granted interviews unquestioningly and were unfailingly hospitable. Thank you, Tommy and Mallory; Julia, Claire, Georgia, Teddy, and Sam; and Gary, Danny, and Casey-Ray. Thanks also to Morgan Cavett for contributing his own research, lending assistance, and sharing laughs. I would be remiss in not giving a special thanks to Alexandra ("Zee") for fielding regular requests for letters, files, and photographs. I

am so fortunate to have her count me as a friend. Thanks for the "witchy-poo" spells and magic.

As fundamentally good and decent people, Ray and Maggie Bradbury attracted and were surrounded by good and decent people. Chief among them were Patrick Kachurka, his charming wife, Cathy, and their two winning boys, Eric and Jonathan. From the beginning of this enormous undertaking, a journey that began four years ago, the Kachurkas opened up their home to me, offered a bed to sleep in, a pool to swim in, home-cooked meals, and, most important, friendship. Ray and Maggie called Patrick "Saint Patrick" for good reason.

I am also mightily indebted to Ray's longtime agent, Don Congdon, for granting me numerous interviews and complete access to his agency deposits at the Butler Library at Columbia University, and permission to quote from his voluminous, unpublished 1971 interviews with Ray Bradbury. Forrest J Ackerman, a perfect gentleman, granted numerous interviews, shared photographs, and opened the doors to his world-famous "Ackermansion."

I have been fortunate to have a remarkable agent and friend for this book. Judith Ehrlich didn't just believe in this project from the beginning, she believed in me. Her assistant, literary agent Meredith Phelen, was a constant source of good energy, wit, and wisdom. I would also like to thank Linda Chester for her involvement in the early book proposal stages. Liza Nelligan, who passed away during those early days, offered exquisite advice. Kyra Ryan stepped in and helped wrangle my proposal into shape and stayed with me as a confidante, editor, and friend throughout the writing of the book.

I have been blessed with a fine publishing house in William Morrow. My editor, Jennifer Brehl, displayed infinite patience. I have never worked with a more skilled, thoughtful, or incisive partner. Katherine Nintzel, Jennifer's gracious assistant, was perpetually sunny and helpful. Thanks to Jack Womack for his heroic efforts in the publicity department. The beautiful photograph that graces the cover of this book comes courtesy of Ray's longtime friend photographer Ralph Nelson, and was used to stunning effect by Morrow art director Richard L. Aquan. The book's striking design is the creation of Judith Stagnitto Abate. I am extremely grateful to copy editor Sonia Greenbaum and production editor

Andrea Molitor, both of whom displayed painstaking and sensitive attention to detail while working with this manuscript.

The most unexpected reward of researching and writing this book were the new friends I made. Craig and Patty Graham were a joy to be with and their advice on this project was always most welcome. Their willingness to help on any level—from going through files, to finding Ray's childhood residence in Tucson, Arizona—will always be appreciated. Their son Michael was continually a source of Gen-Y savvy opinions. The kindness and insight of Ray's longtime friend Sid Stebel and his terrific wife, Karen Ford, were much appreciated. Marsha and Gregg LuMetta offered warm friendship and logistical support when I filed my Freedom of Information Act request with the Department of Justice. Arnold and Marlene Kunert offered to help on many, many levels, sharing photographs, archival materials, and knowledge. For insights, I am grateful to Anne Hardin, Terry Pace, and Thomas Petitpas. For kindness and generosity, I greatly thank Frank Darabont and Julie Richardson. Wonderful people, all. Thanks also to Erlean Trapp for her thoughtfulness over the course of these last years, and also to Sam Nahabedian, still another superb person in Ray Bradbury's universe.

My sincere gratitude goes to those who patiently shared memories and insights about Ray Bradbury. And to those who were influenced by Ray Bradbury himself and offered testimonials, thank you. In the years it took to assemble this narrative mosaic, some of these have included Edwin "Buzz" Aldrin, Mary Anderson, Frank Black, Leonard "Skip" Jr. and Sonja Bradbury, Leonard "Brad" Spaulding Bradbury III, Michael Chabon, Sir Arthur C. Clarke, Norman Corwin, Laraine Day, Tim Delaney, April Derleth, Dennis and Kris Etchison, Dr. H. Regina Ferguson, Stan Freberg, Ace Frehley, Neil Gaiman, John Gay, National Endowment for the Arts chairman Dana Gioia, Vivian Gneuwich, Bob Gorman, Howard Green, Los Angeles mayor James K. Hahn, Ray Harryhausen, Philip Hartigan, Hugh Hefner, John Huff, Edna Hutchinson, Jon Jerde, Stanley Kauffmann, Stephen King, Dan Kolsrud, Nard Kordell, David A. Kyle, Stan Lee, Ursula K. Le Guin, Norman Lloyd, Leonard Maltin, Joe Mantegna, Lydia V. McColloch, Kevin Miller, William F. Nolan, Dr. Mary Beth Norton of Cornell University, Frederik Pohl, Julius Schwartz, Terrence Shank, Marty Sklar, Charles Rome Smith, Steven Spielberg,

Jeffrey Stanton, Thomas Steinbeck, Bernie Taupin, Studs Terkel, Carol Moberg Treklis, Peter Viertel, Dan Waldron, Jerry Weist, Larry Wilcox, Bonnie Wolf, Steve Wozniak.

Much work occurred in the dark corridors of libraries and archives across the United States. I am grateful to the countless number of librarians and archivists who gave me invaluable assistance. Ann Darrow and Beverly Millard at the Waukegan Historical Society were tremendously helpful. Thanks also to the many reference librarians at the Los Angeles Central Library, Chicago's Sulzer Regional Library, the Harold Washington Library, the Chicago Historical Society, the Newberry Library, the New York Public Library, the UCLA Research Library, Tucson-Pima Public Library, the State Historical Society of Wisconsin, the Robert L. Parkinson Library and Research Center at the Circus World Museum in Baraboo, Wisconsin, and the Jerome Library Center for Archival Collections at Bowling Green State University. I would also like to thank Susan Augustine at the Columbia College Chicago Library, as well as Jo Cates, who truly knows how to run the library of the twenty-first century. Sincere thanks go to Chicago Public Library commissioner Mary Dempsey for her unflinching support over the years.

For assistance with additional research material, I must thank Michelle Ray of the National Cable and Telecommunications Association; David Motley of the City of Waukegan Office of Public Affairs; Lake County Clerk's Office; Lake County Medical Examiner's Office; the U.S. Department of Justice FOIA Division; Richard Kaminsky; Daniel R. Patch Jr. of Peterson & Patch Funeral Home; Alex Eisenstein; James J. J. Wilson and Michael Stein of *Outré* magazine; Eric Kirsammer; Mike Gentry at NASA; the Venice Historical Society; Genesee Theater; Wayne Munn of the Carnegie Preservation Society; Lt. Walter Holderbaum of the City of North Chicago Police Department; the National Archives Records Administration, Great Lakes Region; Christine Badger; and Laure Ann Treklis-Dansbury.

I have a tremendous and ongoing debt to those who assisted my research, principally, my friend Mike Dooley of the Chicago Police Department. Mike's willingness and profound generosity to pound the pavement proved to me that good researching is always rooted in methodical and patient detective work. A nicer man I do not know. Dave

MacFarlen, also of the Chicago Police Department, tirelessly led the way with photographs, restoring dozens of pictures, many more than a century old. Norman Schwartz lent his considerable expertise in the field of genealogical research in helping assemble the rather complex Bradbury family story. JB Mulholland, my skilled research assistant, made himself available at all hours of the day and night, scouring libraries, wandering graveyards, staring into blurry microfiche machines; when JB was unavailable, his resourceful girlfriend, Jennifer Krueger, stepped in. Also on the research front, I give profound thanks to Randy Kryn, who kindly shared his collection, and Professor Jonathan R. Eller, of the English Department at Indiana University, who was readily available to answer questions and lend valuable insight into Ray Bradbury's publishing history. Professor Donn Albright of the Pratt Institute was most kind in verifying facts and pointing me in the right direction in locating hard-to-find documents. Thanks also to Jason Marchi for research advice.

I am grateful to those authors who have written scholarly books on Ray Bradbury, laying the groundwork for my own research into his life and works. Thanks to Richard Steven Dimeo, Jonathan R. Eller and William F. Touponce, Martin H. Greenberg and Joseph Olander, Wayne L. Johnson, David Mogen, William F. Nolan, and Robin Anne Reid.

Many professional colleagues have imparted wisdom, offered keen advice, acted as sounding boards. Among my friends in the worlds of journalism and publishing, I am grateful to the *Chicago Tribune*'s Elizabeth Taylor, who gave me the assignment to write a Ray Bradbury cover story. In the subsequent months and years to follow, Liz shared her own insights of writing the biography of Chicago mayor Richard J. Daley. I am beholden to Rick Kogan, who offered valuable structural and narrative suggestions and lit the path that is William Morrow way. To my former colleagues at *Publishers Weekly,* notably Nora Rawlinson, Daisy Maryles, John F. Baker, John Mutter, Kevin Howell, Calvin Reid, Bridget Kinsella, and, of course, Matt Hurley—I thank you for the privileged opportunity. And to the many Midwest publishers, distributors, and booksellers I worked with in my years with *PW,* thank you. I would also like to acknowledge my former teams at *Newcity* and *Gravity* magazines.

A good many colleagues at Columbia College Chicago made themselves readily available to help in myriad ways. Dr. Randall Albers, chair of the Fiction Department, has been a reliable friend and mentor for a good many years. His creative suggestions were numerous and invaluable. Professors Don DeGrazia, Eric May, Joe Meno, Phyllis Eisenstein, and Patricia Ann McNair—peers par excellence—lent advice during different stages of creation. Professors Emeriti John Schultz and Betty Shiflett set the stage for this book with their innovative approach to the teaching of writing. Garnett Kilberg-Cohen, chair of the English Department, has been unwavering in her support. I thank her for the thrill of allowing me to teach a class on the life and works of Ray Bradbury.

I would like to acknowledge my mentors, the teachers who ignited my love of research and writing: at Elgin Academy, Peter Barra; during my undergraduate and MFA days at Columbia College Chicago, Professor Ann Hemenway; and Professor Paul Max Rubenstein, in the Columbia College Chicago Film Department, set me on my path. These fine instructors abided by Ray Bradbury's first rule of teaching—to inspire.

I'd like to thank my friends: Sam Jemielity, who has been a true pal, a savvy editor, smart writer, and an invaluable sounding board; Frank Sennett, my editorial Obi Wan Kenobi; Barry Brecheisen, a magnificent photographer, who offered photos from his own archives, and flew to Los Angeles to take more; Jerry Vasilatos, who helped me locate elusive Hollywood luminaries; Keir Graff, who listened patiently to my anguish and shared thoughtful advice during the early proposal stages. Christina Vasilatos lent her legal expertise, and Shane Graff gave photographic assistance early on. John and Mary Fournier, Steve Edwards and Andrea DeFotis, Monty and Diane Colvin, Alex Ross, Brian Vaughan, and Norman Alexandroff have been constant and reliable friends, always lending me an ear when I needed it. I would also be remiss in not thanking all my friends at Southwest Airlines.

Many family members assisted in many ways. First and foremost, I must thank my father, William G. Weller, who introduced me to the works of Ray Bradbury long ago. Beyond this, he has been a constant pillar, willing to listen, to read manuscript pages, to offer knowledge on the art of storytelling, and to (very important) dog-sit as I traveled about the country. He has just been a great dad. To Barbara J. Weller, my beloved

mother, who gently and unobtrusively introduced me to the wonders of reading, I hope this book makes you proud. I know you played a hand in the fate that led to it. Deepest thanks go to my sisters, Betsy Hetzler and Suzanne Smith, who gave me unwavering love and support, and my brother, Dr. David Weller. I depended on Dave's indispensable wisdom and advice for this biography. And to their excellent spouses—Paul, Tim, and Sarah—I thank you. And, of course, a nod of appreciation goes to the kids: Abbey, Eian, Keaton, Elin, and Maggie. Thanks, too, to my mother-in-law, Tam Tran, who stepped in during the early days of parenthood and the late, taxing days of revisions; my brother-in-law, Tuan Nguyen, who has been singing my praises to librarians across the Lone Star State; and, of course, Tri, Tran, Ky-Tai, Sylvie, and Minh-Tan. A sincere thanks, as well, goes to my extended family in Illinois, Wisconsin, and to the Quan Le family in Texas. And to Disney and Sage, my best friends, I owe an eternal debt of love and gratitude for standing by me throughout.

And finally, to my wife, Jan Nguyen, who has stood by me throughout this fantastic voyage—a more loving and loyal partner does not exist. Jan assisted on every conceivable level and, in the end, delivered the miracle that is our baby girl, Mai-Linh Nguyen Weller. In the days that followed, in between a blur of changings and feedings, and in the throes of book revisions, Jan became my collaborator—implementing edits, reading the manuscript numerous times, and rewriting me. She very literally delivered two babies and, for this, I am forever in her debt. I love you.

NOTES

THE FOUNDATION of this book came from the hundreds of hours of conversations I had with Ray Bradbury. All quotes and information came from RB during these interviews, unless otherwise noted.

CHAPTER 1

Page 11: "Ray Douglas Bradbury arrived in the world . . .": Certificate of Birth, Ray Douglas Bradbury, August 22, 1920, Lake County Clerk's Record #4750.

Page 12: "Born to Mr. and Mrs. Leo Bradbury . . .": *Waukegan Daily Sun,* Aug. 29, 1920.

Page 12: ". . . a friend of Ray's . . .": Letter dated July 10, 1947, from Ray Bradbury to Anthony Boucher. From RB's private collection.

Page 14: "The first people . . .": Osling, *Historical Highlights of the Waukegan Area;* Holmes, *The History of Waukegan.*

Page 15: "As urban legend has it . . .": *Waukegan News-Sun,* Nov. 5, 1984.

Page 15: "A town member who attended the event . . .": *Waukegan Historical Society* extracts of Waukegan daily papers from February 1909.

Page 15: "Another noteworthy Waukegan event . . .": Holmes, *The History of Waukegan.*

Page 16: "Waukegan, in 1920 . . .": *The Fourteenth Census of the United States.*

Page 16: "Bradbury genealogical records . . .": Lapham, *The Bradbury Memorial.*

Page 16: "On July 26, 1692 . . .": Boyer, *The Salem Witchcraft Papers.*

Page 16: "I am wholly innocent . . .": Ibid.

Page 17: "The charges against Mary Bradbury . . .": Ibid.

Page 17: ". . . on September 6, 1692 . . .": Ibid.

Page 18: "From her . . .": Kunitz, *20th Century Authors.*

Page 18: "Samuel Irving Bradbury . . .": Obituary of Samuel I. Bradbury, "Yard Scrapbook," Waukegan Historical Society.

Page 18: ". . . Dec. 1st, felled the first tree . . .": Ibid.

Page 18: "Little more than a month . . .": Ibid.

Page 19: "Sam and Mary had three children . . .": Lapham, *The Bradbury Memorial.*

Page 19: "Samuel Hinkston Bradbury was born . . .": State of Illinois Death Certificate of Samuel Hinkston Bradbury, Lake County Clerk's Record #1023.

Page 19: "Samuel Sr. had moved . . .": Obituary of Samuel I. Bradbury, "Yard Scrapbook," Waukegan Historical Society.

Page 19: ". . . but it once stood at 22 North State Street . . .": Bradbury Collection, Waukegan Historical Society.

Page 19: ". . . with its cellar roots . . .": Bradbury, *From the Dust Returned.*

Page 20: ". . . a mouse in every warren . . .": Ibid.

Page 21: ". . . on January 21, 1896 . . .": State of Illinois Certificate of Birth Record, local file #602.

Page 21: ". . . By the time the 1900 . . .": No Bradbury daughter appears on the 1900 United States Census.

Page 21: "But, oddly enough . . .": Rose M. Bradbury appears on the 1910 United States Census, enumerated on June 19, 1910.

Page 22: "After returning home . . .": The 1906–1907 Waukegan City Directory lists Leonard S. Bradbury's occupation as "printer."

Page 23: "In 1912, Leonard Bradbury . . .": Author interview with Leonard "Skip" Bradbury Jr. Additionally, the earliest existing photograph of Leonard S. Bradbury and Esther Marie Moberg, taken during their courtship, is dated on the back, 1912.

Page 23: "Leonard and Esther married . . .": Marriage Certificate of "Leo Bradbury" and "Esther Moberg," from the papers of Ray Bradbury.

Page 23: "Like many other Swedes . . .": Gustaf Moberg's occupation as a heater at the local wire mill is listed in all Waukegan City Directories in the collection of the Waukegan Historical Society dating from early 1905 to 1922.

Page 23: ". . . worked as a driver . . .": Waukegan City Directories, the Waukegan Historical Society.

Page 24: "On July 17, 1916 . . .": Author interview with Leonard S. "Skip" Bradbury Jr.

Page 24: ". . . on September 30, 1918 . . .": State of Illinois Death Certificate.

Page 25: "For that fine madness . . .": *Annual Waukegan High School 1912.*

Page 25: ". . . Captain Sam Bradbury was buried . . .": Letter from Jacques R. Adelée of the American Battle Monuments Commission, European Office, to RB, dated August 25, 1989. Captain Samuel H. Bradbury is located in Plot C, Row 12, Grave 18. Fourteen years after his death, in September 1932, Ray's grandmother Minnie Bradbury, a Gold Star Mother, traveled aboard the SS *Leviathan* to France to visit, at long last, the grave of her son. "I have traveled over 3,000 miles to see and visit a bit of earth over which stands a white cross," she said in the September 16, 1932, edition of the *Waukegan News-Sun*. ". . . [O]nly a mother who has seen her son go off to war happy in the thought that he is serving his country, but with the fear in her heart as the result of the realization that he may never come back, will understand."

Page 25: "He was just an ordinary little boy . . .": Author interview with Edna Hutchinson.

Page 26: "About seven o'clock . . .": Bradbury, *Dandelion Wine.*

Page 27: ". . . It was February 1924 . . .": Advertisements for *The Hunchback of Notre Dame* indicated it played in Waukegan for the first time in mid-February 1924.

Page 28: "When I talk of myself . . .": Cunningham, 1961 UCLA Oral History Program transcript.

CHAPTER 2

Page 30: "I have often thought that Neva . . .": Ray's essay about his aunt Neva, "The Wingless Bat," was likely written in the mid- to late 1940s. It has never been published.

Page 32: "autobiographical fantasy . . .": Mogen, *Ray Bradbury.*

Page 32: "On the morning of Friday . . .": State of Illinois Death Certificate of Samuel Hinkston Bradbury, Lake County Clerk's Record #1023.

Page 32: ". . . after lying in a coma for six days . . .": *Waukegan News-Sun,* June 5, 1926.

Page 32: ". . . when all the fireworks . . .": Don Congdon/RB interviews, 1971.

Page 32: ". . . and my uncle Bion had cracked a few windows . . .": Bion's first wife, Ray's aunt Edna Hutchinson, recalled the origins of the brass cannon: "Bion was a tool-and-die maker and he made the canon and they always used to bring it out and shoot it on the Fourth of July. I was scared to death of the thing. I thought that someone would get hurt." As legend would have it, the fate of the brass cannon is uncertain. Edna Hutchinson divorced Bion and recalls hearing that the old cannon was buried in the beach at Lake Michigan by a group of children on a Fourth of July many years later. Bradbury memorabilia collectors take note: Uncle Bion's infamous brass cannon, to the best of anyone's recollection, is, to this day, still buried deep in the sand on the Lake Michigan shoreline in Waukegan, Illinois.

Page 34: ". . . These windows . . .": Today, visitors to the old house at 619 W. Washington will only find one of the stained glass windows still intact. Somewhere over the course of time, one of the windows has been removed. Even still, it's hard not to stand below the remaining window and imagine a little boy behind it, peering out with an altered perception.

Page 35: ". . . For a brief time . . .": While he has been coined "The World's Greatest Living Science Fiction Writer," Ray Bradbury was not a big believer in the idea that Earth had been visited by extraterrestrials. "I believe there is life on other worlds but we'll never know. It's all too far away. It's a secret thing in our hearts; we wish it were true, because we'd love to have these visitors."

Page 37: "On March 27, 1927 . . .": The birth date of Betty Jane Bradbury is, sadly, listed on her State of Illinois Death Certificate issued less than a year later.

Page 38: "The concept of this soul-image . . .": Hillman, *The Soul's Code*.

Page 38: "I have a strange and incredible Muse . . .": From the 2002 RB essay, "My Demon, Not Afraid of Happiness."

CHAPTER 3

Page 39: ". . . enrolled at Chicago's School of the Art Institute . . .": From the records of the School of the Art Institute, Chicago.

Page 39: "When mother and father and I . . .": From the unpublished RB essay, "The Wingless Bat," circa mid-1940s.

Page 40: ". . . the newly constructed Genesee Theatre . . .": The complete history of the Genesee Theatre is listed on the theater's official

Website, www.geneseetheatre.org. In February 2001, the city of Waukegan approved funding of up to $20 million to renovate the grand old palace.

Page 40: "on the morning of February 8, 1928 . . .": State of Illinois Death Certificate, County Clerk's Record #11856.

Page 40: "At dawn, men arrived . . .": Various published chronologies of Ray Bradbury's life, including the timelines in David Mogen's critical tome, *Ray Bradbury*, and William F. Nolan's *The Ray Bradbury Companion*, list Elizabeth Bradbury's death in 1927, when in fact it was 1928.

Page 41: "His show had lots of action . . .": Author interview with Blackstone biographer Daniel Waldron.

Page 43: ". . . has a large following among science fiction readers . . .": Knight, *Ray Bradbury*, Modern Critical Views series.

CHAPTER 4

Page 45: "In 1929 . . .": Bradbury introduction, Williams, *Buck Rogers: The First 60 Years in the 25th Century.*

Page 47: ". . . Skip, the family athlete . . .": Author interview with Leonard "Skip" Bradbury Jr.

Page 48: "At breakfast . . .": RB introduction, Porges, *Edgar Rice Burroughs: The Man Who Created Tarzan.*

Page 50: ". . . the twin Schabold brothers . . .": Ray made brief mention of the Schabold twins—an homage of sorts—in the short story "The Lake."

Page 50: "In the last week of 1931 . . .": Blackstone's appearance was widely advertised in the *Waukegan News-Sun.*

CHAPTER 5

Page 52: "Ray wrote of this simple, childhood memory . . .": "Someone in the Rain" did not appear until 1997 in the collection *Driving Blind.*

Page 52: "Once I learned to keep going back . . .": RB, "Just This Side of Byzantium."

Page 53: ". . . Bradbury scholar Wayne L. Johnson noted . . .": Johnson, *Ray Bradbury*.

Page 54: ". . . the annual lakefront festival . . .": The Labor Day Weekend Festival on the lakefront was written up in the *Waukegan News-Sun*, Aug. 31, 1932.

Page 54: ". . . steaming calliope, strung mazda bulbs . . .": RB, from

Nolan's *Ray Bradbury Review. The Ray Bradbury Review* had a print run of 1,200 copies and is a relatively rare publication.

Page 55: "Lester Thomas Moberg . . .": Interviews with RB, Skip Bradbury, Ray's cousin Vivian, and Lester Moberg's daughter Carol Moberg Treklis.

Page 55: "He worked as an attendant . . .": State of Illinois Death Certificate listed his occupation, marital status, and children.

Page 55: "Monday evening . . .": Descriptions of the events come from the Lake County Coroner's Inquest and a newspaper report in the Oct. 18, 1932, edition of the *Waukegan News-Sun*.

Page 55: "Ghost stories . . .": RB, "House Divided," from *Driving Blind*. RB: "I wrote 'House Divided,' the story about fingerprinting Vivian, in the 1940s when I still lived with my parents and I left it lying around the living room and my mother picked it up and read it. And she went into shock. All these years I'd had this secret affair with Vivian. Her son! She said, 'Why, you dirty . . . how could you write a thing like that?' I said, 'Ma, I lived it.'"

Page 57: "The first time . . .": RB, *The Ray Bradbury Review*.

Page 57: "It was an experience . . .": Eller and Touponce, *Ray Bradbury: The Life of Fiction*.

Page 58: "Lester Moberg's death certificate . . .": State of Illinois Death Certificate, Lake County Coroner's Inquest, *Waukegan News-Sun*, Oct. 24, 1932, and *The Independent Recorder*, Oct. 27, 1932

Page 58: "But Ray Bradbury was . . .": Interviews with RB, Skip Bradbury, Ray's cousin Vivian, and Lester Moberg's daughter Carol Moberg Treklis.

Page 59: "There was also no record . . .": From an author interview with Fred Dahlinger Jr., director of Collections and Research at the Circus World Museum in Baraboo, WI. Dahlinger had no record of "Mr. Electrico." He did find entries in his collection for a "Mlle. Electra" (1911–1914) and a "Miss Electricia" (1926 and 1946). Bradbury researchers have commonly mistaken the popular 1930s traveling outfit "The Sam B. Dill Circus" for RB's mythic "Dill Brothers Combined Shows." The circus trade magazine *White Tops*, however, in its Jan.–Feb. 1955 issue, stated the Sam B. Dill Circus was in Crawfordsville, IN, on Labor Day. RB said emphatically that it was not the Sam B. Dill Circus. In Waukegan on that Labor Day weekend coincidentally were two other circuses: the popular Hagenbeck-Wallace and the Downie Brothers circuses. The

Waukegan News-Sun did mention a lakefront carnival but not by name. The Dill Brothers Combined Shows and Mr. Electrico, to this day, remain a mystery.

CHAPTER 6

Page 62: "Little did we know . . .": RB, "The Inspired Chicken Motel," *I Sing the Body Electric!*

Page 63: "We both wanted to be magicians . . .": Author interview, John Huff.

Page 66: "Opened to much fanfare . . .": Gleisten, *Chicago's 1933–34 World's Fair: A Century of Progress.*

Page 68: "The kids found out . . .": Author interview with Lydia V. Mc-Colloch.

CHAPTER 7

Page 72: ". . . He was horny": Author interview with Vivian Gneuwich.

Page 72: "In those days . . .": RB article "George, Marlene and Me" from *Life* magazine, July 1991.

Page 76: "Eventually, though, Burns . . .": Ibid.

Page 77: "When I think back on how I must've looked . . .": Congdon interviews.

CHAPTER 8

Page 81: "Ray was a suffering . . .": Author interview with Bonnie Wolf.

Page 83: "The boy persevered . . .": RB, "Death's Voice," *Anthology of Student Verse for 1937.*

Page 85: ". . . he acted in 106 films . . .": Author interview with Forrest J Ackerman.

Page 85: "Ray was a rather . . .": Ibid.

Page 86: "On November 22 . . .": Letter from Burroughs to RB, from RB's private collection.

Page 87: ". . . A Truck Driver After Midnight . . .": RB, *Anthology of Student Verse for 1938.*

CHAPTER 9

Page 89: ". . . He was aggressive . . .": Author interview with Bob Gorman.

Page 90: ". . . He saw the film . . .": Author interview with Forrest J Ackerman.

Page 90: "We had a mutual interest in dinosaurs": Author interview with Ray Harryhausen.

Page 90: "and all the Merian Cooper pictures": Merian C. Cooper was the codirector and coproducer (along with Ernest B. Schoedsack) of *King Kong*.

Page 91: "The future to me . . .": Author interview with Ray Harryhausen.

Page 92: "Filled with sorrow . . .": Sometime soon after, Ray's aunt Neva brought her cremated remains back to Waukegan, where she was to rest next to her husband, Ray's grandfather, Samuel Hinkston Bradbury. Both are buried at Union Cemetery on Waukegan's west side.

Page 92: ". . . he caught a double matinee . . .": RB's 1939 calendar, from his private collection.

Page 95: ". . . stylishly dressed in the fashions of the 25th century . . .": Pohl, *The Way the Future Was*.

Page 95: "I just kind of thought . . .": Author interview with Forrest J Ackerman.

Page 95: ". . . recalled fans mobbing writers . . .": Author interview with Julius Schwartz.

Page 96: ". . . Asimov noted in . . .": Asimov, *Asimov on Science Fiction*.

Page 96: "The number of young people . . .": Author interview with David A. Kyle.

Page 96: ". . . so typical of us all . . .": Ibid.

Page 96: "It was a dollar . . .": Author interview with Forrest J Ackerman.

CHAPTER 10

Page 98: "Robert Heinlein was . . .": From http://heinleinsociety.org; a biography by William H. Patterson Jr.

Page 99: ". . . led by a promising brunette . . .": Katz, *The Film Encyclopedia*.

Page 100: "He asked very earnestly . . .": Author interview with Laraine Day.

Page 101: "I, like many other . . .": RB letter to Arkham House publishers August Derleth and Donald Wandrei, Nov. 23, 1939.

Page 102: "still so brash . . .": Williamson, *Wonder's Child: My Life in Science Fiction*.

Page 104: "If I were to give advice . . .": Cunningham, 1961 UCLA Oral History Program transcript.

Page 104: "Schwartz sold 'Pendulum' . . .": Schwartz and Thomsen, *Man*

of Two Worlds, and Schwartz's story sales for RB, from RB's private collection.

CHAPTER 11

Page 105: "Two hundred and thirty miles . . .": Van der Vat, *Pearl Harbor.*

Page 106: ". . . with the headline proclaiming: WAR DECLARED BY U.S. . . .": *Los Angeles Evening Herald Express,* Dec. 8, 1941.

Page 106: "Skip desperately wanted . . .": Author interview with Skip Bradbury.

Page 106: " 'Gabriel's Horn' and 'The Piper' fetched sixty dollars . . .": While "Gabriel's Horn" and "The Piper" both sold in the last quarter of 1941, the stories were not published until the first quarter of 1943.

Page 107: ". . . though Leigh's was spelled . . .": Clute, Nicholls, Peter, Stableford, and Grant, *The Encyclopedia of Science Fiction.*

Page 107: ". . . Leigh Brackett, as writer Jack . . .": Williamson, *Wonder's Child: My Life in Science Fiction.*

Page 108: "In the early forties, Leigh lived . . .": Leigh Brackett's beach-side bungalow was not far from the house that Ray used as imaginative inspiration for the residence of his character Constance in the books *Death is a Lonely Business, A Graveyard for Lunatics,* and *Let's All Kill Constance.*

Page 108: ". . . Ray was 'an ebullient kid' . . .": Walker, *Speaking of Science Fiction: The Paul Walker Interviews.*

Page 108: "When Leigh showed Ray . . .": Congdon/RB interviews, from RB's private collection.

Page 108: ". . . what Bradbury scholar Garyn Roberts . . .": Wetzel, *Book* magazine, Sept.–Oct. 2003

Page 109: "She cemented her name . . .": Clute, Nicholls, Peter, Stableford, and Grant, *The Encyclopedia of Science Fiction.*

Page 110: ". . . Julie Schwartz sold 'The Candle' . . .": Schwartz's story sales for RB, from RB's private collection.

Page 110: "On February 15, 1942 . . .": Freedom of Information/Privacy Act No. 0966766-001.

Page 110: "On Monday morning . . .": RB, "Drunk and in Charge of a Bicycle," from *Zen in the Art of Writing.*

Page 110: "Soon after Ray registered with the draft board . . .": Many published chronologies of Ray Bradbury's life list the family's move to Venice in 1941. But according to the Federal Bureau of Investigation's file on Ray Bradbury, obtained through the Freedom of Information

Act, when he registered for the draft in February 1942, he still listed his address as 3054½ West Twelfth Street.

Page 111: "The Bradburys' house in Venice . . .": Author interview with Kevin Miller, owner of record of 670 Venice Boulevard, 2004.

Page 112: "I realized I had . . .": RB, "Run Fast, Stand Still," *Zen in the Art of Writing*.

Page 113: "It was September . . .": RB, "The Lake," *Dark Carnival*.

Page 113: "In a 1961 interview": Cunningham, 1961 UCLA Oral History Program transcript.

Page 114: "Ray appeared on July 16 . . .": Freedom of Information/Privacy Act No. 0966766-001.

Page 115: "The day after Ray's appearance . . .": Schwartz's story sales for RB, from RB's private collection.

Page 115: "Did I learn a hard, fast, or even an easy lesson . . .": RB, "Run Fast, Stand Still," *Zen in the Art of Writing*.

Page 115: ". . . the first 'classic' Bradbury story . . .": Nolan, *The Ray Bradbury Companion*.

Page 116: ". . . Ray sold twelve stories . . .": Schwartz's story sales for RB, from RB's private collection.

Page 119: ". . . he sold twenty-two tales.": Ibid.

Page 119: "Derleth, who was planning . . .": RB to Derleth, May 17, 1944, from RB's private collection.

Page 119: "Initially, Derleth and . . .": Ibid.

Page 119: "Corresponding with Derleth . . .": RB to Derleth, July 5, 1944, from RB's private collection.

CHAPTER 12

Page 122: "First, I want to thank you . . .": RB to Derleth, Jan. 29, 1945, from RB's private collection.

Page 123: "The cover jacket might possibly illustrate . . .": RB to Derleth, Mar. 8, 1945, from RB's private collection.

Page 123: "[M]any of my short stories . . .": Cunningham, 1961 UCLA Oral History Program transcript.

Page 125: ". . . eating, almost exclusively, hamburgers . . .": Ray often joked that when he died, he wanted his ashes placed in a can of Campbell's tomato soup that could be rocketed to Mars and buried in the soil of the Red Planet.

Page 126: "We got out in the jungle . . .": Congdon/RB interviews, from RB's private collection.

Page 129: "Dear Mr. Elliott . . .": Letter from Don Congdon, dated Aug. 27, 1945, from RB's private collection.

CHAPTER 13

Page 133: "URGE YOU STRONGLY . . .": Telegram from *American Mercury* editor Charles Angoff, Apr. 15, 1946, from RB's private collection.

Page 133: "Yet, interestingly . . .": Eller and Touponce, *Ray Bradbury: The Life of Fiction*.

Page 134: "Other early weird tales, such as 'The Poems,' 'The Ducker,' 'Trip to Cranamockett,' and 'The Watchers' . . .": "The Poems," "The Watchers," and "The Ducker" had all previously appeared in the pages of *Weird Tales*. "Trip to Cranamockett" was unpublished and would remain that way until it finally appeared as "West of October" in 1988's *The Toynbee Convector*. It would resurface again as part of the narrative fabric of 2001's loosely connected novel of vampire family stories, *From the Dust Returned*.

Page 136: "They put together an entire October issue . . .": RB, afterword, *From the Dust Returned*.

Page 137: "I was dazzled . . .": Author interview with Maggie Bradbury.

Page 137: "His energy was enchanting . . .": Ibid.

Page 138: "I think it's something . . .": Ibid.

Page 138: "Once I figured . . .": Ibid.

Page 139: "Marguerite Susan McClure . . .": Ibid.

Page 140: "He couldn't keep his hands . . .": Ibid.

Page 141: "Earlier that month . . .": RB to Derleth, June 2, 1946, from RB's private collection.

Page 142: "I was kept constantly inebriated . . .": RB to Derleth, Oct. 30, 1946, from RB's private collection.

Page 142: "It will become sort of a *Christmas Carol* . . .": RB to Addams, Feb. 11, 1948, from RB's private collection.

Page 142: "Those ideas revolved . . .": Congdon/RB interviews.

Page 144: "But with 'The Man Upstairs' . . .": Western Union telegram from *Harper's* editor Katherine Gauss to RB, dated Dec. 24, 1946, from RB's private collection.

Page 144: "On April 29, 1947 . . .": RB to Derleth, Apr. 29, 1947, from RB's private collection.

Page 144: "He also received word . . .": RB to Derleth, Apr. 23, 1947, from RB's private collection.

CHAPTER 14

Page 146: "I just felt . . .": Author interview with Norman Corwin.

Page 146: ". . . *New Yorker* editor Katharine S. White . . .": K. S. White to RB, July 26, 1947, from RB's private collection.

Page 147: "I don't have to tell you . . .": Don Congdon to RB, May 6, 1946, from RB's private collection.

Page 147: "Schwartz had been moving out . . .": Author interview with Julius Schwartz.

Page 147: ". . . his final Bradbury sale . . .": Schwartz's story sales for RB, from RB's private collection.

Page 147: "The minister asked . . .": Author interview with Maggie Bradbury.

Page 148: "In the afternoon . . .": Author interview with Ray Harryhausen.

Page 148: "We were just dressed . . .": Author interview with Maggie Bradbury.

Page 149: ". . . a loud avalanche of big red trolley car . . .": RB, *Death Is a Lonely Business*.

Page 149: "Other nights we'd walk down to Ocean Park . . .": Graham, *H20: The Magazine of Waterfront Culture*.

Page 150: "I called out for Ray . . .": Author interview with Maggie Bradbury.

Page 151: "His short story 'Powerhouse' . . .": Rejection letters from *Harper's* editor Katherine Gauss to RB, dated Oct. 17, 1946, and from *Collier's* associate fiction editor MacLennan Farrell, dated Aug. 5, 1946, from RB's private collection.

Page 152: "In early 1949, Don Congdon . . .": Author interview with Don Congdon.

Page 152: "They sent it back . . .": Cunningham, 1961 UCLA Oral History Program transcript.

CHAPTER 15

Page 153: "He also had a new short-story collection in mind . . .": RB to Derleth, Oct. 15, 1948, from RB's private collection.

Page 153: "Ray came close to working with *New Yorker* cartoonist . . .": RB to Addams, Feb. 11, 1948, from RB's private collection.

Page 154: ". . . Don Congdon had managed to drum up some interest from Doubleday . . .": Author interview with Don Congdon.

Page 155: "It was a typical hot June night in New York . . .": RB, "The

Long Road to Mars," an introduction to the fortieth-anniversary edition of *The Martian Chronicles,* Doubleday, 1990.

Page 155: ". . . How I Wrote My Book": Unpublished RB essay, from RB's private collection.

Page 157: "$750 for *The Creatures That Time Forgot* . . .": Eller and Touponce, *Ray Bradbury: The Life of Fiction.*

Page 157: "Ray bought a ticket for a seat on the Union Pacific train . . .": Union Pacific Railroad receipt, dated June 23, 1949, from RB's private collection.

Page 159: "[Bradbury] created moods with few words . . .": Asimov, *Asimov on Science Fiction.*

Page 160: "At 9:38 A.M. . . .": Author interview with Susan Bradbury.

Page 160: "I am pleased to announce that we have a baby girl!": RB to Derleth, Nov. 22, 1949, from RB's private collection.

Page 160: "The eleven-page manuscript . . .": Original manuscript from RB's private collection.

Page 161: "In early 1950 . . .": Ray recalled attending Norman Corwin's United Nations broadcast *before* his trip to New York in June 1949. He was adamant about this. However, in the 1961 Cunningham UCLA Oral History Program transcript, he recalled the broadcast as early 1950. Since this was Ray's first, albeit at a distance, encounter with John Huston, he also remembered that Huston was with his new wife, Ricki, who was pregnant at the time. Ricki gave birth to their first child on April 16, 1950. She was not even pregnant when Ray ventured off to New York, so it is likely that this pivotal encounter transpired in early 1950. Ray insisted otherwise.

Page 162: "Well, it's one of those times in your life . . .": Cunningham, 1961 UCLA Oral History Program transcript.

CHAPTER 16

Page 163: "Ray had begun to lecture sporadically at colleges and universities . . .": *Daily Trojan,* Friday, April 30, 1948.

Page 163: "If the story is good . . .": Ibid.

Page 165: "My nephew—you awe me . . .": Letter from Neva Bradbury to RB, dated Aug. 21, 1950, from RB's private collection.

Page 166: "Early on in the assembly . . .": Preliminary table of contents dated "May 20, 1950" from RB's private collection. The tentative title for the collection at this point was "Frost and Fire."

Page 167: "I think it's better . . .": Walter Bradbury to RB, July 13, 1950, from RB's private collection.

Page 167: "The dinosaur, hearing the foghorn blowing . . .": Cunningham, 1961 UCLA Oral History Program transcript.

Page 169: "Another possibility was taken . . .": Walter Bradbury to RB, Aug. 3, 1950, from RB's private collection.

Page 169: "They moved in on August 3, 1950 . . .": Moving receipt from Bay Cities Van & Storage Co., from RB's private collection, dated Aug. 3, 1950. The total cost of the move, which included two men and a moving truck, from the apartment at 33 South Venice Boulevard to the new house at 10750 Clarkson Road was the princely fee of just $18.42.

Page 169: "Poe's name comes up . . .": Isherwood, *Tomorrow*.

Page 170: "His brilliant . . .": Ibid.

Page 171: "May I ask now, very humbly . . .": RB to Walter I. Bradbury, Sept. 29, 1950, from RB's private collection.

Page 172: "The Art Department tells me . . .": Walter I. Bradbury to RB, Oct. 10, 1950, from RB's private collection.

Page 173: ". . . Heard had the ability . . .": Cunningham, 1961 UCLA Oral History Program transcript.

Page 173: "I was really frightened . . .": Ibid.

Page 173: "He put me at ease immediately . . .": Ibid.

Page 174: "Gerald Heard was a charming man . . .": Author interview with Sid Stebel.

Page 174: "There was quite a to-do . . .": Ibid.

Page 175: "It was the first time . . .": Ibid.

Page 175: ". . . but in the early to mid-1950s . . .": Dunaway, *Huxley in Hollywood*.

Page 176: "offered an advance of $500 . . .": Don Congdon to RB, Mar. 2, 1951, and Mar. 26, 1951, from RB's private collection.

Page 178: "Dore Schary, then vice president . . .": Grobel, *The Hustons*.

Page 178: "By the end of the screening, Huston knew his film was doomed . . .": Huston, *An Open Book*.

Page 178: "Impressed is hardly the word . . .": Undated, handwritten letter from John Huston to Ray Bradbury written on Claridge's stationery, Brook Street, London W1. Given Ray Bradbury's recollection of the timing and the reference of the recent meeting between the two men in the letter, it can be presumed that this correspondence was written in Feb. 1951.

CHAPTER 17

Page 180: "My first . . .": King, *Danse Macabre*.

Page 180: "This would have been broadcast in 1951 . . .": According to the *Dimension X* radio logs, the episode of "Mars is Heaven" that Stephen King referred to aired on Jan. 7, 1951, which was a re-broadcast of the original airing on July 7, 1950. Logs at http://www.oldtime.com/otrlgs/dx_.log.

Page 181: "Ray wrote Hart-Davis in wholehearted agreement . . .": Letter from RB to Rupert Hart-Davis, Nov. 16, 1950, from RB's private collection.

Page 184: "In April 1952 . . .": The details of Ray and Maggie's visit to the gallery and Ray's introduction to the work of Joe Mugnaini have varied slightly depending on the source. Ray steadfastly insisted that the gallery was in Beverly Hills, in the space that would later be occupied by Sloan's Gallery. Joe Mugnaini remembered the exhibit occurring in Hollywood. In the 2002 book, *Bradbury: An Illustrated Life*, by Jerry Weist (William Morrow), the author cited the location as Venice, California. In the end, Ray Bradbury was positive the gallery where he met his lifelong artist collaborator was in Beverly Hills. Further clouding the details of the evening, Joe Mugnaini remembered the lithograph that Ray bought that night was of *The Caravan*. Again, Ray was positive that the lithograph he saw in the window that night was *Modern Gothic*. "There was no lithograph of *The Caravan* until twenty years later," Ray insisted. "But the painting of *The Caravan* was inside the gallery that night."

Page 185: ". . . sort of place a beast like myself might want to live in . . .": Tibbetts, "The Third Elephant," *Outré*.

Page 186: "Joe Mugnaini was an Italian-born . . .": Ibid.

Page 186: "California artist Mary Anderson . . .": Author interview with Mary Anderson.

Page 186: "I had heard of [Ray Bradbury] . . .": Tibbetts, "The Third Elephant," *Outré*.

Page 188: "Ray has always been a very open . . .": Ibid.

Page 189: "As the artist recalled . . .": Ibid.

Page 190: "His jaw dropped, his eyes bugged . . .": Kunert, *Take One*, May–June 1972, interview by Arnold Kunert.

Page 190: "On July 3, 1952, Hal Chester's company . . .": Motion Picture Rights Agreement between RB and Mutual Pictures of California, Inc., dated July 3, 1952, from RB's private collection.

Page 193: "First established in 1938 . . .": Cunningham, *The McCarthy Hearings*.

Page 193: "In my estimation . . .": Huston, *An Open Book*.

Page 193: "Yet even as Hollywood's elite . . .": Cunningham, *The McCarthy Hearings*.

Page 194: "Along with Chairman J. Parnell Thomas . . .": Ibid.

Page 195: "Letter to the Republican Party . . .": *Daily Variety*, Nov. 10, 1952, from RB's private collection.

Page 197: "I was proud . . .": Author interview with Maggie Bradbury.

Page 197: "I was all . . .": Author interview with Don Congdon.

CHAPTER 18

Page 199: "When Hitler burned a book . . .": RB, from "Burning Bright," a foreword by RB for the fortieth-anniversary edition of *Fahrenheit 451*.

Page 203: "Being hit and run over . . .": From the introduction to *Fahrenheit 451*, 1966 edition.

Page 203: "Certainly the paperbacks . . .": Author interview with Professor Jonathan R. Eller.

Page 204: "He writes in a style . . .": *New York Times* review by Charles Poore, Mar. 19, 1953.

Page 205: "I feared for refiring the book . . .": from "Burning Bright," a foreword by RB for the fortieth-anniversary edition of *Fahrenheit 451*.

Page 207: ". . . looking at far places—Rome and Paris and London and Egypt . . .": RB, Confederation, Guest of Honor Speech, from *Science Fiction Chronicle*, Dec. 1986.

Page 207: "We did that . . .": Author interview with Stanley Kauffmann.

Page 207: "None of us at Ballantine": Ibid.

Page 208: "Ray's attention span . . .": Author interview with Maggie Bradbury.

Page 208: "I've never eaten more ice cream . . .": Author interview with Stanley Kauffmann.

Page 208: "We knew it was brilliant": Ibid.

Page 208: "Noted *New York Times* critic Orville Prescott lauded . . .": *New York Times*, Oct. 21, 1953.

Page 209: "The first hardcover printing was 4,250 copies . . .": Eller and Touponce, *Ray Bradbury: The Life of Fiction*.

Page 209: ". . . the novel was in its seventy-ninth printing . . .": RB, *Fahrenheit 451*, 1989 Ballantine paperback.

Page 210: "On Tuesday, August 18 . . .": RB's 1953 datebook, from RB's private collection.

Page 211: "It's an ocean of fantastic bits and pieces . . .": Kunert, May–June 1972, *Take One*.

Page 212: "He would be paid $12,500 . . .": *Moby Dick* contract, dated Sept. 2, 1953, from RB's private collection.

CHAPTER 19

Page 214: On Saturday, September 12, 1953 . . .": RB's 1953 datebook, from RB's private collection.

Page 214: "It took me all of about an hour . . .": Author interview with Dr. H. Regina Ferguson.

Page 214: "Two days later . . .": RB's 1953 datebook, from RB's private collection.

Page 214: "We forgot to pack diapers . . .": Author interview with Maggie Bradbury.

Page 215: "The Bradburys boarded the SS *United States* . . .": www.ss-united-states.com.

Page 215: "Regina Ferguson had been on ships before . . .": Author interview with Dr. H. Regina Ferguson.

Page 215: "Ray was on the edge . . .": RB's 1953 datebook, from RB's private collection.

Page 215: "It was a very strong storm . . .": Author interview with Dr. H. Regina Ferguson.

Page 215: "There were lots of bumps and bruises . . .": *Chicago Daily Tribune,* Sept. 23, 1953.

Page 216: ". . . the SS *United States* arrived . . .": RB's 1953 datebook, from RB's private collection.

Page 216: "In the 2000 essay 'Beautiful Bad Weather' . . .": RB, "Beautiful Bad Weather," May–June 2000, *National Geographic Traveler*.

Page 218: "Left to our devices . . .": Viertel, *Dangerous Friends: At Large with Huston and Hemingway in the Fifties*.

Page 218: "The screenplay they presented Huston . . .": Huston, *An Open Book*.

Page 218: "Luckily for Huston . . .": Ibid.

Page 218: "As the train sped through the dark . . .": Author interview with Dr. H. Regina Ferguson.

Page 219: "There was snow everywhere . . .": Author interview with Susan Bradbury.

Page 219: "I was really very fond . . .": Author interview with Dr. H. Regina Ferguson.

Page 219: "When the curtain went up . . .": Ray Bradbury, speech at the Sons of the Desert annual banquet, Oct. 6, 2001.

Page 220: " 'Very simply,' said Huston to Ricki . . ." RB, *Green Shadows, White Whale*.

Page 220: "John Huston and Enrica Soma . . .": Madsen, *John Huston*.

Page 221: "John Huston had fallen . . .": Huston, *An Open Book*.

Page 224: "He was weird . . .": Author interview with Maggie Bradbury.

Page 224: "Peter was a very intelligent man . . .": Ibid.

Page 224: "Huston had bought Ricki . . .": This scene is described exactly how RB remembered it in Peter Viertel's book *Dangerous Friends: At Large with Huston and Hemingway in the Fifties*.

Page 224: "The normal reaction . . .": Author interview with Maggie Bradbury.

Page 226: "Huston very wisely . . .": Cunningham, 1961 UCLA Oral History Program transcript.

Page 226: "John had a rough way . . .": Author interview with Peter Viertel.

Page 226: "Huston was really . . .": Ibid.

Page 227: "This man . . .": Huston, *Open Book*.

Page 227: "Author Gary Fishgall . . .": Fishgall, *Gregory Peck*.

Page 228: "politically very liberal . . .": Author interview with Don Congdon.

Page 229: "Hugh Marston Hefner . . .": Author interview with Hugh Hefner.

Page 229: ". . . Hefner bought the fifty-thousand-word . . .": 1954 story sales, from RB's private collection.

Page 229: "The story seemed . . .": Author interview with Hugh Hefner.

Page 229: ". . . after seven months of hard work . . .": Ray Bradbury, acceptance speech for Distinguished Contribution to American Letters, at the National Book Awards, Nov. 15, 2000.

Page 229: ". . . the script was completed . . .": Ray noted the date he completed work on *Moby Dick* on a one-page notation titled "90 Minutes in Paris," from RB's private collection.

Page 230: "Ray left London on April 16, 1954 . . .": Ibid.

Page 230: ". . . the most difficult picture I ever made . . .": Huston, *Open Book*.

Page 230: "Gregory Peck acknowledged . . .": Fishgall, *Gregory Peck*.

Page 230: "Huston was not that good . . .": Ibid.

Page 230: ". . . placing ninth among the ten top-grossing films . . .": *Daily Variety*.

Page 231: "On Saturday, April 17, 1954 . . .": "90 Minutes in Paris," from RB's private collection.

Page 231: "It was as if . . .": Author interview with Dr. H. Regina Ferguson.

Page 233: "When you go to museums . . .": Samuels, *Bernard Berenson: The Making of a Legend*.

CHAPTER 20

Page 235: "My understanding . . .": Leon Uris to RB, May 19, 2001, from RB's private collection.

Page 235: "Cowards! McCarthyites! . . .": The entire episode at the Crystal Room was substantiated by Martin A. Berkeley, a confessed former member of the Communist Party, in the FBI's secret file on Ray Bradbury. Freedom of Information/Privacy Act No. 0966766-001.

Page 235: "As for Leon Uris . . .": Ibid.

Page 236: ". . . that country where it is . . .": RB, *The October Country*.

Page 237: "He was paid $2,250 for the script . . .": Story sales record for 1955, from RB's private collection.

Page 237: "Alfred Hitchcock left the day-to-day . . .": Author interview with Norman Lloyd.

Page 237: "The director, according to Norman Lloyd . . .": Ibid.

Page 237: "Ray's strength . . .": Ibid.

Page 240: "My Irish cabdriver was a human being when drunk . . .": RB to *Playboy* editor A. C. Spectrosky, May 17, 1965, from RB's private collection.

Page 240: "All of the months of walking the Dublin rains . . .": RB to Walter Bradbury, Jan. 27, 1955, from RB's private collection.

Page 241: "Somehow the people . . .": RB, *Dandelion Wine*.

Page 242: "If you just take hold . . .": Cunningham, 1961 UCLA Oral History Program transcript.

Page 244: "As Gay recalled . . .": Author interview with John Gay.

Page 244: "Ray was a most unusual character . . .": Ibid.

Page 245: "God knows . . .": Ibid.

Page 245: "They were fine with it . . .": Ibid.

Page 246: "We were reunited in joy . . .": RB, "The Renaissance Prince and the Baptist Martian," *Horizon,* July 1979.

Page 248: "The funeral for Leonard Spaulding Bradbury was held . . .": Obituary, *Waukegan News-Sun,* Oct. 21, 1957.

CHAPTER 21

Page 250: "I was trying to get out of cooking Thanksgiving dinner! . . .": Author interview with Maggie Bradbury.

Page 250: "helped define television as a dramatic art form . . .": Presnell and McGee, *A Critical History of Television's The Twilight Zone, 1959–1964.*

Page 252: ". . . the bureau began investigating . . .": Freedom of Information/Privacy Act No. 0966766-001.

Page 253: ". . . the pilot episode . . .": Presnell and McGee, *A Critical History of Television's The Twilight Zone, 1959–1964.*

Page 254: ". . . the fifth episode of *The Twilight Zone,* 'Walking Distance' . . .": Ironically, despite Ray's assertions that "Walking Distance" had its origins in his story "The Black Ferris," Rod Serling, as well as *Twilight Zone* fans the world over, consider the fifth episode of the series to be one of the very best.

Page 254: "On one level . . .": Conlon, "The Many Fathers of Martin Sloan," *Filmfax,* Dec. 2000–Jan. 2001.

Page 255: "The authors also present another theory, quoting Rod Serling . . .": Presnell and McGee, *A Critical History of Television's The Twilight Zone, 1959–1964.*

Page 255: ". . . as his agent, Don Congdon, complained . . .": Author interview with Don Congdon.

Page 256: ". . . As you know, I've been under contract to you people now for 11 years . . .": Ray Bradbury to Doubleday, Tim Seldes, June 2, 1960, from RB's private collection.

Page 257: "After eleven years . . .": Letter from Ray Bradbury to Tim Seldes, July 8, 1960, from RB's private collection.

Page 258: "We used to run down Washington Street . . .": Author interview with Skip Bradbury.

Page 259: ". . . producer Sam Goldwyn Jr. purchased 'Black Ferris' for six hundred dollars . . .": Story sales record for 1954, from RB's private collection.

Page 261: "I was very excited about it . . .": Kunert, May–June 1972, *Take One.*

Page 262: "In an unpublished *Paris Review* interview . . .": Handwritten *Paris Review* interview done by RB, date unknown, from RB's private collection.

CHAPTER 22

Page 262: "In 1962, two men appeared at the front door . . .": RB unpublished speech to the American Institute of Architects, July 20, 2001.

Page 262: "[I] walked among the cities of the future . . .": Ibid.

Page 263: "beliefs in architecture and the buildings of the future . . .": Ibid.

Page 263: "I was afraid for the future . . .": Ibid.

Page 265: ". . . Johnson denied any plagiarism charges . . .": Calls and faxes sent to George Clayton Johnson's agent for this book were not returned.

Page 265: "I think that a lot of Bradbury was used in *The Twilight Zone* . . .": Sander, *Rod Serling: Television's Last Angry Man*.

Page 267: "Often after . . .": Author interview with Bettina Bradbury.

Page 267: "Mr. Blackstone . . .": RB, foreword, Blackstone Jr., *The Blackstone Book of Magic & Illusion*.

Page 268: "Ray was a terrific father and the girls just adored him . . .": Author interview with Maggie Bradbury.

Page 268: "The slogan of the fair was . . .": http://naid.sppsr.ucla.edu/ny64fair/.

Page 268: "I was just five . . .": Author interview with Alexandra Bradbury.

Page 273: "On Thursday, January 13, 1966 . . .": Weist, *An Illustrated Life*.

Page 273: "The French director had purchased . . .": Jacob and de Givray, *François Truffaut: Correspondence 1945–1984*.

Page 273: ". . . Paul Newman had agreed . . .": de Baecque and Toubiana, *Truffaut: A Biography*.

Page 274: "Truffaut had initially considered . . .": Jacob and de Givray, *François Truffaut: Correspondence 1945–1984*.

Page 274: "Using Julie Christie": de Baecque and Toubiana, *Truffaut: A Biography*.

Page 274: ". . . [W]henever I work from a novel . . .": Weist, *An Illustrated Life*.

Page 275: "Principal photography on *Fahrenheit 451* . . .": de Baecque and Toubiana, *Truffaut: A Biography*.

Page 275: "I'll never be able to film courage . . .": Ibid.

Page 275: "We must put up with each other . . .": Ibid.

Page 276: "On the morning of January 13, 1967 . . .": The date of Ray's arrival in Houston was documented in his typed notes for the *Life* story, from RB's private collection.

Page 276: "After Ray checked into . . .": Ibid.

Page 276: "That evening . . .": Ibid.

CHAPTER 23

Page 279: "Ray had sold the story rights . . .": Literary purchase agreement between RB and Solitaire Productions, dated Dec. 1, 1967, from RB's private collection.

Page 280: "Ray had sold the rights to 'In a Season of Calm Weather' . . .": Letter from Ray's Hollywood agent, William Tennenat to producer Roy Silver, dated Dec. 14, 1967, from RB's private collection.

Page 282: ". . . the Bradburys enjoyed tennis as a spectator sport . . .": Ray loved playing badminton with his daughters and enjoyed watching tennis. Ray's mother was a religious listener to Chicago Cubs baseball games when the family lived in Waukegan, so he understood the game, although he never followed it. As a teenager and a young man, he attended several USC Trojan football games with his father and his brother. Later in life, Ray occasionally watched football, preferring the games that counted: playoffs and the Super Bowl.

Page 283: "This is an effort to become immortal . . .": CBS Report 7/20/69.

Page 284: "By 1971, the Bantam paperback editions . . .": Bantam Books, Inc., cumulative unit sales report on Ray Bradbury's titles, dated Mar. 29, 1971, from RB's private collection.

Page 287: "I've got to hand it to you . . .": Letter from Robert Gottlieb to RB, Dec. 3, 1971, from RB's private collection.

Page 287: ". . . but felt that the balance of the story was somehow off-kilter . . .": Letter from Robert Gottlieb to RB, dated Mar. 8, 1972, from RB's private collection.

Page 291: ". . . To get people to come back to the core of the city . . .": "Up Close: Architect Jon Jerde," *Planning,* December 2000.

Page 291: "reached beyond the cultural elite . . .": From the *Los Angeles Times,* April 9, 2000.

Page 291: "My interests have always been the ordinary, common man . . .": Author interview with Jon Jerde.

Page 292: "Anybody who would think to write a story . . .": Ibid.

Page 292: ". . . $140 million center . . . to be built in downtown San Diego . . .": "Breaking Open the Mall," *Newsweek,* Apr. 18, 1988.

Page 293: "[E]ven in our interior malls . . .": RB, "The Aesthetics of Lostness," *Designers West,* Nov. 1988.

Page 294: "I opened it . . .": RB, "Remembrance," *When Elephants Last in the Dooryard Bloomed.*

CHAPTER 24

Page 296: "By 1974, his stories had been collected in more than two thousand anthologies . . .": Nolan, *The Ray Bradbury Companion.*

Page 296: "it is doubtful that the work of any American author . . .": Ibid.

Page 299: "In *Fellini's Films* . . .": RB, *Los Angeles Times Book Review,* Nov. 27, 1977.

Page 299: "I admire you very much . . .": Letter from Federico Fellini to Ray Bradbury, dated Jan. 26, 1978, from RB's private collection.

Page 303: "We marched down the streets . . .": Author interview with Bettina Bradbury.

Page 303: "Two amazing visionaries . . .": Ibid.

Page 305: "If you look at the average page of any of my novels or short stories . . .": "An Interview with SF Legend Ray Bradbury," *Outré,* vol. 1, no. 4, 1995.

Page 308: "Dan Kolsrud, Clayton's assistant director . . .": Author interview with Dan Kolsrud.

Page 310: "Prominent *Chicago Tribune* film critic . . .": Siskel, *Chicago Tribune,* May 3, 1983.

CHAPTER 25

Page 310: "People ask, 'Where do . . .'": From the introduction of *The Ray Bradbury Theater.*

Page 312: "HBO nibbled . . .": Author interview with Larry Wilcox.

Page 312: ". . . the beginning of . . .": Ibid.

Page 312: "[W]e spent many late evenings . . .": *Bradbury Stories: 100 of Bradbury's Most Celebrated Tales,* introduction.

Page 313: "HBO, in its infancy . . .": Ibid.

Page 313: ". . . the series received six Cable Ace . . .": Statistics from the National Cable & Telecommunications Association.

Page 313: "In total . . . the program was nominated . . .": Ibid.

Page 313: ". . . regularly visiting the productions on location where they were shot in Canada, New Zealand, and France . . .": *The Ray Brad-*

bury Theater was shot outside the United States because production costs were more affordable in these countries.

Page 314: "Ray had written mystery short stories before . . .": Fifteen of Ray's early detective pulp stories were collected in the 1984 book *A Memory of Murder*. Ray was not in favor of these stories being reprinted in book form, but he had no choice. One of the few mistakes that his first agent, Julius Schwartz, made was selling the rights to Ray's stories. Ray no longer owned these detective tales and so, begrudgingly, he agreed to write an introduction to *A Memory of Murder* in exchange for getting the rights to the stories back. Per this agreement, Ray also asked that the printing of *A Memory of Murder* be limited to just a single, small run. Why didn't Ray want these stories published? Very simple: "Most of them weren't very good," he said.

CHAPTER 26

Page 318: "Where did that judgment . . .": RB, *Zen in the Art of Writing*.

Page 319: "Much of the text is dialogue . . .": *Publishers Weekly*, Sept. 22, 1997.

Page 319: ". . . paints vivid word pictures of people . . .": *Library Journal*, Nov. 15, 1997.

Page 319: "Most authors peak . . .": Author interview with Maggie Bradbury.

Page 320: "I've been a great saver and I still am . . .": Cunningham, 1961 UCLA Oral History Program transcript.

Page 322: "The whole experience has been good for me . . .": Weller, *Chicago Tribune Magazine,* Aug. 13, 2000.

Page 323: "Mr. Bradbury's life work has proclaimed the incalculable . . .": National Book Award Foundation.

Page 323: "Novelist, short-story writer, essayist, playwright . . .": Martin, 2001 National Book Awards speech.

Page 325: "January 21, Saturday: 'It rained glorious rain all day . . . '": From RB's 1939 journal, RB's private collection.

Page 330: "We're going to make it . . .": Weller, *Chicago Tribune Magazine,* Aug. 13, 2000.

Page 330: "The thing that makes me happy . . .": Ibid.

Page 330: "Moore even felt that his title . . .": E-mail from Michael Moore to author.

Page 332: "Upon its release, *Fahrenheit 9/11* broke records . . .": *Daily Variety*, Sept. 8, 2004.

SELECTED BIBLIOGRAPHY

ARTICLES, PAMPHLETS, UNPUBLISHED INTERVIEWS, UNPUBLISHED SPEECHES, AND OTHER MATERIALS

Bradbury, Ray. "The Aesthetics of Lostness," *Designers West*, November 1988.

———. "Beautiful Bad Weather," *National Geographic Traveler*, May–June 2000.

———. Book review, *"Fellini's Films,"* *Los Angeles Times Book Review*, Nov. 27, 1977.

———. "George, Marlene and Me," *Life*, July 1991.

———. "How I Wrote My Book," unpublished essay, 1950.

———. "Letter to the Republican Party," *Daily Variety*, Nov. 10, 1952.

———. "My Demon, Not Afraid of Happiness," unpublished essay, 2002.

———. "The Renaissance Prince and the Baptist Martian," *Horizon*, July 1979.

———. Speech for Distinguished Contribution to American Letters Award at the National Book Awards, Nov. 15, 2000.

———. Speech at the Sons of the Desert annual banquet, Oct. 6, 2001.

Bradley, Matthew. "An Interview with SF Legend Ray Bradbury," *Outré*, vol. 1, no. 4, 1995.

"Breaking Open the Mall," *Newsweek*, Apr. 18, 1988.

Congdon, Don. Unpublished interview transcripts with Ray Bradbury, 1971.

Conlin, Christopher. "The Many Fathers of Martin Sloan," *Filmfax*, December 2000–January 2001.

Cunningham, Craig. UCLA Oral History Program Transcript, 1961.

"Dies After Being Sick Long While," *Waukegan News-Sun,* June 5, 1926.

"Father of Author Bradbury Is Dead," *Waukegan News-Sun,* Oct. 21, 1957.

Graham, Craig. "Ray Bradbury on the Waterfront: Interview," *H2O: The Magazine of Waterfront Culture,* quarterly, 2000.

Kunert, Arnold. "Ray Bradbury on Hitchcock and Other Magic of the Screen," *Take One,* May–June 1972.

"Moberg Dies from Bandit Shot," *Waukegan News-Sun,* Oct. 24, 1932.

"North Chicago Bandit Victim Dies of Wounds," *Independent Recorder,* Oct. 27, 1932.

Prescott, Orville, book review, *Fahrenheit 451, New York Times,* Oct. 21, 1953.

"Program of 4-Day Event Announced," *Waukegan News-Sun,* Aug. 31, 1932.

Siskel, Gene. Film review, *Something Wicked This Way Comes, Chicago Tribune,* May 3, 1983.

State of Illinois Birth Certificate, Ray Douglas Bradbury, Lake County Clerk's Record #4750.

State of Illinois Certificate of Birth Record, "Bradbury," "Female."

State of Illinois Death Certificate of Betty Jane Bradbury.

State of Illinois Death Certificate of Lester Thomas Moberg.

State of Illinois Death Certificate of Samuel Hinkston Bradbury.

State of Illinois Death Certificate of Samuel Hinkston Bradbury III.

"Thief Fires Upon Victim of Robbery," Oct. 18, 1932, edition of the *Waukegan News-Sun.*

Tibetts, John C. "The Third Elephant," *Outré,* no. 19, 2000.

Transcripts for Nevada Marian Bradbury, the School of the Art Institute of Chicago.

United States Department of Justice, Freedom of Information/Privacy Act No. 0966766-001.

"Up Close: Architect Jon Jerde," *Planning,* December 2000.

U.S. Individual Income Tax Return for Ray and Marguerite Bradbury.

"WAR DECLARED BY U.S.," *Los Angeles Evening Herald Express,* Dec. 8, 1941.

"Waukegan History on View," *Waukegan News-Sun,* Nov. 5, 1984.

Weller, Sam. "Semper Sci-Fi," *Chicago Tribune Magazine,* Aug. 13, 2000.

Wetzel, Eric. "The Firebrand," *Book*, September–October 2003.

"Yard Scrapbook," special collection of the Waukegan Historical Society.

BOOKS

Asimov, Isaac. *Asimov on Science Fiction*. New York: Doubleday & Company, Inc., 1981.

Baecque, Antoine de, and Serge Toubiana. *Truffaut: A Biography*. New York: Alfred A. Knopf, 1999.

Blackstone, Harry, Jr. *The Blackstone Book of Magic & Illusion*. New York: Newmarket Press, 1985.

Bower, Paul, and Stephen Nissenbaum, eds. *The Salem Witchcraft Papers*. New York: Da Capo Press, 1977.

Clute, John, and Peter Nicholls, eds., Brian Stableford, cont. ed., and John Grant, tech ed., *The Encyclopedia of Science Fiction*. New York: St. Martin's Griffin, 1995.

Cunningham, Jesse G., ed., and Laura K. Egendorf, asst. ed. *The McCarthy Hearings*. New York: Greenhaven Press, 2003.

Dunaway, David King. *Huxley in Hollywood*. New York: Harper & Row Publishers, 1989.

Eller, Jonathan R., and William F. Touponce. *Ray Bradbury: The Life of Fiction*. Kent, OH: Kent State University Press, 2004.

Fishgall, Gary. *Gregory Peck: A Biography*. New York: Scribner, 2002.

Grobel, Lawrence. *The Hustons*. New York: Charles Scribner's Sons, 1989.

Hillman, James. *The Soul's Code*. New York: Random House, 1996.

Huston, John. *An Open Book*. New York: Alfred A. Knopf, 1980.

Jacob, Gilles, and Claude de Givray. *François Truffaut: Correspondence 1945–1984*. New York: Cooper Square Press, 2000.

Johnson, Wayne L. *Ray Bradbury*. New York: Frederick Ungar Publishing Company, 1980.

Katz, Ephraim. *The Film Encyclopedia*. New York: HarperPerennial, 2001.

King, Stephen. *Danse Macabre*. New York: Everest House, 1981.

Kunitz, Stanley, and Howard Haycraft, eds. *20th Century Authors*. New York: H. W. Wilson, 1955.

Lapham, William Berry. *The Bradbury Memorial: Records of Some of the Descendents of Thomas Bradbury, with a Brief Sketch of the Bradburys of England*. Portland, ME: Brown Thurston & Company, 1890.

Madsen, Axel. *John Huston*. Garden City, NY: Doubleday & Company, Inc., 1978.

Mogen, David. *Ray Bradbury*. Boston, MA: Twayne Publishers, 1986.

Navasky, Victor. *Naming Names*. New York: Viking Press, 1980.

Nolan, William F. *The Ray Bradbury Companion*. Detroit, MI: Gale Research, 1975.

Osling, Louise, and Julia Osling. *Historical Highlights of the Waukegan Area*. Waukegan, IL: The Waukegan Historical Society and The City of Waukegan, Bicentennial Commission, 1976.

Pohl, Frederik. *The Way the Future Was*. New York: Ballantine Publishing Group, 1978.

Porges, Irwin. *Edgar Rice Burroughs: The Man Who Created Tarzan*. Provo, UT: Brigham Young University Press, 1975.

Presnell, Don, and Marty McGee. *A Critical History of Television's The Twilight Zone, 1959–1964*. Jefferson, NC: McFarland & Company, Inc., 1998.

Samuels, Ernest, with the collaboration of Jayne Newcomer Samuels. *Bernard Berenson: The Making of a Legend*. Cambridge, MA, and London, England: Belknap Press of Harvard University Press, 1987.

Sander, Gordon F. *Rod Serling: The Rise and Twilight of Television's Last Angry Man*. New York: Dutton, 1992.

Schwartz, Julius, with Brian M. Thomsen. *Man of Two Worlds: My Life in Science Fiction and Comics*. New York: Harper Entertainment, 2000.

Van der Vat, Dan. *Pearl Harbor: The Day of Infamy—An Illustrated History*. New York: Basic Books, 2001.

Viertel, Peter. *Dangerous Friends: At Large with Huston and Hemingway in the Fifties*. New York: Nan A. Talese/Doubleday, 1992.

Walker, Paul, ed. *Speaking of Science Fiction: The Paul Walker Interviews*. Oradell, NJ: Luna Publications, 1978.

Waukegan Historical Society. *Waukegan Illinois*. Chicago: Arcadia, 2000.

Weist, Jerry. *Bradbury: An Illustrated Life*. New York: William Morrow, 2002.

Williams, Lorraine D., ed. *Buck Rogers: The First 60 Years in the 25th Century*. Lake Geneva, WI: TSR Incorporated, 1988.

Williamson, Jack. *Wonder's Child: My Life in Science Fiction*. Chappaqua, NY: BlueJay Books, 1985.

SELECTED BOOKS BY RAY BRADBURY

The Best of Ray Bradbury: The Graphic Novel. New York and London: Simon & Schuster, 2003.

Bradbury Stories: 100 of His Most Celebrated Tales. New York: William Morrow, 2003.

The Cat's Pajamas: Stories. New York: William Morrow, 2004.

Classic Stories 1: Selections from The Golden Apples of the Sun and R Is for Rocket. New York: Bantam, 1990.

Classic Stories 2: Selections from A Medicine for Melancholy and S Is for Space. New York: Bantam, 1990.

The Complete Poems of Ray Bradbury. New York: Ballantine, 1982.

Dandelion Wine. New York: Doubleday, 1957.

Dark Carnival. Sauk City, WI: Arkham House, 1947.

Death Is a Lonely Business. New York: Alfred A. Knopf, 1985; London: Grafton, 1986.

Dogs Think That Everyday Is Christmas. Layton, UT: Gibbs Smith Publisher, 1997.

Driving Blind. New York: Avon, 1997.

Fahrenheit 451. New York: Ballantine, 1953.

From the Dust Returned. New York: William Morrow, 2001.

The Golden Apples of the Sun. Garden City, NY: Doubleday, 1953.

A Graveyard for Lunatics: Another Tale of Two Cities. New York: Alfred A. Knopf, 1990.

Green Shadows, White Whale. New York: Alfred A. Knopf, 1992.

The Halloween Tree. New York: Alfred A. Knopf, 1972.

The Haunted Computer and the Android Pope. New York: Alfred A. Knopf, 1981.

The Illustrated Man. Garden City, NY: Doubleday, 1951.

I Sing the Body Electric! New York: Alfred A. Knopf, 1969.

Let's All Kill Constance: A Novel. New York: William Morrow/Harper-Collins Publishers, 2003.

Long After Midnight. New York: Alfred A. Knopf, 1976.

The Machineries of Joy. New York: Simon & Schuster, 1964.

The Martian Chronicles. Garden City, NY: Doubleday, 1950.

A Medicine for Melancholy. New York: Doubleday, 1959.

A Memory of Murder. New York: Dell, 1984.

The October Country. New York: Ballantine, 1955.

One More for the Road. New York: William Morrow, 2002.

Quicker Than the Eye. New York: Avon, 1996.

R Is for Rocket. Garden City, NY: Doubleday, 1962.

S Is for Space. Garden City, NY: Doubleday, 1966.

Something Wicked This Way Comes. New York: Simon & Schuster, 1962.

The Stories of Ray Bradbury. New York: Alfred A. Knopf, 1980.

Switch on the Night. New York: Pantheon, 1955.

They Have Not Seen the Stars: The Collected Poetry of Ray Bradbury. Lancaster, PA: Stealth Press, 2002.

The Toynbee Convector. New York: Alfred A. Knopf, 1988.

Twice 22. New York: Doubleday, 1966.

The Vintage Bradbury: Ray Bradbury's Own Selection of His Best Stories. New York: Vintage Books, 1965.

When Elephants Last in the Dooryard Bloomed: Celebrations for Almost Any Day in the Year. New York: Alfred A. Knopf, 1973.

Where Robot Mice and Robot Men Run 'Round in Robot Towns. New York: Alfred A. Knopf, 1977; London: Hart-Davis, MacGibbon, 1979.

With Cat for Comforter. Layton, UT: Gibbs Smith Publisher, 1997.

Witness and Celebrate. Northridge, CA: Lord John Press, 2000.

Yestermorrow: Obvious Answers to Impossible Futures. Santa Barbara, CA: Capra Press, 1991.

Zen in the Art of Writing. San Bernardino, CA: Borgo Press, 1990.

INDEX

About the author

About the book

Read on

Insights,
Interviews
& More . . .

Meet Sam Weller

© 2004 Barry Brecheisen

SAM WELLER familiarized himself with the words of Ray Bradbury even before he was born. During the infamous Chicago blizzard of January 1967, as drifting blankets of snow created white-out conditions in the Windy City, William Weller, Sam's father, read Bradbury's seminal classic *The Illustrated Man* aloud to his pregnant wife, Barbara. The baby, nine months in utero, turned and listened with keen interest. . . .

Flash forward to the present.

Sam Weller is the authorized biographer of one of the most influential authors of the twentieth century—Ray Bradbury, the poet laureate of the dark fantastic; the gatekeeper to "October Country"; the man who immortalized Green Town, Illinois, the planet Mars, and a dark dystopia where books are banished forever. *The Bradbury Chronicles: The Life of Ray Bradbury* is the first-ever biography of Ray Bradbury, a creator and visionary who, more than any other author, altered the fabric of popular culture.

Sam Weller is the former Midwest correspondent for *Publishers Weekly.* He is a regular feature writer for the *Chicago Tribune Magazine,* as well as the Chicago Public Radio program *848.* He is a frequent literary critic for the *Chicago Tribune* and the *Chicago*

66 During the infamous Chicago blizzard of January 1967 Sam Weller's father read Bradbury's seminal classic *The Illustrated Man* aloud to his pregnant wife. 99

Sun-Times. He writes about punk rock for *Punk Planet* magazine and his essays have appeared on the National Public Radio's *All Things Considered.* He is a contributor to Playboy.com and a former staff writer for the alternative weekly *Newcity,* where he was given the Peter Lisagor Award—the highest honor in Chicago journalism. His short fiction has been published in *Spec-Lit,* an anthology of science fiction edited by the noted SF author Phyllis Eisenstein. Sam is a frequent lecturer on the life and works of Ray Bradbury, as well as on the writing process and getting published. In February 2004, he was the special guest of the Commonwealth Club in San Jose, California.

Sam Weller is a professor in the fiction department at Columbia College, Chicago. He lives in Chicago with his wife, baby daughter, and two dogs. He is at work on a graphic novel about truck drivers who save the universe, as well as a fictional suspense novel about the real-life Chinese magician Ching Ling Foo. ～

" Weller was given the Peter Lisagor Award—the highest honor in Chicago journalism. "

All's Weller That Ends Weller

by Ray Bradbury

I'VE ALWAYS CONSIDERED that allowing someone to write one's biography is an act of supreme egotism.

Commenting on the finished product seems to me to be even more outrageous. Nevertheless, I will try to weigh Sam Weller's book and give you my prejudiced opinion.

If anything, the book seems to me to be an adjunct to my book *Zen in the Art of Writing*, which was published many years ago.

I can recommend it on this level because I see my younger self, as portrayed in Sam Weller's book as the untalented youth who wanted to write stories, essays, poems, plays, or screenplays, but didn't know how.

When you start with very little or nothing, the advancement you make over the years can be of some mild interest to other writers starting out on the road.

One way or another I was able to ignore my seeming lack of talent by doing two things that Weller writes about again and again: spending my life in the library from the end of one year to the other, and writing every single day of that year and the years to follow. I was so busy writing that there was no time to notice how inadequate was the result, and the library provided me with a haven where the talents of other writers caused me to believe, by some reflected glory, that perhaps one day I would achieve their talent. On these two levels I'm able to comment comfortably and without my ego getting in the way.

I must confess that I rather like my younger self because I wrapped my ignorance around myself and got my work done.

> " I will try to weigh Sam Weller's book and give you my prejudiced opinion. "

Over the years when people have asked if I was an optimist, I said and proved otherwise. In other words, I was an optimal behaviorist. Any writer coming to this biography will find that I behaved every day of my life as if I knew where I was going.

The lessons that can be learned from this book are simply that if you write for a single day, at the end of that day you're pleased with the fact you wrote something. If you write every day for a week, you're even more pleased. And at the end of a year if you can look back on 365 days of writing every single day, a feeling of optimism rewards you.

It has always been my belief that optimism comes from action, not from imagined things about yourself and the future.

One of several things I can point out in this book, and of which I am mildly proud, is the fact that I wrote for thousands of days, pretending not to notice that I was inside the skin of a mildly ignorant person, on his way somewhere, who was going to the library for the information that I needed to get there.

So as a preamble or sequel to my *Zen in the Art of Writing,* I cannot help but recommend Sam Weller's patient recitation of my early days to show other young talents how to keep so busy that they won't be able to recognize their failures or their inadequacies.

Beyond that, Weller's discussion of the accomplishments and the rewards that came late in life is most pleasant, but nevertheless of no practical use to anyone planning a future of writing.

Sam Weller's *The Bradbury Chronicles* is a handbook of days—my days—where progress was slow, but continuous. I can only stand back and recommend Weller himself and let him speak with no further comment from me. ∾

> " Over the years when people have asked if I was an optimist, I said and proved otherwise. "

> " *The Bradbury Chronicles* is a handbook of days—my days—where progress was slow, but continuous. "

A Passage to Somewhere

by Sam Weller

To me, good research is often written with invisible ink. You can't see it, but it's there. It's only later, after reading an entire work that the apparition of all the inquiry begins to emerge and shimmer and rise to the surface. In writing *The Bradbury Chronicles,* I hoped to take nearly five years of fact-finding and to weave it well under the surface of a compelling, inspirational narrative—in this case, the fantastic life-voyage of Ray Douglas Bradbury.

Obviously, research is paramount to a credible biography, and I was always committed to contributing to Bradbury scholarship. I am confident I have done so. But, in my opinion, nothing stops a biography faster than the eight-hundred-page doorstop written in the tweed-and-tobacco vernacular of dissertation babble. With this mission in mind, to emphasize research, but to integrate it into rich, gripping storytelling, my journey began in a mysterious, often dizzying realm—a graveyard of ghosts Ray Bradbury liked to call: "Somewhere."

This notion of "somewhere" was a running joke between us. It began early in my research, when I would fly out every two or three weeks from my home in Chicago to visit Ray Bradbury at his home in the Cheviot Hills neighborhood of Los Angeles. We would spend mornings and early afternoons doing interviews. Then, Ray would take his requisite nap, a battery-charging ritual of sorts he has carried on throughout his life. During this time, I was free to explore the catacombs of the Bradbury house. I foraged through boxes, rifled filing cabinets, crept through cobwebs in the garage, and I rummaged deep through the vast laboratory of the imagination that is Ray Bradbury's storied basement office. I remember the very first time my eyes zeroed in on a file cabinet with a drawer marked "Novels in Progress," and another labeled "Short Stories in Progress." The files were bursting. But discovering documents and manuscript pages and letters often led to more questions than it gave answers. When Ray would awake from his siesta, I would ask him if he knew where I could find a particular letter, or a contract, or a photograph.

He would always laugh and sigh. "Oh . . . it's *somewhere!*"

Somewhere meant anywhere. Ray's house was organized chaos, much to the dismay of Maggie, his beloved wife of fifty-six years. Often times Ray could perform a miracle and direct me straight toward what I was looking for. But more often than not, I was left to my own devices—like Howard Carter sifting Egyptian sands on the mighty quest for Tut.

And somewhere meant elsewhere. During my years working on *The*

Bradbury Chronicles, Ray Bradbury's birthplace of Waukegan, Illinois, very nearly became a second home. One January afternoon, temperatures in the single digits and my own body temperature nearing a flu-induced 103 degrees Fahrenheit, I prowled through snow-blanketed local graveyards hoping to piece together the enigma of the vast Bradbury family tree. I spent days in the deeps of Waukegan's city hall, poring through records. I spent more time staring blurry-eyed into microfiche machines in the town library. Green Town is where Ray's imagination was born, and it was essential for me to illustrate how it came to be.

My travels took me to New York for a who's-counting-martini-lunch with Ray's agent of seven decades, Don Congdon. In my travels, I found every house Ray Bradbury had ever lived in. Bradbury geeks rejoice! I interviewed Maggie Bradbury for hundreds of hours. And in the post–9/11 world, where government information is often restricted Fort Knox–style, I hounded the Federal Bureau of Investigation through a Freedom of Information Act request to divulge that, indeed, they had a file on Ray Bradbury and that agents had parked on his palm-tree-lined street in the late 1950s to watch him, assuming he was a communist sympathizer. I interviewed hundreds of people, collected an office brimming to the rafters with transcribed interviews, archival letters, manuscripts, contracts, diaries, and photographs. I charged myself with funneling it all into visual story. I wanted *The Bradbury Chronicles* to read like a movie. Gripping! Amazing! A thrilling wonder-story about a boy born into nothing who made something incredible out of his life. This was premier in mind. For I believe that Ray Bradbury's rich sense of storytelling was born, in large part, of his early love of the cinema. It all started on an ice-gusted day in February 1924 when Ray's mother took her son to see *The Hunchback of Notre Dame* starring Lon Chaney.

In the end, *The Bradbury Chronicles* is the biography of an immense imagination and the origin of ideas. And this is the question Ray Bradbury is asked most often. Where do you get your ides?

The answer, simply?

Ray will tell you. "Somewhere!"

Or, better yet, as you hold this book in your hands, the real solution will emerge. Where does Ray Bradbury get his ideas? The answer appears in ever-materializing research. Wait a bit longer. Wait. Wait. You see it? You *will*.

The answer is written in invisible ink. All you need to do is hold it up to the light. ∾

The Books That Shaped My Imagination

by Ray Bradbury

Buck Rogers, comic strips by writer Phil Nolan and artist Dick Calkins

For me, it all starts with a comic book. Buck Rogers came into the world in October 1929 at the start of the Great Depression. I began to collect it, and it plummeted me into the future. It changed my life. Ray Bradbury, born August 22, 1920, in Waukegan, Illinois: destined to travel to Mars and never return from that year on.

Tarzan of the Apes, Edgar Rice Burroughs

Male animals want to control the world. When you're a nine-year-old boy, you're still trying to find your way in the world and you're just starting to learn about death. How can you conquer death? And Tarzan, this great masculine character, says, "I'll tell you what, watch me. I'll do it. And you do the same."

The Wizard of Oz, L. Frank Baum

I could hardly wait for summer vacation because I would sit by the open door of our house and look out the screen and reread *The Wizard of Oz.* I would play all the parts. I was a budding actor.

Complete Stories and Poems of Edgar Allan Poe

God created me as a metaphoric stickum creature; any metaphor sticks to me. The stories of Poe are all metaphors: "The Cask of Amontillado," "The Black Cat," "The Pit and the Pendulum." Wonderful stories.

The Invisible Man, H. G. Wells

In my teens, Wells understood my native-born paranoia. Boys of seventeen, eighteen, and

nineteen are paranoid. All the novels of H. G. Wells are paranoid. The invisible man said, "If the world doesn't behave, I will teach it to behave." Young men are full of that. They try to control what can't be controlled. By reading a good story by Wells, you can purge yourself of this.

Of Time and the River: A Legend of Man's Hunger in His Youth, **Thomas Wolfe**
Certain novelists open the gates of life to us. Wolfe says about life, "Look at that banquet out there. Fantastic, isn't it? How are you going to eat it all?"

The Grapes of Wrath, **John Steinbeck**
On my way back from New York, I went to Waukegan and bought a copy of *The Grapes of Wrath* at the United Cigar Store. I got on the Greyhound bus and I went west on the same Route 66 that the Okies took going to California. Can you imagine a better circumstance to read that book? I was out of my mind!

Winesburg, Ohio, **Sherwood Anderson**
Finishing the book, I said to myself, "Someday I would like to write a novel set on the planet Mars, with similar people." I immediately jotted down a list of the sorts of folks I would want to plant on Mars.

Moby-Dick, **Herman Melville**
I went to see *Moby Dick* at a silent film theater. I came home and I had a copy of *Moby-Dick* in the living room and I said to my wife, Maggie, "I wonder how long it will be before I finally read this book." A month later, John Huston said to me, "Read the book. I want you to write the screenplay for my adaptation." I read it and immediately saw the metaphors. I went back the next day to John and said, "I'll do it."

Plays by George Bernard Shaw
I have always thought that George Bernard Shaw deserved to be the patron saint of the American theater. Avant-garde in 1900, he remains light years ahead of our entire avant-garde today.

And the Films . . .

by Ray Bradbury

Robin Hood (1922)
Douglas Fairbanks was the star of this picture and I was named for him when I was born. So many of these early favorite films all had the same theme—unrequited love. I must have made the connection at some secret level. Maybe I was preparing myself for a failed love affair.

The Phantom of the Opera (1925)
I saw it when I was five and there was an element in me that reacted to the metaphor. If his mask could have stayed on, perhaps the phantom could have had real love. The more I look at my life and all of the films that influenced me, there's always the metaphor there.

The Lost World (1925)
The dinosaurs were instant loves. I knew that they had existed millions of years before and I was amazed at the size and the beauty of these things and the fact that they had been dead for millions of years and with all my heart and soul I wanted them to be alive again. And this movie provided me with a means to make them to be alive. Dinosaurs have been constant companions through all of my life.

The Black Pirate (1926)
This was Douglas Fairbanks again. It was one of the first Technicolor films and I saw it while I lived in Tucson in 1926. It had wonderful color. The tales of derring-do. The romantic adventures of people like pirates influenced me very much when I was quite young.

The Mysterious Island (1929)
Jules Verne was the master of metaphor either under the sea or on mysterious islands or visits to the moon or around the world in eighty days or traveling to center of the earth. The immense size and complexity of the metaphors shocked me.

The Skeleton Dance (1929)
When I was eight years old, they showed *The Skeleton Dance* by Walt Disney at the Genesee Theater in Waukegan and I was so enchanted with it that I stayed on and saw it at least three times. And they were running a terrible film, I believe with Adolphe Menjou, full of love and mush. I put up with it. I ran to the bathroom a lot and came back and saw *The Skeleton Dance* and realized that I had seen something that had changed my life. My father had to come to the theater that night to drag me out and to take me home. I didn't want to leave.

The Mummy (1932)

Again, it's unrequited love. The mummy is trying to bring back his lost love from 4000 years before and it's an impossible situation. I saw the film at a theater in the center of Tucson when I was twelve. The theater was having some sort of union trouble and someone threw a stink bomb inside so that people would be uncomfortable and wouldn't stay for the performance. But they couldn't do that to me. I stayed through with my brother and I thought it was one of the most beautiful films ever.

King Kong (1933)

I remember every theater I saw every film in. I saw *King Kong* in the Fox Theater in Tucson, Arizona. I sat there in the front row and when Kong hit the screen, boy, I tell you, he fell on me. It was a concussion. He was so titanic. It's so simple. It rises and rises and rises to series of climaxes and then a super climax. This film changed my life forever. After seeing it, I went home and wrote the screenplay on my dial typewriter. It took forever, but I wanted to remember the dialogue. Later, in 1934 when we had moved to Los Angeles, the girl who lived next door had her father's typewriter and I went over and retranslated my screenplay and submitted it in my short-story class at high school. My teacher, Jeanette Johnson, was very sweet. She wrote on the script, "I don't know what you're doing, but you're doing it very well." All of my early stories were bad imitations like this. I hadn't found myself yet so I was busy imitating.

Things to Come (1936)

H. G. Wells was very paranoid and so much of his stuff was negative. But at the end of this film, where they shoot the rocket off to the moon and Cabal and his partner watch the image on a giant screen and his partner says, "Is that all there is? I mean, what is this all about?" And Cabal says, "Which shall it be, the stars or the grave?" I left the theater after seeing this and I was crying. The music came up and the voices kept repeating, "Which shall it be . . . which shall it be . . ." and I knew which one it had to be. I saw this film three or four times in the next week sneaking in each time because I had no money.

Fantasia (1940)

I saw it in the summer of 1940 with my aunt Neva. We couldn't go to the premiere because it cost, maybe, two or three dollars and we didn't have that. But I think the first night after the premiere it was a dollar. Neva and I went and I came out raving—raving about the film. Of course, my Aunt Neva was crazy for it too. I was selling newspapers on a street corner at the time and I took all of my money and invested it in tickets to *Fantasia*. I took my friends to see it and I watched their faces during the film. And if they didn't like it that was the end of the friendship!

Have You Read?
More by Ray Bradbury

AHMED AND THE OBLIVION MACHINES

Ray Bradbury's wondrous children's fable traces the adventures of a lost boy who makes the acquaintance of a long-forgotten, though very powerful, ancient god.

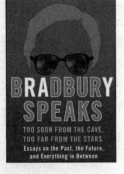

BRADBURY SPEAKS

A highly personal, deeply felt collection of essays, *Bradbury Speaks* offers an intimate look into one of the most fertile and dazzling imaginations of the modern age.

BRADBURY STORIES

The one hundred stories in this volume were chosen by Bradbury himself, and span a career that blossomed in the pulp magazines of the early 1940s and continues to flourish in the new millennium.

THE CAT'S PAJAMAS

In this 2004 collection, Ray Bradbury presents twenty-two new and amazing tales, all but two never before published.

DANDELION WINE

The author's most deeply personal work, *Dandelion Wine* is a semiautobiographical recollection of a magical small town summer in 1928.

DEATH IS A LONELY BUSINESS

Ray Bradbury dips his pen into the cryptic inkwell of noir to create a stylish and slightly fantastical tale of mayhem and murder set in Venice, California, in the early 1950s.

DRIVING BLIND

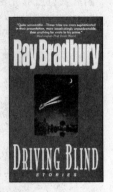

Driving Blind is a stunning collection of short fiction. Here are unforgettable excursions to the fantastic, glorious grand tours through time and memory, unexpected side trips to the disturbing and eerie.

FROM THE DUST RETURNED

In an extraordinary flight of the imagination a half-century in the making, Ray Bradbury takes us to a most wondrous destination: into the heart of an Eternal Family.

A GRAVEYARD FOR LUNATICS

Halloween night, 1954. A young, film-obsessed scriptwriter has just been hired at one of the great studios. An anonymous invitation leads him from the studio's back lot to an eerie graveyard separated from the studio by a single wall.

GREEN SHADOWS, WHITE WHALE

In this comic autobiographical novel, Ray Bradbury recounts his unexpected odyssey through Ireland, where, in 1953, he was summoned by famed director John Huston to write a screenplay for *Moby Dick*.

I SING THE BODY ELECTRIC!

Each of these twenty-eight classic Bradbury stories (and one luscious poem) has something profound to tell us about our own humanity.

THE ILLUSTRATED MAN

The Illustrated Man is widely believed to be one of Bradbury's premier accomplishments: eighteen startling visions of humankind's destiny—a kaleidoscopic blending of magic, imagination, and truth.

LET'S ALL KILL CONSTANCE

On a dismal evening, a once-glamorous Hollywood star pounds on a writer's door. In her hands are two anonymously delivered books that have sent her running in fear: twin lists of the Tinsel town dead and soon-to-be dead . . . with her name among them.

THE MARTIAN CHRONICLES

Of all the dazzling stars in the vast Bradbury universe, none shines more luminous than these masterful chronicles of Earth's settlement of the fourth world from the sun. *The Martian Chronicles* is a classic work of twentieth-century literature whose extraordinary power and imagination remain undimmed by time's passage.

A MEDICINE FOR MELANCHOLY

Sinister mushrooms growing in a dank cellar. A family's first glimpse at Martians. A wonderful white vanilla ice-cream summer suit that changes everyone who wears it. All those images and many more appear in this trade edition of thirty-one classic Bradbury tales.

THE OCTOBER COUNTRY

The author's first collection of stories takes readers to many places: a picturesque Mexican village where death is a tourist attraction; a city beneath the city where drowned lovers are silently reunited; a carnival midway where a tiny man's most cherished fantasy can be fulfilled night after night.

ONE MORE FOR THE ROAD

Another round on Ray Bradbury—eighteen new stories and seven previously published but never before collected. Here is a rich elixir distilled from the pungent fruit of experience and imagination, expertly prepared by a superior mixologist.

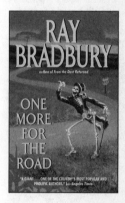

QUICKER THAN THE EYE

In these twenty-one stories, the master tells all, revealing the strange secret of growing young and mad; opening a Witch Door that links two intolerant centuries; joining an ancient couple in their wild assassination games.

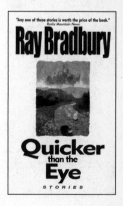

Read on

Have You Read? *(continued)*

SOMETHING WICKED THIS WAY COMES

Few American novels have endured in the heart and memory as has this unparalleled literary classic. When Cooger & Dark's Pandemonium Shadow Show comes to town, two boys learn all too well the heavy cost of wishes . . . and the stuff of nightmare.

A SOUND OF THUNDER AND OTHER STORIES
(previously titled *The Golden Apples of the Sun*)

Here are thirty-two of Bradbury's most famous tales—prime examples of the poignant and mysterious poetry he uniquely uncovers in the depths of the human soul.

FAHRENHEIT 451 (Audio)

Internationally acclaimed with more than five million copies in print, *Fahrenheit 451* is Ray Bradbury's inspired novel of censorship and defiance. Read by the author himself, this audio edition of an American classic is as resonant today as it was when it was first published nearly fifty years ago.

Don't miss the next book by your favorite author. Sign up now for AuthorTracker by visiting www.AuthorTracker.com.